A MYRIAD OF AUTUMN LEAVES

THE EXHIBITION AND CATALOG WAS MADE POSSIBLE BY
A GENEROUS GRANT FROM **SCM** SCM CORPORATION

A Myriad of Autumn Leaves

JAPANESE ART FROM THE
KURT AND MILLIE GITTER COLLECTION

CATALOG BY

Stephen Addiss
Michael R. Cunningham
Pat Fister
William Jay Rathbun
Melinda Takeuchi

NEW ORLEANS MUSEUM OF ART

1983

3,000 copies of the catalog were published for the exhibition, *A Myriad of Autumn Leaves: Japanese Art from the Kurt and Millie Gitter Collection.*

New Orleans Museum of Art November 13, 1983—January 15, 1984

The Walters Art Gallery, Baltimore February 15—April 22, 1984

ISBN 0-89494-017-1
Library of Congress catalog card number 83-43150

Cover Illustration: detail, Sakai Hōitsu, *Maple Leaves* (from Triptych)

Designed by Jerry Schuppert, Printing Production Service, Inc., New Orleans, La.
Photography: Paintings photographed by Rick Brocato
 Ceramics and sculpture photographed by Owen Murphy
Typography by Forstall Typographers and Martin/Greater Film Graphics, Inc., New Orleans, La.
Printed in the United States by Congress Printing Company, Chicago, Ill.

CONTENTS

FOREWORD AND ACKNOWLEDGEMENTS

No other people in the world have a greater sensitivity to nature and its changing cycles than the Japanese. These feelings are portrayed in their earliest literature and paintings and have continued to provide inspiration for generations of artists. One aspect of this attitude, termed in Japanese *mono no aware*, involves a bittersweet perception of the transience of all living things. The beauty of the seasons, as well as human life, is ephemeral. Autumn is both the most beautiful and the saddest of seasons. A poem of the seventh century by Princess Nukada, comparing spring to autumn, is an early expression of these feelings:

> *We see the leaves*
> *On an autumn hill;*
> *We pick the red leaves,*
> *Admiring and praising;*
> *We leave the green ones,*
> *sighing and grieving.*[1]

Many of the paintings in this exhibition of Japanese art from the collection of Kurt and Millie Gitter have seasonal references. Such works attest to the preoccupation of artists of the Edo Period with these subjects, no matter in what school or style they worked. The title of the present exhibition—*A Myriad of Autumn Leaves*—seems especially appropriate for a survey of the rich diversity of the art of the Edo Period.

This is the second exhibition that the New Orleans Museum of Art has organized of works from the Gitter collection. The first, *Zenga and Nanga: Paintings by Japanese Monks and Scholars*, was presented in 1976 and focused on artists of two particular schools of the Edo Period. The present exhibition, which includes only one work from the first show (the great *Virtue* calligraphy by the monk Hakuin), is broader in scope, with paintings from nearly all the major schools of the period, as well as ceramics and sculpture. However this exhibition also reflects the personal tastes and passions of the collectors. Works of the Nanga and Zenga schools predominate in the selection of paintings. The Gitters have a special admiration for three artists, who are among the greatest Japan has produced: Ike Taiga, Yosa Buson, and Hakuin Ekaku. These masters are represented in the exhibition by, respectively, seven, four, and five works each. Thus the exhibition retains the personal flavor of a private collection, while presenting a survey of Edo painting.

Working closely with Kurt and Millie Gitter, the Museum began planning the exhibition three years ago. Under the direction of the Museum's Adjunct Curator of Japanese Art, Dr. Stephen Addiss, Associate Professor of Art History, University of Kansas, a team of guest curators was assembled to select the exhibition, research the works, and write the catalog. Joining Dr. Addiss were four other distinguished American scholars: Dr. Michael Cunningham, Curator of Japanese Art, Cleveland Museum of Art; Dr. Pat Fister, Research Fellow of Japanese Art, New Orleans Museum of Art; William J. Rathbun, Curator of Japanese Art, Seattle Art Museum; and Dr. Melinda Takeuchi, Assistant Professor of Art History, Stanford University. The New Orleans Museum of Art is most grateful to these five

scholars for their thoughtful and original contributions to this publication. In conjunction with the opening of the exhibition, each of the guest curators, together with other noted scholars from Japan, the United States, and Britain, will participate in an International Symposium on the Arts of the Edo Period. We hope that both the exhibition catalog and the symposium will make a significant contribution to the growing appreciation and knowledge of Japanese art in America.

An exhibition of this scope and complexity results from the efforts of many individuals and organizations. First the Museum is pleased to acknowledge the important support received from SCM Corporation. The generous grant from SCM was a key factor in the successful presentation of the exhibition and publication of the catalog.

The guest curators called upon their colleagues both here and abroad for advice and opinions in the process of their research. On behalf of the authors, I want to thank all of these individuals, who are acknowledged where appropriate in the text. The catalog of the exhibition has been beautifully designed by Jerry Schuppert, with a sensitivity and intelligence that the Japanese would term *shibui*.

Working in an art museum is a continuing aesthetic education. In this respect, nothing has been more personally rewarding than my friendship with Kurt and Millie Gitter. As one of our Trustees, Kurt has been intensely involved with the Museum for the past decade. During this period, the Gitters have generously assisted the Museum in building a fine collection of Japanese art of its own. I have had the opportunity of traveling with them to Japan on several occasions, thereby receiving a unique introduction to the art and people of that extraordinary country. I have shared with them the excitement of the pursuit and acquisition of some of the works in this exhibition, in the process observing their discriminating connoisseurship at first hand. The two exhibitions of selections from the Gitter collection organized by our Museum are but one indication of Kurt and Millie's enthusiasm for sharing with a wider public their love of the arts of Japan. The New Orleans Museum of Art is proud to join with the Gitters in presenting this exhibition.

E. John Bullard
Director

[1] Translated by Geoffrey Bownas and Anthony Thwaite, *The Penguin Book of Japanese Verse* (Middlesex, England, 1964).

PREFACE

Japanese aesthetics have influenced Western culture for more than a century. When Admiral Perry entered Japan in 1853 and initiated the reopening of foreign trade, the self-imposed 240 year isolation from outside influence which characterized the Edo Period (1615-1868) ended. This permitted the cultural and artistic expressions of Japan to fully permeate Western societies. These influences were disseminated primarily in the fields of architecture, painting, and the decorative arts. After the Second World War, the economic and social aspects of Japanese society had a similarly significant impact on West, most profoundly during the past thirty-five years in which the United States has become Japan's greatest trading partner, as well as ally.

Significant collections of Japanese ceramics began to form in the nineteenth century, when export porcelains from Arita, Kakiemon, and Kutani were appreciated in Europe and influenced the domestic porcelain industries in the West. Japanese woodblock prints representing life in the "floating world" of Edo, likewise, were highly admired and appreciated in Europe and America and influenced the creative expressions of the impressionists, post-impressionists, and early 20th century painters in terms of color, design and perspective. The impact of understated design, simplicity, and elegance in Japanese architecture (both ancient and contemporary) was evident in the genius of Frank Lloyd Wright and the Bauhaus School. These influences have persisted today and affect architectural design throughout the world.

Prior to World War II, the appreciation of Japanese painting in America was limited to only a small group of collectors such as Charles Freer, Ernest Fenollosa, Edward Sylvester Morse, Richard Fuller and a few others. These clairvoyant men, by virtue of first-hand experiences in Japan, with their connoisseurs' instincts, assembled large collections which were later made available to the public for study and enjoyment. The Freer Gallery of Art, the Museum of Fine Arts in Boston, and the Seattle Art Museum inaugurated their great Japanese collections through the activities of these collectors.

The most dramatic changes in art collecting and scholarship occurred in the post-1945 period when American-Japanese relations gained momentum and the interchange between our two countries expanded on a cultural, economic and political basis. As a result of these interactions, there was an increased appreciation of things "Japanese" including art. The number of scholars, connoisseurs and collectors specializing in Japanese art has dramatically increased since 1950. The scholarship in this new field has been exemplified by an outpouring of books and articles and a significant increase in the number of exhibitions organized (with catalogs in English), which have introduced the general public in the West to a greater aesthetic appreciation of Japanese art.

Simultaneously, in the post war period, many American museums such as the Metropolitan, Freer, and those in Boston, Cleveland, Chicago, Kansas City, San Francisco, Los Angeles, New Orleans, Detroit, Brooklyn and others have either established significant Japanese art collections or continued to expand previously existing ones. The Japan Society and the Asia

Society have both been instrumental in educating the public through thoughtfully organized exhibitions and educational programs. In Japan, the Agency of Cultural Affairs (Bunkachō) also has successfully organized important traveling exhibitions to foreign countries (culminating in The Great Japan Exhibition of Edo art in London, 1981-82) which have helped to gain increasing international recognition for Japanese art.

In post-World War II Japan, there was a great supply of fine art available for purchase because of the depressed economic state and the relative lack of interest in native arts by the Japanese. Consequently, it was during the past thirty-five years that many of the important public and private collections in the West have been assembled. In the past ten years, an increasing awareness of the magnitude and significance of Edo period art in Japan has brought forth changes in the art market followed by a decreasing supply of fine objects and rising prices. Regional museums have sprung up throughout Japan, and are now intent on establishing their own collections, stimulating and awakening a general interest in the Japanese people for the art of their own country.

My wife Millie and I began collecting Japanese art in 1963-64 during a two-year Air Force assignment on the island of Kyūshū. Living in a small rural rice village on the seashore in a Japanese style home with the surrounding natural environment was a direct contrast to the urban centers of the northeastern United States, from which we had just come. The beauty of nature, the mannerisms and character of the Japanese people, and, above all, the aesthetics of their everyday culture, had an immediate and long-lasting impact on us. On returning to New Orleans, we chose to live in a Bauhaus style house and incorporated many of the Japanese aesthetics into our everyday existence.

From this time on we turned our collecting instincts (which previously had been focused on contemporary American art and post-impressionist prints) toward Japanese objects. Appreciation of Japanese painting for the most part is an acquired taste that increases with exposure. Our first acquisitions were sculpture, including the haniwa in this exhibition, along with Japanese ceramics, and a few paintings. The haniwa, although dating from the fifth century A.D., was simple and beautiful in form, relating as much to contemporary art as to Japanese antiquity.

In 1969, a visit to Japan for a medical conference prompted a renewed interest and inaugurated a fifteen year active process of collecting all forms of Japanese art. During this period, annual trips to the Orient resulted in an ever-increasing awareness of the depth and breadth of Japanese art and an increasing commitment to enlarge the scope and quality of our collection. On each successive trip, through continued exposure and learning, our understanding of Japanese art expanded, confirming our belief about the greatness and excellence of these fine arts as compared to other cultures. We concentrated mainly on Edo period painting because of a natural love for the works, particularly Nanga and Zenga, and because of its availability and relative undervaluation at the time. In 1975, the New Orleans Museum of Art first exhibited part of our painting collection in a show entitled Zenga and Nanga: Paintings by Japanese Monks and Scholars, which travelled to six other American museums. Since then we have broadened our horizons to collect other schools of painting (such as Rimpa, Shijō, Kanō), as well as more ceramics and sculpture.

The Japanese name *Manyoan* (a myriad of autumn leaves) was originally conceived by our late and dear friend, Harold P. Stern, the former Director of the Freer Gallery of Art. While visiting our country farm seven years ago, during his terminal months, Phil was struck by the simple beauty of its natural setting and suggested the name *Manyoan* for the farm. When this new exhibition was in the planning stages, my wife appropriately thought of using this name for the title of the show, since it calls forth a visual image of beauty and serenity.

This fifteen year active process of learning and acquiring fine Japanese objects have been a source of continued pleasure and growth for us. We are gratified that our ties to the New Orleans Museum of Art have prompted an increasing awareness of the significance of Japanese art in a region of the country where it had been previously less appreciated than the arts of other cultures. We are pleased and privileged to make this collection available for public view and enjoyment and to share in the overall concern for greater scholarship and understanding of Japanese art.

<div align="right">Kurt A. Gitter, M.D.</div>

WORKS IN THE EXHIBITION

Paintings

MUROMACHI, KANŌ AND TOSA PAINTING

1. SESSON Shūkei (1504-1589), *Grapes and Bamboo*
2. School of Kanō SANRAKU (1559-1635), *Scholars Practicing Calligraphy*
3. Attributed to Kusumi MORIKAGE (late 17th century), *Sericulture*
4. Kusumi MORIKAGE (late 17th century), *Hollyhock and Sparrows*
5. Kanō TSUNENOBU (1636-1713), *Landscape with Figures*
6. Kanō TSUNENOBU (1636-1713), *Fifty Noted Places in China and Fifty Noted Places in Japan*
7. Tosa MITSUOKI (1617-1691), *Quail*

RIMPA PAINTING

8. Style of Hon'ami KŌETSU (1558-1637), *Calligraphy: Although the Wind Still Blows*
9. Signature of Tawaraya SŌTATSU (fl. first half of 17th century), *Duck Flying Over Iris*
10. School of Tawaraya SŌTATSU (second half of 17th century), *The Four Sleepers*
11. Anonymous (second half of 18th century), *Black Lacquer Cosmetic Box with Design of Chrysanthemums and Stream*
12. Nakamura HŌCHŪ (fl. 1790-1818), *Hollyhocks*
13. Sakai HŌITSU (1761-1828), *Maple Branch*
14. Sakai HŌITSU (1761-1828), *Triptych of Flowers and Rising Sun*
15. Suzuki KIITSU (1796-1858), *Morning Glories*
16. Suzuki KIITSU (1796-1858), *Autumn Grasses and Flowers*
17. Sakai ŌHO (1808-1841), *Autumn Maple*

ZENGA

18. FŪGAI Ekun (1568-1654), *Daruma on a Reed*
19. Ōbaku TAIHŌ (1691-1774), *Bamboo in Snow*
20. HAKUIN Ekaku (1685-1768), *Two Blind Men Crossing a Log Bridge*
21. HAKUIN Ekaku (1685-1768, *Ant on a Stone Mill*
22. HAKUIN Ekaku (1685-1768), *Monkey*
23. HAKUIN Ekaku (1685-1768), *The Bridge at Mama*
24. HAKUIN Ekaku (1685-1768), *Calligraphy: Virture*
25. TŌREI Enji (1721-1792), *Ensō*

NANGA—INDIVIDUALISTS IN ŌSAKA AND KYOTO

55. Totoki BAIGAI (1733 or 1749-1804), *Album of Twelve Months*, 1803
56. Signature of Okada BEISANJIN (1744-1820), *Mist and Waterfalls Amidst the Mountains*, 1812
57. Uragami GYOKUDŌ (1745-1820), *Spring Clouds Like Thick Paste*

NANGA—CONSERVATIVES IN KYOTO AND NAGOYA

58. Rai SAN'YŌ (1780-1832), *Mountain Landscape*
59. Nakabayashi CHIKUTŌ (1776-1853), *Summer Mountains in Clearing Rain*, 1841
60. Yamamoto BAIITSU (1783-1856), *Green Willows and White Herons*
61. Nukina KAIOKU (1778-1863), *Fu-ch'un Mountain and Te-sheng Embankment*
62. Nukina KAIOKU (1778-1863), *Willow Landscape*, 1860
63. Hine TAIZAN (1813-1869), *Dawn Bell at Nan'pin*
64. Hine TAIZAN (1813-1869), *Spring and Autumn Landscapes*, 1865
65. Nakabayashi CHIKKEI (1816-1867), *Landscape Screens*, 1857
66. Fujimoto TESSEKI (1817-1863), *Myriad Peaks and Fragrant Waters*, 1858
67. Murase TAIITSU (1803-1881), *Western Journey*

INDIVIDUALISTS

68. Itō JAKUCHŪ (1716-1800), *Kanzan and Jittoku*
69. Soga SHŌHAKU (1730-1781), *Orchid Pavilion*

MARUYAMA SCHOOL PAINTING

70. Komai GENKI (1749-1779), *Woman Washing Clothes in a Stream*
71. Nagasawa ROSETSU (1754-1799), *Cormorant Fishing*
72. Yamaguchi SOKEN (1759-1818), *Kamo River Party*
73. Watanabe NANGAKU (1767-1813), *Two Women Embroidering*
74. Maruyama ŌSHIN (1790-1838), *Children Playing in Summer and Winter*

SHIJŌ SCHOOL PAINTING

75. Matsumura GOSHUN (1752-1811), *Sweeping Flower Petals*
76. Matsumura GOSHUN (1752-1811), *Man with Hoe and Bamboo* and *Old Man with Hoe and Basket*

77. Matsumura KEIBUN (1779-1843), *Spring and Autumn*

78. Shiokawa BUNRIN (1808-1877), *Boating Party and Farmers*

79. Shibata ZESHIN (1807-1891), *Samurai By the Bridge*

Ceramics

80. Haji ware, Kofun period, 4th century, *Jar*

81. Seto ware, Kamakura period, 13th-14th century, *Vase*

82. Shigaraki ware, Kamakura period, 14th century, *Storage Jar*

83. Shigaraki ware, Muromachi period, early 15th century, *Storage Jar*

84. Shigaraki ware, Muromachi period, 16th century, *Tea Jar*

85. Tamba ware, Kamakura period, 14th century, *Storage Jar*

86. Echizen ware, late Kamakura period-early Muromachi period, 14th-15th century, *Storage Jar*

87. Bizen ware, Muromachi period, 16th century, *Seed Jar*

88. Bizen ware, Momoyama period, 16th century, *Tea Jar*

89. Iga ware, early Edo period, first quarter of 17th century, *Cold Water Jar*

90. Mino ware, E Shino type, Momoyama period, late 16th century, *Food Dish*

91. Takeo Karatsu ware, Yumino kiln, Edo period, 18th century, *Wide-mouth Storage Jar*

92. Takeo Karatsu ware, possibly Yumino kiln, Edo period, 19th century, *Saké Bottle*

93. Seto ware, Edo period, early 19th century, *Oil Plate*

94. Seto ware, Edo period, early 19th century, *Oil Plate*

95. Seto ware, Edo period, 19th century, *Oil Plate*

96. Seto ware, Edo period, ca. 1800, *Serving Plate*

97. Seto ware, Edo period, ca. 1800, *Serving Plate*

KITAŌJI ROSANJIN (1883-1959):

98. *Rectangular Deep Bowl*

99. *Bizen ware style Jar*

100. *Bizen ware style Large Plate*

101. *Oribe ware style Rectangular Bowl*

102. *Oribe ware style Square Bowl*

103. *E Shino ware style Square Bowl*

104. *Round Dish with Three Feet*

Sculpture

6 Kanō Tsunenobu (1636-1713), *Jingō-ji on Mt. Takao,* from album of *Fifty Noted Places in Japan*

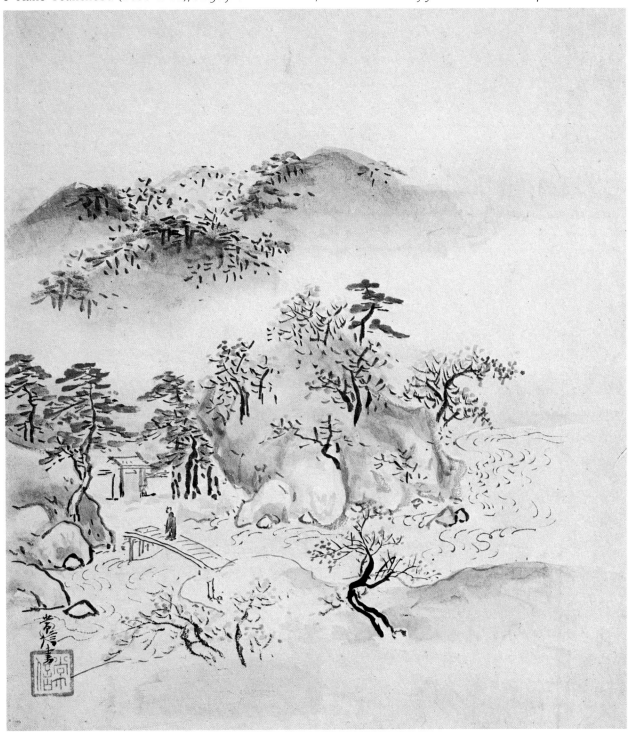

12 Nakamura Hōchū (fl. 1790-1818), *Hollyhocks*

37 Ike Taiga (1723-1776), *Pleasures of Fishing*

得魚尋常事泊
酒人蘆荻蒼 霞進

39 Ike Taiga (1723-1776), *Lake Landscape with Boating Party* (detail)

46 Yosa Buson (1716-1784), *One Hundred Old Men* (detail)

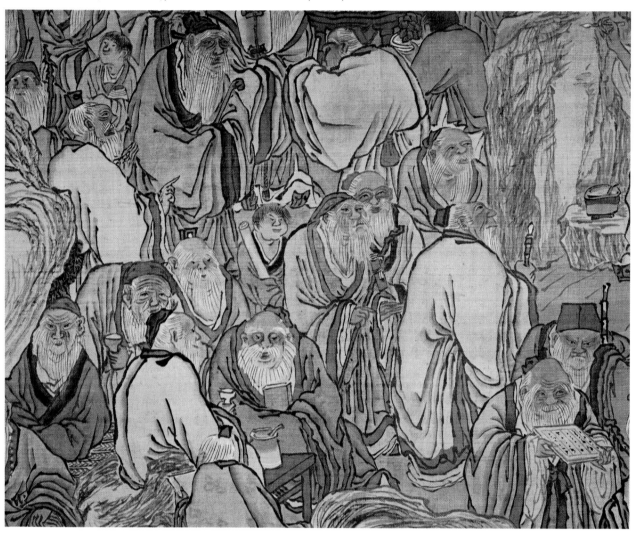

Tsubaki Chinzan (1801-1854), *Lotus Leaves and Willow Tree in Moonlight* (detail)

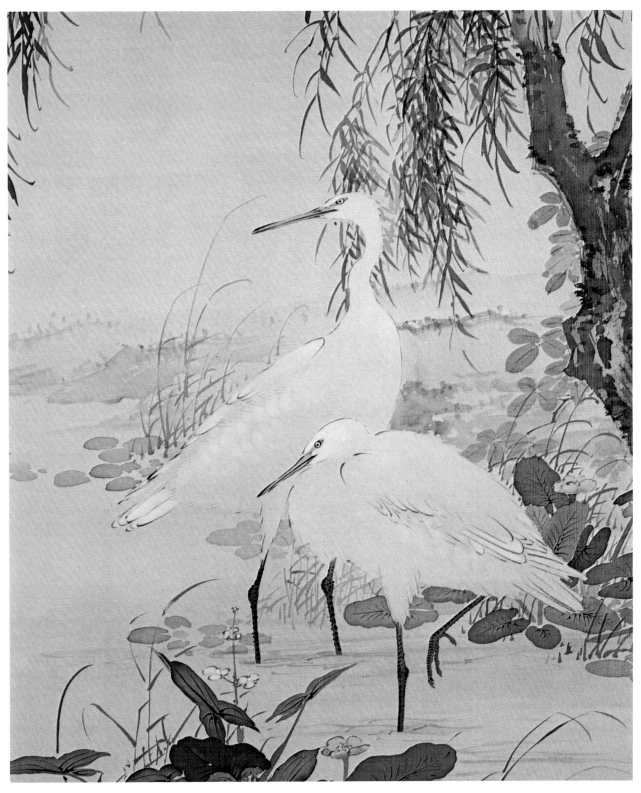

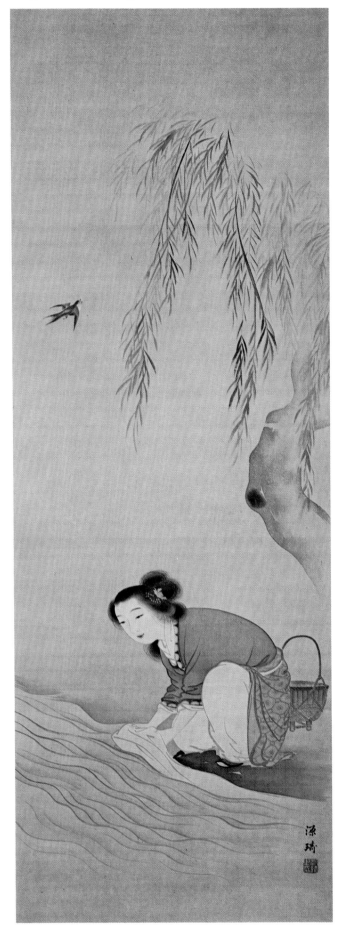

72 Yamaguchi Soken (1759-1818), *Kamo River Party*

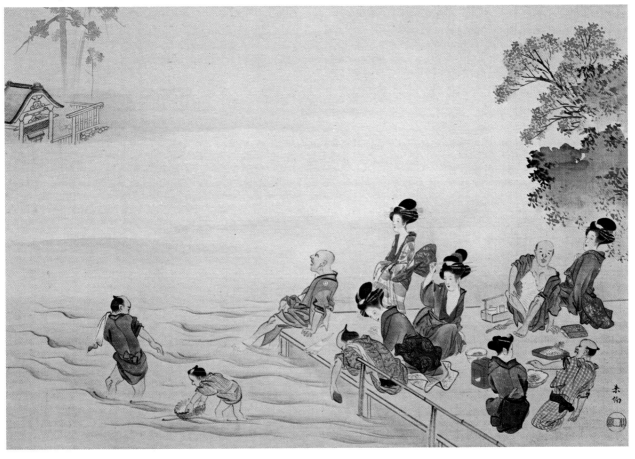

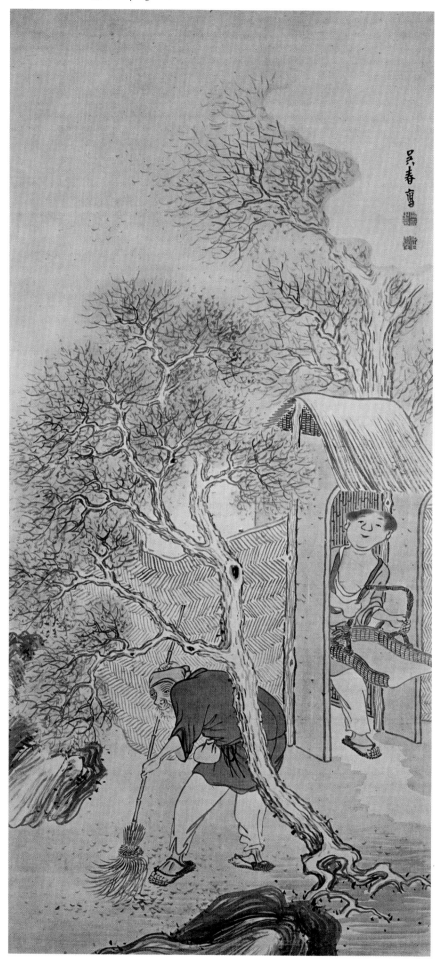

77 Matsumura Keibun (1779-1843), *Spring and Autumn* (detail)

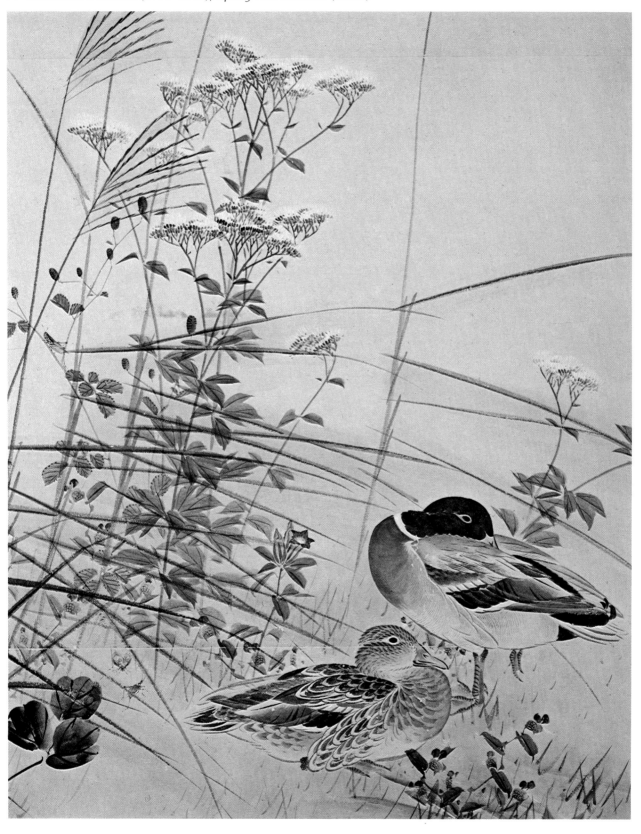

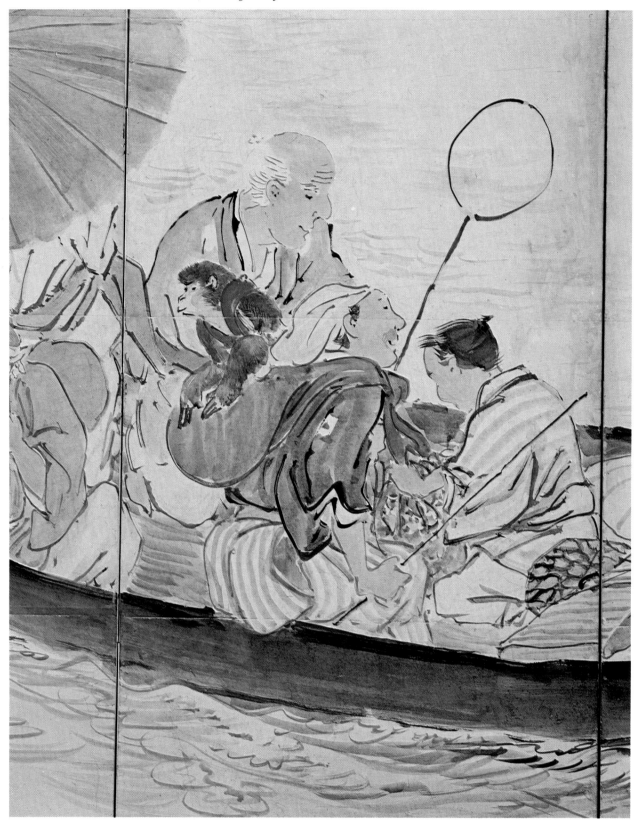

89 Iga Ware (first quarter of 17th century), *Cold Water Jar*

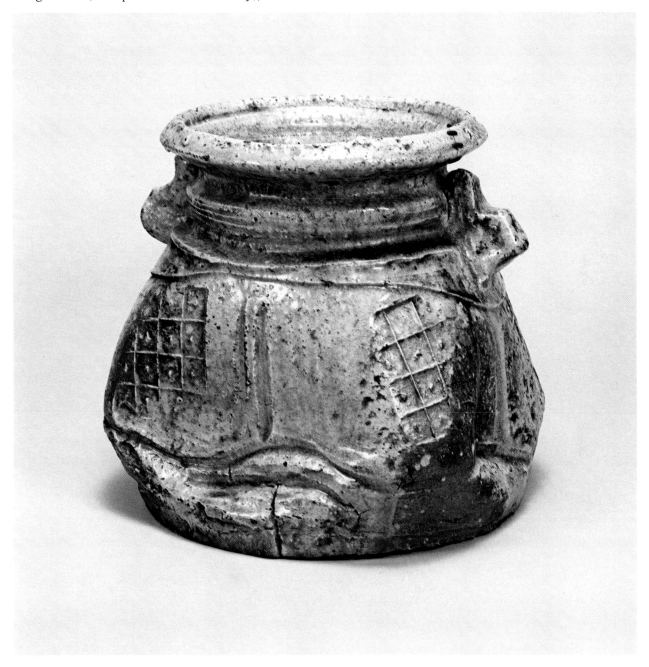

102 Kitaōji Rosanjin (1883-1959), *Oribe ware style Rectangular Bowl*

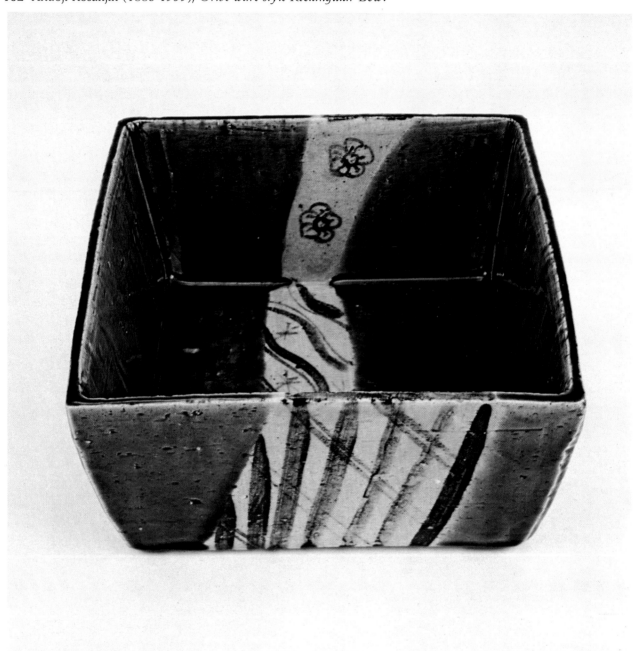

NOTES TO THE CATALOG

The author of each entry is indicated by initials at the end of each entry: SA, Stephen Addiss; MRC, Michael R. Cunningham; PF, Pat Fister; WJR, William Jay Rathbun; and MT, Melinda Takeuchi. Translations not otherwise credited are by the author of each entry.

Measurements, exclusive of mountings, are given in centimeters and inches, height preceding width. Photographs of the seals on the paintings have been reproduced actual size. All Japanese names are rendered in the traditional Japanese manner, with surname preceding given name.

Those objects reproduced in color are indicated by an asterisk in front of the catalog number of the entry. Pairs of screens, when illustrated on the same page, are reproduced right over left.

MUROMACHI, KANŌ AND TOSA PAINTING

One of the richest of Japanese art traditions is that of monochrome ink painting. The subject, whether landscape, plants or figures, is painted almost solely with ink which has been ground and mixed with water to create a variety of tones comparable to shades of color. The brush techniques in ink painting are also diversified, and it is remarkable to watch the lines, strokes and wash transform into trees, mountains or figures. The first great flowering of this tradition occurred in the Muromachi period (1336-1573) when Japan was under the control of the Ashikaga family. Its leaders adopted the title of Shōgun and established a new military administration in Kyoto, ending temporarily the civil wars which had lacerated Japan for over a century. Trade with China was encouraged at this time, and merchants returned with a wealth of art objects. Among the many art forms brought to Japan were monochrome ink paintings which had developed into a major form of expression in China.

During the first century of the Muromachi period, the development of Japanese ink painting was closely linked with the Zen sect of Buddhism. The great Zen monasteries developed into intellectual and cultural centers, and Japanese monks became deeply involved in Chinese scholarship and the arts. Many of the monks were closely associated with the Ashikaga family, and it was largely through their influence that monochrome ink painting established itself in Japan. The Ashikaga Shōguns were great patrons of the arts, and in many cases skilled painters themselves.

Initially, it was mainly Zen monks like Sesson Shūkei (No. 1) who painted in the Chinese manner, but gradually the style was taken up by professional painters. Among the professional artists, it was the Kanō School which grew to have the most profound and lasting impact on the development of Japanese painting. Its origins can be traced back to Kanō Masanobu (1434-1530) who served as an official artist to the Ashikaga Shogunate. He established the Kanō as a line of professional painters who worked on commission for warrior patrons, a status which continued into the nineteenth century. At first Kanō artists painted subjects traditionally associated with Zen, such as legendary Zen figures or mountain retreats, but their works became more secular in spirit and increasingly independent of the subtle Zen philosophy. In addition to landscapes (No. 50), they specialized in bird-and-flower and figure subjects, frequently depicting Chinese themes exemplified by *Scholars Practicing Calligraphy* (No. 2).

By the Edo period (1615-1868), the Kanō School had become an enormous organization, with certain families dominating different areas of Japan. They continued to be patronized by Japan's ruling samurai class, and were traditionally favored for decorating palaces and castles. Aspiring artists often received their first training in Kanō workshops, even though some eventually left and developed independent styles (see Nos. 3 and 4).

In the seventeenth and eighteenth centuries, artists of all schools turned to the native landscape for inspiration, and the Kanō School was no exception. Although the school had traditionally emphasized Chinese-style landscapes, Kanō artists began to paint the celebrated beauty spots of Japan in answer to the rising popular demand. Kanō Tsunenobu's albums of famous places in

China and Japan (No. 6) is significant for it represents both the continued interest in Sinophile painting and natural love for Japan.

Another important hereditary line of painters was the Tosa School which was patronized by the Imperial court from the fifteenth century on. In opposition to the Kanō School which focused on Chinese subject matter and styles, the Tosa School specialized in Japanese themes painted in the traditional *yamato-e* style, using delicate brushwork and bright colors. A combination of the word *yamato* which refers to Japan and *e* meaning painting, the term *yamato-e* is used generally to describe a work in which Japanese sensibilities are communicated. Although the Tosa School suffered a decline in the sixteenth century due to the increasing popularity of the Kanō School, it continued into the Edo period where it was revitalized by Tosa Mitsuoki, whose paintings are noted for their gem-like precision (No. 7).

The Kanō and Tosa Schools remained dedicated to preserving earlier painting traditions throughout the Edo period. Although individual artists made personal modifications, the styles were overwhelmingly steeped in the flavor of the past.

PF

1

Sesson Shūkei 1504-1589

Grapes and Bamboo

Hanging scroll, ink on paper, 31.4 x 44.5 cm., 12⅜ x 17½ in.
SEALS: Sesson, Shūkei
PUBLISHED: Harold P. Stern, *Birds, Beasts, Blossoms and Bugs*
(New York, 1976), no. 16.
Etō Shun, "Sesson no kachōga," *Museum* no. 281 (1974),
pl. 1.
Nakamura Tanio, "Kaigai ni okeru Sesson ga," *Museum*
no. 281 (1974), pl. 12.
Tanaka Ichimatsu and Nakamura Tanio, *Sesshū to
Sesson* (Tokyo, 1973), no. 115.

Although Sesson is generally regarded as the finest
ink painting master of the sixteenth century, few factual
details are known of his life, and his style has often
been misunderstood as a provincial version of the
Sesshū tradition. As has been pointed out in a recent
study by Barbara Ford, Sesson was an artist who drew
inspiration from the cultural milieu of Eastern Japan,
particularly that of the Kamakura area, and established
his own individual style which harkened back to the
work of early Muromachi era monk-painters and
presaged elements of Momoyama and Edo period
painting.[1]

As a monk-painter of the Zen sect, Sesson depicted
a large number of subjects in a variety of brushwork
manners during a career that spanned fifty years, thus
making generalities about his work difficult. Neverthe-
less, certain features of his art express his personal
background and character. First, he made a profound
study of the earlier Chinese and Japanese masterworks
that were extant in eastern Japan in his time, including
paintings following the Southern Sung Zen master
Mu Ch'i. Second, he seems to have pursued the literati
ideal of an independent and cultured life, although
closely associated with various feudal lords (*daimyō*)
in his area. Third, his brushwork is notable for its
strength and vitality, sometimes eschewing grace in
favor of expressive power. All three of these character-
istics can be seen in the small painting of *Grapes and
Bamboo* in the Gitter collection.

The early ink painting tradition in Japan was
influenced not only by the Zen art of China, but also
by the literati tradition that had developed on the
continent. Thus in addition to representations of Zen
avatars such as Daruma, Japanese masters of the early
Muromachi period also painted such scholarly themes
as bamboo, orchids and grapes, considered "ink-play"
by literati artists. This tradition, however, tended to
languish in the later Muromachi era, so its appearance
in a work by Sesson indicates his assimilation of earlier
Chinese and Japanese prototypes rather than merely
following the trends of his own time. This scroll recalls
small ink paintings of plants and fruits attributed to
Mu Ch'i as well as other depictions of these themes
painted in a free "boneless" style without outlines.

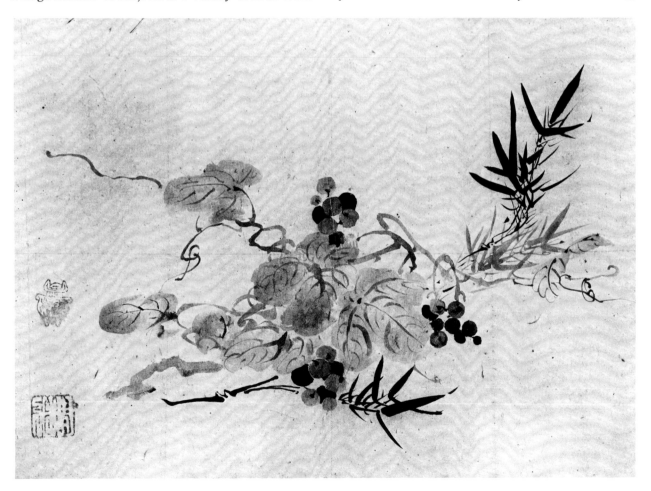

As Barbara Ford suggests, Sesson's painting was probably created for use in a small tea gathering, an occasion for refined cultural enjoyment of just such a modest but evocative scroll.[2]

The brushwork of this painting is both bold and subtle. In a short essay on painting attributed to Sesson, he advised students to "apply the dark ink first and then the lighter tones. A painting should be about seven parts dark to three parts lighter tones."[3] Since many later painters have worked in the opposite manner, from light strokes to overlays of dark ink, these comments are extremely interesting. Here, it is not easy to tell in which order the brushstrokes were applied, but the dark areas are in the minority, not the majority, giving the painting a quiet beauty appropriate to viewing at a tea ceremony. Nevertheless, the boldness of the black bamboo leaves, rendered with confident brushwork, effectively contrasts with the soft wash strokes of the grape leaves. The varied tonalities of the grapes themselves offer the same contrasts in miniature that the painting as a whole embodies. There is nothing effete about Sesson's style; even in a modest work such as this, the force of his personality is apparent. It is this boldness of approach that suggests that Sesson was a precursor to the art of the Momoyama and Edo periods, when dramatic visual effects became the norm. By absorbing the fine qualities of earlier ink painting and heralding the new, Sesson became the most important painter of his era.

SA

1. See Barbara Brennan Ford, *A Study of the Painting of Sesson Shūkei* (Columbia University Ph.D. dissertation, 1980).

2. Ibid., p. 195. Ms. Ford suggests that the most likely date for this painting is in the 1560's when Sesson was living in Aizu.

3. Ibid., p. 18.

2

School of Kanō Sanraku 1559-1635

Scholars Practicing Calligraphy

Hanging scroll, ink and light color on paper, 94 x 115.5 cm.,
 37 x 45⁷/₁₆ in.
Unsigned
PUBLISHED: *New Orleans Collects* (New Orleans Museum of
 Art, 1971), no. 295.
 Shrine of the Universe Art Institution, *The Shrine of
 the Universe Art Collection* (Ōsaka, 1962).

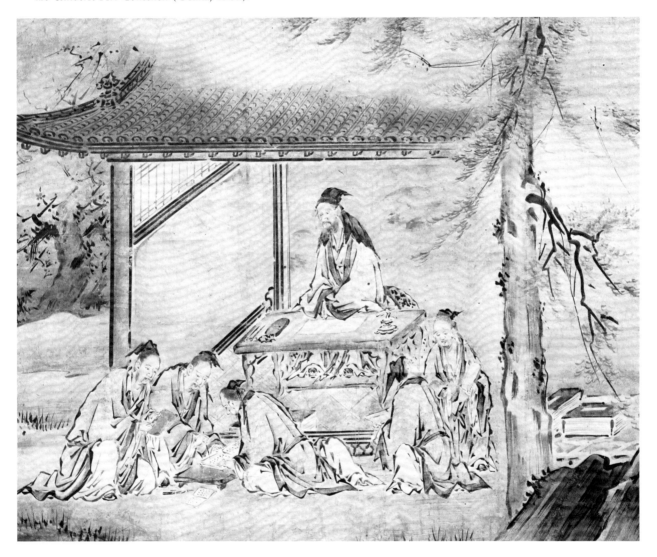

The subject of the *Four Noble Pastimes (Kinki shōga)*, including a scene of scholars practicing calligraphy, became a mainstay of the Kanō school beginning early in the sixteenth century. Typical of the many new subjects introduced into Japan with the extensive importation of Chinese painting during the early Muromachi era, it provided the Kanō with an opportunity to flatter their clients (who frequently were not highly educated) and to test their skills at expanding a modest visual statement into broad vistas appropriate for decorating room walls.

Judging from the size and type of paper used for this hanging scroll, it is likely a cut-down section of a much larger *fusuma* (interior sliding panel) composition. It has been reduced on all sides so as to delete severely damaged areas and to focus on the central theme. This is conveyed by the studious attitude of the five young men conversing about classical Chinese texts or using them as models for practicing calligraphy — the most exalted art form in China. Prominent *Kinki shōga* compositions antedating this example exist in the work of Kanō Shōei (1519-1592), Kanō Yukinobu (1513-1575), and Kanō Eitoku (1543-1590).

Eitoku's well-known *fusuma* of 1566 at the Jukō-in subtemple of the Daitoku-ji[1] provides the basic figural and stylistic model upon which the appropriate historical

setting of this hanging scroll can be ascertained. Under the influence of the Momoyama period individualists Hasegawa Tōhaku (1539-1610) and Kaiho Yūshō (1533-1615), Eitoku transformed sixteenth century figural painting, directing it away from the earlier conventions of Kanō Motonobu (1476-1559) towards more dynamic formulations of brush and ink. The pair of hanging scrolls portraying *Hsü-yu* and *Ch'ao-fu* in the Tokyo National Museum illustrate the character of brevity and assuredness in Eitoku's figural style.[2] These scrolls, in turn, may be instructively compared with Kanō Sanraku's later renditions in the same collection.[3] A more fluid brushline and dominating figural scale characterize the artist's approach to the subject in these paintings which can be reasonably dated towards the end of his career.

In all probability Sanraku had been apprenticed earlier to Eitoku, working on such major projects as Ōsaka and Azuchi castles, and at the Jurakudai complex of Hideyoshi. Indeed with Eitoku's death in the midst of the decoration of the Tōfuku-ji *hōdo* (lecture hall) sponsored by Hideyoshi, Sanraku took over the work and completed it. He continued to receive important commissions for *fusuma* cycles, *emakimono* and ceiling paintings, especially at Zen temples. He also participated in the extensive painting compositions at Nijō Castle following his reconciliation with the new Tokugawa government after a disaffection caused by his close ties with Hideyoshi.

A study of Sanraku's remaining oeuvre reveals an uneven but complex artistic personality at work, frequently with the aid of assistants. The figural type in this hanging scroll as well as the overall general configuration of the garment designs is based upon an Eitoku model of the last quarter of the sixteenth century. But the actual delineation of interior garment patterns, particularly the spiky, highly contrasted brushwork of the landscape components places the painting at least in the Keichō era (1595-1615). These elements reveal the essentially *retardaire* nature of the *Kinki shōga* theme by the end of the sixteenth century, and the emerging, expressive potency of the Edo Kanō artists.

Sanraku and his younger contemporary, Sansetsu (1589-1651), are among the most important artistic figures effecting the aesthetic transition into the seventeenth century. Both men worked in a traditional Kanō studio setting, normally preferring to identify only hanging scrolls, fan paintings, and some screens as autograph works. While this painting cannot be considered autograph it does provide a glimpse of what was once an impressive composition comparable with other efforts by Sanraku and his studio which depict Chinese allegories and court scenes.

MRC

1. For reproductions see Tokyo National Museum, *Kanō-ha no kaiga* (Tokyo, 1979), no. 75.
2. Ibid., no. 86.
3. Ibid., no. 87.

REFERENCES:
 Doi Tsugiyoshi. *Kanō Sanraku/Sansetsu* (Tokyo, 1976).

3

Attributed to Kusumi Morikage
(late 17th century)

Sericulture

Pair of six-panel screens, ink, color, and gold on gold ground
 paper, 157.7 x 365.9 cm., 62⅛ x 144¹/₁₆ in.
Unsigned
PUBLISHED: *New Orleans Collects* (New Orleans Museum of
 Art, 1971), no. 296.
 Shrine of the Universe Art Institution, *The Shrine of the
 Universe Art Collection* (Ōsaka, 1962).

The theme of sericulture in Japanese painting is rare.
Although the many tasks fundamental to the production
of fine silk form an intrinsically interesting genre subject,
Japanese artists did not favor it. In part this was due
to silk's foreign nature—it was produced in China and
imported into Japan as highly valued, finished material.
Indigenous production began considerably later in rural
Japanese villages.

But in China relatively early documents and paintings
record sericulture among the acceptable painting
repertory and, interestingly, pair it with agriculture.
Indeed the renowned Southern Sung court artist Liang
K'ai rendered these themes in a handscroll, as attested
by a Kanō school copy of the work in the Tokyo
National Museum.[1] The Edo scroll records a late fifteenth
century inscription at the end of the handscroll stating
Liang K'ai's authorship by Sōami (1485?-1525), who
was largely responsible with other members of his
artistic family for the care of the Ashikaga shogunal
collection of Chinese paintings, calligraphy, and ceramics
used in the tea ceremony.

The sericulture section of what may well be the
original Liang K'ai handscroll recently entered the
collection of the Cleveland Museum of Art from a
provenance in Japan.[2] Painted on silk, it describes with
elevated perspective and compressed focus the suc-
cessive steps required for silk production. Stylistically,
a nervous, almost jagged brush manner characterizes
much of the figural and architectural drawing. In
particular, facial delineations display prominent undulat-
ing contours, and clothing patterns contain numerous

detail

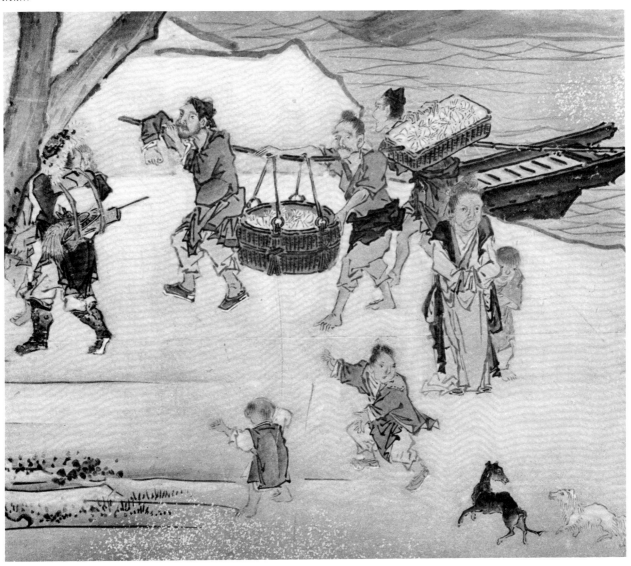

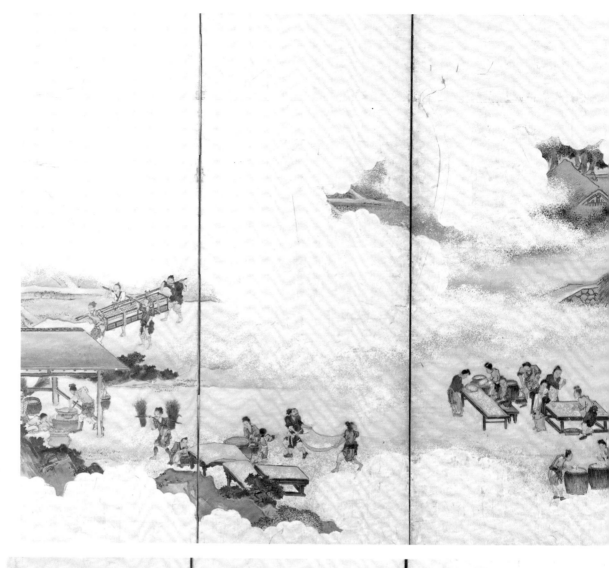

3

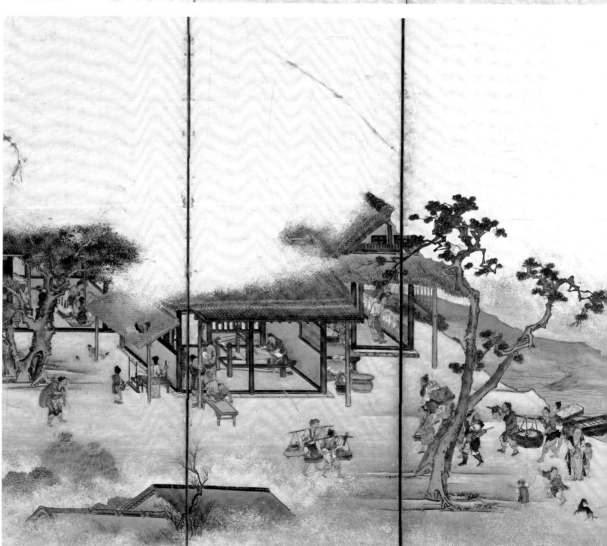

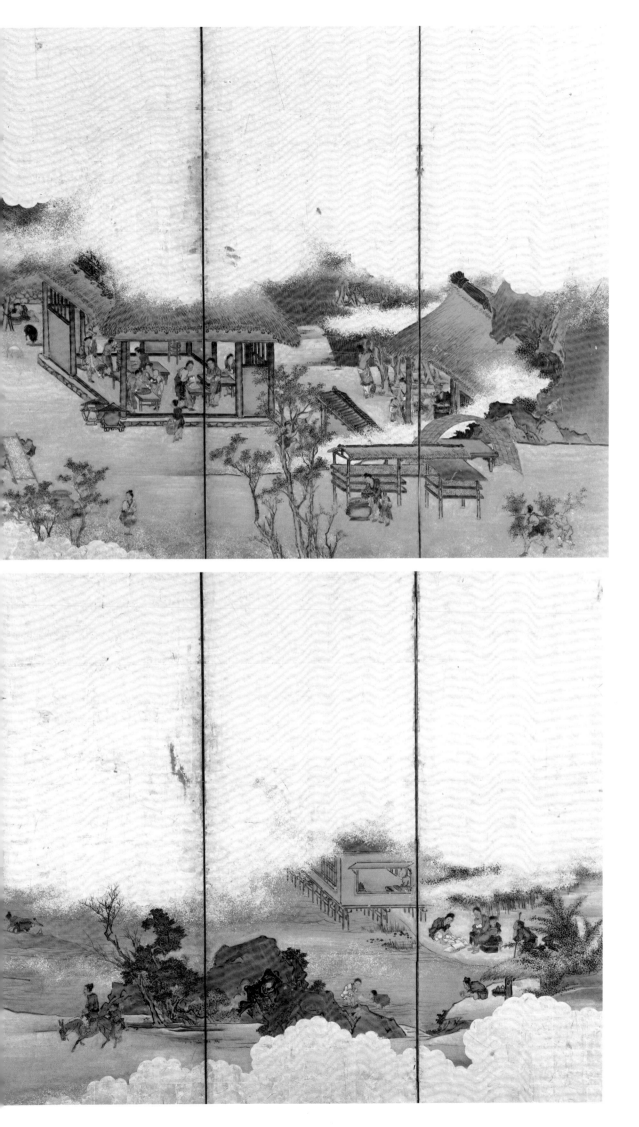

short wavering brushstrokes beginning with a "nail head" configuration.

These features are faithfully retained in the Kanō handscroll copy and in this unusual pair of screens. This suggests that the artist was familiar with one of several recensions of the thirteenth century work associated with Liang K'ai's highly revered name and brush manner. Compositionally, these screens illustrate the freedom with which such traditional subject matter could be altered in Edo art, despite differences in format. The anonymous Kanō-trained artist has introduced a village setting at the edge of rice fields, alongside a river. The vista is replete with workers, dawdlers, children at play, animals, and other human activities unassociated with silk manufacture. These vignettes give it its genuinely plebian, vibrant character, thereby identifying a patently Japanese approach to genre subject matter characteristic of the later seventeenth century.

Observed from this point of view the traditional attribution of these screens to Kusumi Morikage (see also No. 4) is intriguing and, ultimately, more convincing than other possibilities, given the present state of knowledge about this artist and the numerous Kanō practitioners of the period. Art historical tradition holds that Morikage studied with Kanō Tan'yū, collaborating with him and other Kanō school members on *fusuma* projects at the Chion-in and Shōju-Raigō-ji in the early 1640's. But these efforts hardly explain Morikage's later accomplishments, particularly in agricultural and pastoral screen compositions rendered in stylistic modes increasingly independent of Kanō school influences. Comparison of these sericulture screens with his major works in the Ishikawa, Berlin, and Tokyo museums strongly suggest an early date for the screens, perhaps before Morikage's alleged falling-out with Tan'yū.

The somewhat awkward figural description, the ample use of a decorative gold background and cloud banks, the lack of a signature, and indeed the very subject allude as much to authorship by a young anonymous Kanō disciple as to Morikage himself. Although it is unlikely this matter will be convincingly resolved, this should not detract from the engaging manner in which the courtly, moralizing sericulture theme has been perpetuated and revitalized in these screens.

MRC

1. A section of this handscroll is published in *Suiboku bijutsu taikei* (Tokyo, 1975), vol. 4, fig. 20.

2. For reproductions see Cleveland Museum of Art, Nelson-Atkins Museum, *Eight Dynasties of Chinese Painting* (Cleveland, 1980), no. 61.

REFERENCES:

Kobayashi Tadashi. *Morikage/Itchō* (Tokyo, 1978).

Kusumi Morikage (late 17th century)

Hollyhock and Sparrows

Hanging scroll, ink and color on paper, 112.3 x 39.9 cm.,
 44³/₁₆ x 15¹¹/₁₆ in.
SIGNATURE: Painted by Morikage
SEAL: Morikage
PUBLISHED: I'izuka Bei'u, *Nihonga taisei* (Tokyo, 1931-34),
 vol. 6, pl. 139.

One of the most fascinating aspects concerning
the cultural relations between China and Japan in the
Muromachi period is the attempt to determine on what
basis certain Chinese artists, subjects, and individual
paintings came to be prized in Japan. By the fifteenth
century many hundreds of scrolls filled the shogunal
collection alone, and extant inventories and tea diaries
laude the aesthetic merits and cultural heritage of the
imported scrolls owned by an ever-widening circle of
collectors. They tended to prefer unadorned Zen
paintings as well as the works of professional court
artists whose assertive brush and color proved visually
attractive. They also sought paintings illustrating specific
subjects.

One of these, bird and flower painting, has enjoyed
continual popularity in Japan regardless of artist,
technique, or the work's philosophical underpinnings.
Thus, for instance, Yüan Dynasty (1279-1368) landscape
or bamboo paintings by the great literati masters are
extremely rare in Japan. But the more conservative,
decorative genre of birds and flowers executed by
professional artists or minor literati figures do exist in
considerable numbers. The same may be said for Ming
Dynasty (1368-1644) painters, but with less ideological
ground separating scholar and professional. The actual
appearance of their paintings is not so far apart.

The sources for this delicate painting by Morikage
lie in the work of the mid-fourteenth century follower

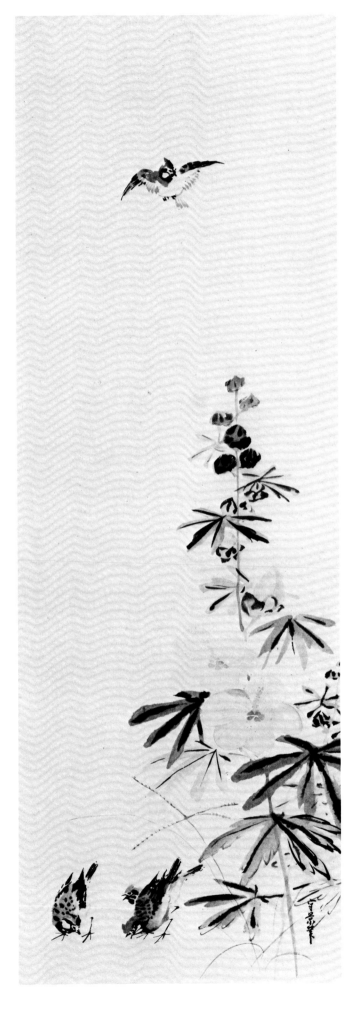

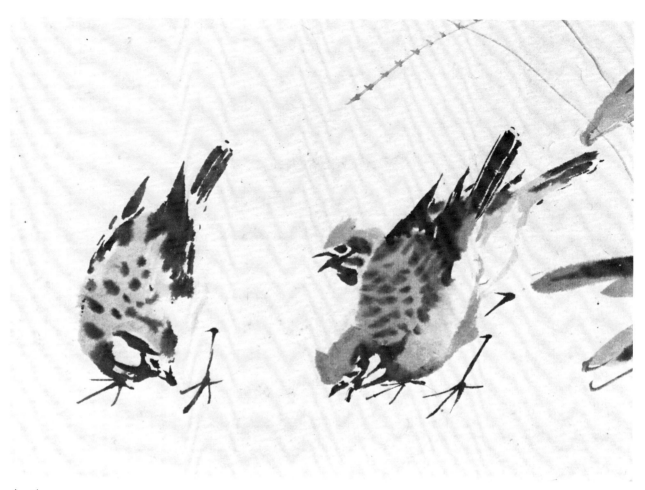

detail

of Chao Meng-fu (1254-1322), Wang Yüan, and the important Ming literatus Shen Chou (1427-1509). Both artists executed paintings containing compositional features and stylistic mannerisms so compatible with Morikage's that the existence of prototypes from which the Edo artist drew his inspiration must be presumed. The Perry collection *Quails and Sparrows in an Autumn Scene* (1347) by Wang Yüan and the Nelson Gallery *Rose Mallows* (1475) by Shen Chou[1] illustrate successive progressions in the reduction of compositional elements and an emphasis upon the unassuming appearance of nature expressed through the technique of employing ink washes devoid of outlining structure ("boneless" painting: *mo-ku*).

Morikage has adapted this technique somewhat by heightening tonal contrasts in the ink washes and by composing a more spartan setting, devoid of any believable ground. In both respects this epitomizes the appearance of the best known *Hollyhock* painting in Japan—Mu Ch'i's (active mid-thirteenth century) small scroll in the Daitoku-ji.[2] The dramatic asymmetrical

setting, and wet, charged ink washes appear in this scroll by Morikage in more studied, decorative arrangement than in the Chinese prototypes—or even in other "boneless" paintings by the artist.

While it is taken for granted that he studied with Tan'yū, an eminent painter-connoisseur of Japanese and Chinese paintings, rarely does one see such a subtle but clear transformation of Chinese literati painting sources. Morikage is praised in Japan for his sympathetic portrayals of rural life rather than his reformulations of classic Muromachi landscapes. This delicate painting adds another dimension to appreciating his talents as a gifted individualist and sophisticated student of Chinese painting history.

MRC

1. For reproductions see Cleveland Museum of Art, Nelson-Atkins Museum, *Eight Dynasties of Chinese Painting* (Cleveland, 1980), nos. 87 and 149, respectively.

2. This scroll is published in Tokyo National Museum, *Sung and Yüan Painting* (Tokyo, 1962), pl. 75.

5

Kanō Tsunenobu 1636-1713

Landscape with Figures

Hanging scroll, ink and color on silk, 74.9 x 141.5 cm.,
 29½ x 55¹¹/₁₆ in.
SIGNATURE: Painted by Hōgen Kosensō
SEAL: Bokusai
PUBLISHED: Shrine of the Universe Art Institution, *The Shrine
 of the Universe Museum Art Collection* (Ōsaka, 1962).

Perhaps Tsunenobu's grandest composition is the pair of screens belonging to the Tokyo University of the Arts which depict phoenix in a golden landscape.[1] The theme is an auspicious one which originates in Chinese lore, although in China it never enjoyed such diverse visual representation as can be found in Japanese art since Heian times. Painted in vivid colors, the mythical birds in these folding screens cavort along a

Kajibashi close to Edo Castle, the source for many of his important painting commissions as an official painter. Consequently Tsunenobu studied initially under his father's tutelage in the Kobikichō manner which, judging from Naonobu's surviving work, differed in important aspects from the dominant Tan'yū (Kajibashi line) formulas.

But it is clear that Tsunenobu turned increasingly towards Tan'yū's influence following his father's death and as his own considerable technique developed beyond that which Tan'yū's own disciples demonstrated. Tsunenobu participated in several major commissions at the imperial palace spanning a fifty year period, and by the later decades of the seventeenth century was considered the master painter of the Kanō school artists. He essentially assumed Tan'yū's mantle as official painter to the military government and court alike, and served as connoisseur of classical Chinese and Japanese paintings brought for his inspection by prominent *daimyō* families.

These activities were rewarded first in 1704 with the honorary Buddhist title *Hōgen* and then in 1709,

Rimpa-like stream bed encompassed by abbreviated rock formations, flowering paulownia trees, and gold cloud formations. It is a playful, somewhat romantic Edo evocation of Heian court painting and, significantly, derives from a very similar composition by Kanō Tan'yū (1602-1674), now in a private Japanese collection.[2]

Tan'yū was the older brother of Tsunenobu's father Naonobu (1607-1650), and both collaborated on major painting cycles following Naonobu's arrival in Edo circa 1630. He lived there and maintained a studio in the Kobikichō district, adopting that name to identify his family line of painters. Tan'yū enjoyed a residence at

Hōin. This hanging scroll can be dated between those years since the signature includes the designation "Hōgen." This documentation, the painting's generous scale, as well as the mounting and superb condition indicate a prominent provenance. Clearly it was intended to be displayed in surroundings of considerable dimension, and was only infrequently displayed. From this point of view a striking parallel exists in the *Four Seasons* landscape screens owned by the Hatakeyama family.[3] These are immaculately preserved and like this hanging scroll have a Chinese setting, including a scholar's waterside pavilion in the country. Both

47

compositions are executed primarily in *sumi* and can be linked to precursors in Tan'yū's oeuvre beginning as early as the 1650's.

Tsunenobu's rendering of this traditional visiting theme possesses a more concentrated focus and more relaxed brushwork. While this can be attributed, at least in part, to the hanging scroll format, it also points to a lingering indebtedness to Naonobu's legacy and in addition reflects one of Tsunenobu's characteristics: an interest in deriving expressive force from the juxtaposition of firmly controlled brush delineations with broad, summary ink washes.

MRC

1. For reproductions see Tokyo National Museum, *Kanō-ha no kaiga* (Tokyo, 1979), no. 147.

2. Tanyū's painting is published in Takeda Tsuneo, *Kanō Tan'yū* (Tokyo, 1978), pl. 13.

3. These screens are reproduced in Hatakeyama kinenkan, *Shūki, tōki tenkankaiki* (Tokyo, 1982).

*6

Kanō Tsunenobu 1636-1713

Fifty Noted Places in China and *Fifty Noted Places in Japan*

Pair of albums, ink and color on paper, each leaf 23.7 x
21.2 cm., 9⁵/₁₆ x 8⁵/₁₆ in.
SIGNATURE: Painted by Tsunenobu
SEALS: Tsunenobu, Ukon, Tsunenobu
PROVENANCE: Masuda Collection, Matsudaira Collection

Kano Tan'yū's (1602-1674) interest in the bustling
Edo world about him inspired a formidable outpouring
of painting activity, some projects of major proportions,
while others were of a modest, decidedly personal nature.
These paintings often depict native Japanese themes in
a brush manner identifiable with traditional *yamato-e*
conventions. Such paintings must be counted among
Tan'yū's finest accomplishments, and they ultimately
derive from his first-hand observations and recordings
of the plants, animals, landscapes, and artifacts with
which he came in contact. Sketchbooks by Tan'yū
have fortunately survived illuminating his working
methods as well as an abundant, relatively early interest
in the "real" world. Of the thousands of sketches
(*shukuzu*) he made as Edo's preeminent connoisseur
recording paintings brought to him for authentication
and appraisal, the preponderance refer to continental
subjects. Of note is the fact that these works are
executed in the firm *kara-e* (Chinese painting) manner.

In both cases (*yamato-e* or *kara-e*) Tan'yū, and then
his successor Tsunenobu, seem to have been particularly
adept at utilizing a small, rather intimate format. It
seems this was done both for their personal enjoyment
and edification, and as infrequent, special commissions.
This double album by Tsunenobu, formerly in the
important Masuda and Matsudaira collections, represents
a special effort by the artist to associate imagined
geographical locations on the mainland in one album
with specific views of Japan's familiar landscape. The
Chinese album illustrates the artist's dependence upon
model paintings reminiscent of fifteenth and sixteenth
century Muromachi ink paintings, and Southern Sung
compositions which Tsunenobu saw in abundance in
seventeenth century Edo in his capacity as the official
government expert in matters of connoisseurship.
The names of Liang K'ai (early 13th c.), Mi Fu (1051-
1107), Ma Yüan (act. before 1189-after 1225), Hsia
Kuei (act. ca. 1180-1224), Shūbun (act. mid-15th c.),
and Sōami (1485?-1525), come immediately to mind.

The Japanese album contains views of Mt. Fuji and
Mt. Hiei, the Yoshino and Ama-no-Hashidate areas,
Mii-dera in Ōtsu, the Kitano and Gion districts of
Kyoto as well as other subjects. All are executed in
varying combinations of dry and wet brushstrokes,
fine and broad ink passages, and subtle washes of *sumi*

and color. In traditional *yamato-e* fashion the point of
view is elevated considerably and the landscape com-
ponents are reduced in number and detail. After Sesshū
(1420-1506), Tan'yū was the first Japanese painter to
sketch from life and to make identifiable places in Japan
an ostensible, continuing theme in his oeuvre. A
handscroll of *Twelve Famous Places in Japan,*[1] completed
by Tan'yū when in his sixties, includes several sites
which are also in this Tsunenobu album. But Tsunenobu
eschewed Tan'yū's exclusive use of *sumi* ink tones in his
album of Japanese scenes preferring to use that medium
for the Chinese counterpart.

Each album leaf bears the signature and seal of
Tsunenobu. The Japanese leaves have appended labels
noting location names, provinces, and occasionally the
season. The albums may be tentatively dated prior
to Tsunenobu's attainment of the rank of *Hōgen* in
1704.

MRC

1. For reproductions see I'izuka Bei'u, *Nihonga taisei* (Tokyo, 1931-
34), vol. 6, pl. 24.

49

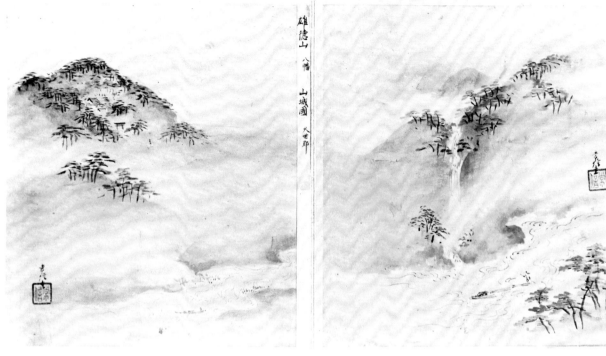

雄德山　八幡　山城國　久世郡

大井河　山城國　葛野郡

leaf 25, Otokoyama, Yamashiro province

leaf 24, Ōi River, Yamashiro province

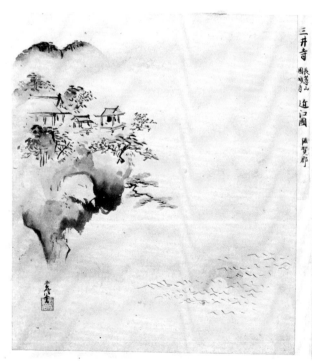

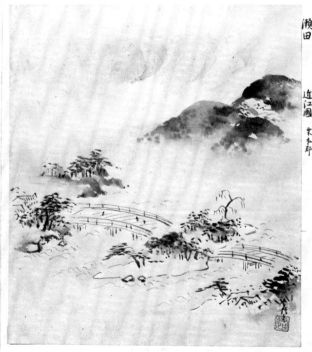

三井寺　長等山　園城寺　近江國　滋賀郡

瀬田　近江國　栗本郡

leaf 9, Miidera, Ōmi province

leaf 8, Seta, Ōmi province

leaf 23

leaf 22

leaf 37

leaf 36

51

Tosa Mitsuoki 1617-1691

Quail

Hanging scroll, ink and color on silk, 37.4 x 51.9 cm.,
14¾ x 20⁷/₁₆ in.
SIGNATURE: Painted by Tosa Hōgen Jōshō
SEAL: Mitsuoki
INSCRIPTION: see text below

Like Tsunenobu (Nos. 5, 6) and Morikage (Nos. 3, 4), Tosa Mitsuoki was an active and influential painter of the latter part of the seventeenth century, culminating with the Genroku era (1688-1704) when the arts in Japan experienced a special renaissance. However, unlike his Kanō-trained contemporaries, the foundation for Mitsuoki's endeavors must be sought in the courtly *yamato-e* traditions transmitted to successive generations of Tosa school artists since the fourteenth century.

But the classical *yamato-e* subjects with their vividly colored painted surfaces did not subsequently enjoy wide patronage in medieval Japan. The central and provincial governments of the time turned their support towards artists working primarily in *sumi* ink. They depicted Chinese themes and imagined landscapes from the continent rather than the literary and historical conceits so admired at court. This shift resulted in the decline of Tosa fortunes and reputations which had been essentially dependent upon Kyoto's aristocratic

largesse. As a result these artists turned to Japan's emerging middle class for patronage, becoming either "town painters" (*machi-eshi*) or apprentices in the increasingly dominant Kanō school studios. Fortunately the simple, rather naive *machi-eshi* paintings attracted the attention of the lower nobility, segments of the warrior class (samurai), and merchants alike, assuring the Tosa school's viability for over a century.

Tosa Mitsuoki's father Mitsunori (1583-1638) did not even live in Kyoto or maintain strong ties with nobility there until the end of his life. Following his father's example he maintained his residence in the flourishing port city of Sakai where ample support for the arts existed during the sixteenth century. But in 1634 Mitsunori took his son Mitsuoki to live in Kyoto for the purpose of reestablishing the Tosa position as official painters to the court. Twenty years later Mitsuoki's virtual single-handed revival of the Tosa school tradition was acknowledged by his appointment as chief of the court painting bureau (*kyūtei edokoro azukari*). Later the Buddhist honorary titles of *Hokkyō* (1681) and *Hōgen* were conferred.

Mitsuoki's oeuvre is large and his range of themes surprisingly extensive, encompassing all formats. The subject with which he is most commonly identified, paintings of quail, enjoys a particularly revered ancestry in Japan. Beginning with the gem-like paintings attributed to the twelfth-century Chinese court painter Li An-chung and the Hui-tsung emperor, and progressing through Muromachi individualists and the early Kanō, paintings of quail were coveted by tea followers. Mitsuoki is surely the Edo master of this theme, although the reasons

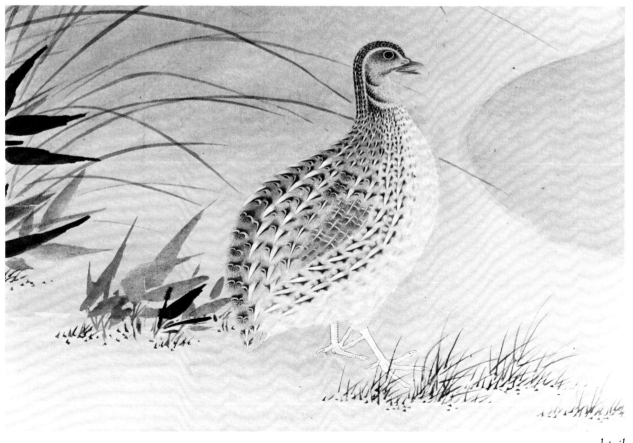

detail

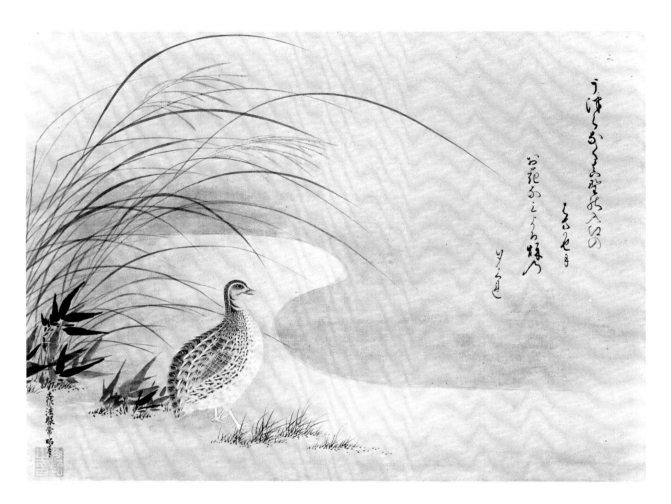

for the popularity of the subject in his lifetime remain something of a mystery. It may be that to his patrons Mitsuoki's paintings successfully invoked that air of tranquility and unassertive, crystalline skill which typifies Northern Sung bird and flower painting.

This modest example is entirely representative of his work. In addition the artist has included some rather special stylistic and compositional elements, the most novel of which are the soft, wet ink washes defining the *sasa* grass clusters behind the quail. These indicate Mitsuoki's awareness of Kanō techniques and are quite sensitively placed against the muted background tones and the rhythms of the pampas grass *(suzuki)*. These stalks, the quail's position and gesture, and the sloped embankment create a compositional and emotional resonance with the *waka* poem which is fully in keeping with *yamato-e* traditions. The *waka* is by Minamoto no Toshiyori (1055-1129) and is included in the imperial anthology *Kinyōshū*.

Uzura naku *When the shorewind blows*
Mano no irie no *Along the banks of Mano inlet,*
Hamakaze ni *Where quail softly cry,*
Obana namiyoru *Waves of plumegrass bend across the fields*
Aki no yūgure *In the last light of an autumn day.*

 (Translated by Edwin A. Cranston)

 MRC

REFERENCES:
 Amagasaki Bunka Senta. *Genroku nobi to bungei* (1977).
 Suntory Art Museum. *Tosa-ha no kaiga* (Tokyo, 1982).

RIMPA PAINTING

Rimpa painting is admired in the west for its bold, colorful designs which appeal directly to the senses. It is a visually stimulating, purely decorative style which many people feel best represents the native Japanese tradition. Although "Rimpa" literally means the school of Kōrin, the originators of the tradition were Hon'ami Kōetsu (1558-1637) and Tawaraya Sōtatsu (fl. first half of the 17th century). Both of these artists were members of the wealthy merchant class of the ancient capital Kyoto, which still remained the traditional artistic center of Japan despite the rapidly expanding culture in the new capital of Edo. The merchants are credited with rebuilding Kyoto into a prosperous commercial metropolis after it had been nearly devastated by the Ōnin War (1467-77), and the more successful among them found their way into the social circles of the courtier and warrior elites. By forming close ties with the Imperial family, they consequently developed tastes for traditional art and literature which enjoyed a revival in the late sixteenth and early seventeenth centuries.

Because of their roots in traditional Kyoto culture, Kōetsu and Sōtatsu drew much of their inspiration from classical painting and literature produced during the Heian period (794-1185) when Japan experienced a peak in the development of native arts. At times their subject matter paralleled that of the Tosa School, but it was reworked in a personal and more dynamic manner, and frequently transposed onto a monumental scale. Kōetsu was skilled in many arts (see No. 8), and his ideas and designs served as inspiration to those around him. In 1615 he was granted a tract of land called Takagamine in northwestern Kyoto by the Shōgun Tokugawa Ieyasu. Kōetsu founded an artistic village there, gathering together craftsmen active in ceramics, lacquer, paper-making and printing. All were influenced by his bold new interpretations of classical themes, and it was here that the Rimpa style was born.

Sōtatsu, the other acknowledged founder of Rimpa, was a friend of and possibly related to Kōetsu through marriage. They collaborated on a number of projects, with Sōtatsu painting or printing designs on paper or silk, over which Kōetsu then wrote out calligraphy. Among Sōtatsu's most famous works are his brilliant designs on gold foil screens. He occasionally painted using only monochrome ink (see Nos. 9, 10), but compared with earlier Japanese examples, the compositions are simplified and the handling of ink somewhat different. In particular, Sōtatsu applied ink or color in broad areas rather then building up series of small strokes, and he frequently dropped more ink or color onto areas still saturated, creating extraordinary blurred textures.

Sōtatsu's interest in the Chinese-derived style of ink painting may have been stimulated by his active involvement in the tea ceremony world, where such works were favored for display. He had a thriving atelier of artists who assisted him in carrying out his own commissions and continued the tradition after his death. In addition to selecting themes from Japanese literary classics, these artists often painted subjects from nature. They filled screens, hanging scrolls, and fans with visions of flowers and plants, dramatically silhouetting them against plain or gold backgrounds and arranging them on diagonal lines.

None of Sōtatsu's pupils achieved their master's fame; the next leading Rimpa artist was Ōgata Kōrin (1658-1716) who was born after Sōtatsu had died. The son of a Kyoto textile merchant, Kōrin learned by copying Sōtatsu's masterworks, and created a boldly decorative style which was even more resplendent in its design. As a painter he was followed by Nakamura Hōchū (No. 12), but Kōrin also did designs for ceramics, textiles and lacquerware which were later adopted by anonymous craftsmen because of their striking visual effects (No. 11).

Although the early Rimpa tradition had been centered in Kyoto, through the activities of Kōrin and his brother Kenzen the style was introduced to Edo. It became immensely popular in the new capital, perhaps because the nouveau-riche merchants there were eager to imitate the culture of Kyoto. Kōrin's legacy in Edo was carried on by Sakai Hōitsu (Nos. 13, 14), a member of the samurai class. He had no direct teacher in the Rimpa line, but was introduced to the style through works in the Sakai family collection. Hōitsu and his pupils Suzuki Kiitsu (Nos. 15, 16) and Sakai Ōho (No. 17) preferred bird and flower subjects, perhaps responding to the growing interest in plant life by scholars and by the general public of Edo at this time. Their compositions and motifs were drawn from Kōrin's oeuvre, but their works became increasingly refined and delicate. In terms of brushwork, the raw vigor of Sōtatsu and Kōrin was replaced with an understated elegance which introduced a more relaxed and gentle flavor to the Rimpa tradition.

PF

8

Style of Hon'ami Kōetsu 1558-1637
Calligraphy: Although the Wind Still Blows

Hanging scroll, ink on paper decorated with gold, 21 x
 17.7 cm., 8¼ x 6¹⁵/₁₆ in.
Unsigned
INSCRIPTION: see text below
PROVENANCE: Hosomi Ryo, Ōsaka

The tradition of writing poems on decorated paper
was initiated in the Heian period, but enjoyed a spirited
revival during the seventeenth and eighteenth centuries
among both aristocrats and upper-class merchants of
Kyoto. The poems were usually in the form of *waka,*
composed of 31 syllables arranged in lines of 5, 7, 5, 7, 7
syllables. They were frequently selected from the great
anthologies of the past. The poem written out here is
from the *Komachi shū,* a collection of poetry written
by the ninth century poetess Ono no Komachi. She
was famous as a woman of great beauty who repeatedly
turned down offers of marriage. After her beauty
faded, she was forced to spend her days as a beggar.
Her poetry is permeated with allusions to the ephemeral
qualities of life, exemplified by this poem which reads:

Fuki musubu *Although the wind*
Kaze wa mukashi no *Still blows*
Aki nagara *As in autumns past,*
Arishi ni mo ninu *I am no longer the same—*
Sode no tsuyu kana *Dew on my sleeve.*

Following Heian custom, the calligraphy was written
in a combination of Chinese characters and Japanese
phonetic symbols called *kana.* The soft, fluid writing
style of this work is reminiscent of Hon'ami Kōetsu,
who during his lifetime gained renown as one of the
finest calligraphers of Japan. Becoming an exemplar for
other artists of his age, Kōetsu drew inspiration primarily
from the classical aesthetics of the Heian period. In
addition to writing out poetry on decorated paper
mounted as handscrolls, Kōetsu did numerous poem
cards like this one in the small square format called
shikishi. He frequently collaborated with other artists
who prepared the special papers and embellished them
with woodblock-printed or painted designs. His works
became so popular that many artists emulated his style
and technique. The creator of *Although the Wind Still
Blows* is not known, but he was clearly inspired by the
Kōetsu tradition.

A notable feature of the Kōetsu writing style is his
fluid brushwork which exhibits dramatic changes in
width. The resulting characters range from bold to
threadlike, but the line is always soft, full and sensuous.
The calligraphy in the Gitter work follows this mode,
but the contrasts in line width are more exaggerated
and the balance is not as harmonious as in the best-
accepted Kōetsu calligraphy scrolls.

The underpainting of waterbirds and reeds is not
directly related to the poetry, but designed more to
complement the written script. Sketchlike underdrawings
of waterside scenery were frequently used to decorate
the pages of Heian poetry anthologies.[1] The bird and
plant forms have been freely brushed with delicate

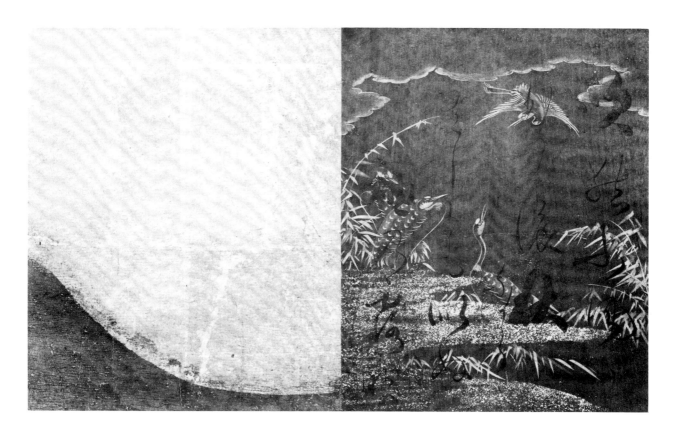

lines of gold which gleam softly from the dyed indigo-blue background. This appears to be a variation on a color scheme originally used for Buddhist sutra scrolls which was also adopted in the cover decoration of Nō texts.[2]

The design itself is self-contained, with reeds gracefully bending inward from either side. Within this enclosed cell, the birds are positioned so that they seem to be communicating with one another. In contrast to the linearity of most of the painting, a light gold wash was added to soften the contours of the clouds, and the sand bank below created by the sprinkling of fine gold powder. The pictorial design is dominated by elegantly curving shapes which cause the decoration and writing to interact with subtle sophistication. In both painting and calligraphy, the linear rhythms are smooth and flowing.

The companion square of paper seems to be unrelated to the poem card, but was perhaps added by the mounter purely for its striking visual design. Its decoration is restricted to a gently rounded hillock (once silver but now tarnished) which was juxtaposed against a background of gold foil squares. The combination of the two papers, one with refined, intricate designs and the other audaciously simplified, is extraordinarily bold and reminiscent of the sumptuous calligraphic works of the Heian period.

PF

1. Julia Meech-Pekarik, "Disguised Scripts and Hidden Poems in an Illustrated Heian Sutra: Ashide and Uta-e in the Heike Nōgyō," *Archives of Asian Art* 21 (1977-78), p. 55.

2. John Rosenfield and Fumiko Cranston, *The Courtly Tradition in Japanese Art and Literature* (Fogg Art Museum, 1973), p. 261.

9

Signature of Tawaraya Sōtatsu
(fl. first half of 17th century)

Duck Flying Over Iris

Hanging scroll, ink on paper 102.9 x 48.7 cm., 40½ x 19³/₁₆ in.
SIGNATURE: Sotatsu hokkyō
SEAL: Taiseiken
PUBLISHED: Itabashi Art Museum, *Karasuma Mitsuhirō to Tawaraya Sōtatsu* (Tokyo, 1982), no. 77.
 Yamane Yūzō, ed., *Rimpa kaiga zenshū* (Tokyo, 1977-80), vol. 2, no. 133.
 Nihon keizai shimbun, *Sōtatsu ten* (Tokyo, 1966).

The artistic personality of Tawaraya Sōtatsu continues to elude definition despite the recent studies by leading Japanese scholars. Although he is heralded as one of the great innovators of decorative design, only a few biographical facts are known and even these are somewhat veiled in mystery.

Sōtatsu belonged to the wealthy merchant class of Kyoto and operated a painting atelier called the Tawaraya. Unlike some painting workshops which specialized in fans or screens, Sōtatsu's atelier seems to have dealt in a broad range of painting formats. His collaborative efforts with Hon'ami Kōetsu are well known, and Sōtatsu may have married the younger sister of Kōetsu's wife. In addition to associating with the tea master Sen Shōan (1546-1614), he was active in the cultural circle centered around the court of Emperor Gomizuno-ō. Sōtatsu's artistic skills were recognized in his own day, for he was honored with the Buddhist rank of *hokkyō*. Yamane Yūzō suggests that Sōtatsu was given this title in 1621 upon completing the paintings at Yōgen-in, a temple in Kyoto rebuilt at the order of the wife of Hidetaka, second of the Tokugawa shōguns.[1]

Although he is most acclaimed for his brilliant designs in the colorful screen format, Sōtatsu also proved himself to be adept at the more austere art of ink painting. Countless ink paintings bear his signature or are attributed to him, but only a few works are generally accepted as authentic. Among these are his paintings depicting ducks and reeds once attached to a wall in the Muryoju-in at Daigo-ji which was built in 1622. These works are unsigned, but their authenticity is not questioned since it is known that Sōtatsu was closely associated with Daigo-ji and he was commissioned to do a number of works for the temple. *Duck Flying Over Iris* is clearly patterned after this prototype, and may once have been mounted on a six panel screen along with views of other flying ducks.[2] Numerous versions of these birds exist, most of them bearing a "Sōtatsu hokkyō" signature and "Taiseiken" seal. In his article on Sōtatsu's signatures, Kōno Motoaki relegates such works to pupils in Sōtatsu's atelier who

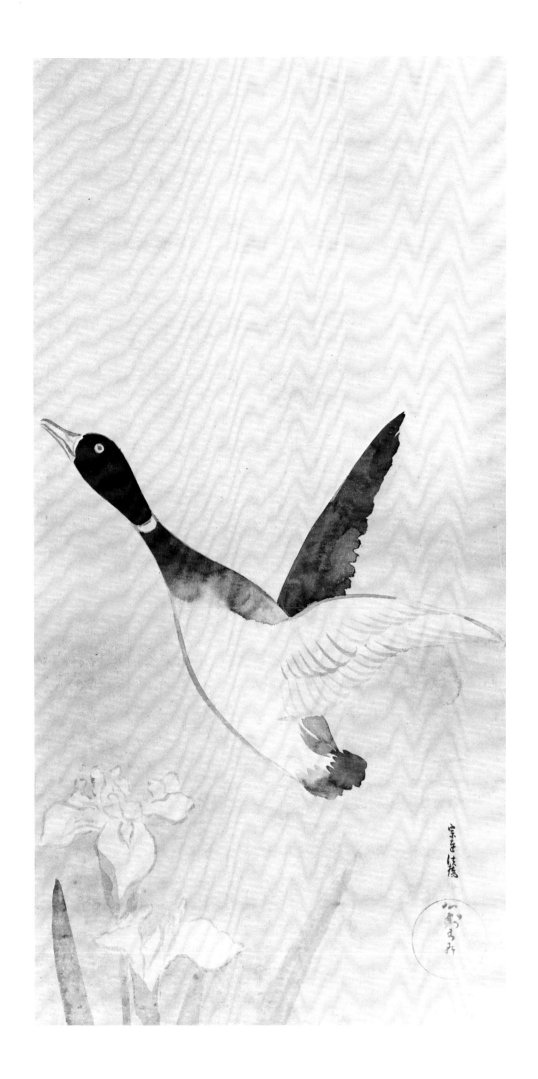

59

inherited his title.[3] Although different hands can be distinguished among the extant works, since we have no information regarding the identity of these artists it is perhaps best to consider such works as all belonging to the Sōtatsu tradition.[4]

In his ink paintings, Sōtatsu was heir to the great Chinese tradition which had been transmitted to Japan during the Kamakura and Muromachi periods. The fact that both he and Kōrin worked in this medium indicates that the Chinese style remained a viable tradition to the Japanese despite the growing popularity of a more native decorative art. Sōtatsu's interest may have been stimulated by his activities in the tea ceremony world where ink paintings were favored for display in the *tokonoma*. Sōtatsu's connection in the Kyoto tea world undoubtedly gave him access to both Chinese and Japanese paintings in temple collections, and it is often stated that the technique of *tarashikomi*[5] which Sōtatsu developed was inspired by the "boneless" style of Mu Ch'i. It is more likely that Sōtatsu was emulating Chinese Ming paintings displaying a similar technique, such as works by Ch'en Shun and Hsu Wei. However, as is also characteristic in the colors of his more decorative paintings, Sōtatsu's handling of ink took on an unmistakably Japanese quality.

Duck Flying Over Iris has a simple, classical beauty which is the hallmark of Sōtatsu's style. A hushed stillness pervades this scene as the bird effortlessly takes wing into the overcast, misty sky. All background elements have been eliminated so that the emphasis is on the forms in the foreground. Nature has been arranged with an eye for design: the spread of the duck's wings is echoed by the pointed leaves of the iris. The success of such a simple painting depends upon effective contrasts, areas of light versus dark, and ink wash versus soft, sensuous outlines. The handling of the ink is particularly masterful: lines have been brushed with a delicate confidence, and the *tarashikomi* on the feathers of the duck has a marvelous, ragged quality. The concentration of darker ink in the center of the painting adds weight, acting as an anchor so the forms do not dissolve into the misty atmosphere which envelops them.

PF

1. Yamane Yūzō, *Sōtatsu* (Tokyo, 1962), p. 3.

2. There is a pair of screens with this kind of format in the Freer Gallery. See *Rimpa kaiga zenshū*, vol. 2, no. 134.

3. Kōno Motoaki, "Tawaraya Sōtatsu no rakkan," *Rimpa kaiga zenshū*, vol. 2, pp. 62-64. Kōno states that the signature "Sotatsu hokkyo" reflects the third person and hence was used by pupils, whereas Sōtatsu himself would have employed the signature "Hokkyō Sōtatsu."

4. For reproductions of other versions of duck ink paintings, see pp. 301-302 of vol. 2 of *Rimpa kaiga zenshū*. A similar illustration also appears in the second volume of the *Kōrin hyakuzu* published in 1826, indicating that Kōrin also painted this subject.

5. A technique of dropping pigments onto an already painted surface which is still wet, causing the ink or colors to spread in an uneven but highly controlled manner.

10

School of Tawaraya Sōtatsu
(second half of 17th century)

The Four Sleepers

Hanging scroll, ink on paper, 95.9 x 51.6 cm.,
 37¾ x 20⁵/₁₆ in.
SEAL: Inen
PUBLISHED: Yamane Yūzō, ed., *Rimpa kaiga zenshū* (Tokyo,
 1977-80), vol. 1, pl. 63.
 Yamane Yūzō, *Sōtatsu* (Tokyo, 1962), pl. 120.

The Four Sleepers was a popular Zen theme, representing the two eccentrics Kanzan (Chinese: Han Shan) and Jittoku (Shih-te) immersed in slumber with the Zen monk Bukan (Feng-kan) and his pet tiger. The origin of legends concerning these Chinese figures can be traced to a collection of three hundred T'ang poems known as the *Han-shan-tzu-shih-chi.* The preface, written by the official Lu Ch'iu-yin, describes Kanzan as a poet recluse living on Mt. T'ien-t'ai in Chekiang province. He was friendly with Jittoku, who worked in the dining hall and kitchen at the Zen temple Kuo-ch'ing-ssu, and the two were frequently seen laughing and behaving in mysterious ways. Jittoku had allegedly been found as a child by the Zen monk Bukan, who took him back to the temple and cared for him. Bukan later befriended a tiger, showing that he was in tune with all natural beings. Although Kanzan and Jittoku were not actually Zen monks, their perception of life went beyond that of this world, and they were singled out as models of carefree, enlightened Zen laymen.

Paintings of the four in repose were done in China as early as the Southern Sung period: numerous paintings labeled the "Four Sleepers" are recorded in the collected sayings of Southern Sung Zen masters.[1] The oldest Chinese example is a painting in the Tokyo National Museum inscribed by several Zen priests who were active in the fourteenth century. The most famous extant version of the four sleepers is the painting by the fourteenth century Japanese Zen monk Mokuan Rei'en based on a Chinese model. The arrangement of the figures in the Gitter work is somewhat different, but it is likely that it was modeled upon a similar Japanese painting.

The Four Sleepers is not signed, but it bears the Inen seal associated with Tawaraya Sōtatsu and his school. There is evidence that Sōtatsu himself may have used this seal, but in general the works stamped with it are believed to be products of his school or that of his pupil Sōsetsu. Thus this work presumably dates from the middle or late seventeenth century.

Since Sōtatsu and his followers were clearly producing works for middle-class merchants, it may seem odd that they would paint subject matter so permeated with Zen. *The Four Sleepers* in many respects epitomizes the secularization of Zen subject matter and the ink painting tradition which had begun to occur in the fifteenth century with masters of the Kanō School. It proves that ink paintings continued to be appreciated despite the growing popularity of more bold and colorful styles. Zen figure paintings also held a special appeal for tea ceremony enthusiasts who we know numbered among Sōtatsu's patrons. There are a number of paintings of Zen figure subjects extant by Sōtatsu school artists, but paintings of the four sleepers are rather rare.[2]

Although the subject matter is the same, there are many differences in style between the Gitter *Four Sleepers* and its Muromachi period prototypes. As in other Rimpa works, the background has been totally eliminated to create a more bold and simplified design. The tiger bends gently around the figures, forming a giant pillow, its front legs elegantly crossed. The position of its huge round paws is echoed by the dark heads of Kanzan and Jittoku. The brushwork is very restrained, lacking the rough spontaneity of earlier Zen painting. Grey ink-tones predominate, enhancing the dreamlike quality. The brushstrokes themselves are soft and rounded, gracefully tapering in a manner which became a special feature of Rimpa painting. Also characteristic of this school is the use of *tarashikomi*, here apparent in the tiger's fur. The subdued ink tones and mellow brushwork are very soothing, evoking a quiet, restful mood also suggested by the figure of Bukan who gazes dreamily upward as though in a trance. The style of painting is well suited to the subject matter, for the four sleepers are generally interpreted as symbolizing the ultimate tranquility of the enlightened mind.

PF

1. Shimizu, Yoshiaki, *Problems of Mokuan Rei'en (?-1323-1345)* (Princeton University Ph.D. Dissertation, 1974), vol. 2, p. 63.

2. One other example has been published in *Suiboku bijutsu taikei* (Tokyo, 1975), vol. 10, pl. 71.

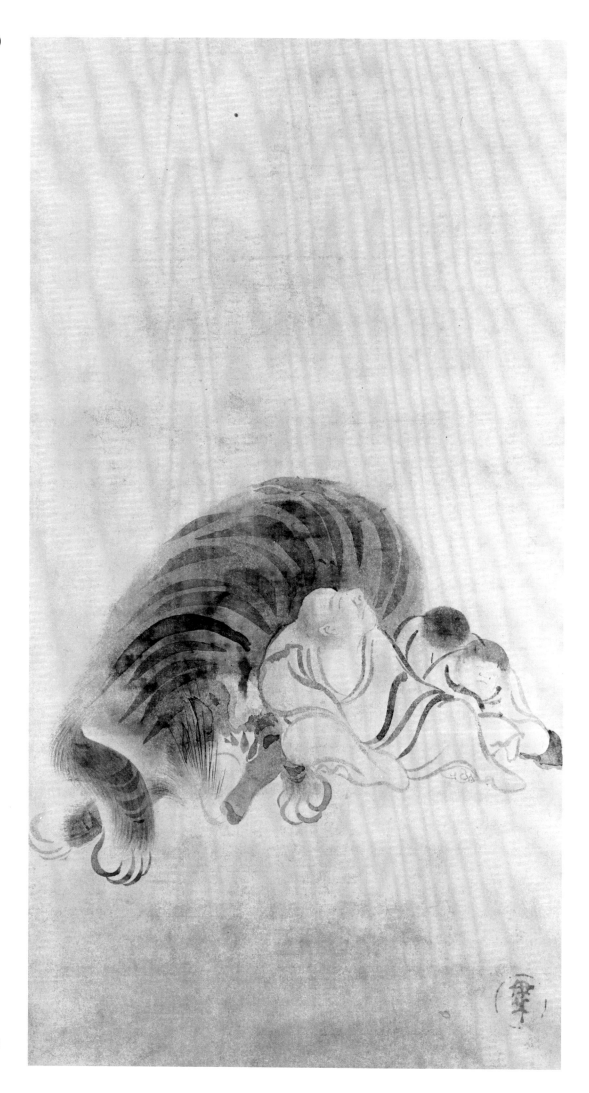

11

Anonymous (second half of 18th century)

Black Lacquer Cosmetic Box with Design of Chrysanthemums and Stream

Gold and silver *maki-e*, 18.5 x 26.5 x 20 cm.,
 7¼ x 10⁷/₁₆ x 7¹³/₁₆ in.
PROVENANCE: Hosomi Ryo, Ōsaka
PUBLISHED: *Maki-e* (Kyoto, 1975), vol. 17. no. 164.

The bold, highly stylized designs of artists working in the Rimpa tradition inspired lacquerers for many succeeding generations. Hon'ami Kōetsu and Ōgata Kōrin both figured prominently among lacquer designers of their day. Appealing to wealthy merchants with refined, classical tastes, their works met with instantaneous success. Riding on the crest of their popularity, lacquerers of the Edo period came to rely upon Rimpa paintings and printed books as sources of motifs for decoration.

The use of lacquer for preserving and decorating objects was developed by the Japanese to a remarkable degree of technical and artistic refinement. Oriental lacquer is made from sap of the *Rhus vernicifera* tree which is prepared for use by evaporating the excess moisture and filtering off impurities. Lacquer produces a lustrous and extremely durable coating, sealing porous materials such as wood and making them impervious to moisture. The coloring agents most commonly used are vermilion for red and lampblack or iron filings for black. The art of lacquering requires incredible patience and care, for it is applied in thin layers, each of which must be allowed to harden before adding the next. A finely lacquered object may require 30 or more applications and take months or years to complete.

Lacquer has been used in Japan since the late Jōmon period. More advanced techniques were imported from China during the Nara period, and although at first used primarily for Buddhist statuary, lacquer became a leading medium of decoration for furniture, serving trays, and a variety of containers. It was not until the Edo period that its use extended to the middle class, at which time craftsmen established themselves in areas previously not noted for lacquer production.

The motif of chrysanthemums growing along a stream appears frequently in decoration of Japanese lacquers beginning in the Muromachi period.[1] It refers to Chu Tz'u-t'ung, a legendary Chinese youth who during exile for a minor offense, spent each day writing a magical phrase on chrysanthemum petals. The dew which washed away the writing is said to have become an elixir of immortality. Here the motifs are used primarily for their decorative potential. The flowing stream and flowers recall the dramatic designs of Kōrin, here even further abstracted from reality. The exquisite designs were rendered in a uniquely Japanese technique called *maki-e* where powdered gold and silver are sprinkled over patterns first drawn in damp lacquer. The entire surface was covered with another layer of lacquer which was carefully rubbed off until the metal-covered designs showed through. A coating of clear lacquer was then added for final protection. *Maki-e* was first employed during the Nara period, but the designs frequently reflected foreign tastes. It was only in the late Heian era that native Japanese designs began to appear. Decorated lacquer has a striking visual appeal, for the dramatically simple patterns of gold and silver glow brilliantly from the jet black lacquer surface. Rimpa works can sometimes be overwhelming in their splendor, but here the pattern is refined, the curving strands of water flowing harmoniously over the lid and around the sides of the box. The design is repeated on the inner lid and tray, illustrating the extraordinary Japanese talent for integrating object and design.

PF

1. For two other examples of this theme, see Ann Yonemura, *Japanese Lacquer* (The Freer Gallery of Art, 1979), nos. 20 and 30.

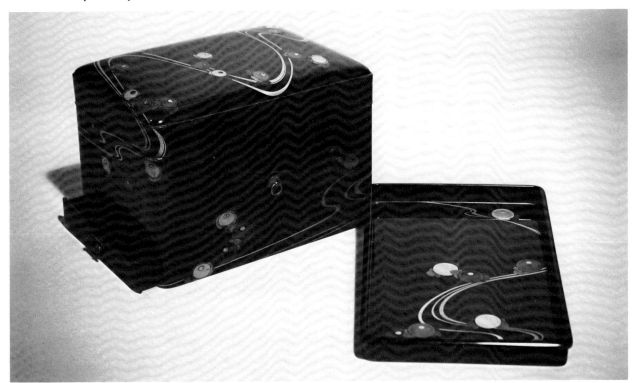

Nakamura Hōchū fl.1790-1818

Hollyhocks

Fan, ink and color on paper, 20.7 x 51.4 cm., 8⅛ x 20¼ in.
Signature: Painted by Hōchū
Seal: Hōchū
Published: Yamane Yūzō, ed., *Rimpa kaiga zenshū* (Tokyo, 1977-80), vol. 4, no. 223.

Decorative screens with fans attached or painted directly on the surface became a popular format in Rimpa painting through its promotion by Tawaraya Sōtatsu and his atelier. Examples by Sōtatsu are in the Sambō-in at the Kyoto temple Daigo-ji and the Imperial Household Collection, the subject matter consisting of scenes from classical tales as well as flowers and grasses. This painting by Hōchū of *Hollyhocks* is from a group of ten fans which were once mounted on a two-panel screen.

Hōchū lived most of his life in Ōsaka although he was born in Kyoto. He was active in both Ōsaka and Kyoto artistic circles, and was friendly with Kimura Kenkadō (1736-1802), Totoki Baigai (No. 55), and Aoki Mokubei (1767-1833).[1] It is also speculated that Hōchū knew Ike Gyokuran (No. 40) and that as a youth he studied her husband Taiga's style.[2] Hōchū was a gifted *haiku* poet, and frequently included poems on his humorous figure paintings which show the influence of both Yosa Buson (Nos. 44, 45, 46) and Jichōsai (fl. 1781-1788). Like Sakai Hōitsu, Hōchū was attracted to the work of Ōgata Kōrin; in 1799 he traveled to Edo and three years later published a book entitled the *Kōrin gafu* filled with his interpretations of Kōrin's designs.

Hōchū was especially fond of the fan format, judging from his numerous extant paintings in this shape. Red and white hollyhocks had been favored by Kōrin who painted them on one half of a pair of screens now in the Hinohara collection in Tokyo. Kōrin also singled out the hollyhock for fan designs, exemplified by his painting in figure 1. In addition to Hōchū, this subject was taken up by a number of Rimpa painters.

In *Hollyhocks*, Hōchū has employed a similar design, but he has increased the sense of immediacy and directness by bringing the flowers forward and simplifying the forms. Hōchū was highly inventive in his application of *tarashikomi*, exploiting this technique in a way that distinguished him from other Rimpa artists. Whereas Hōitsu (Nos. 13, 14), Kiitsu (Nos. 15, 16) and Ōho (No. 17) later employed this technique with a polished suavity, Hōchū's *tarashikomi* has a playful, refreshing quality. Instead of smoothly finished contours, Hōchū's flower and leaf shapes exhibit an unevenness suggesting a more spontaneous handling of the brush. Although Hōchū has used only red and green pigments, by mixing the colors with water he has created a variety of shades. The flowers are not simply flat shapes but have texture and individual character. Light touches of gold paint glimmer softly from the surface of the leaves brushed with ink and green color, imparting a subtle decorative effect. The overall design is bold, but Hōchū's *Hollyhocks* have a childlike simplicity also hinted at in his signature which recalls the playful script of Taiga. Be it flowers or figures, Hōchū's paintings display an unaffected brushwork which imbues them with a natural and relaxed charm not common in other Rimpa painting.

PF

1. Kenkadō noted in his diary that Hōchū visited him nine times in 1796 and ten times in 1800. Kenkadō also wrote that Hōchū

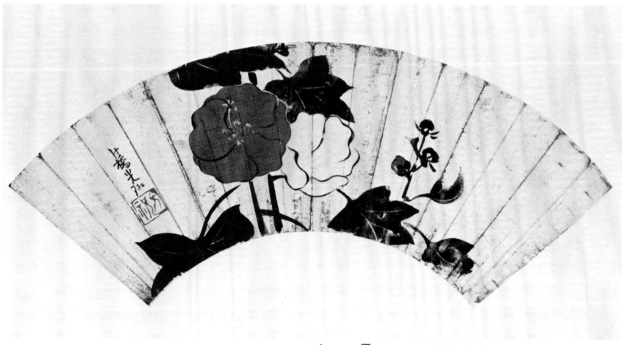

figure 1 Ōgata Kōrin, *Hollyhocks*, Private Collection, Japan

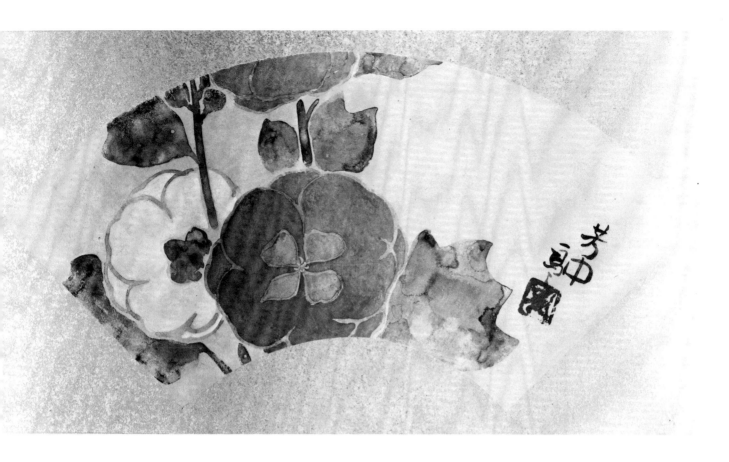

introduced him to Mokubei who first came to visit in 1796. There is an undated letter from Baigai addressed to Hōchū describing a cherry-blossom viewing party at Arashiyama. See Nobuo Tsuji, ''Nakamura Hōchū ni tsuite,'' *Rimpa kaiga zenshū,* vol. 4, pp. 45-47.

2. Ibid., p. 46.

13

Sakai Hōitsu 1761-1828
Maple Branch

Fan, ink and color on paper, 19.1 x 48.2 cm., 7⁹/₁₆ x 19 in.
SIGNATURE: Painted by Hōitsu
SEAL: Uge-an
PUBLISHED: *Sakai Hōitsu ten* (Tokyo, 1977), no. 56.

Although the Rimpa tradition first blossomed in Kyoto with the artistic efforts of Hon'ami Kōetsu (see No. 8), Tawaraya Sōtatsu (see Nos. 9, 10), and Ōgata Kōrin, the style was carried to Edo and there developed to a high degree by Sakai Hōitsu. Hōitsu was born in Edo in 1761, the second son of Sakai Tadamochi, lord of Himeiji castle in Harima province (present-day Hyōgo prefecture). He was educated in a manner befitting a member of a wealthy samurai family, receiving instruction in literary as well as martial arts. Hōitsu became well-versed in *haiku* and *kyōka* (a form of comic verse), and published several volumes of his own poetry.

The Sakai family seems to have supported a salon which was frequented by poets, tea masters, painters and physicians, and this environment undoubtedly fostered and encouraged Hōitsu's interest in the arts.[1] In addition to being exposed to many forms of culture, Hōitsu also became close friends with a number of the leading Edo artists including Ota Nampō (active c. 1840), Tani Bunchō (No. 52), and Kameda Bōsai (No. 51). He devoted himself to the arts, studying the *Ukiyo-e* style of Utagawa Toyoharu (1735-1814), the Kanō tradition of painting, and the Nagasaki bird and flower painting style of Sō Shiseki (1712-1786).

In 1797 Hōitsu traveled to Kyoto and took the Buddhist vows at the Jōdo shinshū temple Nishi Hongan-ji, returning to Edo soon thereafter. Although illness has been noted as the reason for the prematureness of this event, it is more likely that Hōitsu took the tonsure in order to pursue a life free from the restrictions of his family.[2]

It is often stated that Hōitsu took up the Rimpa style of painting upon the advice of his friend Bunchō, but there is also evidence that the Sakai family collection contained works by both Kōetsu and Kōrin which undoubtedly served to inspire the young artist. Hōitsu had no direct teacher in this line, but he learned by copying works of his predecessor Kōrin. By the early part of the nineteenth century Hōitsu began producing fine works in the Rimpa style. His devotion to Kōrin was so strong that he collected designs of all the Kōrin paintings he could find, and began publishing them in 1815 in a woodblock book entitled the *Kōrin hyakuzu* (*One Hundred Works by Kōrin*).[3] Although Hōitsu's early Rimpa works were closely modeled on those of Kōrin, he gradually developed a personal manner which was even more stylized and overtly decorative.

Seasonal themes appear frequently in Rimpa painting, for its origins were deeply rooted in the classical literary tradition which was permeated with such imagery. The branch of maple seen here with a *saké* cup would immediately evoke memories of viewing the autumn foliage and poetry inspired by this season. These motifs may also suggest the Nō play "Momiji gari" about Taira no Koremochi who came across a group of people viewing maples while out hunting one day. A high-ranking court lady invited him to join the party, but when he became intoxicated and sleepy, she turned into a demon and tried to kill him. The hero was warned of the danger by a god in his dream, and he was able to escape.

Hōitsu has selectively combined autumnal motifs with tiny blue flowers and a kind of water ladle commonly used during the tea ceremony. The maple branch curves gracefully so that it echoes the format of the fan. The placement of the sprig of blossoms and *saké* cup slightly off center to the left anchors the composition, as does the diagonal thrust of the ladle handle which halts movement to the left. The bright colors of scarlet, blue and green are set off by the luminous gold background. Nature has been made more beautiful by the addition of thin, delicate gold lines to represent veins of the leaves. Hōitsu's paintings are notable for their brilliant colors, for unlike many artists, he was able to afford the most expensive pigments. The bold design is further accentuated by the shiny, jet black spokes of the fan which also provide a striking contrast to the gold background. Hōitsu has effectively utilized the fan format for a sophisticated and decorative painting of a familiar Japanese theme.

PF

1. Tamamushi Satoko, "Hōitsu ga no teihen," *Rimpa kaiga zenshū*, vol. 5, p. 62.

2. Kōno Motoaki, "Hōitsu no denki,"*Rimpa kaiga zenshū*, vol. 5, p. 18.

3. In 1815 Hōitsu also published another collection entitled *Ōgata ryū ryaku impu* (Seals of the Ōgata School). A second volume of the *Korin hyakuzu* was printed in 1826.

Sakai Hōitsu 1761-1828

Triptych of Flowers and Rising Sun

Hanging scrolls, ink and color on silk, each 104.4 x 40.9 cm.,
 41⅛ x 16⅛ in.
SIGNATURES: Painted by Hōitsu (right)
 Painted by Kishin Hōitsu (center)
 Painted by Hōitsu (left)
SEALS: Ōson[1] (right)
 Ōson, Monsen (center)
 Ōson (left)
INSCRIPTION by Kazan'in Aitoku (1754-1829): see text below
PUBLISHED: *Sakai Hōitsu ten* (Tokyo, 1977), pl. 45.
 Yamane Yūzō, ed., *Rimpa kaiga zenshū* (Tokyo, 1977-80),
 vol. 5, nos. 90-92.
 Kumita Shohei, Nakamura Tanio and Shirasaki Hideo, eds.,
 Sakai Hōitsu gashū (Tokyo, 1976), nos. 34, 35, 115.
 Rimpa kaiga zenshū (Kyoto, 1975), vol. 3, no. 18

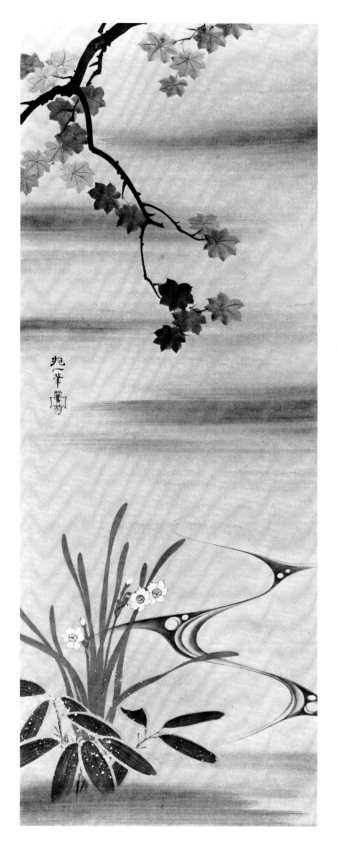

Whereas Sōtatsu and Kōrin had often focused on
classical literary themes drawn from *emakimono*, Hōitsu
seems to have been more inspired by earlier Rimpa
bird and flower compositions. His own oeuvre is replete
with elegant depictions of nature exemplified by *Triptych
of Flowers and Rising Sun.* In the central painting,
Hōitsu has depicted the shimmering red sun slowly
rising above the early morning clouds and mist. Under-
neath, the calligrapher-painter Kazan'in Aitoku (1754-
1829) has written out the following *waka*:

Akirakeki	*Brightly shining*
Miyo soto yomo ni	*Is our emperor's reign*
Shirashimete	*Throughout the world;*
Terasu hikage no	*Its radiant beams*
Kumoru toki naki	*Will never be overshadowed.*

Aitoku is clearly speaking in support of the Emperor
whose authority was recognized by loyalists even
though Japan was being ruled by the Shogunate in Edo.
Aitoku received the title Udaijin (Minister of the Right)
in 1820, and since he used it in his signature here,
we know that this triptych was completed after that
time. Thus it is a product of the last years of Hōitsu's
life. The two flanking paintings depict flowers and trees
representing the four seasons. On the right is a
blossoming cherry tree; underneath flows a river, on
the bank of which stand iris plants whose deep, velvety
blue petals herald the arrival of summer in Japan.
Summer is followed by autumn in the left-hand painting.
A branch of maple bends down into the picture with
its brilliantly colored leaves of crimson, orange and
gold, while underneath grows a narcissus, its leaves
lightly sprinkled with snow. The four seasons have
always intimately affected the lives of Japanese, and
allusions to them are an important element in Japanese

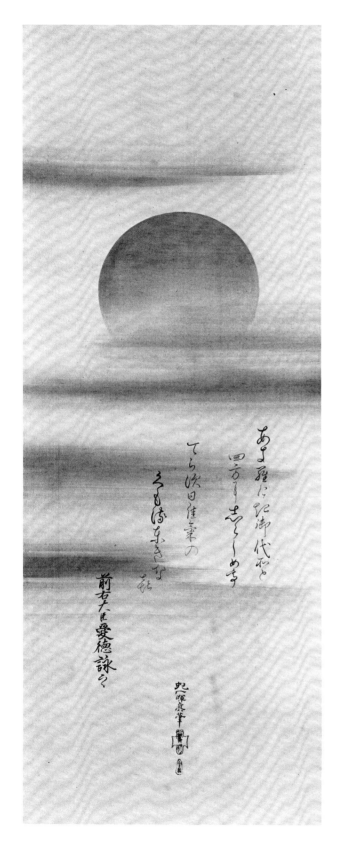

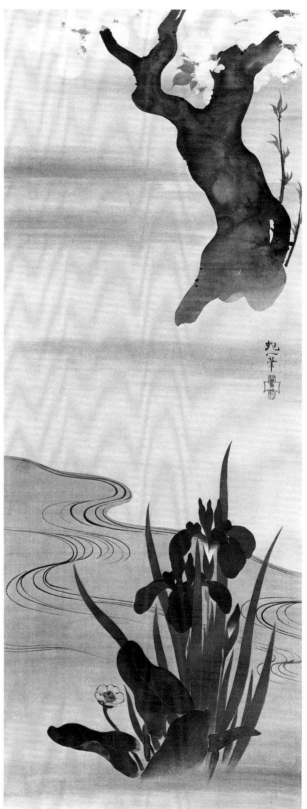

poetry. By his inclusion of plants from each of the four seasons, Hōitsu perhaps sought to suggest the unending cycle of life, a theme which is also hinted at in the motif of the rising sun.

Hōitsu's predilection towards bird and flower subjects was undoubtedly abetted by the great surge in interest in plant life by both the intelligensia and general public of Edo at this time.[2] During the late eighteenth and early nineteenth centuries, numerous botanical studies were published, new varieties imported from abroad, and plant viewing gardens established. The effects of this science extended into the world of painting, stimulating artists to practice methods of realistic depiction. However, Hōitsu did not confine himself to naturalistic studies of plant life. Although he sought to capture the essence of his subjects, he exercised artistic judgment by further simplifying and refining his forms. In the left-hand painting, the stream has been stylized to a point of abstraction which is unusual for Hōitsu. This ethereal feeling is heightened by the brilliant greens, reds and blues and the bands of gold mist which elegantly divide the four seasonal plants. As in the previous fan, gold paint has been painstakingly applied to represent veins on the leaves, increasing the decorative effect. In terms of design and brush technique these works are flawless: just as masters of Japanese gardening and flower arranging have traditionally done, in his paintings Hōitsu manipulated nature so that it reached a formalized state of perfection.

PF

1. The "Ōson" seal on all three paintings is one of several versions of this seal appearing on published works.

2. cf. Tamamushi Satoko, "Hōitsu ga no teihen," *Rimpa kaiga zenshū*, vol. 5, pp. 63-65. This was in part a response to the earlier introduction of traditional Chinese pharmacology called *honzōgaku* which entailed a precise study of the medicinal properties of animal, vegetable and mineral substances.

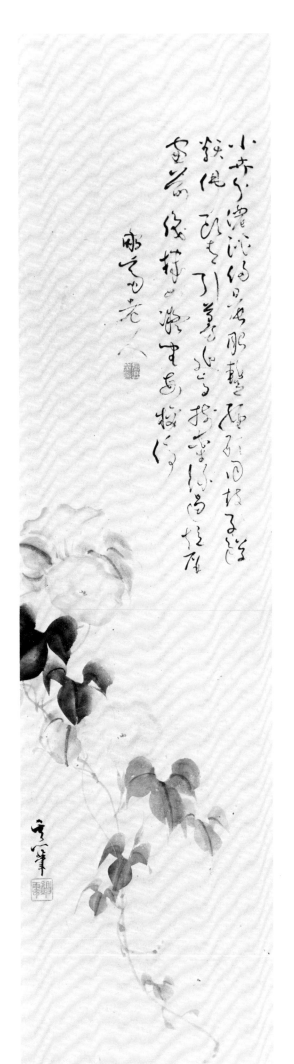

15

Suzuki Kiitsu 1796-1858
Morning Glories

Hanging scroll, ink and light color on paper, 100.4 x 26 cm., 39½ x 10¼ in.
SIGNATURE: Painted by Kiitsu
SEAL: Shaku-un
INSCRIPTION by Kameda Bōsai (1752-1826): see text below
PROVENANCE: Hosomi Ryo, Ōsaka
PUBLISHED: Suntory Museum, *Sakai Hōitsu to Edo Rimpa* (Tokyo, 1981), no. 38.
Nakamura Tanio, *Hōitsu-ha kachō gafu* (Kyoto, 1979), vol. 4, no. 79.
Yamane Yūzō, ed., *Rimpa kaiga zenshū* (Tokyo, 1977-80), vol. 5, no. 164.

The most gifted pupil of Sakai Hōitsu (Nos. 13, 14) was Suzuki Kiitsu who began to study painting in 1813. Kiitsu must have been highly regarded by his teacher, for Hōitsu made arrangements for him to marry the sister of Suzuki Reitan, a samurai serving the Himeiji *daimyō*.[1] In addition to being adopted into the Suzuki family, Kiitsu became an official retainer of the Sakai clan. He served as Hōitsu's assistant until the latter's death in 1828, studying not only painting but also *haiku* poetry and the tea ceremony. Kiitsu remained in the employment of the Sakai family until his own death in 1858.

Following the models set forth by his teacher, Kiitsu most commonly painted bird and flower subjects. *Morning Glories* is unusual among his works because it was painted with ink.[2] In contrast, the majority of Kiitsu's paintings are rendered in color, sometimes pale and subtle, other times lavish and bold. Here Kiitsu has added only light touches of blue pigment to the flower petals, further enhancing their delicate, ephemeral quality. The surrounding leaves were brushed with soft, wet ink which in its great tonal variety suggests different shades of color. The technique of application with an unevenly inked brush immediately recalls the Shijō tradition, which by this time had been transplanted in Edo through the efforts of Watanabe Nangaku (No. 74), Ōnishi Chinnen (1792-1851) and Suzuki Nanrei (1775-1844). There was a great deal of cross-fertilization among many schools of painting in the nineteenth century, and the young Kiitsu seems to have been particularly influenced by the Shijō style. His teacher Hōitsu had also initially experimented with a number of painting traditions, although he eventually devoted himself to learning the Kōrin style.

Rimpa artists frequently painted leaves using a no outline technique, but the product is often calculated in its glowing perfection. In contrast, the brushwork in

Morning Glories has a fresh, unpremeditated quality which is a notable feature of Shijō painting. Artists of this school used a wide, flat-edged brush called a *hake* which permitted broad, sweeping washes, gradated in tone from light to dark. The shapes of Kiitsu's flowers and leaves are instantly recognizable and even show a convincing sense of three-dimensional solidity. Like contemporary Shijō artists, however, Kiitsu was not concerned with lifelike fidelity to nature, but more in evoking an impression. The brushwork can be admired purely for its formal qualities, and a beautiful equilibrium is struck between reality and abstraction. The free and easy brushwork seen here is well-suited to the simple arrangement of forms: beginning at the left edge of the middle of the paper, the vine gently extends downward at a diagonal. The morning glories are wonderfully balanced by the poetic inscription above written out by Kameda Bōsai (see also No. 51), the characters of which twist and move as though they themselves were leaves blowing in the wind. Bōsai was a good friend of both Hōitsu and Kiitsu, and he frequently added inscriptions to their paintings. His poem reads:

This small plant has a range of dark and light tones,
Its flowers only open in the morning sun.
Its form resembles tall grasses,
And its color is blue like a Buddha's head.
It entwines itself in the trunks of tall trees,
And extends over the edge of short trellises.
When it blooms in front of the weaving girl's window,
In admiration she stops her shuttle.

The style of Kiitsu's signature on *Morning Glories* suggests that it was done early in his career, and we know that it must have been completed before Bōsai's death in 1826. The natural freedom of Kiitsu's brushwork observed here seems to have been suppressed in his later works which emphasize complexities of coloration as well as more sophisticated designs.

PF

1. Tsuji Nobuo, "Suzuki Kiitsu shiron," *Rimpa kaiga zenshū*, vol. 5, p. 67.
2. A similar painting by Hōitsu is published in *Rimpa kaiga zenshū*, vol. 5, no. 58.

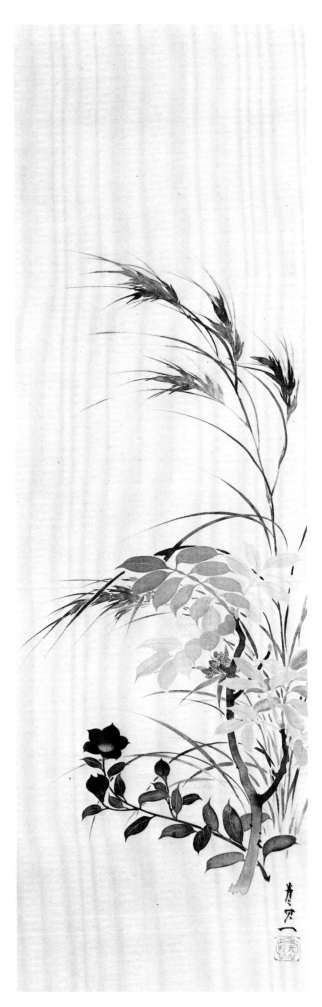

16

Suzuki Kiitsu 1796-1858

Autumn Grasses and Flowers

Hanging scroll, ink and color on silk, 97 x 30.8 cm.,
38³/₁₆ x 12¹/₈ in.
SIGNATURE: Seisei Kiitsu
SEAL: Gen-a
PUBLISHED: Howard A. Link, "Neglected Masters of Rimpa,"
Orientations (December, 1980), p. 30.

In many of Kiitsu's paintings there is an emphasis
on a particular season, exemplified here by his choice
of pampass grass and blue Chinese bell-flowers which
to the Japanese immediately suggest autumn. Silhouetting
the plant forms against a background of plain silk,
Kiitsu has arranged the motifs to form a lovely, delicate
design. The leaves and grasses sprout forth from the
right side of the composition, bending toward the left
as though blown by a gentle autumn breeze. To counter-
balance this movement, the blue bellflower leans grace-
fully upward to the right. In contrast to the meticulous
representation of the flowers and plants in the lower
half of the composition, the tall grasses were brushed
with a freedom that itself suggests the wind. The
individual leaves and stalks were painted with color and
ink utilizing the "boneless" brush method. Bright orange
leaves contrast vividly with the surrounding cool colors
and somber ink tones. In some areas, Kiitsu masterfully
employed the technique of tarashikomi, embellishing
the ink with touches of green and gold. The resulting
suggestion of modeling indicates that Kiitsu was in-
terested in imparting a sense of naturalism to his forms
as well as the overall decorative effect. In this respect
he seems to have been influenced by the Maruyama-Shijō
painting tradition which was extremely popular in
Japan at this time.

Autumn Grasses and Flowers was probably painted
within the last ten years of Kiitsu's life. Although Kiitsu
rarely dated his paintings, Tsuji Nobuo has established

a tentative chronology of his works based on the changes in his signature.[1] The Gitter painting was signed "Seisei Kiitsu," a signature considered to have been used in the artist's late period since a painting dated 1857 bears the same autograph.[2] Another "Seisei Kiitsu" signature which includes the date 1854 is published in the *Nihon gaka jiten*.[3] Kiitsu's sobriquet "Seisei" was probably inspired by Ōgata Kōrin's *gō* "Seisei" which although pronounced the same was written out with different characters. The seal "Gen-a" is rare and appears on only one other published painting by Kiitsu.[4] The Gitter painting also exhibits certain stylistic characteristics which are indicative of Kiitsu's late period such as the simple and coherent placement of the plant forms. Unlike some of his Rimpa School predecessors, Kiitsu limited his design and did not fill the composition with many varieties of flowers. Here the simplification was carried to such an extreme that the resulting design has a chasteness which is uncommon among Kiitsu's works. Breaking away from the overtly decorative compositions of previous Rimpa masters, Kiitsu achieved a quiet, gentle purity in *Autumn Grasses and Flowers* which is the hallmark of his mature style.

PF

1. Tsuji Nobuo, "Suzuki Kiitsu shiron," *Rimpa kaiga zenshū* (Tokyo, 1978), vol. 5, pp. 69-72. Midori Deguchi, a Ph.D. student at the University of Kansas has developed this chronology further in her dissertation research on Suzuki Kiitsu.

2. Collection of Mary Griggs Burke.

3. Sawada Akira, ed., *Nihon gaka jiten* (Tokyo, 1927), vol. 2.

4. See *Hōitsu-ha kachō gafu*, vol. 2, pl. 19

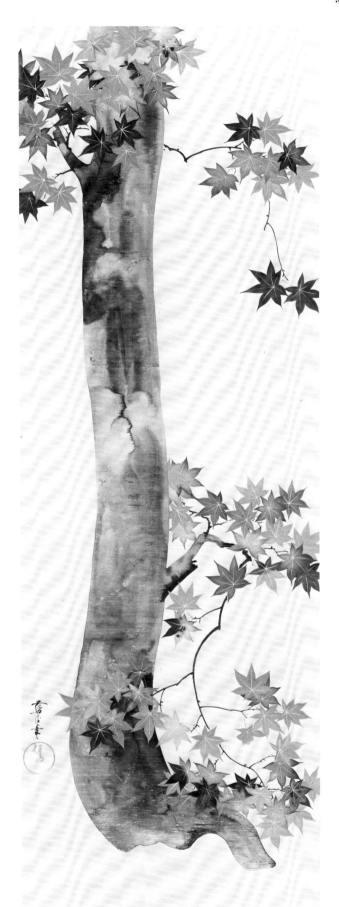

Sakai Ōho 1808-1841

Autumn Maple

Hanging scroll, ink and color on silk, 115.6 x 41.4 cm., 45½ x 16⁵/¹⁶ in.
SIGNATURE: Painted by Ōho
SEAL: Bansei

The Rimpa tradition was maintained and perpetuated throughout the generations by the practice of imitations. Few of the later masters strove for full originality in their works, often contenting themselves instead with following the designs of their mentors. *Autumn Maple* by Ōho is a classic example, for it faithfully reproduces a composition orginated by Hon'ami Kōho (1601-1682), the grandson of Kōetsu (see No. 8).

It is commonly believed that Ōho was the adopted son of Sakai Hōitsu (see Nos. 13, 14). However, Nakamura Tanio has suggested that Ōho may have been the natural offspring of Hōitsu and his lover Shoran.¹ Since it would not have been proper for an unmarried monk to father a son, particularly by a Yoshiwara courtesan, Nakamura theorizes that upon his birth Ōho was taken to the Jōdo shinshū temple Jōei-ji in Ichigaya where he stayed until April of 1818 when he was officially adopted. Hōitsu's sister may have had knowledge of this scandal, for only after her death in March of 1818 did Hōitsu feel it appropriate to reclaim his son. Hōitsu died when Ōho was only 21; although he was the youngest of Hōitsu's pupils (Suzuki Kiitsu (Nos. 15, 16) was 33 and Ikeda Koson was 25), Ōho was given the title Uge-an II and took over his father's studio, the "Rain Flower Hermitage."

Ōho was among the most talented of Hōitsu's followers, as is attested to by the great technical skill seen in *Autumn Maple*. As noted above, the composition dominated by the vertical thrust of a slender tree trunk was developed by Kōho: there are at least three works extant today following this design, two of which are part of a triptych.² Sakai Hōitsu did a copy of one of Kōho's triptychs which he inscribed as following Kōho's model.³ Ōho also did a version of this triptych which is in the Yamatane Museum, but he did not record whether he copied Hōitsu's or Kōho's original.⁴ It is not known whether the *Autumn Maple* reproduced here was once part of a similar triptych. The composition is similar to the works described above, but Ōho has made a number of small variations in the placement of leaves and branches. Perhaps the most notable derivation is that the design is reversed. Both the top and bottom layers of branches extend outward to the right instead of left, and the bottom of the tree trunk also bends toward the right. In all of the known examples by Kōho and Hōitsu, movement is oriented to the left. Whereas in the Yamatane Museum triptych

Ōho adhered to the original design in terms of positioning and even in the application of *tarashikomi,* in the Gitter version he has felt more free to improvise. The use of *tarashikomi* here is soft and nebulous, well-suited to the unbroken line of the tree which seems to flow upward. Over the first layer of ink Ōho has dropped wet pigments of green and gold, creating an elegant, mosslike texture. The suppleness of the velvety wet tree trunk provides a marvelous contrast to the dazzling brilliance of the crisply pointed maple leaves, which Ōho has rendered in multifarious shades of crimson, orange and brown. Although the overall effect is decorative and stylized, the individual coloring of the leaves captures the true feeling of autumnal foliage. Maple trees were a metaphor for the season preceding winter and thus evoked feelings of melancholy and sadness. Ōho has frozen for us that moment in time when the leaves are at the height of their beauty, allowing us to savor it in an almost surreal state of undisturbed tranquility.

PF

1. Nakamura Tanio, *Hōitsu-ha kachō gafu* (Kyoto, 1979), vol. 4, p. 150. I am grateful to Midori Deguchi for calling my attention to this material.

2. Collections of the Freer Gallery of Art, Fujita and Tokyo National Museums. For reproductions of the latter two, see Howard A. Link, *Exquisite Visions: Rimpa Paintings From Japan* (Tokyo, 1980), p. 70 and Tokyo National Museum, *Rimpa* (Tokyo, 1972), no. 197.

3. This work is now in the Atami Museum and is published in *Rimpa kaiga zenshū,* vol. 2, no. 37.

4. See *Rimpa kaiga zenshū,* vol. 2, no. 213.

ZENGA

Although Zen painting had already been a notable tradition in Japanese art for several hundred years, at the beginning of the seventeenth century it was in a somewhat moribund condition. Professional painters had commandeered the style and subject matter of early monk-artists, and Zen itself was losing its dominant position in Japanese culture. Nevertheless, there was a great revival of monk painting and calligraphy during the Edo period, to which the name Zenga (Zen painting) has been applied.

The pure Zen painting tradition was first revived by monks at Daitoku-ji in Kyoto, and by calligraphers and artists associated with the monks of this temple. The increasing importance of the tea ceremony was an important factor in this revival, as a restrained and yet immediately expressive scroll was favored for hanging in the *tokonoma* alcove during the ritual drinking of tea. In addition, individualists monks such as Fūgai Ekun (No. 18) in the countryside turned to brushwork to express their vision of Zen avatars such as Daruma and Hotei.

The fall of the Ming government in China in 1644 led to a number of monks emigrating to Japan, where they were known as the Ōbaku sect. These monks were cultivated calligraphers, and their brushwork was highly appreciated by the Japanese cultural leaders of the day (see No. 19). The most important reviver of Zen painting, however, was the Rinzai sect monk Hakuin (Nos. 20-24), who turned to brushwork in his sixties and poured forth a large number of paintings and calligraphy until his death at the age of eighty-four. Hakuin's earlier works are characterized by their charm and novelty of subject matter. Instead of merely portraying the Zen figures and landscape subjects of the past, he invented numerous themes such as the *Ant on a Stone Mill* (No. 21) and *Two Blind Men Crossing a Log Bridge* (No. 20), both parables of the difficulties in life for those who do not realize their own enlightenment. Late in his life, Hakuin restricted the range of his subjects, and painted with a bold massive force. His late period calligraphy is also monumental in scope and brushwork, such as his large-character rendition of *Virtue* (No. 24).

Hakuin's pupils continued his tradition, both in the revitalization of Rinzai sect Zen and in the arts. Tōrei was the most individualistic of Hakuin's direct pupils, and excelled at the Zen circle symbolizing the void called *Ensō* (No. 25). Other followers such as Reigan (No. 26), Shunsō (No. 30), and Kōgan (No. 29) added their own interpretations of figure subjects to the art of Zenga. Not all masters of this tradition were Zen monks, however. The Shingon monk and Sanscrit expert Jiun is considered a Zenga master for the immediacy and strength of his powerful calligraphy, which has a unique impact (No. 27).

The most popular of later Zenga masters has been the monk Sengai, for he combined variety of subject matter and strength of brushwork with a unique wit and charm (No. 31). His works have been widely appreciated both in Japan and in the West, as they are able to communicate directly with viewers of almost any background. One of the more recent Zen masters, Nantembō, has also been highly appreciated in recent years for

the combination of spontaneous strength and humor in his works, even when portraying the semi-legendary founder of Zen, *Daruma* (No. 32).

Although Zenga has not always been accorded a rank of honor in Japanese art, due to its non-professional style and rapid execution, it has lately been acknowledged as a major art-form by scholars and general public alike. The fact that the monks did not earn their living from their brushwork allowed them the freedom to express themselves with no thought of success or failure. Their long training in calligraphy enabled them to master the technical aspects of their art, and their long years of meditation gave them an internal strength and vitality that is apparent in their scrolls. Zenga communicates the vision of Japanese monks with intensity, immediacy and humor.

SA

Fūgai Ekun 1568-1654

Daruma on a Reed

Hanging scroll, ink on paper, 73.9 x 29.5 cm., 29⅛ x 11⅝ in.
SIGNATURE: Inscribed and painted by Fūgai Dōjin
SEAL: Fūgai

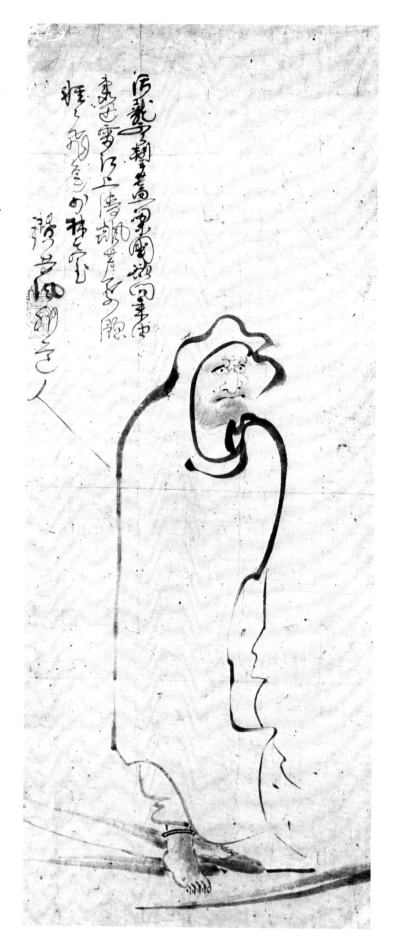

Fūgai Ekun was one of the most fascinating Zen artists of the Edo period. Born in the village of Hijishio in Gumma Prefecture, he became a monk before his tenth birthday, serving in the Sōtō Zen temple of Chōgen-ji and then being sent at age sixteen to Sōrin-ji for further training. At age twenty-nine he began his extensive travels to various temples, acquiring fame as a knowledgeable monk. In 1618 at the age of fifty, Fūgai became abbot of Seigan-ji in Kanagawa. For some reason life in a temple did not satisfy him, and he left to live first in one cave and then another in the Soga mountains.[1] Fūgai's caves were small, cold and dank, but they faced the south and offered splendid views of Mount Fuji from their entrances.

In 1628 Fūgai left his cave and moved to the town of Manazuru where he lived first in a shelter and later in a simple hut next to a shrine. In 1648 he was invited by the feudal lord Inaba Masanori to live at Odawara Castle, but Fūgai is said to have left during a *saké* party, leaving only a poem as explanation. He then sojourned in the Isu mountains, moving to Ishioka near Lake Hamana where he died at the age of eighty-seven. According to local legend, at his request he was buried alive in a meditating posture.

Fūgai's paintings, while almost always undated, seem to have been brushed in his advanced years. He usually confined his subject matter to depictions of Daruma and the happy-go-lucky monk Hotei. Fūgai's portrayals of Daruma are particularly intense, perhaps because the artist had shared some of the profound meditation of the patriarch. Here we see one of the famous incidents in Daruma's life, after he left the Liang Emperor in South China to travel across the Yangtze River to the north. The written character that means "reed" in Chinese once also meant "reed boat", but it has long been accepted as miraculous that Daruma was able to cross the river standing on a reed.

Fūgai's line is dynamic and calligraphic, as can be seen by comparing the brushstrokes of the poem with those of the figure. The final stroke of the inscription points directly to Daruma, who stands on the reed with an expression of haunting intensity that is the hallmark of Fūgai's art.[2] Despite the simplicity and strength of the painting, there is something playful about Fūgai's line, which carries a feeling of spontaneity completely under the control of the artist. Tonal shadings vary from grey to black, with the darkest

ink reserved for the eyelids, pupils, nostrils, mouth and ring around the ankle of the patriarch.

The poem by Fūgai refers to the incidents when Daruma responded enigmatically to the Liang Emperor's requests for Zen explanations, and then crossed the river to the Hsiao-lin temple.

Dragon clouds roll over the Liang countryside,
When the reason is asked, the violent thunder roars.
Crossing the river lightly like the wind,
The sage stops at the Hsiao-lin temple.

Reacting against the complex and professionalized ink paintings of the late Muromachi and Momoyama periods, Fūgai developed a personal style that is closer to early Zen painting than to the art of his own day. He became an important pioneer in Zenga: his depictions are simple and direct, usually include his poetry in expressive calligraphy, and have immediate and spontaneous power rather than painterly elaborations. This portrayal of Daruma, the primal Zen subject, typifies the special intensity of Fūgai's art.

SA

1. His life must have been very much like that of the first patriarch Daruma (Bodhidharma) who meditated in front of a wall for nine years. See *Bokubi* 101 (1960) for further information on Fūgai's biography.

2. For another example by Fūgai of the same theme, see John Rosenfield, ed., *Song of the Brush* (Seattle, 1979), No. 27.

Ōbaku Taihō 1691-1774
Bamboo in Snow

Hanging scroll, ink on silk, 114.3 x 42 cm., 45 x 16⁹/₁₆ in.
SIGNATURE: Painted by Shina Shō-ō Hō
SEALS: Taihō no in, Shakushi Shōgon, Kanchū higetsuchō
 (leisure through the long days and months)
PROVENANCE: Hosomi Ryo, Ōsaka

A group of Chinese Zen monks from Fukien Province emigrated to Japan in the middle seventeenth century after the fall of the Ming dynasty. At first confined to the city of Nagasaki, they were granted special permission to build a major temple compound, Mampuku-ji, near Kyoto. Although they followed Rinzai Zen traditions, this group of monks had somewhat eclectic rituals that included elements from Pure Land Buddhism, so in Japan their sect was called Ōbaku, after the location of their original temple in Fukien. Ōbaku Zen grew and prospered in its first hundred years, in part because the monks were able to convey to the interested Japanese many aspects of Ming dynasty culture.

Taihō became a monk in China at the age of fifteen. Seven years later he emigrated to Japan, and in 1745 he became the fifteenth abbot of Mampuku-ji. He retired after three years, but was persuaded to accept the post again in 1758, becoming the eighteenth abbot. He finally retired in 1765. Many of the Ōbaku monks were fine calligraphers, but Taihō was especially noted for his paintings of bamboo. He developed a personal technique depicting thick culms and criss-crossing leaves. He was particularly adept at portraying bamboo in snow, adding grey wash irregularly throughout the painting, ending in jagged ridges around the leaves. The suggested snow seems wet and thick like the rare snow of Kyoto rather than the frigid dry snow of northern Japan.

The massive symmetry in this painting, including the leaves cascading down from the top and the balance

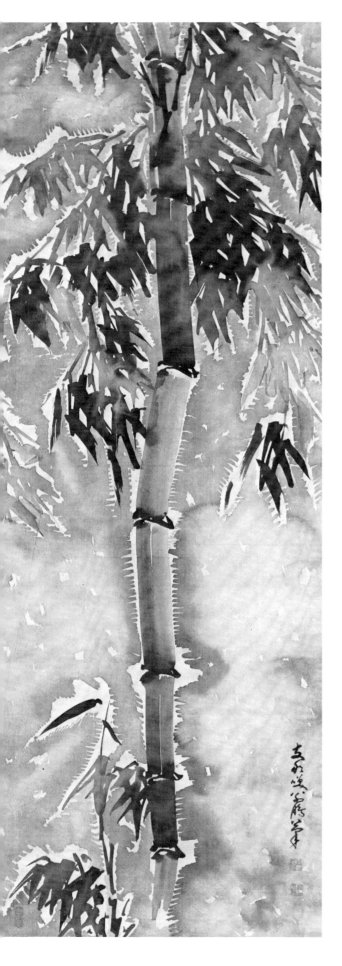

of the signature on the right with a small clump of bamboo on the left, is a Chinese characteristic. The vivid energy of Taihō's brushwork seems to have had a powerful effect upon Japanese artists, several of whom were known to have visited Mampuku-ji or had other Ōbaku connections. The use of varied tonal shadings in the wash, including small areas of blank silk, may have influenced Yosa Buson (Nos. 44, 45, 46). Literati masters who painted bamboo in the style of Taihō include the Nanga pioneer Gion Nankai (1677-1751), Ike Taiga (Nos. 33-39) and his wife Gyokuran (No. 40) and Taiga's pupil Kuwayama Gyokushū (1746-1799).[1] Taiga had been befriended as a youth by Taihō, and later painted many *fusuma* for Mampuku-ji at his request.

Although the Ōbaku monks did not ultimately have a profound religious effect upon Japanese Zen, they did transmit many of the cultural values of sixteenth and early seventeenth century China to their new homeland. They also produced an important body of literati-influenced art. Taihō's paintings helped to revive the popularity of bamboo, known as a "gentleman" because it would bend but not break in the wind and could energetically bring forth new shoots in the spring after remaining green through the cold winter. Taihō expressed a strength of brushwork and a sensitivity to atmospheric effects that Japanese viewers of the time, and Western viewers of today, have highly admired.

SA

1. See Stephen Addiss, *Ōbaku: Zen Painting and Calligraphy* (Spencer Museum, 1978) for further information and a comparison of bamboo paintings by Taihō and Gyokushū.

Hakuin Ekaku 1685-1768

Two Blind Men Crossing a Log Bridge

Hanging scroll, ink on paper, 28 x 83.8 cm., 11 1/16 x 33 in.
Seals: Hakuin, Ekaku no in, Kokan-i (learning from self-
examination)
Published: John Rosenfield and Elizabeth ten Grotenhuis,
Journey of the Three Jewels (New York, 1979), No. 57.

In the early eighteenth century, Japanese Zen was in a weakened condition. Monks were no longer the principal advisors to the government leaders and

crossing this bridge. He emphasized the precarious nature of the journey in simple but evocative brushwork, adding the poem:

Both inner life and the floating world outside us
Are like the blind man's round log bridge —
An enlightened mind is the best guide.

As a vision of our unawakened selves attempting to struggle through life, the painting is an imaginative and humorous allegory. One man holds a staff and carries his sandals so that he can sense the texture of the logs with his bare feet. The other hangs his sandals on

merchants of the country, nor did they entirely rule their own temples due to political interference in the selection of abbots. An increasingly secular and pleasure-loving society turned to Confucian scholars whenever guidance seemed needed, and in larger cities the Zen abbots were revered more for their cultural attainments than for their deep religious insights.

At this time the great master Hakuin appeared, and he so revived the Rinzai Zen tradition that monks of this sect are still taught following his principles. Hakuin attracted scores of pupils whom he trained with a series of unanswerable questions (*kōan*) for them to meditate upon. When they reached the end of their logical reasoning powers, they had the opportunity to break through into a state of enlightenment, crossing beyond dualistic thinking and awakening to the Buddha in their own nature. Hakuin seems to have been the Zen master who could best help them in this task.

Near Hakuin's country temple, Shōin-ji, at Mama, near Izu, there was a steep chasm over a river that people could cross only by a narrow and dangerous log bridge. When Hakuin in his sixties turned to brushwork to express his vision, he occasionally painted blind men

his staff and tucks the staff into his belt in order to cross on hands and knees. If we also see ourselves as travelers, perhaps we should open our eyes. We may find the view, instead of horrifying, breathtakingly beautiful.

Hakuin's paintings were brushed, it would seem, just for this purpose — to be given away to his followers as examples that might help them in the search for enlightenment. Due to their Zen conundrums and simplified brushwork, these paintings were not considered as fine art in Japan until recent years. Our contemporary experiences with action painting, minimalist and conceptual art and other new vanguard movements have assured us that Hakuin's paintings embody all the aspects of meaningful aesthetic expression. Once awakened to the beauty of this art, we may admire the effective composition, the range of brushwork including the blurring to dry stroke that defines the bridge, and the elegant calligraphy. It is the immediacy of effect that is most important, however; the direct nature of Hakuin's paintings is their most vital quality.

SA

detail

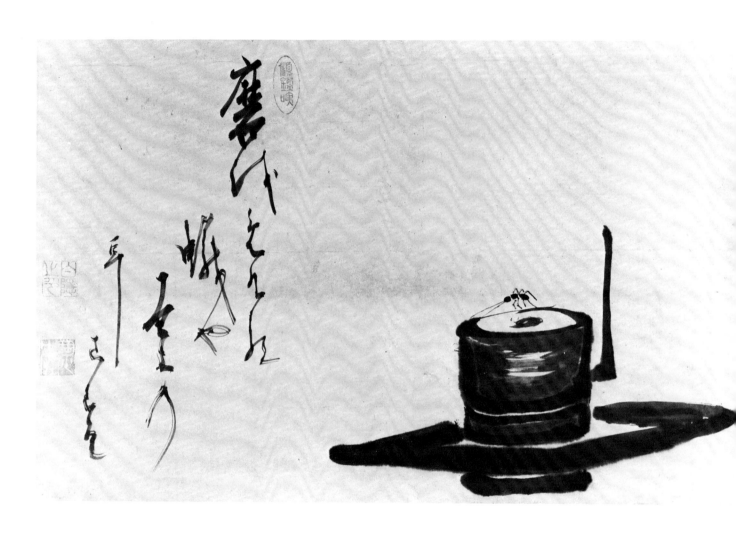

Hakuin Ekaku 1685-1768

Ant on a Stone Mill

Hanging scroll, ink on paper, 38.7 x 59.4 cm., 15¼ x 23⅜ in.
SEALS: Hakuin no in, Ekaku, Kokan-i (learning from self-examination)

The ant on the stone mill is another subject that was first painted by Hakuin,[1] again with a Zen message. As the mill turns, the ant walking around and around in the other direction expends his energy with no result. Many of us may feel we live just like this. Hakuin compared the ant in his poem with a foolish devil, making a pun on the words "grindstone" and "devil", both of which can be pronounced *ma* in Japanese. Hakuin also referred to Daitō Kokushi's explanation of Esoteric Buddhism as an eight-sided grindstone turning around the inner void. The poem is full of puns and idioms of Hakuin's day, but freely translated reads:

The grindstone has nine elements,
But in this world the ant
Cannot escape the cutting edge.

Hakuin brushed this subject frequently in his sixties,[2] as it formed a marvelous allegory representing those caught up in worldly desires, much like blind men crossing a dangerous bridge.

The brushwork is predominantly rendered in wet tones of grey, with the ink occasionally fuzzing such as at the base of the grindstone. Lustrous black is reserved for the depiction of the ant. The calligraphy includes split-brush lines and exaggerated verticals which contrast to the rounded forms and wet tonality of the painting. The composition is strongly asymmetrical, with the mill in the lower right forming the focus of attention. It leans very slightly to the left, the direction the ant faces, with the vertical stroke of the handle forming a partial frame for the simply depicted insect. This vertical is then echoed on the left by the poem which is broken into four lines of spiky calligraphy. The first line stands alone, like the mill-handle, while the other lines cluster into a group shaped like the grindstone. Thus Hakuin achieves a total balance within the asymmetrical design. The ant is facing the poem, but will he understand its message?

Hakuin's vision of people living on what the late American comedian Fred Allen called a "treadmill to oblivion" is very clear in this painting. The work was probably given to someone who might be awakened by it. In his maturity, Hakuin must have felt that he could express himself more directly through brushwork than through words alone. In his *Orategama III* Hakuin had written "If we examine talent in painting, callig-raphy or music, we can never discover exactly where the genius lies. The mysterious spirit with which all people are endowed is like this."[3] Therefore, for Hakuin painting and calligraphy represented his inner spirit. *Ant on a Stone Mill* is not only a delightful painting, but also a manifestation of the inner nature of an extraordinary monk and artist.

SA

1. The metaphor may have been created by the Chinese poet Su Shih, who in 1080 wrote to his brother that his life was like an ant crawling against a turning millstone.

2. The only known example of this theme from Hakuin's later years is in the Shōka Collection.

3. Philip P. Yampolsky, *The Zen Master Hakuin* (New York, 1973), p. 88.

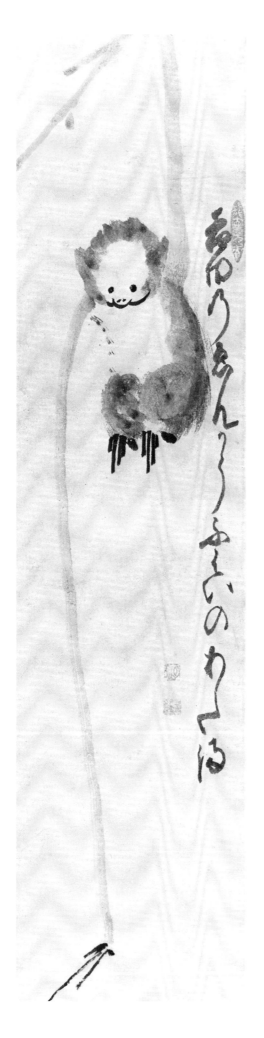

22

Hakuin Ekaku 1685-1768
Monkey

Hanging scroll, ink on paper, 69.5 x 17.2 cm., 27⅜ x 6¾ in.
SEALS: Ryūtoku tenka, Hakuin, Ekaku no in

Hakuin's dramatic personal struggle to attain *satori* led him to encourage others in a patient and humane way. As noted in No. 20, his art served as an important teaching aid, and he frequently used humor and familiar imagery to communicate his principles. In particular, he did a number of paintings featuring animals, exemplified by this delightful monkey. Hakuin has depicted this creature grasping onto a tree branch with its left hand, its right arm extending down to the bottom of the picture plane. The theme of a monkey reaching out to grasp the image of the moon in the water was a common one in Zen art, so even though Hakuin omitted the reflection it would have been clearly understood. There are also other versions of this subject in which Hakuin included the moon.[1] The action of reaching for the reflection in the water represents the unattainable illusions of life and illustrates how futile it is to try to cling to them. In addition to this pithy Zen message, a further interpretation of this painting is suggested by the one line inscription written out at the monkey's right.

> *Yoshida no enkō fu hai no atama*
> *(The monkey of Yoshida is like a fly's head)*

Yoshida is the name of a mountain which was famous for its numerous monkeys. It was also the name of the Buddhist monk and poet Yoshida Kenkō (1283-1350). Yoshida's most famous work was his book entitled *Tsurezuregusa (Essays in Idleness)*, a collection of anecdotes and observations on such varied subjects as poetry, art, traditional customs and contemporary events.[2] The *Tsurezuregusa* did not become popular until the seventeenth century at which time detailed commentaries began to appear and the work was adopted as a basic text for educating the young. Yoshida Kenkō had taken the tonsure in 1324 and his writings are certainly influenced by Buddhist thought. However, it was believed by some that he never attained enlightenment.[3]

Hakuin was very critical of monks pretending enlightenment; this problem was especially prominent

in the Edo period due to the bureaucratic nature of many of the monasteries. Hakuin singled out Yoshida Kenkō on whom to vent his scorn, perhaps because this monk had achieved what Hakuin believed was illegitimate fame. In addition to playing on the name of Yoshida, Hakuin also made a pun on the name of Kenkō which rhymes with a Japanese word for monkey, *enkō*. His poem is clearly mocking Yoshida Kenkō; literally by comparing him to a fly's head which is a Japanese euphemism for narrowmindedness, and figuratively by alluding to his similarity with a monkey. Furthermore, he may also be suggesting that the actions of the monkey represent those of Yoshida, i.e. reaching in vain for something which one cannot obtain.

Hakuin has emphasized the importance of the monkey's gesture by depicting an absurdly long arm with one stroke of the brush. This is in turn underscored by the tall, thin format. In addition, Hakuin has minimalized all superfluous details such as landscape, delineating the branch from which the monkey suspends himself with only three brushstrokes. Although grey ink tones predominate, certain features such as the monkey's face, hands and feet have been accentuated by their bold delineation in black ink. The result is an outwardly charming painting, underneath which lie layers of Zen meanings. One of the most important teaching skills that Hakuin developed was the use of humor. By forcing us to view life in comic perspective as in his representation of *Monkey*, Hakuin hoped to awaken us to deeper truths.

<div align="right">PF</div>

1. One version in the Tanaka collection is published by Yamanouchi Chōzō in *Hakuin: sho to ga no kokoro* (Tokyo, 1978).

2. This book has been translated into English by Donald Keene under the title *Essays in Idleness: The Tsurezure of Kenkō* (New York, 1967).

3. Donald Keene noted that "Kenkō's clinging to traditions, his reluctance to accept change reveal an attachment to this world unbecoming a true monk." Ibid., p. xvii.

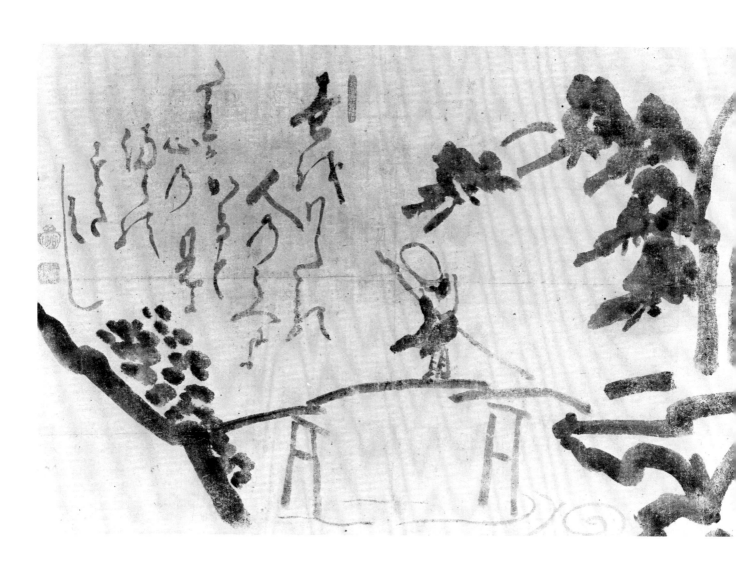

88

23

Hakuin Ekaku 1685-1768
The Bridge at Mama

Hanging scroll, ink on paper, 38.7 x 55.5 cm., 15¼ x 21⅞ in.
SEALS: Kokan-i (learning from self-examination), Hakuin,
Ekaku

The theme of crossing a log bridge became an important one in Hakuin's oeuvre, since it pictorially represented the arduous path one faces in the pursuit of enlightenment. The *Bridge at Mama* embodies the same concept as *Two Blind Men Crossing a Log Bridge* (No. 20), but conveys it in a less graphic, more poetic manner. As noted previously, there was a real wooden plank bridge at Mama in Izu made out of three logs which crossed the Kanō River near Hakuin's temple Shōin-ji. The word describing this type of bridge, *tsugibashi*, appears in poetry included in the *Manyōshū*. Hakuin was inspired by a less ancient and noble source, a satirical song of the time with lyrics referring to one of Emperor Gomizuno-ō's daughters called Tsukihashi no miya.[1] In an effort to make his teachings universally understandable, Hakuin frequently drew upon popular folklore in both his writing and painting. His inscription here reads:

Yo o wataru	*Whoever has*
Hito no ue ni mo	*The plank bridge of Mama*
Kakete miyo	*In his heart—*
Dareka kokoro no	*Let's suspend it*
Mama no tsugibashi	*Across the world of men.*

Hakuin is suggesting that life is full of vexations, the struggles we see all around us coming from our own ignorance. The *Bridge at Mama* can be interpreted as a symbol of salvation—a means of rising above the world and seeing into the nature of our own beings. However, the disciplined path towards enlightenment is difficult; one must go through a great struggle within oneself which is sometimes very long and requiring exacting vigilance. Thus, Hakuin's figure of a solitary itinerant monk slowly making his way across the hazardous log bridge, is undoubtedly a pictorial metaphor of the road to enlightenment. The monk's robes are blown violently by the wind, and swift currents swirl around the rocks underneath the bridge, accentuating the perils of his journey.

There are several examples extant of this theme which were brushed by Hakuin in his early period.[2] Although all three seal impressions on this version appear on early works, the style of writing and painting displays brushwork characteristics of his middle period.

As in much of Hakuin's painting, all superfluous details have been eliminated so as not to distract from the message he wished to convey. He has emphasized the monk crossing the bridge by placing him in the center of the composition. To the figure's right stands a tall pine tree with branches forming the shape of a crescent moon, quietly echoing the curve of his back as he braces himself against the wind. In the space to the left, Hakuin has written out his poetic inscription in the form of *waka*. On both sides of the ravine, a minimal number of brushstrokes were added to represent rocks and foliage. Hakuin has utilized a very wet ink which blurred in some areas when coming into contact with the hard-surfaced paper. As a result, the dominating tonality is grey which well expresses the somberness of the subject. Utilizing a seemingly unsophisticated, almost childlike brush technique, Hakuin poured forth personal feeling into his paintings. At first glance *Bridge at Mama* would appear to be just a simple scene, but Hakuin has imbued it with a powerful sense of drama and intensity.

By using subject matter that was not part of the classical Zen tradition, and presenting it in imaginative new ways, Hakuin altered the course of development of Zen painting of the Edo period. In his hands the function of painting by Zen monks changed; no longer was it just a personal outlet for spiritual expression, but became significant as a visual aid in the instruction of others.

PF

1. The lyrics of this song are: *Yo o wataru, hito no ue ni mo, kakete miyo, ika ni kokoro no, mama no tsukihashi.* Although the words are similar to Hakuin's poem, the meaning is very different. The lyrics allude to the fact that because her mother was the daughter of Tokugawa Hidetada, Princess Tsukihashi was spoiled and regarded as superior to her sisters. See Yanagida Seizan and Katō Masatoshi, *Hakuin,* vol. 9 of *Bunjin shofu* (Tokyo, 1972), p. 175.

2. A printed version of this design also appears in the book *Hakuin oshō jigansanshū* (Collection of Paintings and Inscriptions by the Great Monk Hakuin) published in 1759.

Hakuin Ekaku 1685-1768

Calligraphy: Virtue

Hanging scroll, ink on paper, 117.3 x 55.2 cm., 46³/₁₆ x 21¾ in.
SEALS: Hakuin, Ekaku, Kokan-i (learning from self-examination
PUBLISHED: Stephen Addiss, *Zenga and Nanga* (New Orleans, 1976), no. 14.

This work, dominated by an extraordinarily powerful single character, is surely one of the masterpieces of Zen calligraphy in the United States.[1] The large character, a variant of the word "virtue," seems to support the text above it. The words are from the Chinese historian and scholar Ssu-ma Kuang (1018-1086) who was a model Confucian, having served his government as a statesman in the Northern Sung period. It is characteristic that Hakuin would brush out Confucian sentiments; he also wrote Shintō and Pure Land Buddhist texts, not confining himself to Zen messages. He strove to reach as many people as possible, adapting the various forms of different religious or philosophical systems when he could communicate through them. Here his text, while properly moral in tone for Confucian scholars, nonetheless has a touch of Zen humor.

> *Pile up money for your sons and grandsons—*
> *They won't be able to hold on to it.*
> *Pile up books for your sons and grandsons—*
> *They won't be able to read any of them.*
> *No, the best thing to do*
> *is to pile up merit*
> *quietly, in secret,*
> *And pass this method to your descendants:*
> *it will last a long, long time.*
>
> (translated by Jonathan Chaves)

The strength and simplicity of the calligraphy tells us that this is a work of Hakuin's final years, when he eschewed grace and lightness in favor of a blocky power that has no equal. As so often in his late writings, the characters slightly overlap, leaving little negative space. Hakuin has utilized a combination of standard and running scripts, and his lines are heavy and thick as though the text were emblazoned through the paper onto stone. Columns are slightly tilted, as is the main character, saving the work from excessive symmetry. The slight diagonal movement adds a sense of liveliness to the calligraphy.

The impression of monumentality that one receives from this work is certainly its most notable feature, but a closer examination of the inscription in the upper portion shows a fascinating variety of brushstrokes and character shapes and sizes. The word "mu" (nothingness) is rendered in several different ways. As the third word in the second line (after the two repeat marks) it stands on its four dots like legs; here Hakuin has used regular script, blocky and architectonic. As the first character in the fourth line, however, it was brushed in a quirky running script, with a last squiggle of the brush giving an effect of dance.

The final character of the upper inscription ends in a long line that playfully wriggles ten times as it moves downwards. It resembles the side of a long key, or a blunt sword with a series of nicks taken from it by opposing blades. There is no doubt that Hakuin was varying his brushwork in order to balance the predominant effect of bulk and weightiness. Thus, as in any fine artwork, there is a subtlety and variety underlying the strength of the initial impression that the work evokes. The ink-tones, upon close examination, range from dark black to lighter grey. Hakuin used sized paper that absorbed the ink slowly, so that certain puddling effects where the brush slowed or turned would add depth and interest to the work. We can see Hakuin's mastery of rhythm and tone as well as his power of expression in this major work of his final years.

SA

1. At least two other examples of this subject exist in Japan. One, slightly larger, has the inscription below the main character. The other is on a six-panel screen; the large character is given an entire panel to itself and the accompanying text is written over the next five panels. See Yamanouchi Chōzō, *Hakuin: sho to ga no kokoro* (Tokyo, 1978) and the exhibition catalogue *Zen no sekai to Hakuin* (Nagoya, 1982).

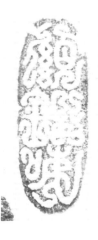

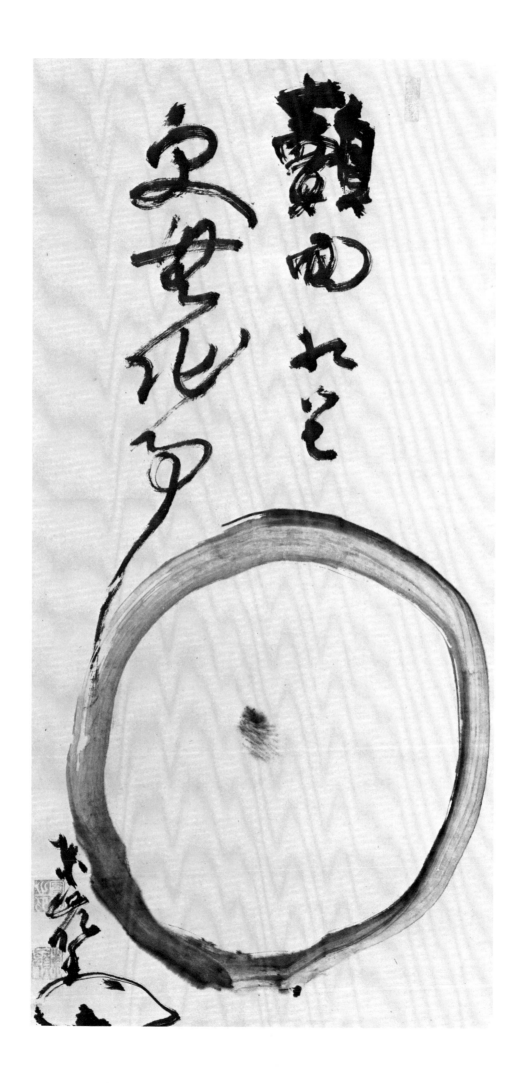

92

Tōrei Enji 1721-1792

Ensō

Hanging scroll, ink on paper, 109.8 x 55 cm., 43¼ x 21⅝ in.
SIGNATURE: Tōrei
SEALS: Unmon Rinzai hyakka no haru, Enji no in, Tōrei
INSCRIPTION: see text below
PROVENANCE: Shun'ō Fukushima Collection
PUBLISHED: *Bokubi* 257 (1976), no. 63.
 Zen bunka 56 (1970), pl. 8.

The circle called *ensō* is the simplest and most universal of Zen subjects. Representing the all, the void, the moon, the Buddha or a rice-cake, in its primal shape and clear activity of the brush it offers an immediate and powerful visual experience to the viewer. The inscription on this work emphasizes the direct communication of Zenga:

The image presents itself
 — nothing else

Another translation of the eight character inscription might be "Instantly face to face, with no distractions." Indeed, there is no way to avoid responding directly to the *ensō*, for the Zen master adds no color, no details, no representational aspects to call forth associations. There is only a circle which never ends.

Tōrei became a monk at Daitoku-ji at the age of eight, studying under Kōgetsu from the age of sixteen and then under Hakuin (Nos. 20-24) from the age of twenty-two. He eventually became abbot of Ryūtaku-ji after Hakuin's death, and was known for his amalgamation of Shintō, Confucianism and Zen. He wrote that Shintō guides our youth, Confucianism instructs our middle years and Buddhism teaches us in old age.[1] He felt that Shintō forms the roots, Confucianism the branches and Buddhism the blossoms. Tōrei also summarized the stages a Zen follower must pass through from shallow to profound enlightenment, describing the psychological states accompanying each stage. Of all of Hakuin's pupils, Tōrei had the most distinct and individualistic brushwork style, featuring great boldness and strength. He was especially noted for his *ensō*, and several examples from his hand are still extant.[2]

In this work we can see exactly how Tōrei moved his brush, which was loaded primarily with grey ink but also with darker tones mixed unevenly. The stroke began in the lower left, then moved rapidly upwards until at the top of the circle Tōrei added pressure. This brought more of the dark tone first on the outside, and then as the brush turned, on the inside of the *ensō*. Moving downwards, Tōrei twisted the brush in a more angular manner and overlapped the beginning of the circle. Thus in a single stroke we can see wet, fuzzing, dry, and mixed brushwork in a range of ink-tones from very light grey to black. Tōrei added a soft furry dot to the center, only rarely seen in the *ensō*, but here an important element in the total composition.

With his large brush now dipped in black ink, Tōrei added the inscription beginning in the upper right. The final character runs down towards the signature, and as the grey ink of the *ensō* was still damp, one may see the black ink fuzzing slightly. The signature shows Tōrei's characteristic clam shape, here incomplete as the work was slightly cropped at some time. This clam shape is a compressed echo of the tall circle of the *ensō*.

Although there are certain characteristics that one may see in all of Tōrei's Zen circle paintings, such as the stroke beginning in the lower left, each is different in the use of ink and movement of the brush. This most basic of shapes is thus the most personal and yet the most universal of subjects. Each *ensō* is unique, yet each offers us a glimpse at the immediacy of enlightenment.

SA

1. See *Bokubi* 100 (1960) pp. 37-39 for further discussion.
2. See Awakawa Yasuichi, *Zen Painting* (Tokyo, 1970) p. 135 and Stephen Addiss, *Zenga and Nanga* (New Orleans, 1976) p. 65 for two rather different *ensō* by Tōrei.

26 Reigen Etō 1721-1785

Pine, Hut, and Crows

Hanging scroll, ink on paper, 33 x 55.5 cm., 13 x 21⅞ in.
SEALS: Eshō, Reigen; oval seal undecipherable
PUBLISHED: Belinda Sweet, "Zen Painting," *Arts of Asia*,
 vol. 12:5 (1982).

The paintings of Hakuin's disciples offer an excellent opportunity to observe individual interpretations of established stylistic convention. While the influence of the master often leaves a strong stamp on theme, composition, or technique, the variations between each pupil's distinctive touch bespeak the range of expression possible within this simple yet highly personal form of painting.

Although Reigen was one of Hakuin's most important disciples from the standpoint of success within the Zen institution—in 1770, two years after Hakuin's death, he rose to the rank of abbot of the Rokuō-in, a subtemple of Tenryū-ji, one of Kyoto's great Gozan or "Five Mountains"—relatively little has been written about him. One account gives his birthplace as Kizu, in Tango, while another cites Mineyama, in Tamba.[1] After taking the tonsure under the Zen master Kōgoku at Zenshō-ji in Mineyama, Reigen, whose name means "spirit source," alternated training with Hakuin with spiritual retreat in the sacred mountains of Kumano, until he eventually received his *inka* (certificate) from Hakuin. Among the various classifications assigned to Hakuin's pupils, Reigen is listed among the "Six Guests."

Pine, Hut, and Crows has a close relationship with Hakuin's style. The dilute but strong cool grey ink is a part of the general school style, as is the rich velvety

texture obtained by applying an extremely wet brush slowly to absorbent paper and encouraging the ink to suffuse across the surface (for examples of this technique in Hakuin's work, see nos. 20-24). Added visual interest in the line has been created by dripping water or ink on the still-wet stroke, a process calculated to produce a scumbled effect. The composition, too, derives from Hakuin: a severely truncated architectural form, here a rustic hut with a round Chinese-style window, capped by a diagonal branch emerging from near the upper right corner of the picture.[2] To this unit is added a poem whose arrangement echoes the preceding compositional scheme. The bold dry brushstrokes evoking the texture of scratchy thatch on the roof of the hut also find parallels in Hakuin's work.

The painting, however, betrays Reigen's distinctive touch, visible in a more delicate rendering of forms than marks his teacher's work. Reigen's characteristic line, a thin, sometimes wavery stroke wherein the brush lingers at the beginning and end, creating thicker ink at the extremities, along with his dots, with their curious little tails, suggest in an extremely cursory manner the branches of the pine. Although the compositional scheme derives from Hakuin, Reigen's work in general shows a greater awareness of the edges of the format, here seen in the careful placement of the two crows parallel to the upper edge, the two seals parallel to the left edge, the blob-shaped form (a pine cone?) near the bottom, and the strong vertical line of the hut reinforcing the right edge of the paper.

The theme of *Pine, Hut, and Crows* seems to be Reigen's own creation, for it does not appear among the paintings of Hakuin and his circle. The five Chinese characters, cursively written with a dry brush (*kappitsu*), mean "crow, color, old, pine, frost." Although not a Japanese poetic form, in brevity and mood the inscription closely resembles a *haiku* and interacts with the image in a manner similar to the relationship between poem and painting in a *haiga*. The momentary is suggested by the flying crows, the timeless by the old pine, and the frost introduces the image of loneliness appropriate to autumn. By a minimum of means, Reigen has created a picture rich in a distinctively Japanese poetic mood.

MT

1. *Bokubi* 257 (January 1976) and the chronology of Hakuin given in Takeuchi Naoji, ed., *Hakuin* (Tokyo, 1964), p. 7 respectively. Biographical information has been taken primarily from *Bokubi*.

2. For an example of Hakuin's use of the composition see Takeuchi, ed., *Hakuin*, pl. 412, a painting of the *Tenjin Shrine*, Aoyanagi Collection, Tokyo.

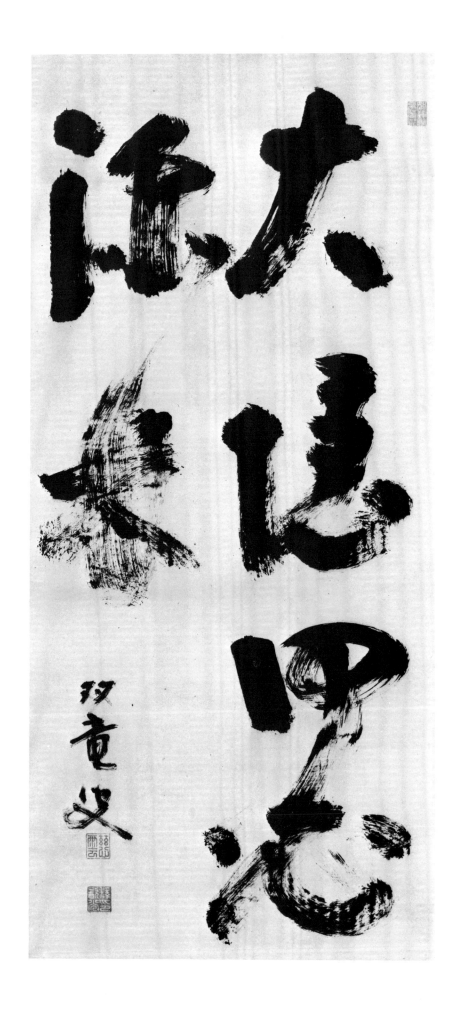

27

Jiun Sonja 1718-1804

Calligraphy: Great Hermit

Hanging scroll, ink on paper, 110.3 x 50 cm., 43 ⁷/₁₆ x 19 ¹¹/₁₆ in.
SIGNATURE: Sōryūsō
SEALS: Jiun, Shaku'onkō in, Nyo renka fu cho sui (like the
 lotus flower, not touching the water)
PUBLISHED: Yabumoto Sōshirō and Yabumoto Sōgorō, eds.,
 Jiun Sonja ihō (Tokyo, 1980), vol. 2, pl. 199.

Few calligraphers combine spontaneity, energy, and discipline as masterfully as does the monk Jiun. The six large Chinese characters ask, "Must a great hermit live in a deep wood?" Executed in Jiun's unique style, the writing displays the almost uncanny quality of appearing simultaneously architectonic and ephemeral. The effect of solidity is achieved by various devices: the abundance of blunt, thick strokes, passages of saturated, unbroken ink, and the careful structuring of the characters to achieve respose by means of daringly distorted counterbalance (see, for example, the first and second characters). The concurrent dynamic movement and transparency are the aesthetic result of Jiun's manipulation of the flow of ink, which in places becomes so dry as to threaten to disappear almost entirely, as in the fourth and sixth characters. Some of the characters, especially the final one, possess a strong three-dimensionality that is the calculated result of the writer's technique of folding the tip of his brush.

It is instructive to compare Jiun's work with another large-character calligraphic work in the exhibition, Hakuin's *Virtue* (No. 24) to underscore Jiun's interest and training in calligraphic technique *per se.* Hakuin's brushwork, although equally powerful, appears flatter and more artless in the manner of structuring the configurations of the strokes. The two artists also use completely different techniques in distributing the flow of ink, producing totally different aesthetic results.

Jiun's calligraphy is sometimes classified with the "Deviants" among the Tokugawa period calligraphers, along with Jakugon, Ryōkan, and Taiga (Nos. 33-39), for it does not follow any of the conventional styles of the day.[1] It is not known where Jiun received his training, but it has been suggested that perhaps the work of the Ming calligrapher Ch'en Hsien-chang served as Jiun's model: techniques such as the rough brush, blunt beginnings and endings of strokes, and abundant use of "flying white" are common to both.[2] Jiun's works, which include writing in Chinese, Japanese, and Siddham scripts, are rarely, if ever, dated, and show a consistency of style throughout his oeuvre. It is difficult, therefore, to know at what stage of his career the present work was created.

Strictly speaking, it is not correct to include Jiun's work among Zenga, for he was a monk of the Shingon sect. He was, however, a man of extraordinarily broad intellectual interests, and his studies and writings range over a variety of areas of learning including Shintō, Pure Land Buddhism, Sanscrit, Chinese classics, and Zen.[3] He wrote exhaustively about religion, and even composed tracts in *kana* script especially for women. His few paintings depict simply-drawn subjects common to Zenga, such as the monk's staff or renditions of Daruma, or literati themes like plum, bamboo, and pine. The sentiments expressed in the work under discussion, the notion of returning to the everyday world after finding enlightenment instead of remaining in seclusion, are part of Zen teaching. A portrait in Jinkōin, Kyoto, of this humane and venerable man, bearing his own inscription, shows an elderly patriarch, lined and white-haired, with bushy brows and surprisingly for a priest a beard and fringes of fluffy white hair surrounding his bald pate.[4] The appearance of the man is like his calligraphy itself: it gives the impression of strength tempered with gentleness.

MT

1. Yujiro Nakata, *The Art of Japanese Calligraphy,* trans. Alan Woodhull in collaboration with Armins Nikovskis (New York and Tokyo, 1973), p. 161.

2. *Shodō zenshū,* vol. 23 (Tokyo, 1956), p. 30; for reproductions of Ch'en Hsien-chang's calligraphy see *ibid.,* vol. 17, pl. 60-61.

3. Accounts of Jiun's life and of his prodigious intellectual accomplishments are given in John M. Rosenfield and Shujiro Shimada, *Traditions of Japanese Art: Selections from the Kimiko and John Powers Collection* (Fogg Art Museum, 1970), p. 253 and in John Stevens, *Sacred Calligraphy of the East* (Boulder, 1981), pp. 11-12, 140, and 159.

4. The portrait is reproduced in *Bokubi* 127 (1962), a special issue devoted to Jiun.

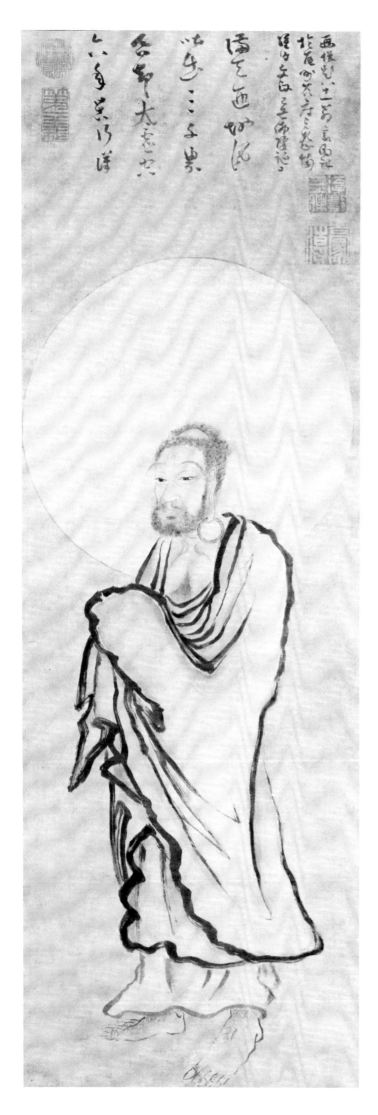

Gōchō Kaichō 1749-1835

Shaka Returning From the Mountains 1829

Hanging scroll, ink and color on silk, 198.3 x 67.3 cm.,
 78 1/16 x 26 1/2 in.
SIGNATURE: Painted and inscribed by Gōchō at age eighty-one
SEALS: Buppōsō hō (Treasure of the Buddhist Law), Dai-ichi
 gi (Highest Righteousness), Musho tokudō, Yūgi
 sammai, Gōchō
INSCRIPTION: Painted in 1829 at Biyō Meifu Sanmitsujō

Although Gōchō was a monk of the Tendai sect
who also studied Pure Land Buddhism, he is accorded
a place in Zenga because of his powerful ink paintings
and calligraphy which convey a spirit of inner strength
and meditation. Born in Kyūshū, Gōchō was the son of
a monk and began his own religious training at the age
of eleven. He was elevated to the rank of abbot of
Jūfuku-ji before he was thirty, and became recognized
for his austere way of life. He is said to have smashed
all the *saké* (rice wine) cups in the temple and to have
slept without a mosquito net even during the summer.
He also became famous as a faith-healer. In 1817 at the
behest of his monk friend Chingyū, Gōchō traveled
to the Nagoya region to treat the *daimyō* of Owari,
who was extremely ill. After the *daimyō* was successfully
cured, he did not allow Gōchō to return to Kyūshū;
in 1823 the *daimyō* completed the construction of the
temple Chōei-ji, where Gōchō lived his final years.

The theme of the historical Buddha returning from
the mountains has been a popular subject for Zen
painting since at least circa 1100 in China, when Li
Kung-lin was known to have depicted this subject. The
oldest extant example is the famous work by Liang K'ai
in the Tokyo National Museum, and Japanese profes-
sional artists and Zen masters have frequently painted
this theme. There is no firm agreement, however, on
the exact meaning of the subject. At first it may have
represented Shaka after six years of meditation and
austerities, but before his enlightenment. A monk would
easily empathize with this gaunt and discouraged figure,
who was still seeking the Buddha within his own being.
In later depictions, however, Shaka seems to be descend-
ing the mountains just after his *satori* to spend the rest
of his life teaching the way to achieve personal salvation.

The yearly celebration of the Buddha's enlighten-
ment calls for a portrait of Shaka to be hung on the
temple wall, and undoubtedly the elderly monk Gōchō
was called upon to paint this large and impressive work
for just such an occasion. Gōchō's poem suggests the
mysterious enlightenment of Shaka, who is seen creating
the "three thousand worlds" of the Buddhist universe.

After six years of austerities
He swallowed up the universal emptiness
And disgorged the three thousand worlds,
Creating a wind which filled the sky and circled
 the earth.

Gōchō's use of a radiant circle of light or halo around the head of Shaka also indicates that enlightenment has already occurred. In other respects, the artist has followed the usual iconography for the historical Buddha, including a tuft of hair in Shaka's forehead (not a third eye), a semi-circle of expanded consciousness on the top of his head, the hair arranged in tight curls and an elongated earlobe. Depicting the earring is somewhat unusual, since Shaka gave away his jewelry when he vowed to enter the religious life, but the long earlobe is a sign of royalty in India as princes wore heavy earrings from childhood. The contrast of heavy lines on the robe with the more delicate depiction of face and feet is traditional, but Shaka has seldom been rendered with such monumental power.

Gōchō devoted considerable attention to this painting, clearly considering it a major work. He first outlined the robe in grey ink and then again in darker tones, and added red color, now mostly visible on the lips. He indicated a sense of volume by the use of grey wash near the lines of the robe, leaving the center of the figure empty to suggest highlighting. The elaborations of the face and beard also demonstrate Gōchō's care with this painting.[1] The portrayal of Shaka is very likely the most impressive work of Gōchō extant outside of Japan.

SA

1 A smaller version with the same inscription dated 1826 was shown and published in a recent exhibition of Gōchō's work, *Gōchō* (Kumamoto Prefectural Museum, 1981), No. 93.

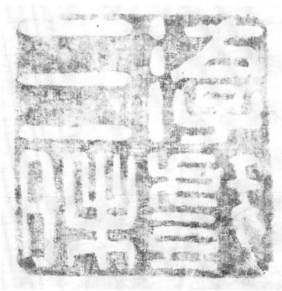

Kōgan Gengei 1748-1821

Kanzan and Jittoku

Hanging scroll, ink on paper, 119.7 x 28 cm., 47⅛ x 11 in.
SEAL: Kōgan
INSCRIPTION BY KAIMON (1743-1813): see text below

Kōgan was born in Kogari Village in Echigo (present-day Niigata prefecture) and began studying Zen at the age of eight at a local temple, Kankō-ji. At sixteen he set out on a long journey, which eventually led him to the circle of Hakuin (Nos. 20-24). By the year Kōgan met Hakuin, 1764, the great master due to his advanced age of seventy-nine had given up taking pupils directly, and so Kōgan first took instruction under Suiō Genro (1716-1789) and finished his studies under another Hakuin pupil Sōkai Sen'un (dates unknown). He is also said to have studied under Gessen (1721-1809), the teacher of Sengai (No. 31). In 1784 or 1785 Kōgan became the twenty-first abbot of Kōgen-ji in Tamba.

Kōgan's surviving paintings are not plentiful. This work depicts one of his favorite subjects, two of the semi-legendary Zen personalities who replaced most of the orthodox Buddhist pantheon. Kanzan and Jittoku are emblems of the Zen notion that enlightenment is not a function of high birth, social position, or decorous behavior, but rather of finding the Buddha nature within oneself. They are often depicted engaging in various kinds of unorthodox behavior, such as clinging to each other and laughing at the moon. Here Kanzan sits on a rocky pedestal, a legacy from the tradition of Muromachi ink painting from which Zenga descends, with his attribute, the scroll, placed in front of him. He casts a quizzical eye at the antics of Jittoku below, who appears to be jumping up and down on one leg and gesticulating excitedly. Jittoku's iconographical attribute, the broom, is not pictured. Other depictions by Kōgan of Kanzan and Jittoku include compositions similar to this one with small variations, such as one passing the scroll to the other.[2] He also showed them standing together reading the scroll.

Visual evidence supports the biographical account that Kōgan studied with Suiō, for on stylistic grounds it is clear that Suiō's paintings, rather than Hakuin's, provided the formal model for Kōgan's subject. Hakuin

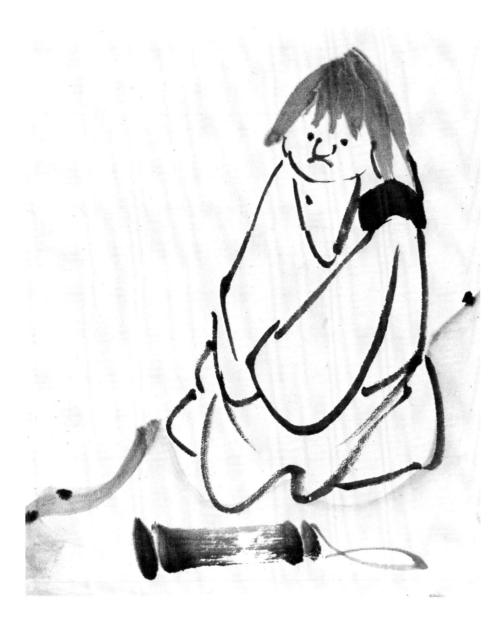

rarely painted Kanzan and Jittoku, while the two figure prominently in Suiō's oeuvre. This compellingly whimsical rendition recalls Suiō's interpretation of the theme, particularly in the mop-like treatment of the hair and in the lineament. The composition, however, appears to be Kōgan's own invention.

Kaimon, the inscriber of the painting, was born in Suo in Yamaguchi. He, too, was a priest in the Hakuin lineage, and ultimately became the chief priest of Myōshin-ji, in Kyoto. His poem can be translated roughly as follows:

The innocent moon is just like
A pure heart, speaking out towards someone;
Raising her head completely,
While straining her eye towards the lonely child
* below.*

MT

1. It is difficult to find information about Kōgan. The best, if brief, account appears in *Bokubi* 257-266 (January, 1976), p. 64.

2. See, for example, Awakawa Yasuichi, *Zen Painting* (New York, 1977), pl. 101 and *Bokubi* 257-266, pl. 53.

Shunsō Sōshū 1750-1835

Hotei Playing the Ch'in

Hanging scroll, ink on paper, 82.8 x 27.6 cm., 32⅝ x 10⅞ in.
Sɪɢɴᴀᴛᴜʀᴇ: Ryū'en
Sᴇᴀʟ: Shunsō

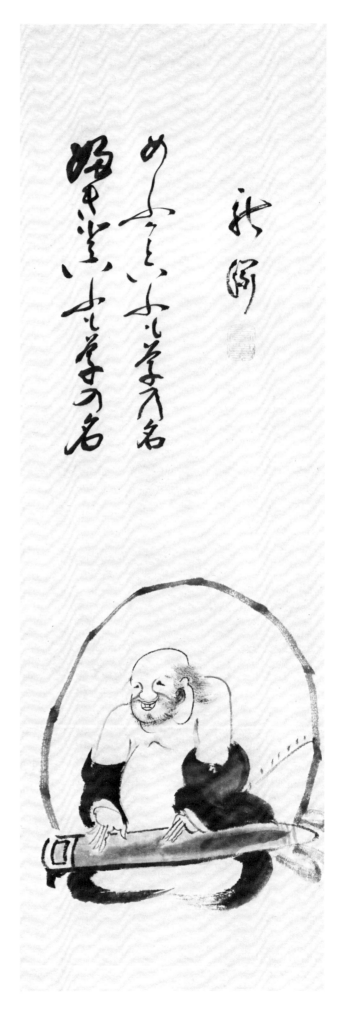

Like Kōgan Gengei (No. 29), Shunsō was a third-generation pupil in the Hakuin (Nos. 20-24) lineage.[1] His biography follows the pattern of many of his fellow monks. A native of Bungo province (present-day Ōita prefecture in Kyūshū), Shunsō began studying Zen locally at an early age and at seventeen embarked on a spiritual pilgrimage. His travels brought him into contact with a number of Hakuin's disciples including Reigen Etō (No. 26), and it was undoubtedly these encounters that prompted Shunsō to pursue Hakuin's brand of Zen. He attached himself to one of Hakuin's most prominent disciples, Suiō Genrō (1717-1789), who was also a painter of Zenga in the Hakuin manner. Under Suiō, Shunsō received his certificate of enlightenment; Shunsō eventually became Suiō's successor. In 1774, at the age of thirty-four, Shunsō became the head of a small country temple, Jikō-ji, in Awa. He died at the advanced age of eighty-nine.

The subject of this painting, Hotei, is a deity not found in the painting of the orthodox Buddhist sects, although one of the many legends surrounding him identifies him with the Buddha of the Future, Maitreya. Hotei's origins are obscure; possibly this mythological figure is based on a quasi-legendary Chinese monk of the tenth century. Hotei's name refers to the great cloth bag that, together with his staff—images of a vagabond—comprise his iconography. The bag symbolizes the blessings that flow from the unfettered life, and Hotei himself is an archetype of enlightened freedom and spontaneity. Like Sengai (No. 31), almost an exact contemporary, Shunsō has devised a highly distinctive visualization of Hotei. Here the unpredictable vagabond, a gleeful expression on his face, is shown merrily playing a Chinese *ch'in*. His long fingers, however, pluck at nothing, for the *ch'in* is stringless. It is possible that by the inclusion of this motif Shunsō intended an allusion to the Chinese poet and recluse

T'ao Yuan-ming (365 or 376-427) and his stringless *ch'in* (see also No. 50). Although in China the relationship between Buddhism and Confucianism was not particularly cordial, the Japanese from the start embraced the literati culture that attended the importation of Zen. T'ao, a paragon of the cultivated man who refuses to bow to the claims of society, was a figure particularly beloved in the Edo period, and although he had nothing whatsoever to do with Zen, contemporary Japanese would have felt that his style of living was sympathetic with what they sought in Zen.

Zen and literati culture were not merely close philosophically during the Edo period; they were related artistically as well. The depiction here of Hotei's face, with its bulbous nose and cauliflower ear, bears an unmistakable resemblance to a figure type made popular by Ike Taiga (Nos. 33-39). Taiga knew Hakuin, and this type of face appears in the work of both artists. It is difficult to know which way the influence went, but it is quite possible that Hakuin learned from Taiga. Taiga knew Shunsō's teacher Suiō as well. The treatment of the bag, rendered effectively as a series of broken lines, is remarkably effective in imparting volume. Shunsō's paintings are distinguished for their pleasing, lucid arrangement of form and for their compositional strength.

The poem is very much in the playful spirit of a good deal of Tokugawa period verse. It is full of puns, which are difficult to convey:

That which is called fuki
(riches) is [merely] something to study;
Myōga *(divine protection), too,*
is something one learns.

The humor lies in the fact that *fuki* is a homophone for another word meaning coltsfoot, an edible plant, and Myōga is a kind of pickled ginger. By juxtaposing the ideal and the mundane Shunsō has delivered that jolt which is characteristic of Zen, which operates on many levels simultaneously.

MT

1 Biographical information has been taken primarily from *Bokubi* 257-266 (January, 1976), p. 64.

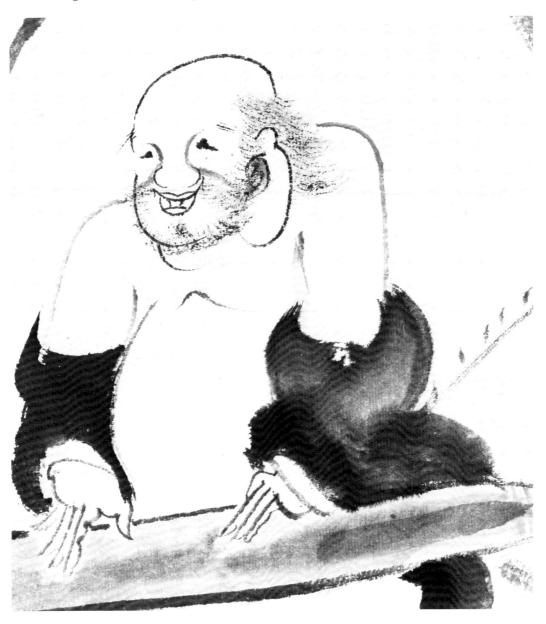

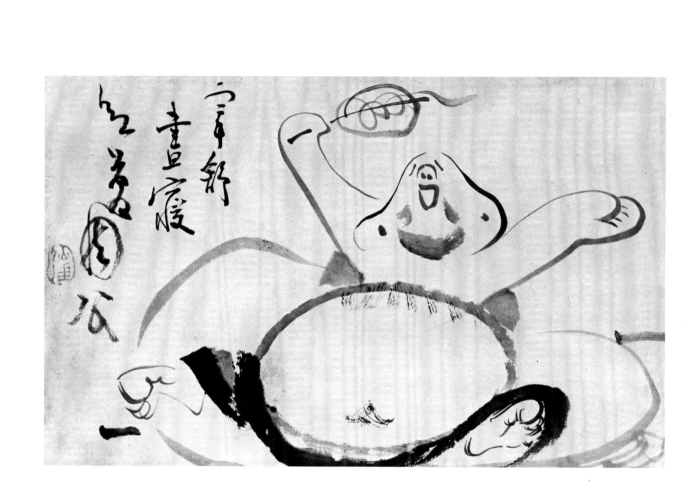

Sengai Gibon 1750-1837

Hotei Yawning

Hanging scroll, ink on paper, 29.5 x 48.4 cm., 11 ⅝ x 19 1/16 in.
SEAL: Sengai

Sengai was one of the most individualistic artistic personalities among the Edo period Zenga artists. His paintings are distinctive for their lighthearted, gentle humor. His works appear casual and amateurish, but these qualities belie the fact that Sengai, most likely a self-taught painter, absorbed artistic inspiration from a variety of sources. A number of authorities mention the influence of the paintings of the monk Hakuin Ekaku (Nos. 20-24).[1] It is probable that certain subject matter too, such as the pestle or the blind man with a lantern, was taken directly from Hakuin. Suzuki Daisetsu feels that Sengai studied the work of Yosa Buson (Nos. 44, 45, 46) and Sengai indeed painted many works that are remarkably similar to Buson's *haiga*.[2] It is also likely that Sengai knew the work of Ike Taiga (Nos. 33-39). The influence of Nanga can be felt in Sengai's many drawings of bamboo, chrysanthemum, plum, and orchid. The range of Sengai's painting subjects was broader than that of any other Zenga master: he did landscapes (including topographical sites in some quantity), drawings of past Zen masters such as Rinzai, Shintō deities including Daigokuten and others, whimsical sketches of toads and other animals, standard Zen iconographic figures like Kannon and Hotei, vegetable and plant life, and everyday scenes including the maidens of Ōhara, farmers, or beggars. He was a prolific painter who frequently gave his paintings away, and also, when he felt like it, he could be an excellent calligrapher.

Sengai's biography follows the pattern of many Edo period Zen monks. In a society in which primogeniture prevailed, younger sons often were sent out to fend for themselves; Sengai, the third son born to a farming family in central Japan, entered a Zen monastery at the age of ten. He embarked on a spiritual pilgrimage at eighteen, settled down under the master Gessen in Kanagawa prefecture for thirteen years until his teacher died, and then spent more years wandering around Japan. His travels tooks him as far as Kyūshū, where he became the abbot of Shōfuku-ji at the age of thirty-nine. He retired fairly young from this position.

Sengai devised a unique representation of Hotei, which he frequently repeated. Here Hotei is shown yawning and stretching, having just awakened from an evidently satisfying nap. The shape of Hotei's head is distorted into something resembling two sides of a triangle with undulating sides and rounded corners; his stubby hands look like paws. The form of his great belly is repeated by his bag, against which he is leaning, and the ends of his staff protrude from either side of the bag. The rich variety of ink tones employed for these various parts of the picture ranges from a velvety suffusion near his right foot to the whimsical dry scratchy brushstrokes that comprise his triangular navel. In his hand he holds a tassled symbol of rank as is carried by those of authority.

The inscription, juxtaposed with the playful, almost toylike figure of Hotei, in typical Zenga fashion is simultaneously didactic, provocative, and amusing:

*Tsai Shu takes a snooze
And dreams of the Duke of Chou*

The allusions are to two great figures of ancient China of the Chou dynasty: the Duke of Chou was a paragon of Confucian virtue, and Tsai Shu, a great orator, warrior, and one of the ten prominent followers of Confucius. Sengai painted a similar picture of Hotei awakening from a nap, with a different inscription, but one which also makes reference to dreaming of the Duke of Chou. In his explanation of the painting, Suzuki Daisetsu expresses the opinion that Sengai has equated himself with Hotei.[3] Dream imagery has been employed with great effect in Zen and Taoism, for it allows the exploration of the illogical and the absurd, two qualities thought to lead to spiritual insight in these related anti-rational philosophical systems. By telescoping these unlikely images in his painting, Sengai in effect preaches the non-duality of the Buddha and hence of all matter.

MT

1. John M. Rosenfield and Shujiro Shimada, *Traditions of Japanese Art: Selections from the Kimiko and John Powers Collection* (Fogg Art Museum, 1970), p. 259 and Stephen Addiss, *Zenga and Nanga* (New Orleans, 1976), p. 80.

2. Suzuki Daisetsu, *Sengai, The Zen Master* (Greenwich, 1971), p. xv.

3. Suzuki, p. 53. The painting, in the Idemitsu Art Gallery, Tokyo, is reproduced as pl. 12.

Nakahara Nantembō 1839-1925

Daruma

Hanging scroll, ink on paper, 137.2 x 56 cm., 54 x 22 $\frac{1}{16}$ in.
SIGNATURE: Kiō Nantembō Tōshū
SEALS: Nantembō, Hakugaikutsu, Tōshū, (skull), Tōshū
INSCRIPTION: Vast emptiness, nothing sacred

Nantembō was one of the most important Zen monks of the Meiji and Taishō eras, and his brushwork displays the continued vitality of the Zenga tradition well into this century. Like many earlier masters, he did not take up painting and calligraphy in earnest until his sixties; most of his extant works were brushed in his seventies and eighties. They have a freshness and a dynamism that bely his advanced years, and he is now considered the finest of the early twentieth century Zenga masters.

It seems that each monk-artist reinterpreted the primal Zen subject of Daruma in a personal manner. In Nantembō's case, the face of the patriarch shows surprise, almost chagrin, contrasting with the special forcefulness of the line defining the robe. We can see the intensity of the staring eyes of Daruma, slightly crossed with concentration, but the lack of a nose adds a touch of humor to the face.

Nantembō's painting and calligraphy are well integrated. The positioning of the head suggests it might become the fifth large character of the inscription. The words are from Daruma's answer to the Chinese Liang Emperor, who had asked him what was the first principle of the sacred Buddhist teachings. "Vast emptiness, nothing sacred" was Daruma's reply. This puzzled the Emperor, who believed that Buddhism could be understood logically and that merit could be achieved by "good works" such as constructing temples rather than by finding the Buddha within oneself.

The robe of the patriarch was painted with such energy that the beginning of the stroke sent ink flying onto the paper. The brush hit so boldly that the paper tore apart; it has since been joined together when the scroll was mounted. The ink is still thick upon the paper, as can be seen at close viewing; when the brushstroke continued the ink fuzzed slightly as it touched the grey ink of Daruma's ear, and then continued rapidly under the head and down to the lower left. The speed of the stroke brought forth "flying white" where the paper shows through the ink. Thus in a single stroke we can see spattering, fuzzing, wet and dry textures and changes of speed and direction of the brush.

One interesting feature of this painting is the lower seal in the shape of a skull, unusual because seals are generally created out of words rather than images. In one sense the skull echoes the shape of the head of Daruma, while on another level it is a reminder of the passing of all earthly life. Higher on the right, Nantembō's signature, executed in cursive script, leads towards the robe line while forming a column parallel to that of the inscription. The four large characters of Daruma's words are written in a powerful combination of regular and running scripts; they demonstrate the spontaneous and yet architectonic nature of Nantembō's character and style.

The mixture of humor and dynamic strength seen in this work is characteristic of Nantembō, who demonstrated tireless energy throughout his life. He was known for his strength of both body and character. Born into a samurai family in Kyūshū, Nantembō studied with a number of masters before receiving his certificate of enlightenment from the monk Ranzan. He continued to travel throughout Japan, carrying a staff cut from the Nanten tree, thus he received the name Nantembō (Nanten staff). He formed several Zen training centers, and was the teacher of General Nogi, who won fame in the Russo-Japanese war. Before he died, Nantembō wrote eleven books and taught in thirty-three different temples. Like other major masters, he seems to have felt late in life that he could convey his Zen understanding through ink on paper, and so he brushed a large number of paintings and calligraphy for his followers. This work probably dates from his seventies, and shows his dynamic nature in a portrayal of the greatest of all Zen subjects.

SA

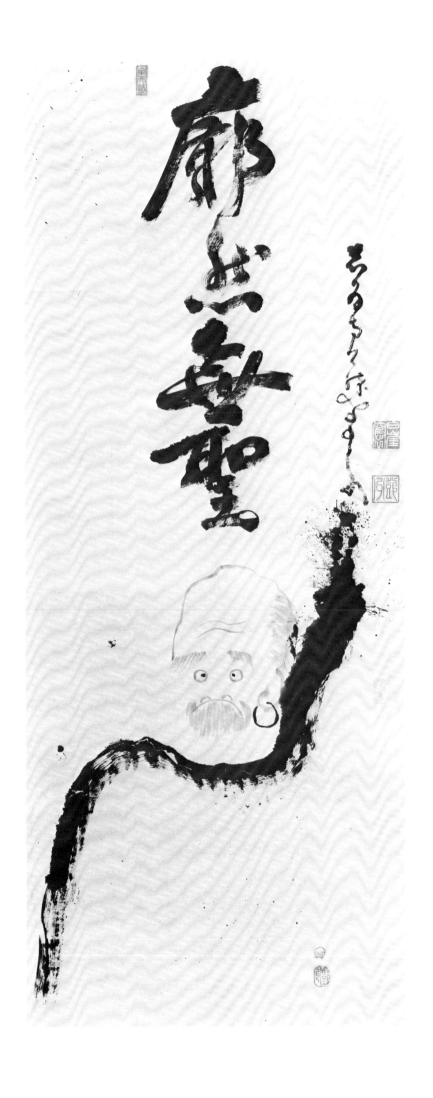

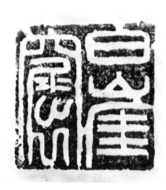

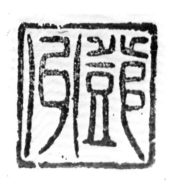

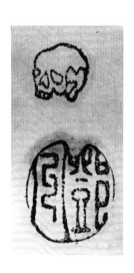

NANGA—TAIGA AND HIS FOLLOWERS

One of the artistic legacies of eighteenth-century Japan is the appearance of a school which took inspiration from Chinese scholars' painting. The school came to be called by two appellations: Nanga (literally "southern painting," which is the Japanese pronunciation and abbreviation of the Chinese characters *nan-tsung hua*); and Bunjinga (literally "literati" or "scholar's painting," the Japanese rendition of the Chinese characters *wen-jen-hua*), Despite the similarities between the Chinese and Japanese terminology, however, the differences between the two varieties of art sharing this common designation are as striking as those between, say, Greek and Roman art, or between Classical Antiquity and the Renaissance.

The concept of Chinese scholars' art had been known in Japan as early as the fourteenth century, when Zen monks looked to China for cultural inspiration. The activities of the so-called literati monks (*bunjin sō*), however, did not make a lasting impact on the art that immediately followed. Nanga was rediscovered in the early eighteenth century by three independent-minded Japanese artists. Two of them, Gion Nankai (1677-1751) and Yanagisawa Kien (1706?-1758), both samurai, were enthusiastic scholars of Chinese Confucianism and viewed Nanga as one of the many arts leading to self-cultivation; they were amateur artists in the Chinese sense. The third member of the triumvirate, Sakaki Hyakusen (1697-1752), a *chōnin* or townsman, approached Nanga as a professional painter. He sensed the dissatisfaction with the established genres of painting and sought to bring the Japanese public something new by incorporating elements of recently imported Chinese paintings into his work.

The new style, however, gained momentum only slowly at the beginning, and after the deaths of the three first-generation practitioners in the 1750's, the mantle for its perpetuation fell on a young artist of remarkable precocity and talent, Ike Taiga (Nos. 33-39). Although Taiga is usually given equal credit with Yosa Buson (Nos. 44-46) as being one of the two great second-generation artists who brought the movement to maturity, an inspection of their biographies reveals that Taiga played a crucial role in the spread of Nanga long before Buson had become a painter of the first rank.

Taiga, who was born in Kyoto, was indeed a child prodigy: at the age of five he was given lessons in the Confucian classics, and in his sixth year he began to study Chinese-style calligraphy.[1] He showed exceptional talent, and in the same year, 1729, he was taken to Mampuku-ji, an Ōbaku Zen temple outside of Kyoto, to perform for the monks. By 1737, at the age of fourteen, he had opened up a shop selling painted fans to support himself and his widowed mother. The paintings were based on designs from the Chinese woodblock manual *Hasshu gafu,* which included works in the Southern School manner. Success came to Taiga relatively slowly, and one early anecdote dating to around 1752 relates that no one wanted to buy Taiga's fans and in frustration he threw them into the river. Contemporaries report that he and his wife Gyokuran (No. 40), also a painter, were so poor in their early years that they would fill virtually any commission that came their way, including painting lanterns and tobacco pouches. By 1748 Taiga acquired his first pupil, Kimura Kenkadō (1736-1802) of Ōsaka, and by 1757 Taiga is

recorded as being renowned in the "Three Capitals" (Kyoto, Ōsaka, and Edo) for his finger painting. It is clear that in addition to Kien and Nankai, many Confucian scholars acted as his patrons and mentors, and Taiga acquired a devoted coterie of pupils as well. He was loved not only for his artistic talent but also for his otherworldly and rather eccentric personality.

Among Taiga's major contributions was to forge a multifaceted, highly individual style based on an eclectic melange of sources, both Chinese and Japanese, and to transmit this style, or more properly, spectrum of styles, to a host of pupils and followers. Taiga's major pupils represented here include his wife Gyokuran (No. 40) and the *saké* merchant Satake Kaikai (No. 41). Followers who did not study directly with Taiga but painted in his manner include Aiseki (No. 42) and Fūgai Honkō (No. 43), both Zen priests. Their works preserved more of Taiga's style than those of some of his direct pupils which tended to be rather quiet and restrained. Aiseki and Fūgai more closely emulated Taiga's brushwork which rhythmically wiggled and undulated as it described figures and landscapes. Although making personal modifications, they both maintained the soaring lightness and sparkling quality that are the hallmarks of Taiga's style.

MT

1. The information here is more fully amplified in Melinda Takeuchi, "Ike Taiga: A Biographical Study," *Harvard Journal of Asiatic Studies,* vol. 43, no. 1 (June, 1983), pp. 141-186.

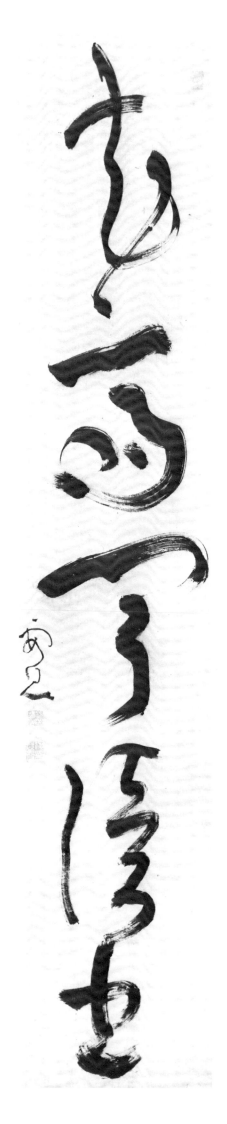

Ike Taiga 1723-1776

Calligraphy: Reading Books in the Flower Studio

Hanging scroll, ink on paper, 131.5 x 25.7 cm., 51¾ x 10⅛ in.
Signature: Kashō
Seals: Junsei, Sangaku Dōja, Ike Arina in
Published: Komatsu Shigemi, ed., *Nihon shoseki taikan*, vol. 22
(Tokyo, 1979), pl. 35.
Edo bijutsu zuroku (Tokyo, 1968), no. 306.

Taiga was a man of diverse interests—among these
were Chinese and Japanese verse, Chinese dancing,
herbalism, and collecting geological specimens—but
next to being a celebrated painter he is best known for
his calligraphy. It has even been argued that Taiga
was more a calligrapher than he was a painter.[1]

Taiga's studies in calligraphy are far better docu-
mented than is his early career in painting; by all
accounts it is clear that as a calligrapher he was a
child prodigy. Even disregarding the remarkable two-
character work *Kinzan* which bears an inscription
dating it to the artist's age of two,[2] we are able to
trace with a certain amount of confidence the early
stages of the young boy's career. The *Ike Taiga kafu* by
Kimura Kenkadō (1736-1802) states that in 1729, at
the age of six, Taiga studied Chinese-style calligraphy
with a priest of the Seikōin, Issei (1673-1740).[3] Issei
was trained in the school of Terai Yōsetsu (1640-1711),
who in turn studied the style of Fujiki Atsunao (17th c.), a
reviver of the distinctive calligraphy of the ninth century
Kōbō Daishi. Taiga's early training, therefore, was not in
the Sino-Confucian world of the literati, but in a school
which had deep stylistic connections with the Japanese
past. The same year that he began studying with Issei he
was taken to the Ōbaku Zen temple to perform calligraphy
for the monks there, and in return for his efforts he
received encomia and prizes. His earliest reliable sur-
viving calligraphic work, in the Mary and Jackson Burke
Collection, New York, is *Two Poems from the Kokinshū*,
dated to 1733 when he was 11; it demonstrates that
Taiga's early training included Japanese calligraphy in
kana script as well as the study of Chinese characters.
One final reference in eighteenth-century literature to
Taiga's training in calligraphy informs us that in 1737
at the age of fourteen Taiga studied calligraphy with
Kuwahara Ikei (1673-1744).[4] Ikei excelled in a form of
archaic Chinese script, *tenrei happun.* Such exotic scripts
were then beginning to enjoy a revival in China and a
surge of popularity in Japan. It is indicative of Taiga's
growing interest in literati culture that he should so
early have sought out a master who could instruct
him in such a recondite subject.

Aside from documented sources for Taiga's formal
studies, other influences may be deduced. His most
intimate comrades were Kan Tenju (1727-1795) and Kō

Fuyō (1722-1784), both of whom were celebrated for calligraphy and for antiquarian studies. Taiga also was acquainted with another important Tokugawa calligrapher, the Zen monk Hakuin Ekaku (Nos. 20-24); Hakuin is thought to have exerted a powerful influence on Taiga's style. Matsushita Hidemaro feels that Taiga, in addition to being influenced by Hakuin, studied the calligraphy of such diverse Chinse masters as Ou-yang Hsün (557-641), Yen Chen-ch'ing (709-784), Mi Fu (1051-1107), Huang T'ing-chien (1045-1105), Wen Cheng-ming (1470-1559), and Tung Ch'i-ch'ang (1555-1636). Despite this imposing list of possible models, Taiga transformed his sources to such an extent that it is extremely difficult to trace specific influences in a given work. His calligraphy is so individualistic, even idiosyncratic, that he has been classed among the "Deviants" among Tokugawa period calligraphers.

Reading Books conforms to a style Taiga frequently employed for large-character single-line works. The characters, rendered cursive almost to the point of illegibility,[6] are written boldly in saturated ink, with an abundance of "flying white." They show an extraordinary degree of balance and symmetry considering the overall feeling of roughness and spontaneity.

Taiga's calligraphy presents as many difficulties to the connoisseur as does his painting. Tanomura Chikuden (1777-1835), for example, relates in his *Sanchūjin jōsetsu* that he was cautioned by Taigadō III (Geppō Shinryō, 1760-1839) about the pitfalls of trying to tell genuine pieces of Taiga's calligraphy from the many fakes that had started to appear even by this relatively early date.[7] Matsumura Kōryū (fl. late 18th-early 19th c.) was but one of many able to imitate Taiga's painting and calligraphy with consummate skill; the work by Satake Kaikai (No. 41) shows another artist who had mastered Taiga's calligraphic style. It is

necessary, therefore, to approach all pieces of calligraphy purporting to be by Taiga with caution. *Reading Books* has excellent credentials: it was stored in the Tokyo National Museum, was exhibited there in 1968, and was published by a distinguished authority (see *supra*), The seals conform to published versions. It might be noted, however, that the work lacks Taiga's characteristic rawness, the almost brutish starkness of angle often found in his works in this style.[8] There is a decorative dip in the center of the horizontal stroke in the third character that is uncharacteristic. The "Ka" in the signature Kashō, when written cursively is customarily considerably more centered,[9] and the final stroke appears to have been executed in two separate movements of the brush. These features do not necessarily argue against the authenticity of the work, but they present themselves as points of departure for future studies of Taiga's calligraphy.

MT

1. This idea was put forth in Yamanouch Chōzō, *Nihon nanga shi* (Tokyo, 1981), p. 99.

2. The work is reproduced in Matsushita Hidemaro, *Taiga no sho* (Tokyo, 1970), p. 6.

3. Yamanouchi, *Nihon nanga shi*, p. 100 cites a source claiming Taiga studied Yōsetsu-style calligraphy with Sanshin Sanrei at the age of two, but this account is probably apochryphal.

4. Kimura Kenkadō, *Ike Taiga kafu*, transcribed in Mori Senzō, *Chosaku shū*, vol. 13 (Tokyo, 1971), p. 61.

5. Matsushita, *Taiga no sho*, p. 16.

6. The reading of the first character, for example is disputed. We have rendered it here as "hana" (flower), but Komatsu Shigemi, ed, *Nihon shoseki taikan*, vol. 22 (Tokyo, 1979), p. 216, gives it as "mottomo" (just, reasonable).

7. Takeya Chōjirō, *Chikuden garon* (Tokyo, 1975), pp. 68-69.

8. See, for example, Matsushita, *Taiga no sho*, p. 1, 2, 12, 15, 19, etc.

9. See *ibid.*, pl. 1, 2, 6, 19, 22, etc.

Ike Taiga 1723-1776

Calligraphy Panel: Chinese Incense

Carved wooden panel, 107.3 x 32.9 cm., 42¼ x 12⅞ in.
SEAL: Ike Arina (or Mumei) in
PROVENANCE: Harold P. Stern Collection
PUBLISHED: Mimura Seizaburō, "Taigadō yowa," *Nanga kanshō*, vol. 8, no. 7 (February, 1934), p. 27.

Three large characters, *Kara* (or *Tō*) *Senkō* (Chinese Incense) proclaim the offerings of the shop where this signboard would originally have been displayed. This piece graphically illuminates the difference between Taiga's status as a *machi-eshi* ("town painter"), a professional who made no apology for producing utilitarian designs, and the Chinese literati ideal of the gentleman who paints on a purely amateur basis for self fulfillment, not profit. Although in China this ideal was rarely observed in its purest form, concessions were made to keeping up the appearance of amateurism. Japanese literati painters, on the other hand, while embracing the concept of self-cultivation, exhibited various degrees of entrepreneurship. Buson, for example, needed money for his *haikai* gatherings and seems to have viewed painting as a means toward obtaining it. Taiga, according to contemporary accounts, began his career operating a fan and seal shop at the age of fourteen. At one point in his early career, he conducted his business sitting on a mat; passers-by would ask for painting, calligraphy, or seals on the spot. It is even said that Taiga and Gyokuran decorated tobacco pouches and lanterns for entertainers.[1] Contemporary biographers are at pains, however, to point out Taiga's indifference to money. They frequently note that payment for services rendered would end up on the floor of Taiga's house, untouched, thus reconciling Taiga's professionalism with the literati ethos.

Taiga seems to have been rather in demand as a designer of *kamban* (shop signs), and there are a number of amusing anecdotes about his sign painting activities. Once, for example, while painting an advertising curtain for an establishment called the Yoshinoya, Taiga finished the first two characters, *Yoshino*, and was suddenly seized with a desire to see the cherries at Yoshino. He returned several days later to complete the final character, *ya*.[2] He is also said to have designed a signboard which advertised "Cold Medicine Which Won't Cure Colds," which was a resounding success because of its enigmatic locution.[3]

The Gitter panel designed but not actually executed by Taiga, is written in regular script (*kaisho*) and lies midway between Taiga's most conservative and

his most flamboyant brush manners. The characters are extremely "fleshy:" the strokes are thick in proportion to the total configuration. It is a prominent feature of Taiga's regular script that visual tensions are produced by placing strokes in close proximity without allowing them to touch. During the Tokugawa period, the serious study of Chinese calligraphy flourished side by side with a vigorous, almost brash form of writing Chinese characters popular with the townsman class, which was employed for writing *jōruri* (puppet theater) texts, *kabuki* handbills, *sumō* programs, shop signs, firemen's jackets, and the like.[4] This signboard combines elements of both modes.

A former owner, Mimura Seizaburō, wrote that he purchased it in Matsuzaka, in Ise, where Taiga at one time produced so many *kamban* that after his death, *kamban* in his distinctive style continued to appear.[5] The product advertised, Chinese incense, was probably used in the Chinese-style *sencha* ("steeped tea") ceremony, which was extremely popular among the aspiring intellectuals in Taiga's circle.

MT

1. Ueda Akinari (1734-1809), the novelist, described Taiga's early poverty and the various means he and Gyokuran resorted to in order to make a living in *Tandai shōshin roku,* quoted in Mori Senzō, *Chosaku shū,* vol. 13 (Tokyo, 1971), p. 8.

2. Mori, p. 106.

3. The Japanese reads *"Kaze kusuri nomite naoranu kaze no kusuri,"* by which Taiga presumably meant that this medicine would cure colds not yet cured by the patient's having drunk other medicine. The text is cited in Mori, p. 6.

4. For a good source of illustrations of this more popular current within Japanese calligraphy, see Hinata Kazuo, *Edo moji* (Tokyo, 1970).

5. Mimura Seizaburō, "Taigadō yowa," *Nanga kanshō,* vol. 8, no. 7 (February 1934), p. 27.

Ike Taiga 1723-1776
Orchid, Thorn, and Rock

Hanging scroll, ink on paper, 122.3 x 27.2 cm., 48⅛ x 10¹¹/₁₆ in.
SIGNATURE: Kashō
SEALS: Kashō; Zenshin sōma Hō Kyukō (In my former life
 I was the horse judge Fang Chiu-kao)
INSCRIPTION by Emura Hokkai (1713-1788): see text below
PUBLISHED: Suzuki Susumu, ed., *Bijutsu senshū*, vol. 9, *Bunjin
 no kachō*, by Kobayashi Tadashi (Tokyo, 1979), pl. 51.

Since the Sung dynasty (960-1279) in China, the
theme of the "Four Gentlemen" (Orchid, Bamboo,
Chrysanthemum, and Plum) had provided the *bunjin*
or man-of-letters a ready-made pictorial repertoire
from which to draw. The subjects were particularly suited
to the amateur artist, for being based on the same
mastery of brush, ink, and composition required for
calligraphy, they did not involve a sizeable leap to more
taxing problems of representation such as perspective
or verisimilitude. Such paintings, like calligraphy, are
essentially exercises in formal composition and display
of individual brushwork, and their performance or
execution was equally as important as the finished
product. There exists, nonetheless, a great variety in
quality among examples of the genre. Untrained artists
could quickly imitate the desired quality of awkwardness
in reducing these botanical specimens to a few con-
ventionalized strokes, leading early Western critics like
Ernest Fenollosa to deride the "feeble spray of orchids"
as a symbol of what he saw as the weakness of literati
art in general.[1]

Taiga's *Orchid, Thorn, and Rock*, however, is any-
thing but awkward. Judged by the criteria of Chinese
scholar-painting, it might, in fact, seem almost too
elegant, too skillfully executed, too dramatic. Indeed,
the calculated range of ink tonalities and textures, the
lines executed with an unevenly saturated brush held
at a slant, and the bravura of the impossibly elongated
composition are hallmarks of Taiga's style.

Although the painting displays the individualism
which characterizes Taiga's oeuvre in general, two
sources may be postulated as having influenced its form.
One is the *Mustard Seed Garden Manual of Painting*,
a Chinese instruction book of woodcuts and one of the
major sources of study for early Nanga painters in Japan.
The section devoted to orchids includes a work in the
manner of the Ming painter T'ang Yin (1430-1523),
which shows similar sorts of fluctuations in the lines
of the leaves, although not nearly so pronounced as
Taiga's, and correspondingly irregularly-contoured
rocks textured by horizontal dots and the pronounced
application of dry ink lines. T'ang, like Taiga, was a
highly skilled professional artist, existing on the fringes

of Chinese literati circles. Although his was one of the most technically accomplished examples in the manual, Taiga's work, with its impossibly snaking leaves, dazzling gradations in tone, and daringly elongated composition, makes T'ang's version, by contrast, appear to have the desired literati quality of "blandness." Taiga's choice of T'ang Yin as a model (Taiga also did a painting in the manner of T'ang) is characteristic of the indifference to orthodox models shown by the second generation of Nanga masters, a trend soon to be reversed in later generations. The other influence visible in *Orchid, Thorn, and Rock* is that of the Muromachi priest-painter Gyoku'en Bompō (c. 1368-c. 1420), a forerunner of the Nanga movement in Japan. Taiga painted a work similar in style to the Gitter piece and inscribed it as being in the manner of Bompō.[2] It is likely that the treatment of the leaves as serpentine, weightless tendrils derives from the older master.

Of equal importance to the painting is the inscription, a seven-character Chinese quatrain, written in running script, by Taiga's older contemporary, the Confucian scholar Emura Hokkai:

> *Green leaves, purple stems, pure, pure flowers*
> *A mysterious figure embraces the rock; the place is*
> *covered with moss and sand;*
> *The recluse touches his brush and transmits the sublime*
> *Sitting in wonder as the fragrance spreads over the*
> *paper.*

Hokkai was adopted by a scholar of the Miyatsu domain, but resigned his position and came to settle in Kyoto, where he became well-enough known for his composition of Chinese poetry to be listed in the Kyoto guide to famous personalities under the heading for scholars. He in many ways epitomizes the kind of person with whom Taiga frequently associated, a samurai (now masterless), man-of-letters, of a higher social status than Taiga but attracted to Taiga's circle because of mutual interest in things Chinese.[3] His acquaintance with Taiga stretches over most of both of their lives; a near contemporary credits Hokkai with having conferred the name Tsutomu ("Diligent") on the young artist.[4] Hokkai, along with his relative Seida (or Kiyota) Tansō (1719-1785), author of one of the most reliable and informative contemporary accounts of Taiga, also inscribed a colophon on Taiga's painting of the Yūbōen, dated to 1772, four years before Taiga's death.[5] *Orchid, Thorn, and Rock* is undated, but probably was painted during the artist's early forties.

MT

1. Ernest F. Fenollosa, *Epochs of Chinese and Japanese Art* (New York, 1963), vol. 2, p. 165.

2. Reproduced in the *Ike Taiga sakuhin shū* (Tokyo, 1960), no. 598.

3. For a discussion of Taiga's circle and the kinds of people who comprised his audience and patrons, see Melinda Takeuchi, "Ike Taiga: A Biographical Study," *Harvard Journal of Asiatic Studies*, vol. 43, no. 1 (June 1984), pp. 141-186.

4. The work is the *Waisan roku* by Tsusaka Tōyō (1756-1825), quoted in Mori Senzō, *Chosaku shū*, vol. 3 (Tokyo, 1971), p. 13.

5. The scroll, but not the colophons, is reproduced in the *Sakuhin shū*, no. 757. Both men were prominent members of Taiga's circle, but their relationship is not clear. Yoshizawa Chū, in his work *Ike Taiga* (Tokyo, 1973), p. 133, states that Tansō is Hokkai's youngest brother, but not all sources agree. The relationship is sometimes given as adoptive father and son.

Ike Taiga 1723-1776

The Tsui-weng Pavilion, copy after Shao Chen-hsien
(c. 1667-1668)

Hanging scroll, ink and color on paper, 30.2 x 33.5 cm.,
 11⁷/₈ x 13³/₁₆ in.
SEAL OF TAIGA: Sangaku dōja (at right edge approximately
 three-fifths from top)
INSCRIPTION: "Tsui-Weng Pavilion, painted by Shao Chen of
 ancient Wu for the venerable Mr. Hai-chen" (followed
 by hand-painted seal reading T'ien-li)[1]
PUBLISHED: Yamanouchi Chōzō, *Nihon Nanga shi* (Tokyo,
 1981), no. 32 and frontispiece #3.
 Sasaki Jōhei, "Ike Taiga—sono seisaku katei ni kansuru
 ikkosatsu," *Yamato bunka* (October, 1979), fig. 48.
 Suzuki Susumu, ed., *Ike Taiga. Nihon no bijutsu* no. 114
 (Tokyo, 1975), no. 28.

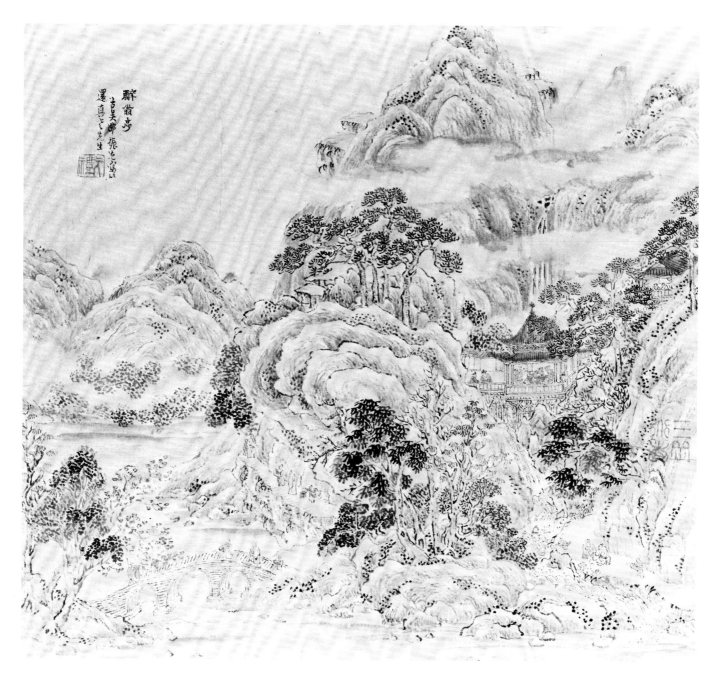

While there is no question that Taiga was one of Japan's most eclectic painters, art historians often have difficulty identifying his far-flung pictorial sources. The *Tsui-weng Pavilion*, therefore, is a valuable work in this connection. Not only is its actual prototype known, it allows us a direct glimpse of part of the process by which Taiga set about transforming his sources, for the work serves as the basis for one of Taiga's most celebrated paintings bearing the same name, one of a pair of screens designated as National Treasures and now in the collection of the Tokyo National Museum.[2]

The *Tsui-weng Pavilion* is based on a leaf from an album painted in China to celebrate the auspicious eightieth birthday of the painter Chang Hai-chen in 1667 or 1668. The work, consisting of twenty paintings faced by twenty poems, was the joint production of four early Ch'ing artists of Suchou: Kao Chien, Niu Chen, Shao Chen-hsien, and Shih Han. It is now mounted into the form of two albums consisting of ten paintings and ten leaves of calligraphy each. Leaf number nine (fig. 1) of the first volume depicts the Tsui-weng Pavilion in Anhui, the site of a famous literary gathering held by the statesman and literatus Oy-yang Hsiu of the Sung dynasty. The subject of leaf number seven of the second volume is the Yüeh-yang Tower, a place also rich in literary and historic connotations since the T'ang dynasty. Both of these leaves were painted by Shao Chen-hsien and together they formed the inspiration for the Tokyo National Museum screens. There was an intermediary stage, however, as this work clearly shows.

Yamanouchi Chōzō believes that Taiga copied the Chinese album on a trip to Sanuki in Shikoku in 1757, at the age of thirty-five.[3] The Gitter leaf was most probably a part of this production. After being furnished with an epilogue by Miyata Baitei, it is believed that Taiga's copy of the album went to a cloth merchant in Shikoku and was subsequently broken up and dispersed.[4]

Taiga's copy sheds valuable light on just what it was this creative artist sought in his models. The composition, for all practical purposes, is identical to Shao's, with the exception that Taiga enlarged certain forms

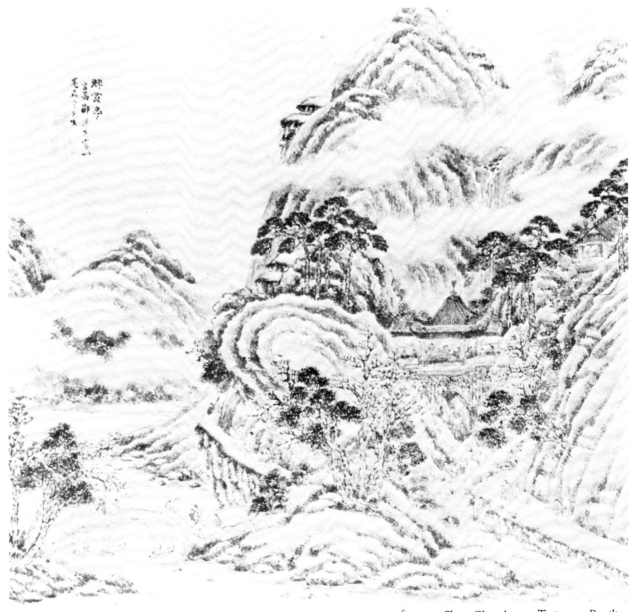

figure 1 Shao Chen-hsien, *Tsui-weng Pavilion*

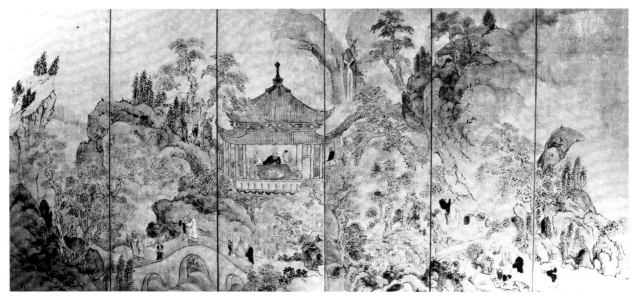

figure 2 Ike Taiga, *Tsui-weng Pavilion*, Tokyo National Museum

slightly (such as the hillock to the left of the pavilion) and brought others closer to the viewer. Taiga's picture appears spatially flatter. The major difference lies in the treatment of forms, i.e. in the brushwork. Taiga eliminated the contrast of high-low values that plays across the surface of Shao's work and accorded his own opus a more uniform tonal treatment. Despite the closeness of original and copy, the vigor and individuality of the Japanese artist's hand can be felt throughout. He has substituted his own brush vocabulary, which is lighter, sketchier, and more playful than that of the Chinese artist. The theme, composition, and to a lesser extent, the forms provided Taiga with a source of inspiration; but it is evident that at the level of brushwork (contour lines, foliage, *ten* (dots), and *shun* (texture strokes), Taiga lacked interest utterly in the "correct" Chinese manner. He copied the inscription exactly but drew in only one of the Chinese artist's original seals.

It is instructive to compare briefly the Gitter leaf with the *Tsui-weng Pavilion* screen (fig. 2) in the Tokyo National Museum, produced several years later. Taiga made a number of compositional changes and gave a larger anecdotal role to his figures. Forms have generally been simplified and monumentalized. The gold-flecked paper of the Chinese original most likely inspired the resplendent gold-leaf background; bright, jewel like mineral pigments are used on the figures, trees, and rocks. The work has been so thoroughly transformed into Japanese Nanga that, were it not for the existence of the preceding two versions, it would be difficult to identify the source. Indeed, many Japanese art historians cite Sōtatsu and Kōrin as having furnished the stylistic inspiration for this pair of screens.[6] The *Tsui-weng Pavilion* in the Gitter Collection helps us to trace the process by which Taiga developed his personal style, and it fits nicely with James Cahill's studies demonstrating the influence of Suchou painting on Nanga.[7]

MT

1. The handwritten seal on the painting in its present state is not the same as the seal which terminated the inscription in the photograph reproduced in Sasaki Jōhei, "Ike Taiga—sono seisaku katei ni kansuru ikkosatsu," *Yamato bunka* (October, 1979), fig. 48. Holding the painting against a strong light reveals that the original seal was effaced and the current seal, a much cruder rendering, was drawn in over the abraded area. Prof. Sasaki had published the work from photographs and had not seen the original. The painting is in every other way identical to published versions, including evidence of cracks, damage, etc. No satisfactory explanation for this mysterious circumstance has been found at the time of this writing.

2. Even these famous screens have not escaped the cloud of uncertainty that hangs over Taiga's oeuvre; there are those who would impugn their authenticity. See Matsushita Hidemaro, *Ike Taiga* (Tokyo, 1967), p. 135.

3. Yamanouchi Chōzō, *Nihon nanga shi* (Tokyo, 1981), p. 113. James Cahill, *Yosa Buson and Chinese Painting* (Berkeley, 1982), pp. 252-254 has written about the importance of Sanuki as a center for collections of Chinese art. For reproductions of some of the other leaves, including the calligraphy, see Sasaki, fig. 37-55.

4. Taiga's album was widely copied and various versions after it exist, some masquerading as originals.

5. Compared to Taiga's virtuoso performance in making exact copies of the calligraphic leaves (see, for example, Sasaki, figs. 37-40), the calligraphy imitating Shao Chen-hsien's *Tsui-weng Pavilion* inscription, in clerical script, seems somewhat weaker.

6. Matsushita, p. 135, is one such writer. Others allege that it belongs stylistically to "Northern School" painting. See, for example, *Nihon byōbu shūsei*, vol. 3: *Sansuiga—Nanga sansui* (Tokyo, 1979), p. 133 and the *Ike Taiga sakuhin shū* (Tokyo, 1960), entry for no. 563-1 and 563-2.

7. See Cahill's *Sakaki Hyakusen and Early Nanga Painting*, Japan Research Monograph 3 (Berkeley, 1983), pp. 12-14 and *passim*.

Ike Taiga 1723-1776

Pleasures of Fishing

Hanging scroll, ink and color on silk, 47.5 x 50.8 cm., 18¹¹/₁₆ in.

SIGNATURE: Kashō

SEALS: Zenshin sōma Hō Kyūkō ([In my] former life I was the horse judge Fang Chiu-kao), Kyūka shōja (Nine mists woodcutter), Ike Arina (or Mumei) Taisei in

PUBLISHED: Addiss, Stephen, "Japanese Nanga in the Western World," *Oriental Art* 27:1 (1981), pp. 172-182, fig. 3.
Suzuki Susumu, ed., *Ike Taiga. Nihon no bijutsu* no. 114 (Tokyo, 1975), pl. 138.
Shrine of the Universe Art Institution, *The Shrine of the Universe Museum Art Collection* (Ōsaka, 1962).
I'izuka Bei'u, *Nihonga taisei* (Tokyo, 1931-34), vol. 33, pl. 26.
Shibata Chikugai, ed., *Ike Taiga sensei shoji yokō* (Kyoto, 1925).

This small painting depicts a panoramic landscape with fishermen on a spring day. Using forms from the everyday world—trees, boats, houses, mountains, and human figures—the artist has managed to create an idealized, almost dreamlike environment through the juxtaposition of a number of seemingly contradictory devices. Some elements of the painting belong to the category of abstraction: the sharp upward tilt of the ground plane in the lower right; the conventionalized brush vocabulary for the leaves of the trees and the "wrinkles" of the earth; the deliberately awkward, distorted, sketchy forms of the houses; and the audacious disregard for even the most rudimentary scale relationships between, for example, the figures on the bridge in the middle ground and the nearby houses they threaten to dwarf. Other devices evoke life's familiar experiences: a wind riffles the willows, animating their branches and causing their leaves to scintillate; fishermen and children accost each other and exchange comments; and water laps gently around the sides of the boats. A panoramic vista is created by overlapping layers of mountains trailing off to a distant horizon, techniques combining the Chinese "deep distance system" with a kind of continuous receding groundline that may be the result of Taiga's familiarity with Western art.

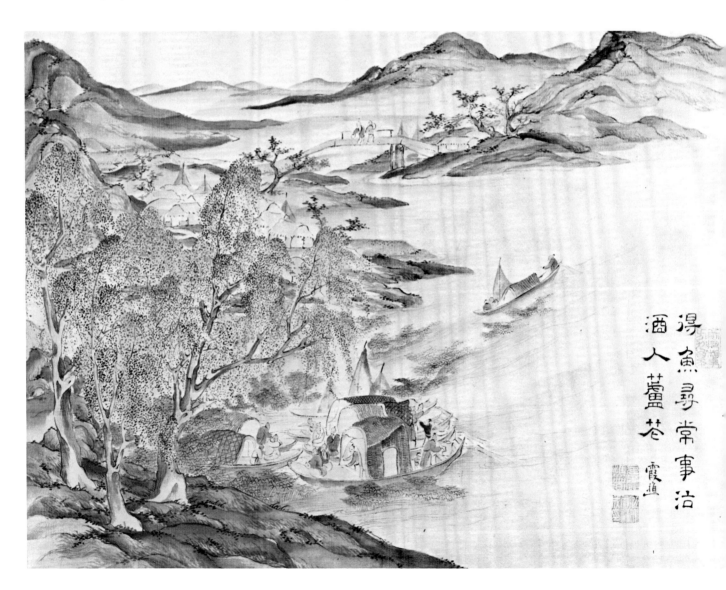

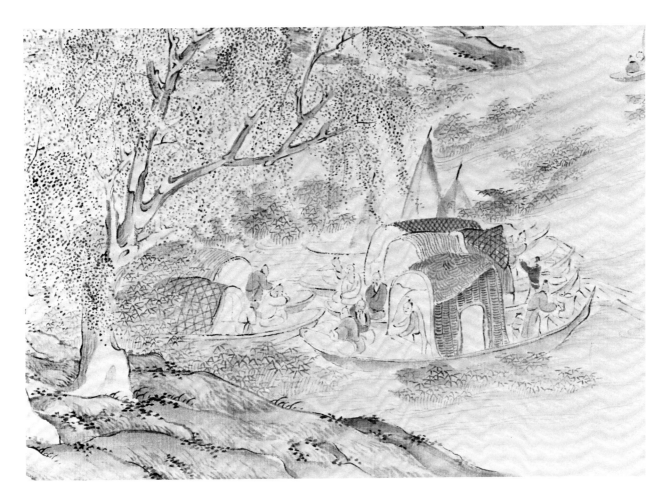

The theme of the fishing village was one that Taiga particularly enjoyed. It held an association with the venerable Chinese theme of the "Eight Views of the Hsiao and Hsiang," (one of the views is "Sunset Glow Over a Fishing Village"), appropriated by the Japanese as early as the Kamakura period (1185-1333). The fisherman in China stood for one who lived close to nature, unburdened by the responsibilities of bureaucratic office. Taiga executed at least five complete surviving versions of the "Eight Views" and in addition used the motif of fisherman singly or in groups with a special fondness. On stylistic grounds this work appears to have been produced during the decade of the artist's thirties (ca. 1753-ca. 1762).

The inscription, a five-character Chinese couplet written in the antique *reisho* (clerical) script, reveals Taiga's long-standing interest in exotic Chinese script styles. His calligraphy, like his painting, is extremely individualistic, and it is difficult to pinpoint the source of his *reisho* style. He is thought to have studied the *reisho* of the Han dynasty (202 B.C.-220 A.D.) calligrapher Ts'ai Yung.[1] Although conservative in comparison to some of Taiga's other *reisho* works, the characters exhibit Taiga's characteristic love of precarious balance in calligraphic composition, exemplified best by the fourth character in the right-hand line, *tsune* (everyday). To the viewers of his day the use of this script style would have enhanced the Chinese flavor of the work, which was intended to present a visionary scene of an ideal world evoking the harmony of man and nature. It epitomizes the ethos of the eighteenth century Japanese would-be literatus, who although forced to live in the "red dust" of this world, carried in his breast an image of the untainted realm of nature, decidedly Chinese in cast, where he could derive inspiration and nurture his soul. The poem reinforces this image of rustic purity:

Catching fish is an everyday thing;
The wine seller [is] in the reeds and the flowers

MT

1. Nakata Yujiro, *The Art of Japanese Calligraphy* (Tokyo and New York, 1973), p. 56. Taiga is supposed to have used as his model a Ming dynasty (1369-1644) replacement of Ts'ai's *Hsia Ch'eng Stele.*

Ike Taiga 1723-1776

Landscape with Yellow Trees

Fan, ink and colors on mica-treated paper, 19.5 x 48.4 cm.,
 7¹¹/₁₆ x 19¹/₁₆ in.
Sɪɢɴᴀᴛᴜʀᴇ: Kashō
Sᴇᴀʟs: Zenshin sōma Hō Kyūkō, Kashō

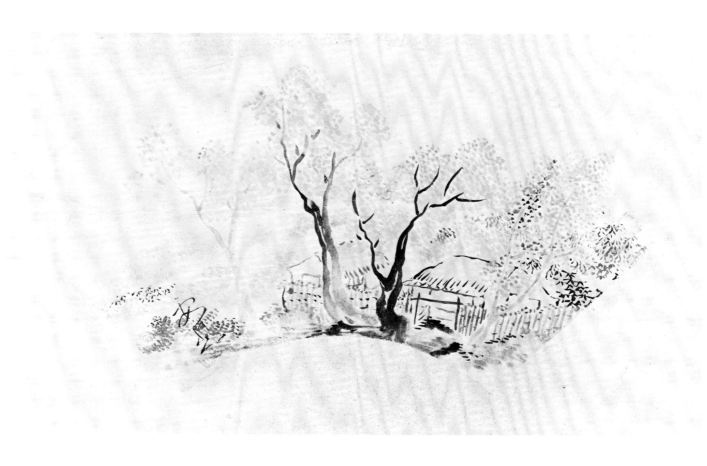

In this peaceful scene, four trees stand gracefully before a rustic enclosure. Although the major forms spread themselves across the foreground plane, a masterful sense of depth is achieved throughout. At right, a receding hedge of twigs is cut off by the picture's edge in implied continuation into depth, and the buildings are placed so as to seem to thrust backwards into space. At left, the forms diminish gradually until the upper left corner opens out into near-emptiness. There is considerable abrasion of the surface so that it is difficult to tell if the bluish stain at upper left was intended to represent a distant mountain, but if this is so, the presence of a river and shoreline is implied. A vertical crack indicates the likelihood that this fan was once mounted as a hanging scroll. Despite the loss of ink and pigment, the picture remains vibrant. The artist's sensitivity to tonal modulations of ink and of the green, blue, yellow, and yellowish-orange pigments employed in the tree trunks, the fence, the architectural forms, and the shimmering, luminous quality of leafy foliage results in an exceptionally effective rendering.

Fans occupy a special position in Taiga's oeuvre and provide the format for some of his loveliest works, such as the *Eight Views of the Hsiao and Hsiang* in the Kumita Collection in Tokyo.[1] Indeed, unlike his training in calligraphy (which was documented by contemporary writers), the first we hear of Taiga's activities as a painter is in conjunction with his opening a fan shop, at the age of fourteen, to support himself and his widowed mother. Styling himself Shūkidō, the presumably self-taught young boy daringly chose to use designs from a Chinese woodblock manual for painting instruction, the *Hasshū gafu*, as the basis for his painted fans. The year was 1737; few of the inhabitants of Taiga's native city of Kyoto had yet heard of the new Chinese style transmitted in the *Hasshū gafu*, but it is extremely likely, in the absence of a teacher, that it was this source which spurred Taiga on his course as a Nanga painter. That Taiga at first was not entirely successful in his endeavor to arouse the public's interest in the new manner is attested by a well-known anecdote. Visiting friends in Shiga prefecture, Taiga painted a number of fans to sell along the way; no one, however, wanted to buy them, and in frustration and disappointment the young artist threw them all into the river.[2]

Even though *Landscape with Yellow Trees* comes from a more profitable period of Taiga's career—it appears to be a work of his fourth decade—it is possible that even by this late date he was still seeking inspiration in Chinese woodblock manuals. In the section of the *Mustard Seed Garden Manual of Painting* (Japanese: *Kaishien gaden*) devoted to human figures, there are several possible sources for the motifs encountered here. On page 274, for example, under "Methods for drawing gateways," is a similar version of gate and fence; page 275, "Example of gate built in an earthen wall, in the shade of an old tree," provides a compositional parallel; and on page 279, in "Example of a back door of a mountain dwelling that may be situated near rocks and trees," is found precisely the same foreshortening of a thatched hut as found in Taiga's right-hand structure.[3]

The color scheme of *Landscape with Yellow Trees* suggests that it is intended to portray an autumnal scene. Because Taiga often executed fans in series, it is possible that this work may have come from a set of *The Four Seasons*. The quiescent, slightly lonely mood of autumn, even to the exclusion of the human figure, is portrayed with a poetry that rivals the paintings of Buson, and the work beautifully expresses the *bunjin* ideal of escape from the "red dust" of the everyday world.

MT

1. All eight pieces, along with their accompanying leaves of calligraphy, are reproduced in the *Ike Taiga sakuhin shū* (Tokyo, 1960), no. 772-1 to 772-16.

2. The incident is described by Taiga's student Kimura Kenkadō in his work *Records of the Ike Taiga Family* (Ike Taiga kafu). See Melinda Takeuchi, "Ike Taiga: A Biographical Study," *Harvard Journal of Asiatic Studies*, vol. 43, no. 1 (June, 1983), pp. 141-186.

3. For convenience I have referred to Mai-mai Sze's *The Mustard Seed Garden Manual of Painting*, paperback edition, Princeton, 1977, because the pages are numbered and the captions translated.

Signature of Ike Taiga 1723-1776

Lake Landscape with Boating Party

Six-panel screen, ink and color on paper, 143.7 x 353.4 cm.,
 56⁹/₁₆ x 139⅛ in.
SIGNATURE: Kashō
SEALS: Kashō, Zenshin sōma Hō Kyūkō
PROVENANCE: Kawabata Yasunari Collection

The variety of Ike Taiga's works is perhaps greater than that of any other Nanga master. He was capable of depicting a great range of subjects in a large number of styles, transforming Chinese and Japanese sources in both themes and brushwork. The playful character of much of his work is delightful, but can also occasionally be frustrating when attempting to evaluate his great and varied contribution to the world of Japanese painting. This screen may be a fanciful depiction of the "Lute Song," a well-known T'ang dynasty poem of Po Chu-i, in which an official in exile is strangely haunted by accidentally hearing a super-annuated courtesan sing songs that had been popular in his halcyon days. The artist, however, felt no need for showing the standard motifs of this subject, such as the lute of the singer, but rather has rendered the landscape setting in a sketchy fashion and the figures in more detail. The large amount of empty space suggests versions of the "Lute Song" as depicted by sixteenth century artists of Suchou such as Wen Chia (1501-1583). The light-hearted mood, however, is a special characteristic of Japanese Nanga as exemplified by Taiga.

From the standpoint of connoisseurship, Taiga's paintings offer formidable problems. Because Taiga became famous and highly sought-after within his lifetime, at the peak of his career requests for his works very likely exceeded the rate of their production, even though he was an extremely prolific painter. Enterprising forgers stepped in immediately to fill the gap between supply and demand, as is documented in

contemporary accounts. One Edo period record, for example, describes a memorial service, held on the first anniversary of Taiga's death, to which twenty or thirty of Taiga's pupils brought examples in their possession of their master's works to exhibit and contemplate. One pupil, who was *persona non grata* because he made his living quite blatantly as a forger of Taiga's works, showed up and asked to be admitted to the gathering. Not wanting to seem ungracious on the solemn occasion, the other pupils reluctantly allowed him entrance, whereupon the cheeky fellow immediately pointed with triumph to three of his own works hanging among those the students had claimed to have received directly from the master. The author of this account, a high-ranking retainer of the shōgun, went on to state that "[virtually] all the 'Taiga' paintings you see [nowadays] in the Eastern Capital [i.e., Tokyo] are fakes."[1] Mori Senzō, commenting on that passage, remarked that it was probably an overstatement to say that all the Taiga paintings in Tokyo by the later Edo period were fakes; more likely only eighty or ninety percent could be so designated.[2] At any rate it is clear that good, late eighteenth century copies of forgeries of Taiga's work exist in some quantity.

Lake Landscape with Boating Party is a handsome work, very much in Taiga's style: it is an interesting composition and subject, with the pronounced anecdotal detail for which Taiga was celebrated; the forms and brushwork of figures, trees, rocks, and mountains are those associated with Taiga's hand; and the colors are bold and pleasing. Close examination of the work, however, raises a number of questions. In its favor are the general stylistic characteristics, the light-hearted mood, and the seals, which match up well with accepted versions. On the other hand, other features in this screen suggest caution before a final attribution can be established. The signature has an excessive number of hooked strokes when compared with other examples,[3] and the brushwork in general is not as fully rendered as usual. Is this work possibly more of a sketch by Taiga than a fully finished screen? Was it partially painted by pupils?

The *katabokashi* (uneven inking of the brush) in the trunks of the willows is not handled with Taiga's custo-

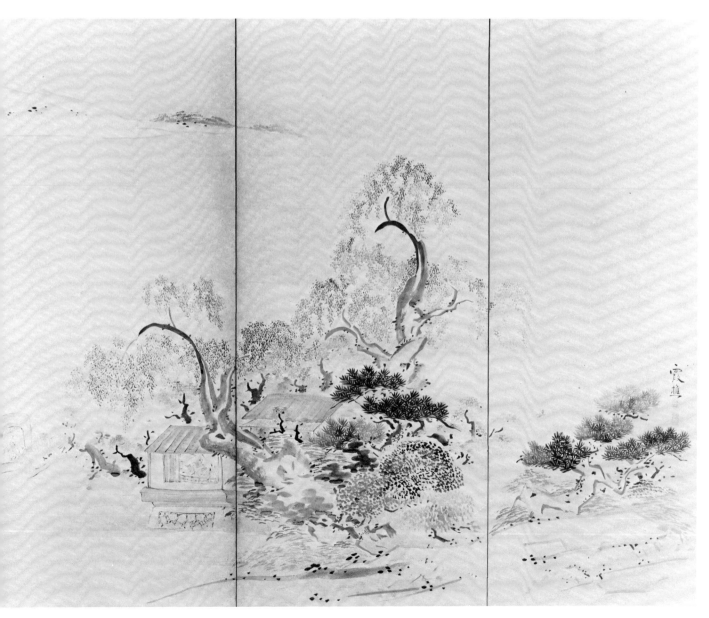

mary sensitivity, and the dark lines that extend and terminate those trunks seem somewhat clumsy. There is a discrepancy in conception between the relatively detailed figures and the highly sketchy landscape. The figures, indeed, seem to be modeled on prototypes found early in Taiga's career, such as his *Beauties Picking Lotus* (Kosetsu Collection, Ōsaka) or his Chinese *Queen Mother of the West* (Kumita Collection, Tokyo), whereas the landscape is handled in a manner most often associated with late works.[4] The brushwork on the trunk of the pine in the lower right lacks the necessary discipline to result in formal cohesiveness, and the treatment of the needles does not display a uniform artistic conception. There are areas of excessive ambiguity throughout the foreground, and the form of the boat is quite different from Taiga's usual treatment of the motif.

These observations do not prove conclusively that Taiga did not paint *Lake Landscape with Boating Party.* Indeed, Taiga is among the most unpredictable and individualistic of Japanese painters, and in his late years, as many authorities have noted, his output was extremely uneven in quality. This phenomenon may have been due to a heavy demand to fill commissions, or possibly to failing health. Taiga's friend Hosoai Hansai referred to Taiga as sickly, and Taiga died at the relatively young age of fifty-three. There is a strong possibility that towards the end, Taiga's wife Gyokuran (No. 40) and pupils helped him keep on with orders for his work, a hypothesis which would account for the partial lack of unity felt in *Lake Landscape with Boating Party.*

Although connoisseurship problems abound in Taiga's surviving works, the astonishing variety in his oeuvre and the joyful nature of his brushwork make him one of the most fascinating and compelling painters in Japanese history. There are none of the heavy or solemn qualities about him that often accompany genius and masterworks. In the work of Taiga and his followers there is a lightness and breadth of spirit that is embodied in formats from the small size of fans and album leaves to the large spaces of screens such as *Lake Landscape with Boating Party.*

MT

1. Suzuki Chōnō, "Hanko no uragaki," quoted in Mori Senzō, "Taiga ibun (216): Taiga no gansaku," *Nanga kenkyū,* vol. 3, no. 7 (Sept. 1959), p. 12.

2. *Ibid.* Mori concludes by expressing the hope that he has not excessively alarmed collectors of Taiga's paintings.

3. Compare, for example, this signature to a similar one taken from the famous *True View of Kojima Bay,* published in *Genshoku nihon no bijutsu,* vol. 18: *Nanga to shaseiga* (Tokyo, 1969), p. 231.

4. One example of a comparable late work is leaf number eight of *Eight Views of the Hsiao and Hsiang* in the Fujii Collection, Niigata, reproduced in the *Ike Taiga sakuhin shū* (hereafter SS) (Tokyo, 1960), no. 761-8. *Beauties Picking Lotus* appears as SS no. 90, and the *Queen Mother of the West* (Hsi-wang-mu), ibid., no. 18.

Ikeno Gyokuran 1727 or 1728-1784

Landscape Handscroll

Handscroll, ink and color on paper, 26.1 x 176.5 cm.,
 10¼ x 69½ in.
SIGNATURE: Gyokuran
SEALS: Gyokuran, Gion Fūryū
TITLE: "Tokka" (Special Sheaves) by Nukina Kaioku
 (1778-1863)

The unconventionality of the Nanga school is underscored by the relatively large number of women artists who practiced the style: Ōshima Raikin (fl. late 18th c.); Yanagawa Kōran (1804-1879), Hashimoto Seikō (fl. c. 1840); and Okuhara Seikō (1837-1913), to name a few. The most prolific and well-known woman painter in the Nanga style, however, was Gyokuran, whose name means "jade waves."

Gyokuran's lineage points to decidedly demimonde origins. Her grandmother, Kaji, and her mother, Yuri, operated a tea house in the Gion area of Kyoto. Such establishments had close connections with the prostitution trade, and quite likely Gyokuran was born out of wedlock, although she adopted her father's surname, Tokuyama. Kaji, Yuri, and Gyokuran were poets of some distinction, who specialized in the ancient 31-syllable verse form, *waka*. Whether Taiga ever formally married Gyokuran is not known, and the two were buried in separate temples; contemporary sources such as the *Heian jimbutsu shi* of 1768 and Taiga's memorial marker erected after his death, in 1777, refer to Gyokuran as Taiga's wife.[1] Gyokuran showed strong determination to become a painter, and some sources even postulate that Gyokuran married Taiga in order to get him to teach her. A work of c. 1750, the *Hōreki banashi*, informs us that Gyokuran's income as a painter regularly supplemented Taiga's, for when Taiga went out travelling, he would take Gyokuran's paintings along to sell.

In this painting Gyokuran takes the viewer on an idyllic journey up a watercourse, using forms that Taiga invented. Motifs such as the clusters of Taiga-esque trees, the Chinese sages, and the nestled houses (which reflect the influence of the *Mustard Seed Garden Manual of Painting*) have all been learned directly from her husband. Also shared with Taiga's work are the characteristic slanted brush outlines of trees and rocks, the texture strokes, the informal overpainting of dilute lines with darker ink, and the general vigorousness of the forms. Gyokuran's individual touch is apparent, however, particularly in her concept of the relationship of line to the form it defines. The trees at the far left, for example, seem first and foremost to be accumulations of calligraphic lines and only second, forms of nature. Similarly the dark contour

of the shoreline above them floats as a form separating itself from the landmass.

Nukina Kaioku, who wrote the title, was born four years after Gyokuran had died. By the time of his addition, the style of Taiga and his followers had gone out of fashion. To Kaioku's eyes, this work must have appeared exuberantly and quaintly archaic. Kaioku (Nos. 61, 62) is considered one of the important calligraphers of the late Tokugawa period. He is classed with the "traditionalists," who studied and modeled their work after that of the early Chinese calligraphers such as Wang Hsi-chih (303?-361?) of the Chin dynasty (317-420) and the major calligraphers of the T'ang (618-907).[2] Wang's works, mostly in the form of copies, had been eagerly collected by the Japanese as early as the Nara period (710-784), but most remained inaccessibly locked away in the Imperial Collection. Over the fifteen centuries intervening between Wang's and Kaioku's lifetimes, the works of that lion among Chinese calligraphers had become extremely rare, even in China. Kaioku could only have studied rubbings of recopied works or else brush originals of works many times recopied. It is not surprising, then, that little of Wang's influence can actually be detected in Kaioku's calligraphy, except perhaps in the manner of separating the right and left components, the slightly bowed shape of the respective verticals on the left side of the characters, and the appearance of easy movement in the turns of the brush, particularly in the diagonals.

Appended to the end of the handscroll is a biography of Gyokuran, dated 1952, by Haku'ei Dōjin.

MT

1. The *Jimbutsu shi* is transcribed in *Bijutsu kenkyū* vol. 53 (May, 1936), p. 219; the text of the commemorative stone appears in Sasaki Yoneyuki, *Ikeno Taiga bohimei* (Kyoto, 1976), unpaged. The *Jimbutsu shi* refers to Ikeno Gyokuran, while the memorial marker calls her Tokuyama Gyokuran.

2. For a discussion of the calligraphy of Wang Hsi-chih, as well as that of Chin and T'ang, see Shen C.Y. Fu, in collaboration with Marilyn W. Fu, Mary G. Neill, and Mary Jane Clark, *Traces of the Brush: Studies in Chinese Calligraphy* (New Haven, 1977), *passim*.

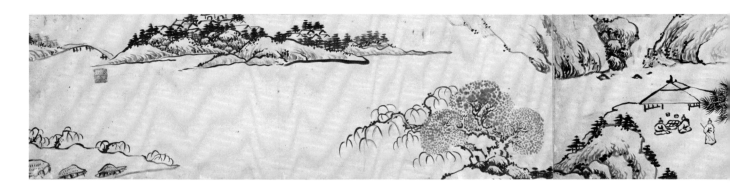

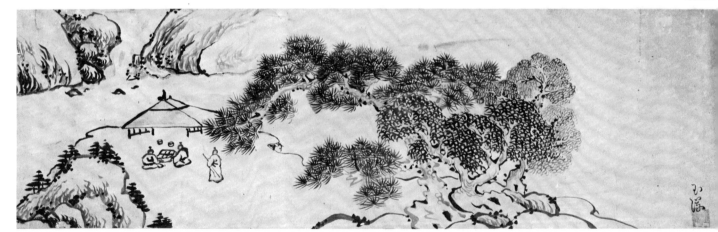

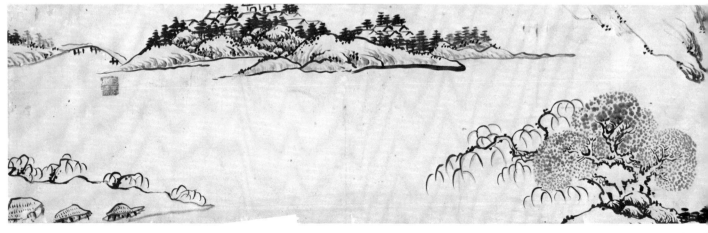

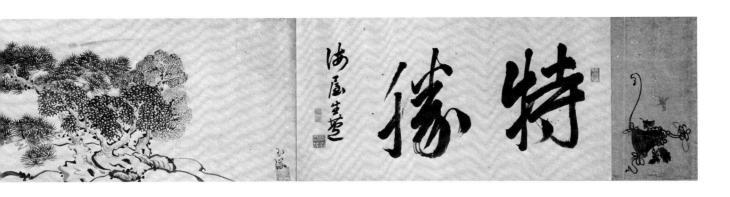

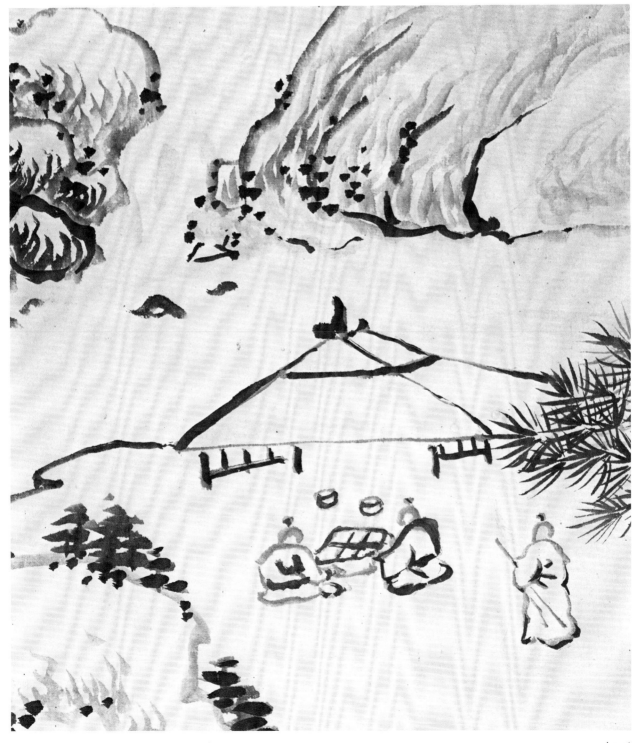

detail

129

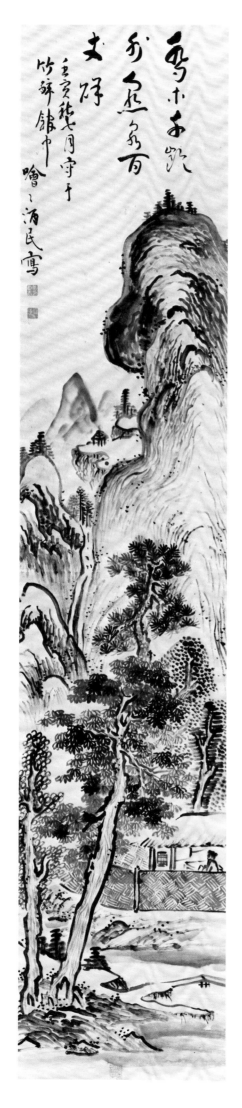

Satake Kaikai 1738-1790
Landscape with Man in Hut 1782

Hanging scroll, ink and light color on paper, 135.3 x 29.2 cm.,
 53¼ x 11½ in.
SIGNATURE: Kaikai Shūmin
SEALS: Sa Sadakichi in, Fukubutsu, Go fukyō jinshi fukyū

Satake Kaikai hailed from a family of *saké* sellers in
Kyoto. Encouraged by the climate of social freedom in
the eighteenth century, Kaikai turned his back on
the humble calling of his ancestors and aspired to the
more prestigious life of a literatus. It is not known
exactly when or for how long Kaikai studied with
Taiga, but Kaikai's painting and his calligraphy both
bear the strong stamp of Taiga's influence, and Kaikai
is cited as one of Taiga's major pupils. Perhaps in
emulation of his master, Kaikai tried to make his living
with his brush, but found that he was unable to support
himself. He returned to the occupation of *saké* selling,
but with a literati twist: he patterned himself after
Baisaō (1675-1763), a friend of Taiga's and an itinerant
peddler of Chinese-style steeped tea (*sencha*), who was
highly sought-after in literati circles because of his
exceptional personality and for his mastery of Chinese
verse. He was seen as the perfect literatus. Kaikai
adopted the name Baishūrō ("*saké*-selling man") as a
playful variation on Baisaō's name, which means "tea-
selling old man." In addition to *saké*, Kaikai purveyed a
delicacy called *konnyaku dengaku*, which is recorded
in the literature of the day as being particularly delicious.
Like Baisaō, the itinerant Kaikai was a regular figure
at the seasonal festivities of various localities and seems
to have been a much-loved personality around Kyoto.
Seida (or Kiyota) Tansō (1719-1785) wrote of Kaikai
that "he offered the wine cup of contentment to those
who were troubled in mind."[1]

This painting is a good example of the Taiga man-
ner as it was practiced in the late eighteenth century;
it was painted six years after Taiga's death, when Kaikai
was 45 years old. Kaikai used one of his master's typical
compositions—a stand of tall trees in the foreground,
an architectural element near the rear edge of the
foreground, and a towering mountain placed at one
edge of the picture[2]—but he has done so with a sort
of baroque elaboration, fitting additional peaks into
the space at left until a complex deep distance com-
prised of overlapping mountain tops has materialized.
Kaikai shares Taiga's love of lively wet and dry brush-
work, and, while displaying Taiga's standard brush motifs,
the lines, particularly the bent texture strokes (*shun*)
have a verve that is Kaikai's own. The color scheme,
too, with the unexpected touch of orange on the
scholar's desk, in addition to the more conventional
blues and pinks, owes a debt to Taiga.

The poem is by the T'ang poet Li Ch'iao:

The tall trees are over 1000 years old
The hanging spring exceeds 100 chang[3]

Kaikai not only imitated Taiga's style of calligraphy, as evidenced by the rough brush manner, the abundance of short, powerful strokes, the extreme variations in the thickness of the line, and the playful imbalance of the characters, it is possible that he also learned of Li Chi'iao's poem from Taiga, for a version by that master also exists.[4]

MT

1. This quotation was taken from Tansō's *Kujakurō hikki* (Peacock Pavilion Notes), transcribed in Mori Senzō, *Chosaku shū,* vol. 3 (Tokyo, 1971), p. 122.

2. Taiga used the composition throughout his career. See, for example, the *Ike Taiga sakuhin shū* (Tokyo, 1960), no. 154, a relatively early work, and no. 656, dating from his later years.

3. A *chang* is 10 Chinese feet; the poet in these paired five-character lines draws a parallel between the 1000 year old trees and the 100-times-10, i.e. 1000-foot height of the waterfall. I am very grateful to Wai-kam Ho for deciphering, translating, and explicating this poem.

4. Taiga's work is reproduced in Komatsu Shigemi, ed., *Nihon shoseki taikan,* vol. 22 (Tokyo, 1979), pl. 36.

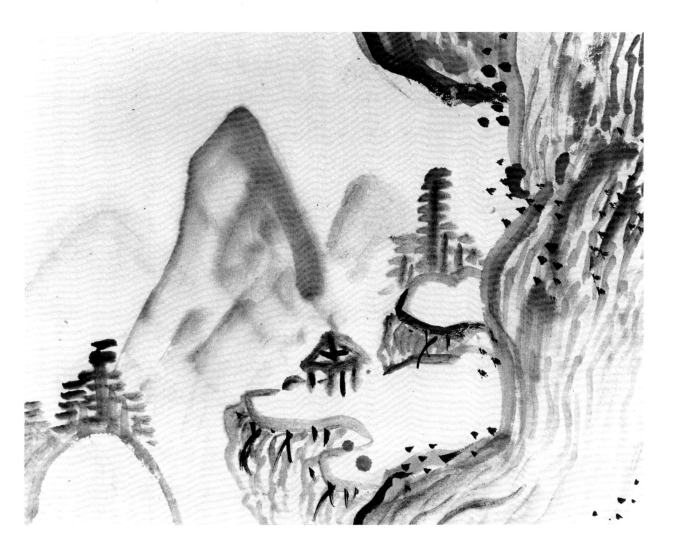

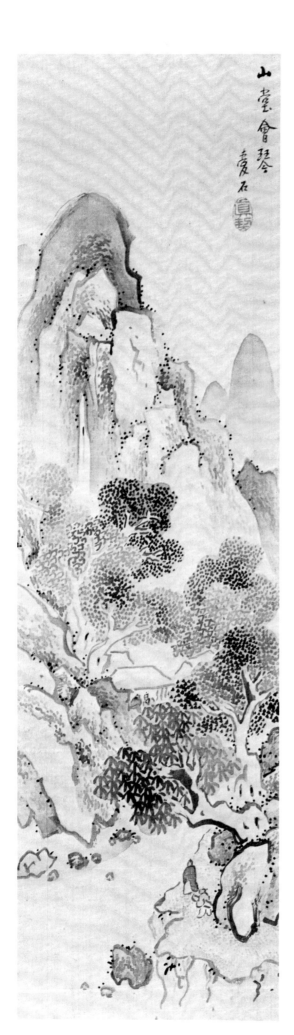

山堂會琴

麦石 真趣

Aiseki (act. early 19th century)
Ch'in Meeting in the Mountain Hall

Hanging scroll, ink and color on silk, 104.1 x 31 cm.,
41 x 12³/₁₆ in.
SIGNATURE: Aiseki
SEAL: Shinkei

By the nineteenth century Taiga's style had to a large degree gone out of fashion among Nanga painters, but it did linger, as Stephen Addiss has observed, among painter-priests such as Aiseki and Fūgai Honkō (1779-1847). The present work typifies this art-historical phenomenon.

Despite the number of attractive paintings that remain from Aiseki's hand, the biography of this individual remains laden with unsolved questions, including even his birth and death dates, his place of birth, and his specific area of activity. The sources that treat him exhibit among themselves considerable diversity. We learn variously that he was from Kii or from Kyoto, and later settled in Ōsaka or in Kyoto.[1] He is reported as having been active ca. 1804-29, in the Kyōwa era (1801-1804), or up to 1837 (?). Only one dated painting by Aiseki survives, a *Landscape in the Style of Wang Wei*, now in the Takeuchi Collection, Kanazawa, painted in 1806. Three authors state that he was an Ōbaku priest,[2] and he has been designated, along with Noro Kaiseki (1747-1828) and Nagamachi Chikuseki (1747-1806) as one of the "Three Stones," because they share the character *seki* in their names.

One of the best sources of information about Aiseki is the paintings themselves. They make it abundantly clear that something in Taiga's exuberant manner struck a resonant chord in Aiseki's temperament. The bulk of Aiseki's work demonstrates a judicious selection of many aspects of Taiga's style: the thick, slanted-brush contour lines, the manner of breaking up the rocky surfaces, the oval *shun* (texture strokes), the lyrical use of color, and the manner of drawing tree foliage. Aiseki's painting exemplifies one direction taken by Taiga's followers, towards an intensification of the ingratiating elements in Taiga's style. The other direction was towards an increasingly dry, formalistic, intellectual manner exemplified first and foremost by Taiga's pupil Kaiseki, with whom Aiseki is said to have studied.[3] The radical difference between their respective approaches to painting, the cerebral versus the emotional, shows that Aiseki took little from Kaiseki. It is more likely that Aiseki's true teacher was Taiga's paintings themselves.

The present painting counts among Aiseki's finest productions. Executed on silk with clear, limpid colors (even though now somewhat faded), and exhibiting many of the characteristic elements of Taiga's work

cited above, it reveals a stability of composition rarely found in the work of Taiga, who preferred the visual excitement of compositional imbalance.

MT

1. Laurance P. Roberts, *Dictionary of Japanese Artists* (Tokyo, 1976), p. 3 and Sawada Akira, ed., *Nihon gaka jiten,* 2 vols. (Tokyo, 1927), volume on names, p. 2, both hold that he was from Kii; Tani Shin'ichi and Noma Seiroku, eds., *Nihon bijutsu jiten* (Tokyo, 1952), p. 43 and Tsune'ichi Hideaki, *Shoga kotto jimmei daijiten* (Tokyo, 1977), p. 601 state that he was a man of Kyoto, not necessarily precluding the possibility that he was born elsewhere. Of the Japanese sources, only Tani and Noma assert that he moved to Ōsaka.

2. Roberts, p. 3, Hitomi Shōka, "Ōbakusō to Taiga, II," *Nanga kenkyū,* vol. 1, no. 5 (1757), p. 11, and Joan Stanley-Baker, *Nanga: Idealist Painting of Japan,* Collections of the Art Gallery of Greater Victoria, no. 17 (Victoria, 1980), p. 35.

3. Roberts, p. 3, goes on to say that Aiseki also studied Ming and Ch'ing painting, a statement which seems diametrically opposed to Hitomi's assertion that Aiseki painted uninteresting, derivative paintings because he never looked farther than Taiga's style. The truth lies somewhere in between.

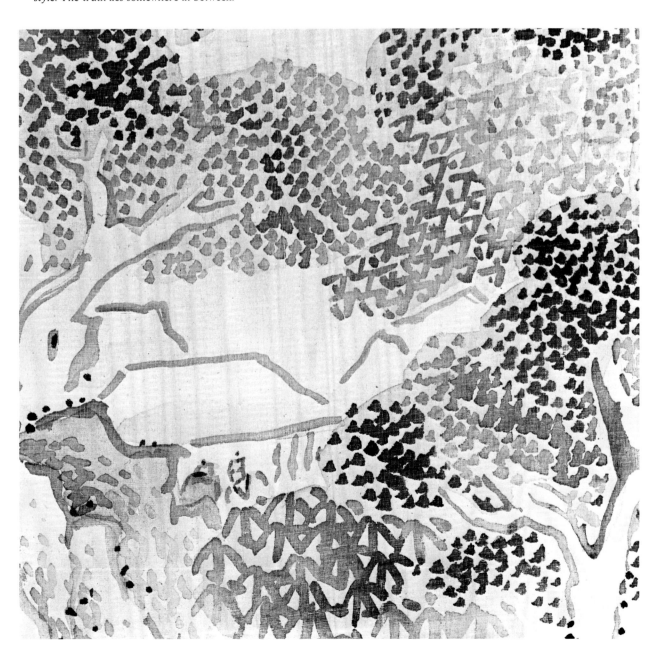

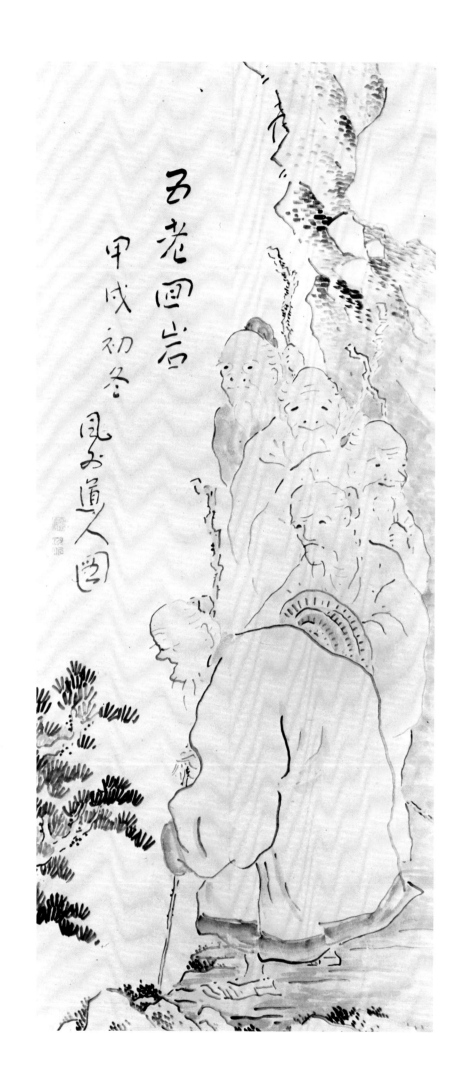

五老圖岩
甲戌初冬
風來道人圖

Fūgai Honkō 1779-1847

Five Elders Coming Around a Cliff 1814

Hanging scroll, ink and light color on paper, 134.6 x 57.2 cm.,
 53 x 22½ in.
SIGNATURE: Fūgai Dōjin
SEALS: ? sei shūjin, Kōhō
INSCRIPTION: 1814, early winter

Fūgai Honkō, like his namesake Fūgai Ekun (No. 18), was a Zen priest of the Sōtō sect. Unlike most Zen monks of his day he chose to paint in the Chinese-based Nanga manner rather than to imitate any of the established lineages of Zenga. What is even more unusual is that he chose to follow the style of Ike Taiga (Nos. 33-39), who had held sway in the latter part of the eighteenth century, but whose works, by the time Fūgai came of age as a painter, had largely ceased to serve as models for aspiring painters. It is almost as if Fūgai, like Shōhaku (No. 68), resorted to archaism as a means of demonstrating his individuality.

Fūgai was born in Ise, and, as was common in poor rural families, he entered the priesthood at the early age of eight. At eighteen he studied Zen with Genrō Ōryū of Ryūman-ji in Tsukuma and in 1809, aged thirty, became Genrō's spiritual successor. At some time during his career, it is thought that Fūgai studied the painting style of Tanke Gessen (1721-1809), who was a priest at Jakushō-ji in Ise Yamada. Gessen himself absorbed influences from a variety of sources including such diverse artists as Sakurai Sekkan (1715-1790), a Sesshū-style painter, Maruyama Ōkyo (1733-1795), and Yosa Buson (Nos. 44-46). According to Prof. Tsuji, Fūgai in addition studied Ch'ing dynasty *dōshakuga* (paintings which are conducive to enlightenment) as practiced by Ōbaku monks.[1] But, as is evident from Fūgai's paintings themselves, the greatest influence on Fūgai's style was Ike Taiga, who had died three years before Fūgai was born. Most sources state that Fūgai learned Taiga's style from frequent travels to the Matuse region near Izumo; a large number of Taiga's paintings had found their way to that area, many of them in the collection of the Zen temple Tenrin-ji. Out of this diverse alchemy of influences Fūgai refined a distinctive and delightful style.

In this painting, five oldsters, whose gently vacuous faces betray various stages of senility, appear in danger of being led over the edge of a steep cliff. Each has a distinctive personality, achieved by the painter's slight variations in the shapes of heads, eyes, noses, and mouths. The "Mi" dots of the cliff, the needles of the pine, and the *katabokashi* (uneven inking) of the slanted-brush outlines are stylistic elements learned from Taiga, as is the pristinely light, airy *kaisho* inscription. Other stylistic currents are discernible: the lead figure, with

his voluminous body and humped back, along with the white-painted wisps of hair, belongs within the figure style of Buson and was probably learned from Gessen. The shading of the faces may have been picked up from the Maruyama-Shijō School (see Nos. 70-79).

Some of Fūgai's compositions are large-scale, elaborate works, as, for example, his dramatic screens of Immortals, painted with bright colors and gold dust,[2] demonstrating that Fūgai was far more professionally accomplished than the average amateur Zen priest-painter. The present work, which dates from Fūgai's thirty-fifth year (and is thus relatively early) manages to recapture the lighthearted whimsy that had largely disappeared from Nanga by the early nineteenth century.

MT

1. See Tsuji Nobuō's entry for the screens of *Immortals*, in the Los Angeles County Museum of Art, reproduced in Mainichi Shimbun, ed., *Zaigai nihon no shibō*, vol. 6: *Bunjinga, shoba* (Tokyo, 1980), pl. 116-119, with explanation on pp. 156-157.

2. See note 1.

NANGA—BUSON AND HIS FOLLOWERS

By the mid to late eighteenth century, Nanga, which had initially been developed in Japan by artists fascinated by its "Chineseness," was becoming Japanized in the hands of both Ike Taiga (Nos. 33-39) and Yosa Buson (Nos. 44-46). Buson was an outstanding *haiku* poet as well as painter, and his heightened poetic sensibilities to the world around him profoundly affected his artistic vision.

Buson was born in a small farming village outside of Ōsaka, but at the young age of 20 set out to seek his fortune in the bustling capital of Edo. There he studied *haiku*, becoming a pupil of Hayano Hajin (1677-1742, also known as Yahantei), a noted poet of the Bashō school. Buson also expressed an interest in Chinese verse and painting, two forms of culture associated with the Chinese literatus, an ideal which was steadily gaining in popularity in Japan. Chinese studies were promoted by the government, and although the first to pursue them were samurai officials, interest gradually filtered down to other social classes. Buson's dual interest in Chinese and Japanese poetry was greatly to influence the course of his development as a painter.

After the death of his teacher in 1742, Buson left Edo and spent the next ten years traveling around the northern provinces. He settled in Kyoto for three years beginning in 1751, but in 1754 went to Tango province where he seems to have devoted himself to the study of painting. Unlike Taiga, who was acclaimed as a child prodigy in painting and calligraphy, Buson's artistic skills took a long time to mature. He taught himself to paint by copying designs from Chinese woodblock-printed manuals as well as by studying available Chinese and Japanese paintings. His early subject matter showed great diversity, ranging from elaborate depictions of birds and flowers to Chinese figures and landscapes. An early style of figure painting that he employed is characterized by complex, rough, angular brushwork (No. 45) based on models by Chinese professional artists. Herein lies one of the great paradoxes of Nanga, for the term literally means "Southern painting school," referring to the literati tradition of China. Many Japanese artists, however, did not confine themselves to "Southern school" models; Buson and others borrowed motifs from the so-called "Northern school" made up of professional artists. By not restricting themselves, Japanese masters took Nanga in many new and different directions, and consequently, their works have an aura of surprise and originality.

Buson returned to Kyoto permanently in 1757 and proceeded to earn his living as a professional painter. In addition to practicing Chinese styles, he developed an abbreviated manner of painting brushed with fluid strokes which came to be called *haiga* (haiku poem painting). His final maturation as a painter did not occur until the 1770's, and in his last decade Buson's talents as both a painter and poet became widely recognized. He continued to paint figures (No. 46), but Buson is most highly praised for his landscape paintings (No. 44) which exhibit a warm and intimate feeling for nature. His methods were based on Chinese prototypes, but Buson succeeded in imbuing his brushwork with natural rhythms akin to the life and movement in

rustling leaves, bubbling brooks, or sunlight streaming down over a verdant forest. More than any other Nanga artist, Buson is admired for his great sensitivity at expressing the transient qualities of nature.

Buson's tradition was carried into the early nineteenth century by two direct pupils, Matsumura Goshun (Nos. 75, 76) and Ki Baitei (Nos. 47, 48). Goshun went on to develop a new style after his master's death, but Baitei remained more faithful to his teacher's tradition. He left Kyoto and moved to Ōmi province in the 1790's, and his brushwork took on a raw, forceful vigor expressive of his own personality. He achieved great fame as a local artist; his paintings have a power and directness reminiscent of folk art, while still maintaining literati values.

Another important follower of Buson was Yokoi Kinkoku (No. 49), who never studied directly with the master, but learned by copying his works. He adopted many of Buson's designs, his way of structuring compositions, and basic brush methods, but transformed his models by injecting a personal dynamism into the brushwork which imbued his forms with an almost electric sense of energy. Kinkoku's admiration for Buson strengthened over the years, and came to a peak towards the end of his life when he retired to his birthplace in Ōmi province.

After the deaths of Goshun, Baitei and Kinkoku, the Buson tradition fell out of favor within the Nanga world. However, through the influence of Goshun, some features of Buson's figural style were adopted into the Shijō tradition which was carried on by artists into the late nineteenth and early twentieth centuries (see No. 78).

PF

44

Yosa Buson 1716-1784

Autumn Landscape 1772

Hanging scroll, ink and light color on silk, 63.5 x 44.3 cm.,
25 x 17⁷/₁₆ in.
SIGNATURE: Sha Shunsei
SEALS: Sha Chōkō in, Shunsei
INSCRIPTION: Painted in the fourth month, summer 1772
PROVENANCE: Rakuzandō Collection

Yosa Buson was not only one of the great masters of Nanga, he was also one of Japan's finest *haiku* poets. The two arts reinforced each other, as his paintings are full of poetic feeling based on a sensory appreciation of the moods of nature, while his *haiku* show his observation and depiction of human and natural conditions and events. He stressed in his teachings to younger poets that it was important to bring forth the special moments in everyday life, rather than extolling grandiose visions. Some critics feel that in his paintings he displays a more sensitive evocation of the nature of Japan than any other Nanga master.

Although Buson learned Chinese techniques and occasionally copied Chinese styles and compositions, his works show a native love of capturing the moment rather than seeking the universal. He was able to express human moods through depictions of particular seasons, times of day or momentary effects of weather and light. Buson's gifts as an artist did not like Taiga (Nos. 33-39) appear in his youth, but rather developed slowly throughout his life. It was not until his middle fifties that he established a personal style based upon the technical facility to depict his poetic visions of man and nature. As he earned his living more from his painting than from his poetry, the recognition that he received as an artist in the early 1770's enabled him to enjoy the security of a settled life in Kyoto, admired for his achievements in the two arts he had long studied and slowly mastered.

The theme of this painting is separation. The autumn season always carries a hint of sadness; here there is no visible way that the two figures, undoubtedly friends and sages, can meet. They are separated not only by the stream and thrusting rocks, but also by mist and emptiness. The landscape shows a Japanese sense of asymmetrical balance. While the right side is relatively empty, the left side is full of rocks, mountains, trees, a hut in a bamboo grove surrounded by a fence and an embankment by a pond which juts upward from the lower corner at an unlikely angle, bisected by a leaning tree trunk with clawing and hooking branches. The cottage, a symbol of man's presence, appears as a dream-like refuge in the midst of the extremely dynamic natural setting. Shapes such as the leaning tree and the upper mountains are cut off by the edge of the format or by mist, just as the figures are cut off from each other by space. The mood is one of stillness within activity, of separation and of nostalgia. Our eyes follow the gaze of the traveler up diagonally through the blank silk to his friend leaning upon a rock, and beyond him to the hut.

This is a painting that well repays repeated viewing. The range of ink-tones varies from strong black, as on the hooking twigs of the trees, to soft silky strokes in grey and misty wash fading into nothing. The colors are also subtle in their tonal shadings, yet the vigor of the brushwork and the diagonal thrusts to the forms maintain a sense of tension within the painting that balances the softer effects. Buson's maturity as an artist allowed him, within this small and seemingly simple landscape, to depict an evocative moment of human emotion echoed by the natural setting.

SA

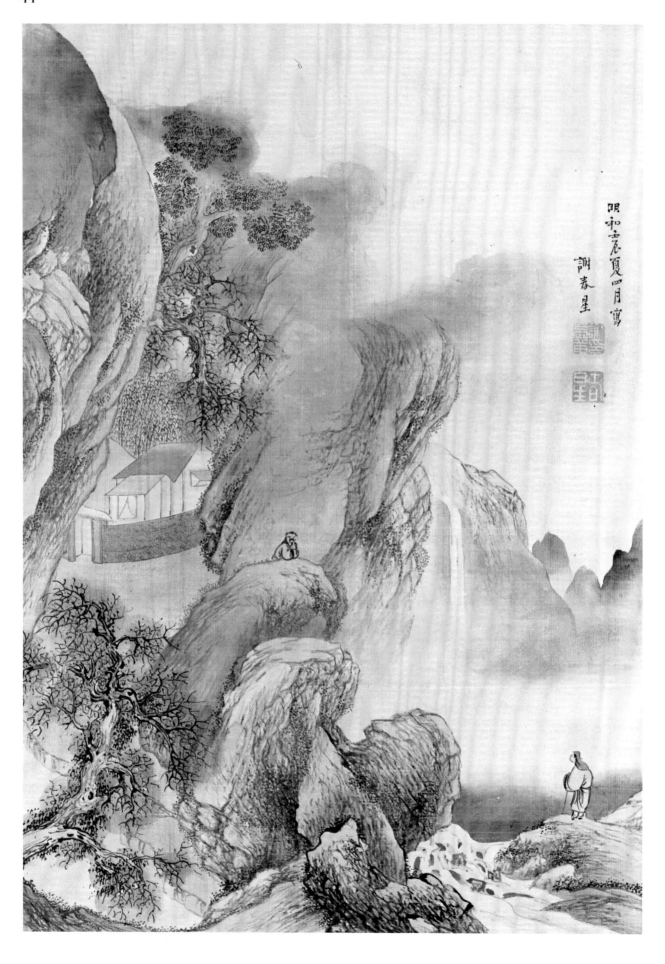

明
和
壬
辰
夏
四
月
寫

謝
春
星

45

Yosa Buson 1716-1784

Pair of Figure Paintings

Hanging scrolls, ink and light color on paper,
 each 128.3 x 56 cm., 50½ x 22¹/₁₆ in.
SIGNATURES: Sha-in painted at Sessai (Snow Hall), Sha-in
SEALS: Sha Chōkō in, Shunsei (left)
 Sha Chōkō, Sha Shunsei (right)

Buson was equally known for his landscapes and his figure painting. In both subjects he showed consistent artistic growth until his final years, when he produced a number of Nanga masterpieces. Although many of his final works are not specifically dated, we can know which paintings are from these years because he utilized the signature "Sha-in" only from 1778 until his death.

Buson's figure paintings show two distinct styles. One is complex, with many parallel lines in the depiction of faces as well as garments. The second is a great deal more simple, and was developed as an adjunct to *haiku* poetry. Buson not only became a great expert at *haiga*, a combination of *haiku* and simplified painting, but also utilized the *haiga* painting style in other works. This pair of scrolls is especially interesting as it displays the two different styles; the large-scale figures display both monumentality and charm, blending thorough depiction with evocative suggestion.

On the right we see an old scholar accompanied by a boy playing the *sheng* (Japanese: *shō*), a musical instrument made of bamboo tubes which are blown through a gourd; the closest Western equivalent would be pan-pipes. The *sheng* has an ancient and honorable history in China, where it has long been utilized in ritual orchestras.[1] The Japanese adopted the instrument during the Nara period and it is still to be heard in the *gagaku* court orchestra. The sound is lonely and haunting; it is the only traditional East Asian instrument from which several notes are played at once, although the sounds are not chords in the Western harmonic sense. The *sheng* is literally a mouth organ, and its inclusion in this painting suggests the antiquarian interests of the scholar as well as a mood of lofty refinement. The sage's face is depicted succinctly in *haiga* style, and he looks directly out at the viewer, an unusual pose developed by Buson that gives his paintings an immediate impact. The boy's face is also simply portrayed, but the garments of both figures are more fully developed in parallel brushlines, showing Buson's more formal style.

The figure on the left is more elaborately depicted, with the parallel lines appearing not only in his robes but also as wrinkles in his face. This scholar carries a "poem-staff" with coins attached on a string; he is ready to wander through nature and perhaps to stop at a wine-shop for refreshment. He points one finger upward, and his eye follows — is he watching a bird in flight, or the sunlight streaming over a mountain? He may be composing a poem in his mind, as there is a look of great concentration upon his face.

In this unusual figure pair from his late years, Buson has displayed his creative synthesis of Chinese and Japanese traditions. His subjects are certainly Chinese sages of the past, as is made clear by the inclusion of the *sheng*. Yet the style of the brushwork shows a Nanga transformation of continental influences. Buson's calligraphic training is apparent in his sure and decisive strokes of the brush, each of which has a structural as well as an expressive function. The relaxation of the line-work, however, as well as the simplification of forms in *haiga* style, is purely that of Buson. This pair of paintings, once mounted on a two-panel screen, exemplifies the mature art of Buson's final years.

SA

1. The recently discovered tomb artifacts in Ma-wang-tui included a well-preserved *sheng* dating to the second century B.C. The *sheng* also appears in slightly different form in Southeast Asia.

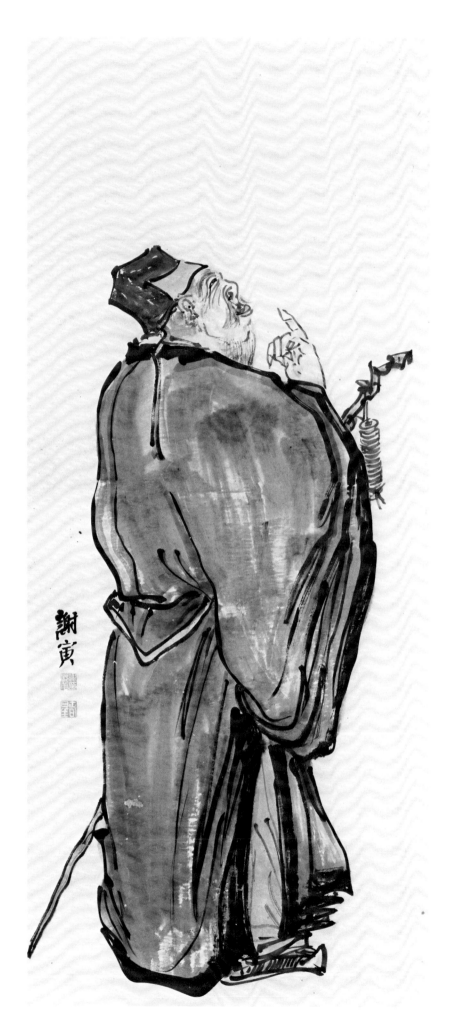

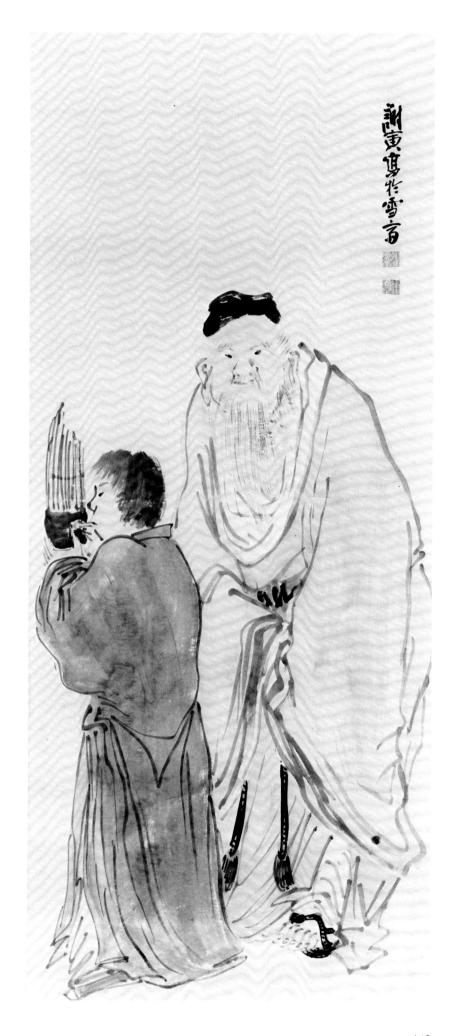

143

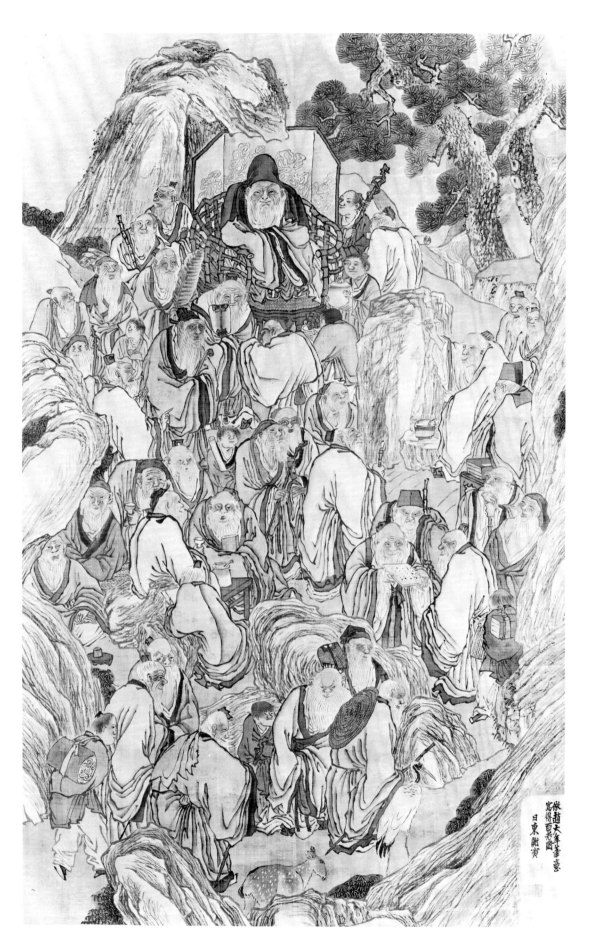

*46

Yosa Buson 1716-1784

One Hundred Old Men

Hanging scroll, ink and light color on silk, 134.6 x 86.4 cm.,
 53 x 34 in.
SIGNATURE: Nitō Sha-in
SEALS: Sha Chōkō, Sha Shunsei
INSCRIPTION: One Hundred Old Men, painted after the brush
 idea of Chao Ta-nien

The subject of gatherings of old men was popular in the later eighteenth century, particularly among Nanga painters. Taiga depicted this subject,[1] and Buson seems to have painted several versions of the theme.[2] In this large hanging scroll on silk, Buson has rendered the old men with more detail and more complex brushwork than in his other versions. From the signature we can be sure that this is a very late work of the artist, and his formal figure style is utilized to good advantage in suggesting the wrinkled faces and complex folds in the robes of the thirty-nine septua- and octogenarians. Chief among them is Jurōjin, a figure with a tall forehead who is a symbol of longevity.

Respect for old age is characteristic of China and Japan, and a wish for long life is common, particularly among the literati. In many cases a poet, calligrapher or painter was just achieving a peak of expressive skill in his late years—Buson himself did not reach his maturity as an artist until his sixties. After six decades, one was thought to have lived a full and responsible lifetime; children were by this time grown, and a scholar or sage was now free to devote himself to his favorite artistic pastimes. These included painting and calligraphy, usually on paper or silk, but sometimes as depicted here on a nearby rock, drinking wine or tea, engaging in elegant conversation, strolling with a crane or deer (symbols of long life), playing the games of go and shoji and enjoying the beauties of nature. Rocks and pines were also associated with long life, and in this painting the wrinkles and minor crevices of the rocks are quite similar to the folds in the robes of the old scholars.

In Nanga painting, although there was certainly a reverence for age, one can also find a spirit of fun; we can smile at these old bearded scholars even as we admire their cultivated yet carefree activities. Buson wrote that he was following the brush idea of Chao Ta-nien (Chao Ling-jang, active 1070-1100), a member of the Imperial Sung family who was noted for his landscape depictions. As is sometimes the case with such inscriptions by Buson mentioning famous Chinese painters, it is difficult to understand the reference. Among Chao's known works there are no such gatherings, and his landscape style does not conform to Buson's brushwork in this scroll. Perhaps Buson had some reason for mentioning Chao's name that we do not under-

stand, perhaps he merely wished for an association with a noble name of the past, or perhaps this was a kind of scholarly and artistic joke. In any event, One Hundred Old Men is one of Buson's most complex and fascinating figure paintings from his final period. We can well imagine the elderly master brushing this work for a still more elderly friend, and both of them smiling at the sight of these old scholars gathered in their geriatric association. The painting has both strength of composition, with the figures generally arranged in diagonals within the enclosing rocks, and rhythmic pulsations of brushwork. It represents the respect plus the touch of humor in a Nanga master's view of his own literati culture.

SA

1. See The Freer Gallery of Art, II Japan (Tokyo, 1972), no. 55.
2. See Buson ihō (Kyoto, 1932) no. 56 for a large painting of 1782 in which eighty-three old men plus their servants are pictured, and Kobijutsu 42 (1973) for a scroll of 1783 with fifty-four old men and their servants.

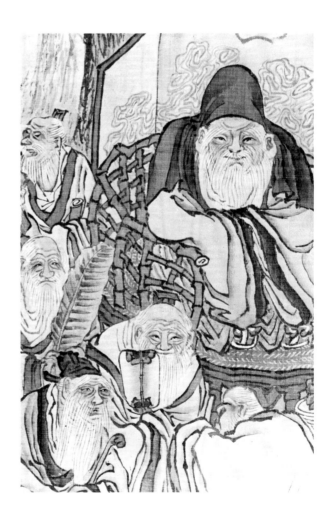

Ki Baitei 1734-1810

Fisherman With Catch

Hanging scroll, ink and color on paper, 125.4 x 59 cm.,
 49⅜ x 23¼ in.
SIGNATURE: Konan Kyūrō
SEAL: Kyūrō

Unlike Taiga (Nos. 33-39), whose pupils were extremely numerous, Buson's followers were fewer in number and tended to remain in the Kansai area. One of the most interesting and important of them was Ki Baitei.

As with many of the biographies of Nanga painters, solid evidence about the facts of Baitei's life is difficult to obtain.[1] Even his birthplace is unknown. He came to Kyoto, evidently made his living (or supplemented his income) painting and selling fans, and came under the influence of Wakaki Randen, who introduced him to Buson, it is said, because of Baitei's talent at *haiku* and painting. His earliest surviving dated painting, however, was not executed until Baitei was forty-four, in 1778. During his studies with Buson, Baitei thoroughly mastered his teacher's style. He left Kyoto in the early 1780s and went to settle in Ōtsu on Lake Biwa, but returned to Kyoto late in 1783 to take care of his master when Buson fell terminally ill. After Buson's death Baitei returned to Ōtsu, where he was active in *haiku* circles and earned the nicknames Ōmi Buson and Ōtsu Buson for his skill in painting in the Buson manner. Indeed, *Two Crows on a Branch* (No. 48), is nearly indistinguishable from a painting by Buson.

It would be a mistake, however, to regard Baitei as a totally derivative painter. Even when working within the Buson mode he in fact often shows considerable individuality as an artistic personality. He tended to amplify elements of Buson's style, seizing what was strong in Buson's work and presenting it with an almost brutal starkness that is somehow very attractive. No study of Nanga figure painting has been made to date, but it is interesting to follow a development from its relatively limited appearance in the first generation of painters to a more widespread adoption with the development of strong individual styles in the second generation. In the work of Taiga and Buson, the primary masters of the second generation, a large proportion of the figure paintings were devoted to worthies such as venerable Chinese sages (see also No. 50) or literary figures, religious personalities, and occasionally, important Japanese. When fishermen appeared, it was primarily in the capacity of archetypes of the ideal life liberated from dreary mundane responsibilities. A large single figure of a fisherman by Buson does exist, proving the likelihood that the master provided Baitei the prototype for his subject.[2] Buson's painting is more

"picturesque" or lyrical, his fisherman more charming. Baitei, on the other hand, despite the fact that he has portrayed his subject with a certain amount of sympathy, gives us something close to a portrait of a rude peasant with a distinctive personality, who strides along looking as if he were mumbling to himself, or perhaps with that curious gesture admonishing the catfish. This is an unusual treatment in the context of Nanga.

Baitei's individual hand comes to the fore strongly in this work. The fisherman boldly fills almost the entire picture surface. The lineament is Baitei's strong, unhesitating line that breaks up curves into angles. Delivered in broad brushstrokes, the grey wash is found in other of his works and provides background texture as a device to keep the forms close to the surface. The fisherman's lined and distorted face is ugly yet congenial and is treated with a sort of cubist universality of angle. The signature, Konan Kyūrō, was used by Baitei roughly between 1783 and the mid-1790s; this painting, therefore, is most likely a work immediately preceding Baitei's latest period.

MT

1. The most comprehensive account in English of Baitei's career, including the various arguments for establishing his birth and death dates, appears in Calvin L. French et al., *The Poet-Painters: Buson and His Followers* (Ann Arbor, 1974), pp. 31-32.

2. Reproduced in James Cahill, "Sakaki Hyakusen no kaiga yōshiki" (The Styles of Sakaki Hyakusen and Their Models), Part I, *Bijutsushi*, nos. 93-96 (1976), fig. 29.

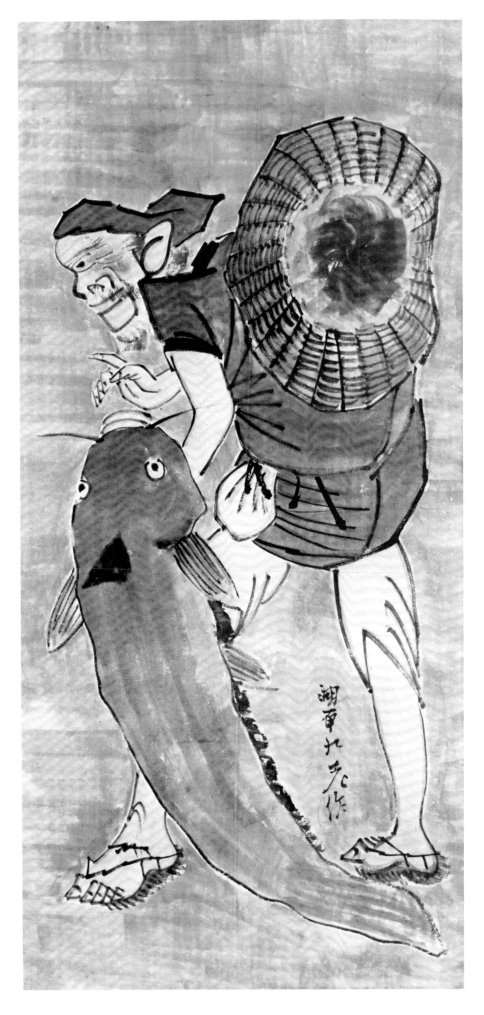

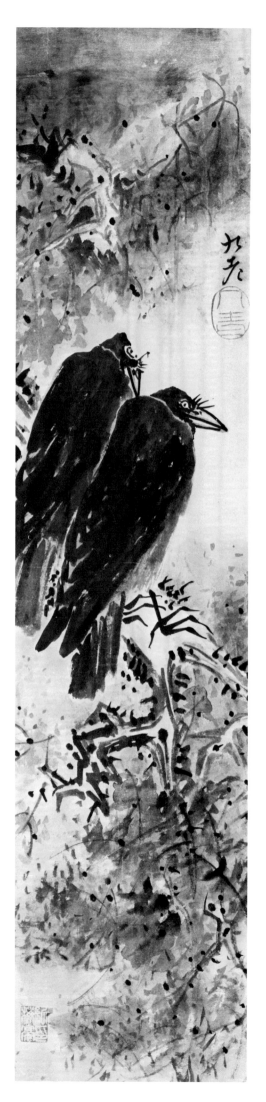

Ki Baitei 1734-1812

Two Crows on a Branch

Hanging scroll, ink on paper, 110.5 x 28.5 cm., 43 1/2 x 11 3/16 in.
SIGNATURE: Kyūrō
SEALS: Kyūrō, Ki Baitei in
PUBLISHED: Suzuki Susumu, *Haijin no shoga bijutsu*, vol. 11:
 Edo no haijin (Tokyo, 1980), pl. 65.

This painting is Baitei's adaptation of one of Buson's most distinguished masterpieces, a pair of hanging scrolls of which the right depicts a kite in a rainstorm, and the left, two crows on a snowy tree trunk (figs. 1 & 2). In his diptych, Buson set up a vivid contrast between the fierce kite clinging tenaciously to a swaying branch and pelted by diagonal sheets of driving rain, and the two almost humorously placid crows, who look on resignedly at the silent dance of snow descending from a lowering grey sky. The one evokes the violence of a late-summer typhoon, the other conveys the austere crackling chill of winter. While it was not uncommon practice for students to make copies of their teacher's works, Baitei has audaciously telescoped aspects of the two paintings into one: the two crows are nearly identical to Buson's (although they occupy a more prominent place in the composition), but they sit on a branch rather than on the main tree trunk. The loose, impressionistic brushwork of the branch more closely relates it to the foliage in the painting of the kite. Baitei's painting has been rendered seasonally ambiguous; the touches of light sienna and darker ochre may hint at autumn.[1] Baitei has also transformed Buson's more structural brushwork into an excited tangle of more freely rendered, often ambiguous forms.

Both Buson's diptych and Baitei's single painting of crows contain little that can be said to derive from Chinese Nanga. Although the subject of flower-and-bird painting had enjoyed a long and rich history in Japan (see Nos. 4, 9, 12-17), works of that genre produced in either country seldom evoke the kind of emotion or mood seen in the paintings of Buson and his followers. Buson's pupils in painting were also *haiku* poets, and Suzuki Susumu, writing of this painting, feels that it has the flavor of *haiku*.[2]

The crow is an ancient motif in Japanese folklore, dating back to early mythology. Yatagarasu, the three-legged crow, is said to have been the *otsukai* (generally translated as messenger, but more correctly, perhaps, as an animal belonging to the gods) of Izanami and Izanagi, the progenitors of Japan. According to some accounts, Yatagarasu is a *kami*, the offspring of Okuni-nushi-no-mikoto, and was sent by Amaterasu, the Sun Goddess, to guide Emperor Jimmu as he advanced his troops into the interior of Japan.[3] Coexisting in the

Japanese mind with this mythological notion of the crow was the more mundane practical reality. This noisy, aggressive bird was considered to have an evil nature,[4] and it is indicative of a general Tokugawa period trend to focus gradually on the everyday rather than the idealized. Bashō used the imagery of the crow in his *haiku* and transmitted it to Buson, who incorporated it into his painting as a motif.

MT

1. Calvin L. French *et al., The Poet-Painters of Japan: Buson and His Followers* (Ann Arbor, 1974), p. 49 and p. 132, speak of the crow as a symbol of late autumn and winter and cite *haiku* by Buson and Bashō placing crows within that seasonal ambience. Buson used the crow as a motif for other seasons as well, however, so it seems inappropriate to equate the crow with a particular season. See, for example, Buson's *Summer Landscape,* reproduced *Suiboku bijutsu taikei* (reduced edition), vol. 12: *Taiga, Buson* (Tokyo, 1977), pl. 111. Suzuki Susumu, *Haijin no shoga bijutsu,* vol. 11: *Edo no haijin* (Tokyo, 1980), pl. 100 reads the white area behind the crows as a snowy mountain, but this is questionable. The crow is not listed as a seasonal motif in such poetic dictionaries as the *Kigo jiten* or *Zusetsu haiku daisai-jiki.*

2. Suzuki, *ibid.,* p. 100.

3. This and other aspects of crow symbolism are discussed in Jean Herbert, *Shintō: At the Fountainhead of Japan* (New York, 1967), p. 403 and p. 443.

4. Suzuki, *ibid.,* p. 100.

figure 1 Yosa Buson, *Kite in a Rainstorm,* Kitamura Museum, Kyoto

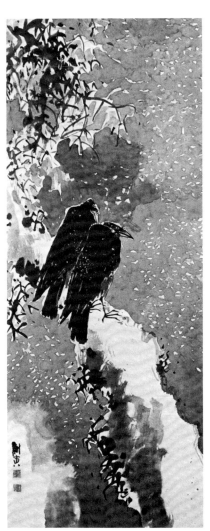

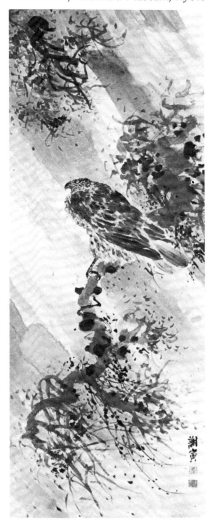

figure 2 Yosa Buson, *Two Crows on a Snowy Tree Trunk,* Kitamura Museum, Kyoto

149

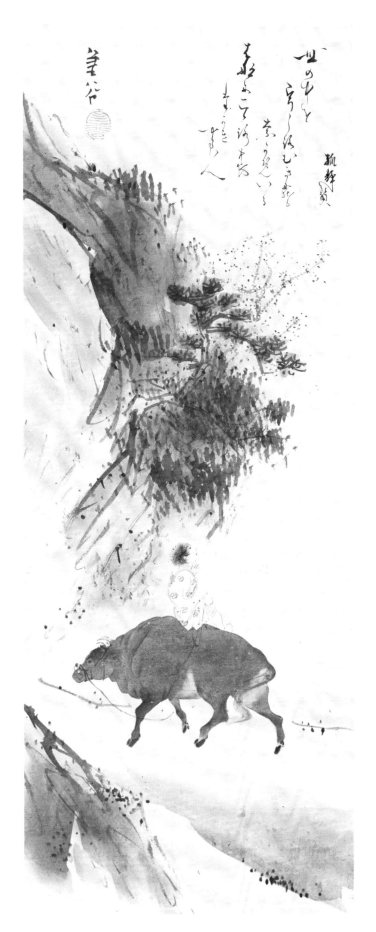

Yokoi Kinkoku 1761-1832
Boy Riding Bull Through Mountains

Hanging scroll, ink and color on paper, 96.8 x 37.8 cm.,
 38⅛ x 14⅞ in.
SIGNATURE: Kinkoku
SEAL: Kinkoku
INSCRIPTION by Kosei (dates unknown): see text below

Yokoi Kinkoku led one of the most extraordinary careers of all artists.[1] Born in a small village in Ōmi province (present-day Shiga prefecture), Kinkoku was sent to the Jōdo temple Sōkin-ji in Ōsaka at the age of nine where he entered the Buddhist priesthood. His youthful spirit reacted against the traditional disciplinary training, however, and Kinkoku mischieviously wreaked havoc at the temple. After being punished for his misdeeds, Kinkoku ran away but was soon caught and brought back to Ōsaka. Ultimately he was unable to conform to a stringent lifestyle and at the age of seventeen left for Edo.

In Edo Kinkoku was admitted into the Jōdo temple Zōjō-ji in Shiba. In addition to Buddhist doctrines, he studied Confucianism and Sanscrit. However, Kinkoku was unable to ignore the many pleasures to be found in the city of Edo and began frequenting the gay quarters. In response to his repeated acts of misconduct Kinkoku was expelled from Zōjō-ji and spent the following years traveling. He returned to the Kyoto area, and after devoting himself diligently to Buddhist studies he was invited to become the head priest of Gokuraku-ji on Mt. Kinkoku.[2]

In 1788 a great fire occurred and Kinkoku's temple was destroyed. This event inspired him once again to take up the life of a wanderer, allegedly traveling as far as Nagasaki. Eventually Kinkoku got married and settled in Nagoya where he associated with a society of haiku poets and became a pupil of the Shijō artist Chō Gesshō (1771-1832). He also became involved with the Shugendō sect at this time, participating in an important pilgrimage to Mt. Ōmine in 1804.[3] Although continuing to make journeys to Shugendō-related mountains throughout Japan, Kinkoku seems to have kept his home in Nagoya until around the age of 63 when he retired to a secluded area in Shiga prefecture.[4]

Boy Riding Bull Through Mountains is notable because it represents a blending of two different painting traditions: the Maruyama-Shijō style of figures and the Nanga style of landscape. The motif of a boy with a bull was a popular one in Japanese painting, especially among artists associated with the Maruyama-Shijō School. Kinkoku's bull, following standard Shijō prototypes, was depicted entirely with washes of ink; no outlines were used. The graded tonalities of ink, and the concentration of darker ink in certain areas as the folds

of the bull's skin, grants a sense of three-dimensional solidity to the animal. In contrast, the figure of the boy was defined exclusively with crisp outlines, within which light washes of pink and blue colors were added to represent the floral patterns on his robe. In both the forms of the boy and bull, a certain quality of restraint is evident.

Kinkoku's unique contribution to this standard genre theme was his act of incorporating it into a Nanga landscape setting.[5] Behind the bull juts forth a rocky cliff supporting a tree satiated with pink blossoms. The brushwork describing the precipice was freely applied in what appears to have been a burst of enthusiasm. The frenzied dotting, variation in line thickness, and interweaving of brushstrokes set up vibrations which are a distinctive characteristic of Kinkoku's art. Over the ink lines Kinkoku has brushed colors of green and orange, evoking the freshness of a spring day. The poem above was written by an unidentified poet Kosei and reads:

Yo no naka o	*Turning his back*
Ushiro muki ni zo	*On the world,*
Nagame iru	*The mountain dweller*
Hana ni kokoro no	*Purifies his heart*
Takaki yamabito	*By gazing at flowers.*

This poem may refer directly to Kinkoku who turned his back on the world and found spiritual satisfaction in the mountains.

PF

1. His autobiographical writings have inspired three modern Japanese authors to write novels based on his life. Fujimori Seikichi, *Taiyō no ko* (Ōtsu, 1975); Sakamoto Masame, *Aru hōro sō no shōgai* (Ōsaka, 1972); Kamisaka Jirō, *Kinkoku shōnin gyōjō-ki* (Tokyo, 1976).

2. It is from this location that he took the name he is most well-known by, Kinkoku.

3. For information on Shugendō see H. Byron Earhart, *A Religious Study of the Mount Haguro Sect of Shugendō* (Tokyo, 1970).

4. For more discussion of Kinkoku's biography and development as a painter, see Pat Fister, *Yokoi Kinkoku: The Life and Painting of a Mountain Ascetic* (University of Kansas Ph.D. Dissertation, 1983).

5. There is another version of this painting which was published by Fujimori Seikichi in *Shirarezaru kisai tensai* (Tokyo, 1965); however, the arrangement of the landscape elements is somewhat different.

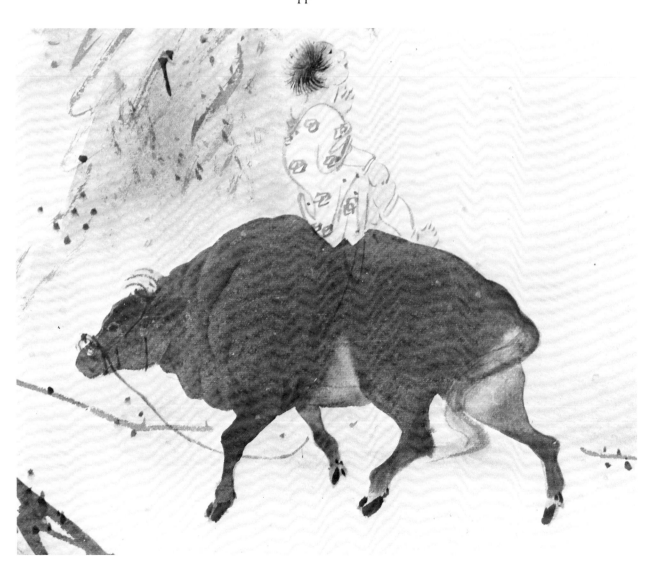

NANGA—MASTERS IN EDO

Although some of its early practitioners came from other parts of Japan, Nanga was by and large a movement centered in the ancient capital of Kyoto. Nakayama Kōyō (No. 50) was one of the first Nanga painters to be active in Edo (present-day Tokyo). He was a native of the island of Shikoku, but moved to Edo in 1759 where he became active in Chinese scholarly circles. Kōyō first studied painting with one of the Nanga pioneers, Sakaki Hyakusen, and developed a personal style deriving in part from works of Chinese professional artists. Thus, from its inception in Edo, Nanga was not at all like the "Southern school" painting of China upon which its foundations were laid.

It was really not until the late eighteenth century that Nanga emerged as a popular art-form in Edo. Its rise in popularity there is mostly credited to the activities of Tani Bunchō (No. 52) who became one of the leading Edo artists. Bunchō studied painting from an early age, receiving training from masters of various schools. He secured a position as an official artist for the Tokugawa government, and one of his initial duties was to research and produce a comprehensive catalogue describing artworks (both Japanese and Chinese) in Japanese collections. During the course of this project Bunchō traveled extensively throughout Japan, coming into contact with a host of painting traditions which undoubtedly influenced his own development as an artist.

Perhaps because of his official connections, Bunchō emerged as a leader in the rapidly expanding artistic world of Edo. Among his intimate circle of friends were artists associated with other schools of painting such as Sakai Hōitsu (Nos. 13, 14), Suzuki Kiitsu (Nos. 15, 16) and Watanabe Nangaku (No. 73). In Kyoto, circles of Nanga painters had been made up almost exclusively of artists interested in the new Chinese style, but in Edo the mood was very different. By broadening his circle of artistic friends, Bunchō also expanded the range of Nanga, which took on a rather eclectic nature in Edo, where there seems to have been a great deal of cross fertilization among the many schools of painting. As a result, most Edo Nanga tended to lose some of the subtle literati overtones which were still present in Kyoto.

Bunchō was not only prolific as an artist, but also in spreading his teachings. His scores of pupils in Edo included Sugai Baikan (No. 53) and Tsubaki Chinzan (No. 54). Baikan eventually left Edo and journeyed to the port of Nagasaki where he studied painting directly with a Chinese visiting artist. His own style exhibits both the boldness of Bunchō and the careful buildup and construction of forms emphasized by his Chinese master. Chinzan is most well-known for his colorful, delicate bird-and-flower paintings. The fact that he is still considered as a Nanga artist shows the broad range of subjects that were accepted in Edo as part of this tradition. In Edo, Nanga developed in a number of new directions, and even such diverse techniques as Western style realism were adopted into the Chinese tradition.

Kameda Bōsai (No. 51), a close friend of Bunchō, was one of the few true scholar-artists active in Edo. Bōsai first made his living as a Confucian teacher, but later retired and devoted himself to travel and the arts. He thus fulfilled the ideal of the Chinese literatus. Bōsai was perhaps most famous as a poet and calligrapher, but he also painted landscapes which have the simplicity and naivete of scholar-amateur painting.

PF

50

Nakayama Kōyō 1717-1780
T'ao Yuan-ming Out Strolling

Hanging scroll, ink on paper, 76.5 x 24.3 cm., 30 1/8 x 9 9/16 in.
SIGNATURE: Kōyō sanjin giboku
SEALS: Teichū no in, Shiwa, Shōsekisai Toshoki
PUBLISHED: Yoshizawa Chū, *Suiboku bijutsu taikei* extra volume
 no. 1, *Nihon no Nanga* (Tokyo, 1976), p. 49.

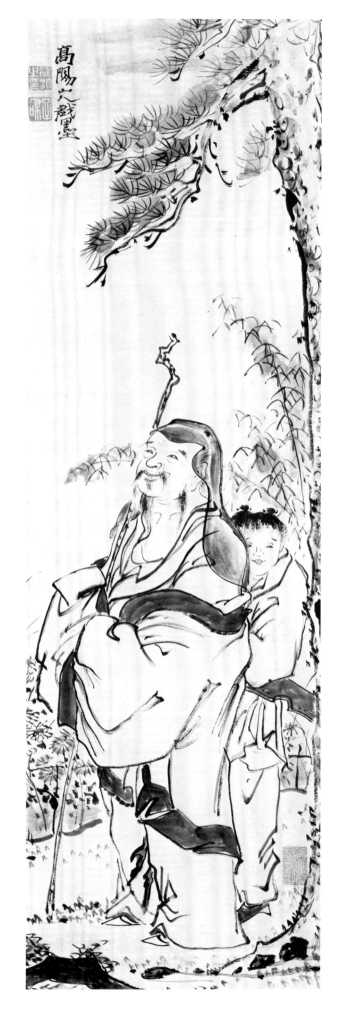

Nakayama Kōyō is one of the most interesting of early Nanga masters, as he not only painted floating landscapes and elegant bird-and-flower works, but also devoted himself to figure painting, much more rare among literati artists.[1] After studying with Sakaki Hyakusen, Kōyō investigated Chinese paintings of the Ming and early Ch'ing dynasties. His style was influenced, according to an article by James Cahill, by "vulgar and shallow" Chinese figure paintings that were no more than "debased images" by "hack artists."[2] This style featured an exaggerated use of fluttery lines, and had passed from organic to "mannered and degenerate" depictions of sages and beautiful women in the hands of secondary Chinese artists.

Opinions may differ whether Kōyō "accentuated the awkwardness" or breathed new life into this tradition by his bold, free-spirited compositions which display a rather light-hearted approach to seemingly serious subjects. One often senses a touch of whimsy in Kōyō's figure paintings that is quite refreshing. Whether the painter understood that the tradition he was following was almost moribund is not certain, but his own lively spirit appeared in his brushwork and thus his best paintings have considerable charm.

Kōyō frequently depicted T'ao Yuan-ming (also known as T'ao Ch'ien, 365 or 376-427), the great Chinese poet who gave up his official position to retire to a life of simplicity and rustic poverty.[3] T'ao became an inspiration for later literati who grew weary of government service. He was devoted to nature, wine, chrysanthemums and the music of the *ch'in*, a seven-string zither beloved by poets and philosophers. After a time, however, he removed the strings from the instrument, commenting that he understood the deeper meaning of the *ch'in* so he no longer needed the sounds of the strings.

T'ao was often depicted in paintings wearing a gauze cap through which he could strain his rough country wine, holding the *ch'in* or admiring chrysanthemums. T'ao's poetry seemed to reach beyond words to express a spirit that was no longer of this world. The fifth in his series of "Poems After Drinking" became especially famous among scholars and poets of Japan as well as China.

154

I've built my hut where people live,
But I hear no noise of passing carts and horses.
Would you like to know how this can be?
With the heart detached, one's place is naturally
 remote.
Picking chrysanthemums by the eastern hedge,
I can see the distant southern hills.
The mountain air sparkles as the sun sets,
Birds in flocks return together.
In these things there is a fundamental truth—
But when I begin to express it, I lose the words.

Kōyō's painting captures the poet's spirit with relaxed ease. We can see the gauze hat, the stringless *ch'in* carried by a servant and the chrysanthemums that T'ao so loved. The rock jutting up in the lower left corner shows Kōyō's study of Chinese professional Che school paintings, where such a rock depicted in strong contrasts of light and dark is frequently seen. The free brushwork of the pine tree and bamboo, however, demonstrates Kōyō's literati touch. The poet, wandering with his staff, seems oblivious to his loosely gathered robe and somewhat inelegant appearance. He is both enjoying nature and responding to his own inner world. His smile suggests serenity, and we can almost see the twinkle in his eye. Kōyō's skill in this scroll has been to capture the spirit of his subject while not taking the painting too seriously. A heavy hand with the brush would have destroyed the spontaneous joy of the work and lost the essence of the great poet.

SA

1. For other examples of Kōyō's work, see *Nakayama Kōyō gafu* (Kochi, 1971). Further information on his life is given in Hosono Masanobe, "Nakayama Kōyō, sono shōgai to sakuhin," *Museum* no. 222 (1969).

2. James Cahill, "Sakaki Hyakusen no kaiga yōshiki", *Bijutsushi* nos. 93-96 (1971). Professor Cahill's articles on Hyakusen have recently been revised and are being published in English as *Sakaki Hyakusen and Early Nanga Painting* (Berkeley, 1983).

3. For another painting of T'ao by Kōyō, see Stephen Addiss, ed., *Japanese Paintings 1600-1900 from the New Orleans Museum of Art* (Birmingham, 1982), pp. 39-40.

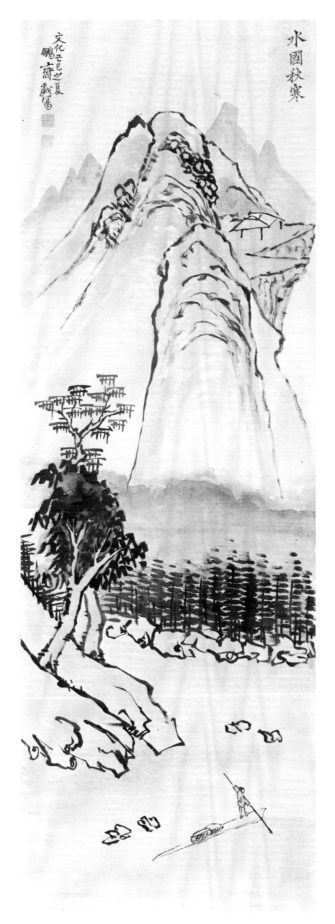

水國秋寒

51

Kameda Bōsai 1752-1826
Autumn Chill in the Lake Country 1809

Hanging scroll, ink and light colors on silk, 111.5 x 38.4 cm.,
43⅞ x 15⅛ in.
SIGNATURE: Playfully painted by Bōsai
SEALS: Chōkō shi-in, Bōsai kanjin, Bokunō (ink farmer)
INSCRIPTION: Autumn chill in the lake country, summer 1809

Bōsai was a scholar from Edo (Tokyo) who favored
a new eclectic philosophy which attempted to draw the
best from different schools of Confucianism. He was an
extremely successful teacher until the Tokugawa govern-
ment banned "alien learnings"; this included everything
but the officially sponsored neo-Confucianism of Chu
Hsi, which stressed loyalty to the state as one of its
prime features. Bōsai's school was not forcibly closed,
but he gradually lost his pupils since they could not
hope for government service if they continued their
eclectic studies. As a result, Bōsai in his mid-fifties
found himself with free time and very little income.
Loving travel, he spent the better part of three years
in northern Japan, staying with former pupils or wealthy
patrons who gladly fed and housed him in return for
his company and perhaps gifts of his painting and
calligraphy.[1] It was at this time that many of Bōsai's
landscapes were brushed, including the present example.

Autumn Chill is one of Bōsai's most imposing works.
A strongly phallic mountain form rises up from the
cloudy mist towards a cluster of peaks; a solitary
pavilion on the plateau gives promise of a splendid
view for anyone able to climb so high. Most of the
painting is organized with verticals and horizontals,
but the lower land-mass and the raft are set in coun-
tering diagonals, allowing a sense of movement into
the landscape. It is truly a scholar's painting, with
brushwork based upon calligraphy. In particular, the
energy of the lines is apparent in the lower left, where
the land is indicated by clawing strokes that are con-
stantly changing direction and shape.

Bōsai organized his composition into a combina-
tion of dense and open areas with varying textures
of brushwork. The mountain top is full of small boulders
and inner wrinkle lines; lower down, the forms are
empty above the mist. The trees are concentrated in
the middleground, while below them the rocks and
boat are set in open space. As in most Bōsai paintings,
the range of motifs is very limited. Tree foliage, for
example, is restricted to three patterns. One is formed
of horizontal dots, and another of groups of two or

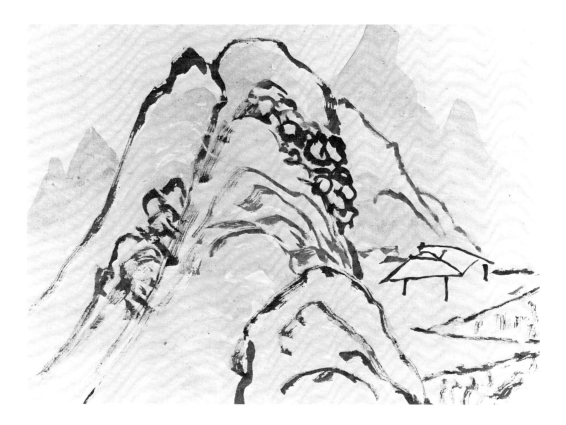

three downward strokes at diagonals. Most unusual is the foliage of the tallest tree, made up of patterns of two horizontal strokes with three, four or (in one case) five vertical lines. This shape is certainly more calligraphic than pictorial, and provides a linear counterpoint to the massed foliage of the other trees.

Although the painting was brushed in the summer of 1809 during Bōsai's travels in the Niigata area, it represents an autumn scene. The empty areas of the painting, the lone figure on a raft, and the stark depictions of the mountains all suggest that the lushness of summer is giving way to the chill of approaching winter. The sharp hooking brushwork also helps to convey a mood of loneliness which Bōsai may well have felt, far from his home in the busy capital city of Edo.

Among Nanga masters, Bōsai ranks as true literatus, who depicted his feelings about nature simply and directly. Better known in his own day as a poet and calligrapher, his landscapes show the union of the three arts through which he expressed his vision of the world. Others may have mastered the techniques of painting more fully, but Bōsai was able to transmit the essence of trees, lakes and mountains through the resources of his inner spirit.

SA

1. For more information on Bōsai's life and poetry, see Sugimura Eiji, *Kameda Bōsai* (Tokyo, 1982); for Bōsai's painting and calligraphy see Stephen Addiss, *The World of Kameda Bōsai* (New Orleans, 1984).

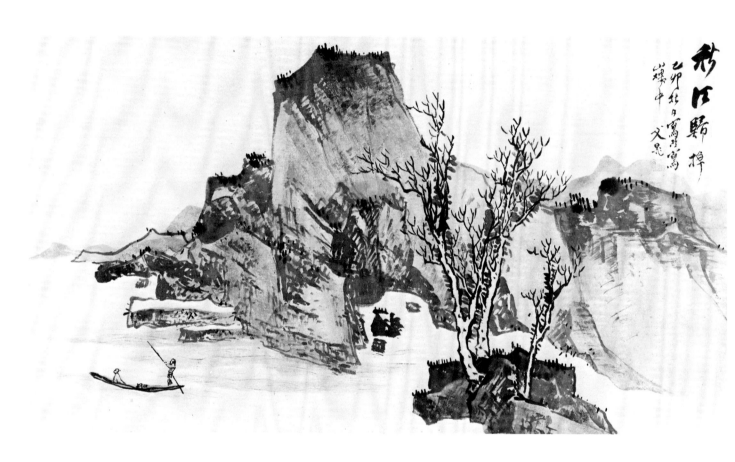

Tani Bunchō 1763-1840

Boat Returning Home in Autumn 1795

Hanging scroll, ink on paper, 53.5 x 96 cm., 21 1/16 x 37 3/4 in.
SEALS: Tani Bunchō, Bunchō Tani-shi
INSCRIPTION: Returning home across the river in autumn; painted on a fall day in 1795 by Bunchō watching from atop the mountains.
PUBLISHED: *Bunchō iboku tenrankai zuroku* (Kyoto, 1932), pl. 222.

In dramatic contrast to most other late Edo literati painters, Tani Bunchō was born into privileged circumstances and enjoyed them—along with fame and wealth—the rest of his life. His father was a noted poet and retainer to the Tayasu *daimyō* who had a circle of intellectual friends and an interest in encouraging his son to study painting from a young age. Bunchō also entered the service of the Tayasu, eventually replacing his father when he was only about thirty. More significantly, he befriended a son of Tokugawa Munetake who subsequently became the Chief Councillor to Tokugawa Ienari (1773-1841) under the name Matsudaira Sadanobu (1758-1829).

Sadanobu appointed Bunchō as his "official" artist, and among other duties, asked the painter to research and produce a catalogue of the important paintings and cultural artifacts—both Japanese and Chinese—then held in Japanese collections. Beginning in his twenties Bunchō traveled extensively, from the Kantō (Edo area) to the Kansai (Kyoto-Ōsaka) and beyond to Nagasaki. There he became familiar with the popular bird and flower paintings of Shen Nan-p'in (1682-ca. 1780) as well as western perspective techniques. Throughout these journeys Bunchō visited collections of Chinese and Japanese paintings, studying and recording them for eventual publication (1800) in an immense catalogue (eighty-five volumes). He also met such influential literati artists and patrons from the Kansai area as Kimura Kenkadō (1736-1802).

Bunchō seems to have been an affable, gifted young man who possessed a voracious appetite for divergent painting styles. His approach appears to have been genuinely pluralistic and unencumbered by such ideologies as divided the northern and southern "schools" of literati painting. At a time when the Edo literati painting circle possessed no appreciable history or leader, he provided the focus as an important teacher, professional, and historian.

Bunchō's oeuvre exhibits extraordinary thematic range and stylistic versatility. A prolific artist who worked in all formats, Bunchō spawned no "school" or copyists, due no doubt to the formidable task of imitating such an accomplished talent. This skill is clearly already present by the artist's early thirties, as can be seen in this large hanging scroll. Along with a relatively small number of other paintings rendered in precisely the same style bearing similar dates, it invokes Sung compositional models as reinterpreted by Ming Dynasty artists. While an exact prototype for this work is not presently verifiable, records show that Bunchō was familiar with paintings attributed to Li T'ang (ca. 1050-ca. 1130) and, more pointedly, with the Ming Che school artists and the painters T'ang Yin (1470-1523), Ch'iu Ying (ca. 1494-1552), and Lan Ying (1585-ca. 1664). The horizontal format filled with crystalline landscape structures rendered in a clear, limited range of ink values and stubby, expressive brushstrokes indicate a sixteenth-seventeenth century model, as does the unsettled, "floating" nature of the mountains. Interestingly, such traits exist also in early Yi Dynasty (1392-1945) Korean painting, providing another provocative avenue of inquiry into the sources of Bunchō's art. Clearly he was not confined in orthodoxy to "southern" school literary ideals as much of his later, more routine and decorative work indicates. This impressive scroll presents the artist in the early stages of a distinguished career, a formative period which can be considered among his finest. It illustrates a time when his evaluation and synthesis of Far Eastern painting history prompted him to produce sturdy, fresh interpretations of quite common themes in the continuum of that extensive artistic tradition.

MRC

REFERENCES:

Hosono Masanobu. *Kindai kaiga no reimei: Bunchō, Kazan to yōfuga.* (Tokyo, 1979).

Tochigi kenritsu bijutsukan. *Tani Bunchō: Edo Nanga no sōshi.* (Utsunomiya, 1979).

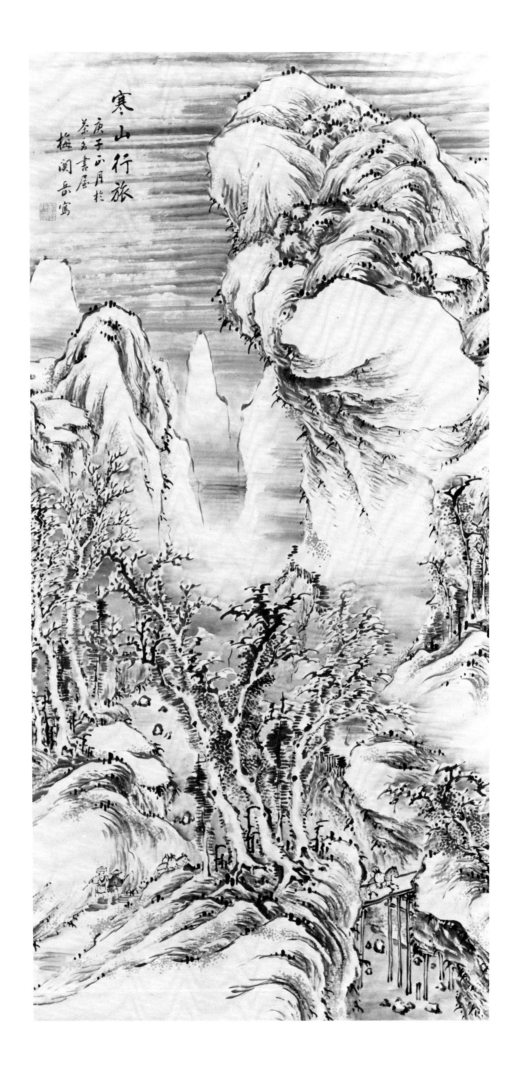

160

Sugai Baikan 1784-1844

Cold Mountain Travelers 1840

Hanging scroll, ink and light color on paper, 167.4 x 83.5 cm.,
65⅞ x 32⅞ in.
SIGNATURE: Painted by Baikan Gaku
SEALS: Kangaku no in, Baikan sō-i
INSCRIPTION: Painted in the first month of 1840 at the
 Chameisho Hall

One of the joys of Nanga comes from discovering a fine work by a little-known or under-appreciated artist such as this large scroll, a late work by Sugai Baikan. The imposing landscape shows the artist's powerful vision of bleak nature; bold and free brushwork matches Baikan's strength of conception. The composition is based upon earlier portrayals of the precipitous mountains of Szechwan province in China, famous even in Japan for their harsh and majestic beauty, through which travelers moved at their peril.

Born in Sendai in northern Japan, Baikan came to love painting in his youth. After being counseled to follow the Chinese literati tradition of the Yüan dynasty, he journeyed to Edo (Tokyo) to study with the eclectic master Tani Bunchō (No. 52). Not caring for Bunchō's circle of friends and students, Baikan continued on to Kyoto and Ōsaka, where he heard that a Chinese literatus had recently come to Nagasaki, the only open port in Japan. Baikan thereupon journeyed to this southwestern city, where he met Chiang Chia-pu (dates unknown), who had come to Nagasaki in 1804 and developed a reputation as a painter and poet. Baikan became Chiang's friend as well as his student, and when the Chinese master returned to his homeland it was the occasion for elegant and sad poems of farewell.

After ten years in Nagasaki, Baikan returned to Kyoto, where in 1830 he met the great literatus Rai San'yō (No. 58). San'yō inscribed several of Baikan's paintings with laudatory poems, and other members of the literati circle in Kyoto became interested in his art-works. Baikan, however, returned to Sendai, where he spent his final two decades as a painter connected with the powerful Date family.

Baikan's works show the influences both of the free ink-play style of Tani Bunchō, and the more conservative manner of Chiang Chia-pu which depended upon many small and unobtrusive brushstrokes to build forms. In his finest paintings, Baikan combined these two styles, creating dynamic but well-constructed landscapes. Winter scenes in which a few travelers venture through inhospitable terrain were not uncommon in the work of Nanga masters, but were seldom as strongly conceived as this work. As is often the case, snow is indicated by the bare paper, while freely applied strokes, dots and washes of ink suggest the twisting and towering mountains which seem to overwhelm the few travelers brave enough to journey through them.

Light touches of color help to enliven this stark landscape; clawing tree branches and twigs also suggest the vigor of life amidst the snow. The size and power of this monumental scroll mark it as one of the most dramatic of the many fine winterscapes in Japanese Nanga.

SA

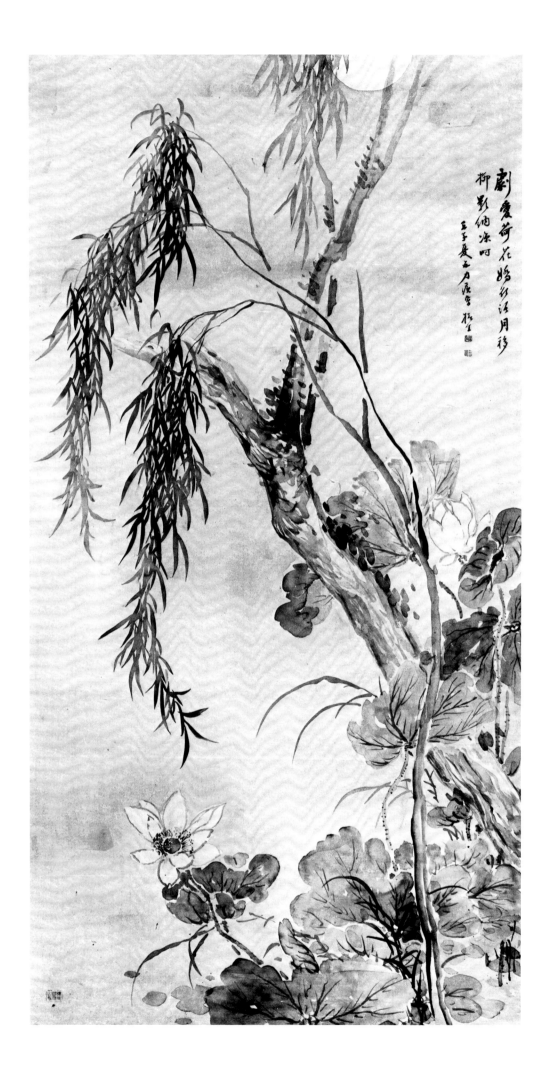

劇愛荷花嬌欲語月移
柳影納凉呀

壬子夏五月虚室摟生

162

Tsubaki Chinzan 1801-1854

Lotus Leaves and Willow Tree in Moonlight 1825

Hanging scroll, ink and color on silk, 156.9 x 84 cm.,
61 3/4 x 33 1/16 in.

Signature: Painted during the summer of 1825 when I was
rather weak, Chinsei

Seals: Hitsu, Chinzan, Tsubaki-shi hekiin sanbō

Inscription: I'm ecstatic of the time when lotus blossoms
ornament the river. As the moon moves through the
willow, casting shadows, I can enjoy the cool breeze.
(translated by Harold P. Stern)

Published: Harold P. Stern, *Birds, Beasts, Blossoms, and Bugs*
(New York, 1976), no. 74.

An air of tranquility and almost tactile absorption
in examining the elements of nature characterizes not
only this sizeable painting, but much of Chinzan's oeuvre.
Here the artist seeks to convey the structural harmony
between willow and lotus fronds bathed in the luminosity
of the moon and its reflection in the water. Executed
exclusively in the "boneless" (*mo-ku*) brush technique
using subtly orchestrated color harmonies, Chinzan
effectively disguises the intensity with which he exam-
ined the "real" world of mid-nineteenth century Edo.

Edo was not an entirely pleasant, even attractive
environment despite the numerous, varied artistic
endeavors of the time portraying it as such. Chinzan
himself suffered a difficult upbringing following his
father's early death and his mother's efforts to provide
for the family on her own. In addition, he suffered
from a tubercular condition which afflicted him through-
out his life. As a result, Chinzan relinquished his training
and certification in clan martial arts in favor of pursuing
a career in painting. Initially he studied with the minor
bird and flower artist, Kaneko Kinryō (died 1817), and
Tani Bunchō (No. 52), followed most significantly by a
life-long association with Watanabe Kazan (1793-1841).

A high-minded literatus who viewed the samurai
world as outmoded and hypocritical, Kazan espoused
direct observation of nature, as well as the life of
the working class. Forged in concert with a moral
awareness of the literati legacy, Kazan produced a group
of true landscape views, portraits, and scenes of daily
life which are remarkable in Japanese cultural history.
Chinzan became Kazan's best student, initially emulating
his teacher's style but rather quickly asserting his own
inclinations. Essentially these maintained Kazan's
thematic approach, but Chinzan placed considerably
greater emphasis upon the subject of bird and flower
painting.

Stylistically, during his mature years (late 40s to
early 50s), Chinzan combined an almost exclusive use
of the "boneless" painting method with refined color
sensibilities to forge a special niche in mid-nineteenth

century Edo. Although the overwhelming influence of
the Ch'ing bird and flower painter Yün Shou-p'ing
(1663-1690) is usually ascribed to explain these traits
in Chinzan's oeuvre, this should be viewed with reserva-
tion. Not only was the accessibility of that artist's
work uncertain, but the existence of many numbers of
mo-ku paintings in Kazan's oeuvre and the discussion
of this technique in their recorded correspondence
provides a more immediate, substantive explanation
for Chinzan's involvement and mastery of the "bone-
less" method.

This hanging scroll represents a major example of
the artist's work in his last years. His continuing in-
firmity noted in the inscription is obscured by the
exquisite application of pale washes to the silk before
the tree and lotus were painted in, the artist being careful
to adjust tones and reserve selected areas. The richness
of the washes and *tarashikomi* patterns, together with
their felicitous placement, further enhance the work.
It is difficult to recollect a contemporary artist capable
of invoking a more lush, poetic reverie of nocturnal
peace. Chinzan has been criticized for lacking the more
dynamic qualities of Kazan, but judging from his oeuvre
his intentions were clearly directed elsewhere.

MRC

References:

Yoshizawa Chū. *Nihon no Nanga* (Tokyo, 1976).
James Cahill. *Scholar Painters of Japan* (New York, 1972).

NANGA—INDIVIDUALISTS IN ŌSAKA AND KYOTO

As Nanga became popularized, many artists no longer felt the need to adhere closely to Chinese models and felt more free to develop personal styles expressive of their individual characters. Nanga artists were usually self-taught, and thus were not bound by the restrictions of a teacher. Indeed, the early pioneers had reacted against the lack of creativity within the academic Kanō school, whose leaders, intent on preserving the heritage of the early masters, set down detailed guidelines regarding the style and methods of brushwork. The new wave of personal freedom in Nanga is especially apparent in the works of three masters of the late eighteenth and early nineteenth centuries, Totoki Baigai (No. 55), Okada Beisanjin (No. 56) and Uragami Gyokudō (No. 57).

All three of these men were active in the area of Kyoto and Ōsaka, commonly referred to as the Kansai region. They and other Kansai literati were in constant contact with one another, the Ōsaka home of Kimura Kenkadō (1736-1802) often serving as a central gathering place. Born into a family of *sake* brewers, Kenkadō was both a friend and pupil of Ike Taiga (Nos. 33-39). In addition to dabbling with painting himself, he had a large collection of both Chinese and Japanese paintings which he openly shared with his literati-minded friends. Kenkadō was friendly with every Chinese-style poet, calligrapher and painter of the day, and was himself a pivotal figure in the dissemination of Nanga. He kept extensive diaries describing his activities and those who came to visit him, and the names of Baigai, Beisanjin, and Gyokudō frequently appear among his many guests. There are also several collaborative works extant which indicate that all four associated with one another; their friendship was certainly founded upon a deep mutual love for Chinese painting and poetry. Later, Nanga artists proliferated, but the number of enthusiasts at the end of the eighteenth century was still small enough so that they sought out one another and formed intimate circles.

Unlike many Nanga painters, the lives of Gyokudō and Baigai perfectly fit the description of the ideal literatus. Both gave up official careers and adopted a bohemian lifestyle, devoting themselves to the arts and traveling as they pleased. The freedom in their lives may have contributed to the intensely individual character of their brushwork. They produced art purely for their own pleasure and for the enjoyment of a few like-minded friends, and were unconcerned with questions of technical refinement. Frequently choosing small, more intimate formats exemplified in *Album of Twelve Months* (No. 55) and *Spring Clouds Like Thick Paste* (No. 57), Baigai and Gyokudō transformed their uninhibited love of nature into rhythmic modulations of brush and ink.

Beisanjin likewise pursued Chinese studies, but he did not have the official training of Baigai or Gyokudō. He made his living primarily as a rice merchant until retiring to the life of a literatus. His interest in Chinese painting and literature led him to associate with other Kansai literati. The strong personalities of the three artists, coupled with the fact that they had no direct teachers in the Nanga tradition, led them to develop unique styles characterized by powerful distortions and vigorous brushwork.

PF

Totoki Baigai 1733 or 1749-1804

Album of Twelve Months 1803

Album, ink and colors on paper, each 14.8 x 11.6 cm.,
 5³/₁₆ x 4⁹/₁₆ in.
SIGNATURE: Painted by Baigai
SEAL: Baigai
INSCRIPTION: 1803, early summer
Title page by Kurata Isao (dates unknown)
PUBLISHED: Jack R. Hillier, *Japanese Drawings of the 18th and
 19th Centuries* (1980), no. 31.
 Martie W. Young, *Asian Art: A Collector's Selection*
 (Ithaca, 1977), no. 2.
 Theodore Bowie, *Japanese Drawing* (Bloomington,
 Indiana, 1975), no. 85.

One of the most interesting but little studied literati artists is Totoki Baigai, who was capable of great novelty in his work as well as following the Nanga models of his day. There is some confusion regarding his correct birthdate since Japanese sources list either 1733 or 1749. Baigai received an education that conformed to the traditional Chinese literati concept, studying Confucianism with Itō Tōshō (1728-1804) and later calligraphy with Chō Tōsai (1713-1786). This thorough training provided the background from which the scholarly flavor of Baigai's works later emerged.

Like many sinophiles, Baigai earned his living as a Confucian teacher. In 1784 he was invited to Nagashima in Ise Province by Masuyama Sessai (1754-1819) to teach at the local school for samurai children. He was given leave to visit Nagasaki in 1790 where he met and received training from the visiting Chinese artist Fei Ch'ing-hu.[1] Baigai's activities during the next few years are unclear, but he resigned his post at Nagashima in 1800, and with no official position he was free to travel and do as he wished. He became friends with many literati in the Kyoto-Ōsaka region, including Uragami Gyokudō (No. 57), Okada Beisanjin (No. 56) and his son Hankō. Baigai's name appears frequently in the diary of the wealthy *saké* merchant and art collector Kimura Kenkadō (1736-1802), an amateur painter with extensive contacts in the artistic world.[2] There are 21 letters remaining today written by Baigai to Uchida Ransho (1747-1832), an influential Nagoya merchant, indicating that he was active in that area of Japan as well.[3] Baigai's contacts with all of the above artists can be substantiated by extant cooperative paintings. However, despite the friendships, little mutual influence can be found in their artworks. This reinforces the notion that these painters were individualists, following their own impulses and ideas and working out their personal styles. Baigai was certainly subject to the flow of ideas and sub-styles going on within the Nanga world during his lifetime. He seems to have had a special admiration for Ike Taiga (Nos. 33-39)

and did at least two copies of the *Jūben jūgi* album in 1800[4] as well as another undated painting modeled after Taiga.[5] In addition, Baigai used a seal which was a direct imitation of one of Taiga's reading "Kōbin."

The range of Baigai's extant dated paintings extends over a short period of fourteen years, with the earliest inscribed with the year 1792. He never really settled into a consistent style, and one does not find the clear-cut chronological development that can be seen in works of an artist who painted for 30 or 40 years. He painted primarily landscapes, focusing some attention on "four gentlemen" subjects. Although he worked with both the hanging scroll and screen format, his smaller paintings are more consistent in terms of quality. In his later years Baigai turned more and more to the album leaves; this work is dated one year before his death.

The *Album of Twelve Months* is unusual in that it contains six bird and flower designs as well as six landscapes, alternating with leaves of *waka* poems written out in a combination of Chinese characters and flowing *kana* script (see leaf 3). The compositions and brushwork of all twelve painted leaves are loosely and broadly rendered with forms reduced to their most schematic essentials. Baigai seems to have been more interested in the qualities of spontaneity and directness than in technical perfection. Some leaves such as the scholar seated in a hut amidst bamboo (leaf 6) recall Taiga's compositions in the *Jūben jūgi,* but others are bold and innovative, particularly in the use of soft, wet brushwork. The paper Baigai used seems to be hard-surfaced so that the ink was not readily absorbed. The resulting textures often resemble the effects of wax-resist dyeing, exemplified in the mountains of leaf 2. Although the landscape here is handled with the economy of means and poetic feeling that we associate with Chinese literati painting, Baigai has infused the Chinese motifs with a special power of design that is uniquely Japanese. In addition to simplifying the composition, he has flattened and abstracted the pictorial space so there is little sense of actual depth. This is also apparent in leaf 12 in which a dark black tree trunk is boldly brushed across the page as though it were a stroke of lightning. Although our mind tells us that the scholar reading in his hut is situated beyond the tree and brushwood fence, the forms all appear to float lightly on the surface.

The bird and flower designs are also characterized by simplified compositions and free, spontaneous brushwork. One leaf, however, is truly remarkable in terms of the formal effects achieved solely with ink and color wash (leaf 7). The subject is a flock of birds flying in front of a waterfall, or over a stream, depending on the point of view taken by the artist. Baigai has imaginatively rendered the scene with wet brushstrokes that fuzz and blur, adding an abstract quality which increases the pictorial drama. Like many Japanese Nanga artists, Baigai was concerned with the non-representational aspects of the design. Such opposing devices of naturalism

and abstraction give his works an added intensity. The confident, unassuming character of Baigai's brushwork imbues this album with a quality of freshness that does not fade upon repeated viewings.

PF

1. Fei Ch'ing-hu first came to Japan in the middle of the An'ei era (1772-1781) and there is evidence that he visited Japan almost every year between 1788 and 1796. See Tsuruta Takeyoshi, "Fei Han-yuan and Fei Ch'ing-hu," *Kokka,* vol. 1036, pp. 15-24.

2. Kenkadō had also been befriended by Masuyama Sessai, and it was perhaps through the *daimyō* that he and Baigai were introduced.

3. These are now in the collection of the Tsurumai Library in Nagoya. See Tsuruta Takeyoshi's article in *Kokka,* vols. 1039 and 1040 (1981) for more information and the texts of these letters.

4. Collections of Mary Griggs Burke and Mr. Yabumoto Shōgorō.

5. Collection of the Los Angeles County Museum of Art.

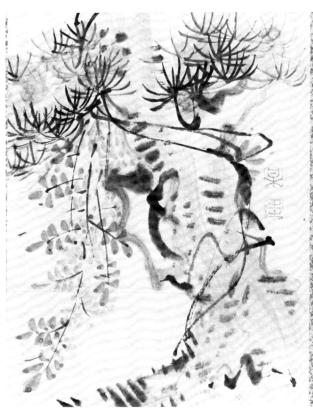

leaf 3

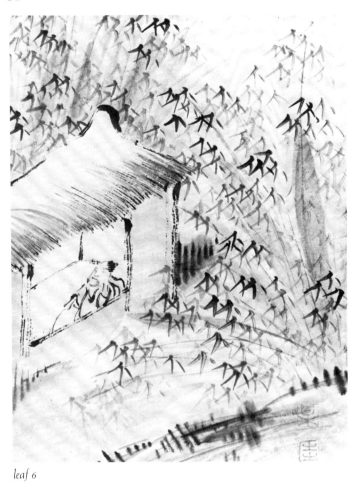

leaf 6

leaf 2

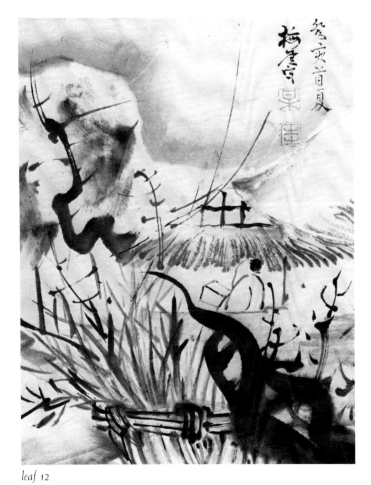

leaf 12

leaf 7

Signature of Okada Beisanjin 1744-1820

Mist and Waterfalls Amidst the Mountains 1812

Hanging scroll, ink and light color on paper, 131.5 x 39.5 cm.,
 51¾ x 15⁹/₁₆ in.
SIGNATURE: Painted by Beisanjin
SEALS: Beisanjin, Denkoku no in
INSCRIPTION: A summer day of 1812

Beisanjin, a friend of Baigai (No. 55) and Gyokudō (No. 57), has been considered an eccentric painter by many Japanese, although his landscapes are often structurally conservative. His brushwork, however, is always bold and distinct, directly expressing his personal character. This scroll dated to the year 1812 displays an imaginative re-creation of the literati landscape tradition. The composition is full of lively patterns of brushwork, each derived from Chinese masters of the past, but combined with a mixture of naiveté and sophistication that is unique to the style of Beisanjin.[1]

The painting is composed of tall vertical shapes almost completely filling the format, with swirling mists outlined in T'ang dynasty style and two different series of waterfalls winding downwards to give a sense of movement. The mountain forms, with clusters of peaks and long parallel interior strokes, are derived from the style of Chu-jan (active 960-980), but the visual insistence on the repeated shapes and lines is a characteristic of Beisanjin's style. Contrasting brushwork includes the incomplete rectangles near the top right, the series of tooth-like plateau shapes in the center, the various patterns of tree foliage, the angular lines of the huts and temple buildings, and the peculiar lower waterfall shapes, like ghostly faces half hidden behind the hills. A dramatic rock in the lower center, in the form of a giant shell lying on its side, suggests a generating force that keeps this powerful landscape in motion. There is very little empty space, so the eye is dazzled by the recurrent eddies of rhythmic repetitions, with color added strategically to warm and clarify the forms.

Beisanjin came to literati painting late in his life. He seems to have had a fondness for Confucian and literary studies from his youth, but worked as a rice merchant for many years (hence perhaps the name Beisanjin, "Rice mountain man") before retiring to literati pursuits. Most of his extant paintings date from his late sixties and early seventies, by which time his son Okada Hankō (1782-1846) was already a more technically accomplished artist. Beisanjin however, achieved a patterned style of brushwork that makes his style instantly recognizable. In his most dynamic compositions, he was able to transform his literati sources into powerful expressions of nature's inner vitality.

SA

1. It is not completely certain, however, whether this scroll is from the hand of the artist or that of a follower. An extremely similar but undated Beisanjin landscape, published in *Kokka* no. 878, is now in the collection of the Seattle Art Museum. It was uncommon but not unknown that a Nanga master painted two almost identical versions of the same composition. The brushwork in the 1812 landscape shown here is of high quality, but it has more layering of brushstrokes than is usual for the artist, and the techniques of dotting and tree foliage strokes are slightly different than in many accepted works. Furthermore, the seals here are variant versions of seals more commonly seen on published paintings.

56

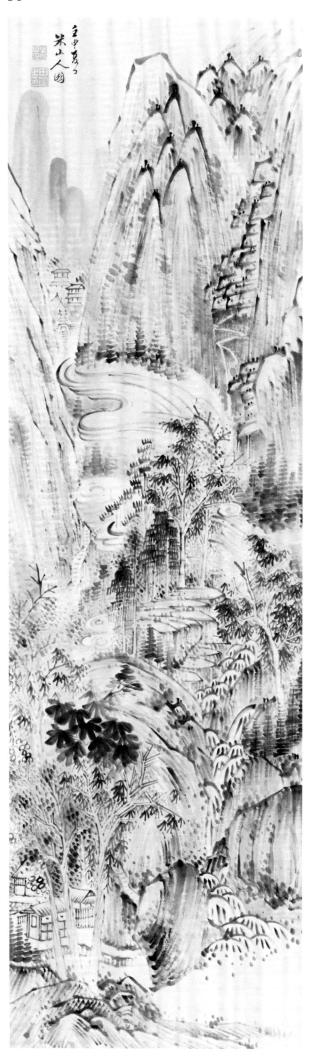

Uragami Gyokudō 1745-1820
Spring Clouds Like Thick Paste

Hanging scroll, ink and light color on silk, diameter 27.6 cm.,
 10⅞ in.
SIGNATURE: Gyokudō
SEAL: Suikyō (Drunken rustic) [impressed upside-down]
PUBLISHED: *Uragami Gyokudō gafu* (Tokyo, 1979).
 Kobijutsu, no. 34 (1971).

Although appreciated in his own day primarily as a musician and poet, Gyokudō is today considered to have been one of Japan's greatest painters. His dynamic and individualistic brushwork was considered strange and rough by his contemporaries, only being appreciated by a few artist friends. Now he seems to have been a precursor of action painting; his dynamic strokes of the brush are full of inner vitality that communicates his personality clearly to the present day.

Gyokudō was an hereditary samurai in the service of a local feudal lord in Bizen (present-day Okayama Prefecture). He became a virtuoso on the Chinese *ch'in* (a seven-string zither beloved of poets and sages) in his youth, and composed and published music as well as poetry in his middle years. At the age of fifty by Japanese count[1] Gyokudō quit his official position and spent seventeen years wandering through Japan developing his music, poetry and brushwork. It was during these years that he truly mastered the art of landscape, inventing a personal technique that enabled him to paint with bursts of energy when the spirit moved him.[2]

In his mid-sixties Gyokudō finally settled down in Kyoto with his painter-son Shunkin (1779-1846); the works of Gyokudō's final decade have a remarkable combination of vigor and clarity, dynamism and serenity. At times he painted within geometric shapes such as this circle; he might have been recalling the traditional Chinese round fan shape, or he may simply have enjoyed working within basic formal limitations. The effect is one of compressed energy. Mountains and trees seem ready to burst beyond the confines of the format, and man's relationship to nature is powerfully conveyed.

Although this work is unusual among Gyokudō's late paintings in that it was brushed on silk rather than paper, it has several typical features of the artist. Included among these are the round and oval plateaus here rhythmically echoing the shape of the format, the sage pausing on the bridge to admire the scenery, and the figures and huts almost cut off from view by dynamically rendered trees. Gyokudō's technique of overlaying grey brushwork with darker accents can be seen in this landscape. The asymmetrical rhythms that animate his musical compositions appear also in the tree foliage and the grouping together of mountain forms. By giving up his official career in order to devote himself to the arts, by allowing his poetic, musical and painterly visions to interrelate, and by delving deep within himself, Gyokudō was able to create master-works of concentrated personal expression.

SA

1. We would have considered him forty-nine.

2. For more information on Gyokudō's life, poetry, music and painting see Stephen Addiss, *Uragami Gyokudō: The Complete Literati Artist* (University of Michigan Ph.D. Dissertation, 1977).

NANGA—CONSERVATIVES IN KYOTO AND NAGOYA

In the early part of the nineteenth century, a major change occurred within the Nanga world which significantly altered the course of its development. Whereas previously many Nanga artists had been undaunted professionals, many of the painters in Kyoto and Nagoya tried more closely to emulate the life of a Chinese literatus. By this time, a greater number and wider range of Chinese paintings were available to artists who began to direct themselves toward capturing the proprieties of the orthodox literati tradition. Brushwork methods were systematized and models were rigidly defined. The artists of this generation were clearly more interested in the problems of technique and form of expression, rather than striking originality in theme or composition. Consequently, the brilliant innovations of such Japanese masters as Ike Taiga (Nos. 33-39) and Yosa Buson (Nos. 44-46) were considered as personal deviations not to be emulated. One result of the new limited range of accepted models was that the paintings by this generation of Nanga artists exhibit similar compositional designs and analagous methods of brushwork. Nevertheless, the different personalities of the artists are apparent in their works.

One of the leaders in this new movement of sinification in Kyoto was Rai San'yō (No. 58), a noted historian, calligrapher and Chinese-style poet. He was a true scholar-amateur, and his paintings are characterized by an overall blandness and restrained brushwork. These qualities had been cultivated by earlier Chinese literati artists who rejected the more colorful and overtly decorative styles practiced by professional artists.

Although born in Nagoya, Nakabayashi Chikutō (No. 59) moved to Kyoto at the age of 28 and joined Rai San'yō's group of scholars, artists and poets. He was so convinced of the superiority of Chinese literati values that he published three books on painting theory. Most of Chikutō's own paintings are personal renditions in the style of famous Chinese Sung and Yüan masters. It is unlikely that he ever saw genuine works by these artists, but rather seventeenth or eighteenth century copies. Chikutō taught his principles and techniques to his son Chikkei (No. 65) who tempered the conservative literati style with a personal boldness.

A close friend of Chikutō was Yamamoto Baiitsu (No. 60) who also lived part of his life in Nagoya. Like Chikutō, Baiitsu painted landscapes following accepted Chinese styles, but he is perhaps more well-known for his exquisite bird-and-flower paintings. Although a literati artist, Baiitsu incorporated elements from both academic and literati painting traditions, which by this time in China had become blended. *Green Willows and White Herons* is an outstanding example of his work, exhibiting multifarious layers of soft, modulated brushwork and a masterful blending of color and ink.

After the death of Rai San'yō, Nukina Kaioku (Nos. 61, 62) became the leading figure among artists active in the old capital of Kyoto. He was one of the boldest calligraphers of the day, but in painting practiced the newly popular conservative style. His pair of screens *Fu'chun Mountain and Te-sheng Embankment* fully exemplify this trend, for they followed a prominent Chinese Ming artist. The brushwork and coloration is restrained, but the transformation of the landscape motifs from small to large scale shows the native love for dramatic design.

One of Kaioku's notable pupils was Hine Taizan (Nos. 63, 64), who later boldly claimed that he had been Kaioku's teacher. Despite his unruly behavior, Taizan's paintings follow conservative formulas and are characterized by a systematic building of forms and restrained brushwork.

The influence of this group of artists was so extensive that the conservative trend continued well into the Meiji period (1868-1911). Nevertheless, there were a few painters who did not conform, either because of eccentric personalities or provincial upbringing. Fujimoto Tesseki (No. 66) was born into a samurai family, but became an avid loyalist fighting to restore the Emperor to power. A noted swordsman, Tesseki was killed in battle, but his surviving paintings show a bold strength that bespeaks his samurai heritage. His brushwork is more vigorous and unfettered than most other painters of the era, and consequently his mountain landscapes are filled with a restless energy.

Although Murase Taiitsu (No. 67) was deeply dedicated to his teacher Rai San'yō (No. 58), he was one of the most individualistic artists of the entire Nanga movement. Taiitsu lost his position as Confucian teacher at the beginning of the Meiji period when the ancient Chinese philosophy was abandoned in favor of Western principles. This gave him a great deal of leisure time which he devoted to the arts, and his brushwork flourished in his final decade. Using bold swift strokes of the brush, Taiitsu carved out a personal style bursting with joyous energy, but at the same time subtle and introspective.

Whether conservative or more individualistic in style, Nanga masters of Kyoto and Nagoya in the nineteenth century combined an understanding of Chinese literati traditions with personal expression. Although their brushwork is usually restrained, their paintings display a mature and refined appreciation of the beauties of nature.

PF

58

Rai San'yō 1780-1832

Mountain Landscape

Hanging scroll, ink on paper, 138.8 x 45 cm., 57⅝ x 17¾ in.
SIGNATURE: Jō
SEALS: Ujō, Shisei, Manheki sansui sōdō
PUBLISHED: *Zusetsu sencha* (Tokyo, 1982), p. 81.
Box lid inscription dated 1849 by Rai Kiyoshi (San'yō's grandson)

In order to fully appreciate Rai San'yō's rather austere *Mountain Landscape*, a special type of connoisseurship is required. A noted historian and poet, San'yō initially took up painting as an avocation. Since he himself was a scholar-amateur, it is appropriate that he adopted a style of painting associated with Chinese literati. Literati painting is often characterized by an overall blandness and deliberately restrained brushwork, which were developed partly in rejection of the more overtly decorative styles practiced by professionals. Plainness or blandness was regarded as a virtue, and the true literatus aimed to produce within this something subtly exciting and personal. The outward forms became mere vehicles for the scholars' brushwork, which, like calligraphy, was considered to be a true reflection of one's personality. Landscapes were popular since they symbolized the literati's desire for communion with nature. Unlike more commercial arts, literati painting was intended to be appreciated by like-minded friends. Therefore, to savor the full flavor of Rai San'yō's work, it is important to understand something about its creator.

San'yō was born in Ōsaka as the son of the famous Confucian scholar Rai Shunsui (1746-1816). When San'yō was only three, Shunsui accepted a position in the service of a *daimyō* in Hiroshima and the family moved there. San'yō showed early promise in his Chinese studies, but he was extremely nervous and temperamental. Thinking it would force him to settle down, his parents arranged for San'yō to marry a fifteen year old girl in 1799. However, this did not stop his dissipation and they were divorced after two years. In 1800 he left his home without securing permission from the local government (illegal in Edo period Japan) and went to Kyoto. Two months later he was arrested and returned to Hiroshima where he was disinherited and confined to his parents' home. San'yō spent the years of his confinement studying and writing, beginning the *Nihon gaishi*, a lengthy history of Japan focusing on the various military families that had been in power from the Heian to the Tokugawa period.[1]

In 1809, San'yō was put in the custody of the family friend and scholar Kan Chazan (1748-1827) who lived in a neighboring district, and two years later he was given permission to go to Kyoto where he opened

a private school. He became renowned as both a scholar and teacher; the *Heian jimbutsu shi* (Who's Who of Kyoto) of 1813 recorded names of over 70 of his pupils. San'yō's prose and poems in Chinese were widely admired, and he developed extensive contacts with sinophiles all over Japan.

Examples of San'yō's calligraphy abound, but his paintings are rather rare. He seems to have first studied painting with the Shijō artist Kawamura Bumpō (1749-1821), but later adopted the Nanga style, perhaps because it more suitably expressed his scholarly tastes. San'yō's landscapes are modeled after two tenth century Chinese painters, Tung Yuan and Chu-jan. By this time their styles had been blended and reduced to a formula, with mountains built up out of systematic repetitions of rocks described by long wavering lines overlaid with horizontal dots. By restricting the variety of ingredients, San'yō has achieved a simplicity and purity of design. He also preferred a relatively dry brushwork which lent clarity to the individual strokes. In order to achieve the prized quality of unadorned chasteness, light silvery tones of grey ink were made paramount, resulting in stability and harmony.

Mountain Landscape is undated, but judging from other dated works it may have been painted around 1825.[2] In contrast to San'yō's earlier works in which the brushstrokes were systematically applied, the Gitter work exhibits a freer handling of ink, especially in the tree trunks of the lower right.

Although the emphasis on formal qualities may have resulted in a loss of spontaneity, the well-balanced composition and astringent brushwork evoke a feeling of tranquility which is conducive to contemplation. It is no surprise that San'yō's paintings are highly prized by *sencha* (Chinese steeped tea) enthusiasts who consider them ideal for hanging in the *tokonoma* during tea ceremonies. San'yō paints a quiet kind of beauty in *Mountain Landscape* which he also communicates in his poem written out above:

> *My feet traverse the wooden corridors*
> *But my heart rests amidst the pines and rocks.*
> *At my western window the autumn rains clear—*
> *Pouring forth black ink I brush the cloudy mountains.*

PF

1. This book was not published until ten years after San'yō's death, but was then praised for its elegant Chinese prose style and expressions of support for the imperial house.

2. For other examples of San'yō's painting, see vol. 18 of *Bunjinga suihen* (Tokyo, 1976).

Nakabayashi Chikutō 1776-1853

Summer Mountains in Clearing Rain 1841

Hanging scroll, ink on paper, 65.4 x 88 cm., 25¾ x 34⅝ in.
SIGNATURE: Chikutō sanjin
SEALS: Seishō no in, Azana Hakumei
INSCRIPTION: Summer mountains in clearing rain, a spring
 day of 1841, after the brush method of Mi Fu

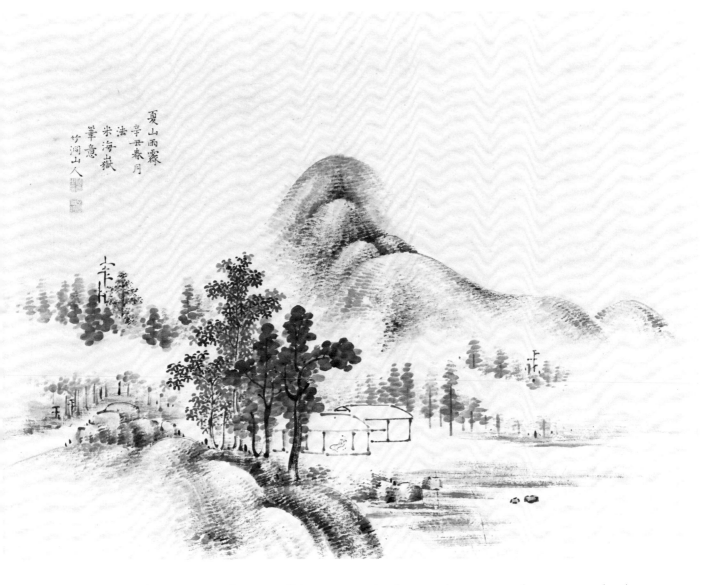

As a young man in his native city of Nagoya, Chikutō was befriended by a collector of Chinese painting named Kamiya Ten'yū. Much of Chikutō's art education took place in Ten'yū's home, where Chikutō copied many of the paintings in his patron's collection. The young artist became so convinced of conservative Chinese literati values that he published two books on painting theory in 1801 and 1802 and compiled a third book which was published in 1815. In these works, and in other treatises which he wrote later, Chikutō expressed his view that the Nanga style was the finest when it arose from a true understanding of Chinese literati works.

At the very beginning students must study the antique method, which means to study Chinese paintings... with the rise of Ōkyo's style, people don't care about the movement of the brush, but fine brush-work is the primary characteristic of Far Eastern painting.[1]

When Kamiya Ten'yū died in 1802, Chikutō moved to Kyoto, still the artistic capital of Japan. He became part of the literati circle of Rai San'yō (No. 58), and supported himself for the rest of his life by painting and teaching. Disdaining public acclaim and usually eschewing the more popular subjects of genre scenes,

animals and flowers, he produced a large body of work in a conservative Chinese-derived tradition. Chikutō was ultimately the only Japanese painter thoroughly to explore the three most notable Chinese literati styles, evolving his own transformations of the compositions and brushwork of Mi Fu, Ni Tsan and Huang Kung-wang.[2]

The style of brushwork attributed to Mi Fu (1051-1107) but more likely developed by his son Mi Yu-jen (1074-1153) features the gradual build-up of forms by laying the side of the brush down on paper or silk, producing horizontal tear-drop or oval shapes that became known as "Mi dots". By utilizing a range of ink-tones from light grey to deep black as well as variations in wet or dry brushwork, he achieved the effect of moist and lush summer scenery. Most Nanga artists painted occasional works in the Mi style, but few perfected a personal expression in this manner as did Chikutō. In his best works in this tradition, he produced an atmosphere of glowing misty light and tonal resonance that is unique.

The Mi style is easy to copy but difficult to master, since it depends upon strength of composition and subtlety of brushwork. In this work of his maturity, Chikutō has arranged his composition to begin in the lower left-hand corner with a land-mass and a small clump of trees. In the middleground are huts; a single scholar or sage rests and views the scenery. Middleground trees are bisected by mist, while distant mountains rise to a rounded peak in the center of the format. Mountains are described by thin "Mi dots", while tree foliage includes rounder "Mi dots" and other patterns of brushwork, nicely accented by a few strokes of dark blue to suggest bare trees. Although Chikutō often built up his compositions with verticals and horizontals, here diagonals predominate, giving this landscape more sense of movement than most works of the artist. Nevertheless the mood is serene, and although a little of the glow of the ink has been lost through time, the painting has a quiet resonance that suggests the hush of summer just after a rain has passed. As Chikutō wrote, when one has thoroughly studied Chinese brushwork, "a painting will never be just a copy, but also achieve personal expression."[3]

SA

1. From *Chikutō garon* (1802), translation based upon that of Andrea Gendler.

2. See Andrea Gendler, "The Hidden Orchid: the *Bunjin* Theoretician and Painter Nakabayashi Chikutō" (University of Michigan Master's Essay, 1973).

3. Translation based on Ibid., p. 39.

Yamamoto Baiitsu 1783-1856

Green Willows and White Herons

Hanging scroll, ink and color on silk, 131.1 x 55.6 cm.,
 51 5/8 x 21 15/16 in.
SIGNATURE: Painted by Baiitsu
SEALS: Ryō in, Baiitsu
Box lid inscription by Baiitsu

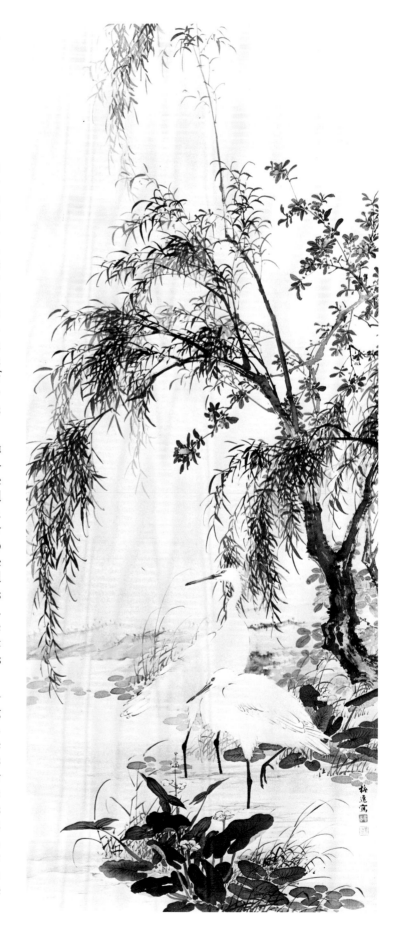

Yamamoto Baiitsu, one of the most talented of Nanga artists, spent much of his long professional career painting decorative bird-and-flower subjects. Although this was not strictly literati in spirit, Baiitsu also was expert at subjects considered more lofty, such as landscape and bamboo.[1] The son of a sculptor in Nagoya, Baiitsu was talented at painting in his childhood. Like Chikutō (No. 59), he was befriended by the collector Kamiya Ten'yū who advised him to study by copying Chinese paintings rather than by serving as an apprentice to a Japanese artist. This would free him from over-professionalization and narrowness of viewpoint. Baiitsu thus based his style on Chinese models of various kinds as well as receiving some influence from the works of his friends such as Chikutō. After living in Kyoto for much of his career, Baiitsu returned to Nagoya for his final years, and painted for the Tokugawa family.

In his speciality of bird-and-flower painting, Baiitsu developed a technique that was a compound of academic and more literati traditions. He disdained the Kanō school style of strong outlines, but amalgamated two techniques, both called mo-ku (Japanese: mokkotsu). Considerable confusion has arisen over this term, usually translated as "boneless" (without outline) but also meaning "sunken outline" or "hidden outline". The Chinese academic artist Shen Nan-p'in had visited Nagasaki in 1732, and his style of delicate outlines covered with rich colors became very popular in Japan. Some of Baiitsu's works utilize the techniques of the Nagasaki School, but more often he painted without outline in a style also derived from China that was imbued with literati overtones.

In Green Willows and White Herons, Baiitsu's brushwork is primarily in the "boneless" style, evincing the brush control that was a hallmark of the artist. The composition, however, in which a bending tree forms a space cell for the major bird motifs, is characteristic of the Nagasaki School. Baiitsu was justly celebrated for his depictions of herons; here they are portrayed with a minimum of outlines and a judicious use of white pigment. The head of the nearer bird is nicely set off against the white belly of its companion; the twisting neck of the farther bird is framed by willow leaves. Higher in the composition, the red of a pomegranate tree adds a contrasting tone to the subtle range of greens in the painting.

Baiitsu's artistic skill has been to combine and balance opposing tendencies in his scroll. The well-defined composition is saved from seeming static by the fact that various motifs stretch beyond the picture plane on the right, left, top and bottom. The exacting brushwork is enlivened by the soft yet descriptive boneless technique. The decorative nature of the scroll is balanced by a sense of naturalism in which the subtle range of color shadings and the use of empty space help the work to "breathe". Thus, Baiitsu's painting is satisfying on several levels, both for its attractive surface qualities and for its expressive brushwork. It is very likely a late work of the artist, as the style is mature and the seals often appear on works dated from the late 1830's until his death. Baiitsu also signed the box lid for the painting, an unusual occurrence that judging from the few dated examples seems to have taken place only during his final years.

<div align="right">SA</div>

1. For further information on Baiitsu's literati works, see Patricia J. Graham, *Yamamoto Baiitsu: His Life, Literati Pursuits, and Related Paintings* (University of Kansas, Ph.D. Dissertation, 1983).

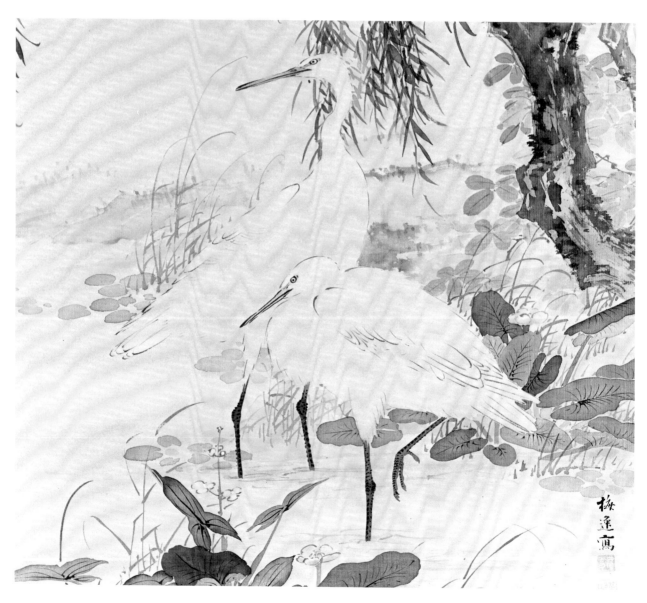

61

Nukina Kaioku 1778-1863

Fu-ch'un Mountain and Te-sheng Embankment

Pair of six-panel screens, ink and light color on satin,
 each 166.7 x 368.9 cm., 65⅝ x 145¼ in.
SIGNATURES: Sū-ō
SEALS: Ichirei shun'ū (one plow in spring rain), Kyokkei
 saimon (humble cottage by a brushwood gate), Ga-ai
 kisei (I love this serenity) Tekisu rō ho, Teki sū-ō
INSCRIPTIONS: see text below

Nukina Kaioku became one of the most celebrated
literati artists in Kyoto during the late Edo period.
After the death of Rai San'yō (No. 58) in 1832, Kaioku
was a central figure among calligraphers and painters
in the old capital. As well as inscribing poems on a
number of paintings by his friends such as Chikutō
(No. 59) and Taizan (Nos. 63, 64), Kaioku brushed a
large number of paintings and calligraphy of his own;
painted screens from his hand, however, are rare.[1]

Born into a samurai family, Kaioku was expected
to follow his father as a teacher of military arts. Instead,
he was inclined to the world of the literati. He studied
both Confucianism and Buddhism, the former in Edo
and the latter on Mount Kōya. He first pursued painting
under a Kanō school master and then under the Nanga
painter Sō Tetsu-ō (1791-1871) in Nagasaki. He studied
both the theory and practice of calligraphy, copying
the style of Kōbō Daishi for three years. Kaioku opened
a Confucian school in Kyoto in 1828, and became
known as an advocate of Chin and T'ang models in
calligraphy. In painting, he seems to have preferred
Ming dynasty and earlier models to those of his own
time. He considered himself primarily a scholar whose
painting and calligraphy were hobbies in the classic
Chinese literati tradition.

These screens are both inscribed as following
paintings of "Ch'ien Shu-pao", better known as Ch'ien
Ku (1508-after 1574), a prominent student of the
literati master Wen Cheng-ming (1470-1559). On the
right is Fu-ch'un Mountain, most famous in a masterful
handscroll by the Yüan dynasty painter Huang Kung-
wang. Kaioku's inscription, however, does not refer to
Huang but merely describes the scenery. The text may
have been taken from Ch'ien's inscription or from a
gazetteer.

*Fu-ch'un Mountain is located to the left side of
Fu-i Prefecture. The small rocky peak overlooks a
large river; on the mountain there is the shrine of
Mr. Yen and the Prefectural drum tower. When you
have climbed up, you can see the scenery of the
entire area.*

181

61

得膦嶺
臨錢舜舉圖
松翁

182

富春山
冨易縣境之左一小
石山臨大江上有
嚴先生祠并縣之
鼓角樓登之可概覽
江山之勝
御题钱村寶圖在前

183

The scene Kaioku paints is much as he described; no towering peaks add drama to the scene, but we see a temple on the left and the drum tower near the path that winds up the mountain. Only one tiny figure can be seen, resting in a boat, while the houses seem deserted but not forlorn; bright colors help establish a mood of sunlight and warmth. The calligraphy in regular script also adds to the sense of restrained vigor in the landscape. The composition of the screen is unusual in that it has its weight to the left of center rather than at the right side. As a result, the painting seems to continue beyond the confines of the screen.

On the left is a more distant view of Te-sheng (Victory) Embankment, also after Ch'ien Ku. As the original paintings by the Chinese artist are now unknown, we can only speculate how Kaioku may have changed them. One way was certainly in scale, since Chinese artists did not attempt this kind of screen painting. The originals may have been album leaves, or possibly sections of a handscroll. Thus, Kaioku's distant view of lakes and mountains must be grander in scope than his model, yet the relaxed brushwork helps to convey the comfortable atmosphere of late spring scenery. Again the houses seem almost ghostly, but the human activity and the scale of the village to the mountains informs us that this is not an awesome landscape, but rather one in which man can live in harmony with nature. Pastel colors overlay long fibrous ink-strokes, while groupings of boulders in darker tones add texture and depth to the mountains. In the lower right is the embankment mentioned in the title, providing support for the houses above it.

Although Kaioku followed a Ming dynasty conception of landscape painting and utilized a conservative brushstroke technique, his own sense of humanity is clearly apparent in these screens. They are undated, but as the artist used the signature "Sū-ō" on works between 1849 and his death, we can assume that these screens were painted during his final fifteen years.

SA

1. For Kaioku's screens based on the literary theme of the *Red Cliff* dated 1855, see *Kokka* 949 (1972).

Nukina Kaioku 1778-1863

Willow Landscape 1860

Hanging scroll, ink and light color on silk, 70 x 122.1 cm.,
 27 $^9/_{16}$ x 48 $^1/_{16}$ in.
SIGNATURE: Painted by Sū-ō in the fourth month of 1860
SEALS: Zōteki, Hōchiku shisha, Ga-ai kisei (I love this serenity)
INSCRIPTION: See text below

Willows are symbols of spring, and Kaioku frequently painted landscapes with willow trees rendered in varied soft shades of green. Dated examples of the subject exist from 1834, 1838, and 1852,[1] leading to this very late work of the artist. The brushwork is soft, befitting the season. Rose and blue colors in pastel shades add a rich and subtle warmth, and the use of empty space is effective in evoking an open and peaceful atmosphere.

The composition is artfully arranged just off-center, avoiding a deadening sense of symmetry. The perspective suggests a slight Western influence, since forms such as the willow trees recede in the distance, and one may almost feel a sense of the earth's curvature. Despite the conservative theme and brushwork, the painting maintains a naturalistic flavor; a viewer can empathize with the solitary fisherman, the sole human inhabitant of the landscape.

The brushwork is much like that of the screens previously discussed, but as the scale is smaller, the touches of the brush are more delicate. Darker areas of land, boulders and mountains accent the quiet spring scenery; the diagonal bending of the willow trunks adds a gentle sense of movement, perhaps a suggestion of breezes along the river, to the tranquility of the scene.

Kaioku's poem, a quatrain of five-character lines, is written in running script, and tells of the fisherman's mood:

Desiring to have fishing companions,
I've built a thatched cottage by the riverside willows.
In order to avoid the tangled willows,
I poke out my long-handled fishing pole.

Kaioku epitomized the conservative trends of Nanga in the late Edo period. His paintings are rarely overtly dynamic, but they reflect his balanced and mature personality. Having depicted similar landscapes over a period of almost three decades, the artist was able to invest this work of his eighty-third year with natural warmth and calm serenity.

SA

1. In the Art Gallery of Greater Victoria, the Shōka collection, and the Brooklyn Museum, respectively.

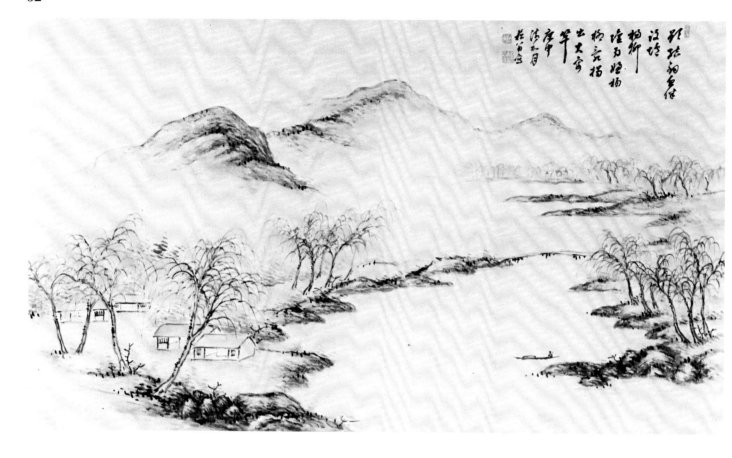

63

Hine Taizan　1813-1869

Dawn Bell at Nan'pin

Hanging scroll, ink and color on satin, 125.1 x 50.6 cm.,
　49¼ x 19¹⁵/₁₆ in.
SIGNATURE: Taizan Hi Shōnen
SEALS: Hi Shōnen in, Chōshoku
INSCRIPTIONS: Dawn Bell at Nan'pin, plus poems by Nukina
　Kaioku and Yanagawa Seigan: see text below
Box lid inscription by Tomioka Tessai (1836-1924) dated 1916

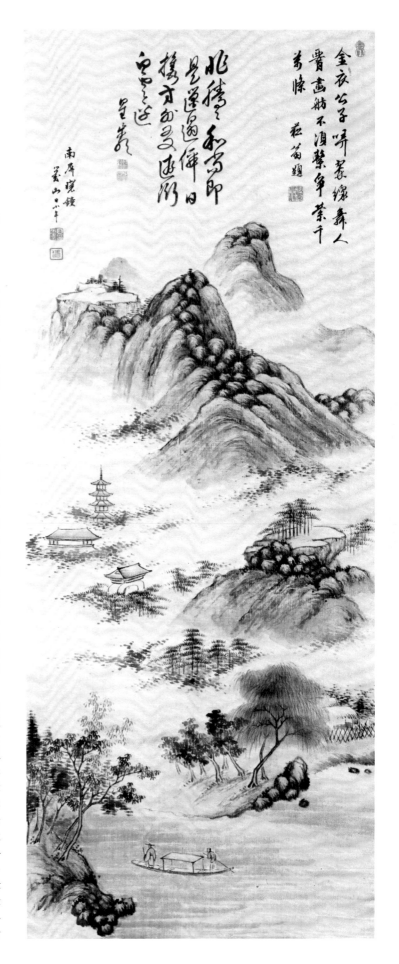

Although Taizan was one of the outstanding Nanga masters in Kyoto at the end of the Edo period, his works are not well known today. This may be in part because he lived into the second year of the Meiji era, and is thus sometimes classified as a Meiji painter. In addition, the generally conservative nature of Taizan's paintings may have hindered recognition of their skillful compositions and poetic but unobtrusive brushwork.

Taizan was born in the village of Hine near Ōsaka. He was a pupil of Nukina Kaioku (Nos. 61, 62) in calligraphy and probably also in painting, but Taizan later claimed that he had been the teacher, not the student, of Kaioku. This claim is unusual in Japanese artistic tradition, where great respect is generally accorded to one's master, and it reflects Taizan's somewhat unruly spirit. Since Kaioku was his senior by thirty-five years, it is unlikely that Taizan was anything more than a talented pupil who felt he had risen above the teachings of his mentor. Since the two remained friends, the story may be apochryphal, but Taizan is remembered for several instances of boorish behavior. For example, he became drunk at a gathering of artists held at the Imperial court in 1864, singing vulgar songs and refusing to allow a court poet to add a poem to one of his paintings.

Taizan's landscapes do not immediately reflect his boisterous spirit, since they follow the orthodox literati tradition that had developed in Kyoto during the early and middle nineteenth century. In his younger period Taizan developed a technique of overlaying brushstrokes in varying tonalities of ink and color, but he did not fully master the total integration of motifs within his paintings. This landscape is one of his early or middle period works, and bears poetic inscriptions by Kaioku and Yanagawa Seigan (1759-1858), whose death provides a terminal date for the painting's possible execution.[1] Both Kaioku and Seigan were among the most noted of Kyoto literati poets and calligraphers, and it is apparent that Taizan was honored by their willingness to inscribe his work. It is clear from the slightly

tentative brushwork that Taizan took especial care with this landscape, working in color on the expensive material of satin.

The painting's title is a variation upon one of the famous "Eight Views of Hsiao and Hsiang", a familiar Chinese theme for poetry and painting which was also popular in Japan; Taizan has substituted "dawn bell" for "evening bell". Kaioku's poem describes a Chinese festival:

Young men chant in golden robes,
Green threads are fastened around the dancers' waists.
There is no need to tie up the painted stone boat;
Competing ribbons flutter in myriad rays of light.

Seigan's poem, rather different in spirit, describes a monk who has freed himself from worldly cares and can enjoy nature to the full:

The monk Hi Saisai is an immortal
Who cares nothing for appearances;
Daily with his layman friends
He wanders to the edge of the white clouds.

Both poets show personal characteristics in their calligraphy; Kaioku is more restrained, and displays his knowledge of early Chinese brushwork styles, while Seigan is more dynamic and flowing with less sense of internal structure to each character.

This scroll is one of Taizan's most carefully wrought works, although the elements are rendered separately rather than being fully integrated. The mountains are painted in the style associated with the Chinese monk-artist Chu-jan (active circa 960-980), with clusters of rounded boulders leading to the summit of the main peak. The temple buildings appearing in space in the middleground suggest the influence of Ming dynasty painters such as Tai Chin (1388-1462). Bands of mist, arranged in horizontals and diagonals, suspend the various elements in space. A willow tree in the foreground is depicted in soft greens, but without the confidence that Taizan would display in his later works; the brushwork is attractive, but cautious rather than fully relaxed.

Although neither of the inscribed poems refers directly to the scene depicted, it would seem that Taizan was well aware that this painting would be honored by two of Kyoto's leading literati masters, one of them his teacher. The work is thus important as an example of the artist's earlier work, and also as a fine example of a literati collaboration towards the end of the Edo period.

SA

1. Of the fifty-seven dated paintings by Taizan known to this author, twenty-nine were brushed between 1860 and the artist's death nine years later. Thus, like most Nanga masters, Taizan painted frequently in his later years; works brushed before his final decade do not show his full maturity as an artist.

Hine Taizan 1813-1869
Spring and Autumn Landscapes 1865

Pair of six-panel screens, ink and color on paper,
 each 157.5 x 345.8 cm., 62 x 136⅛ in.
SIGNATURES: Hi Shōnen
SEALS: Sansei ji taiko, Hi Chōjo Shōnen, Sanrin rōsō
INSCRIPTIONS: Titles as given below, "Painted in the early
 summer of 1865 at the Taizan tower studio"
PUBLISHED: Huntsville Museum of Art, *Art of China and
 Japan* (Huntsville, AL, 1977), no. 312.

These landscape screens show Taizan's fully developed painting style, with a relaxed and natural blending of the different landscape elements. On the right is "Spring Mountains in Bright Beauty," with softly modeled willow trees shielding a path where scholars stroll between modest Chinese-style country estates. On the left is "Streams and Mountains in the Autumn Clear," where again sages are enjoying the natural scenery. These screens display a confidence previously lacking in the artist's work; again the mountains are painted in the style of Chu-jan, but now less literally and with more tonally varied brushwork, while the willows are rendered with relaxed ease.

Despite the influence of the orthodox literati style, one may distinguish Chinese, Japanese and Taizan's personal elements in this pair of screens. The general style and the particular motifs all derive from Chinese tradition. Even the legend on the seals the artist has impressed after his signature:

The mountains are as silent as in antiquity,
The day is as long as a small year.[1]

is taken from a Sung dynasty poet, T'ang Keng. Yet the total expression of the work is primarily Japanese. The format of screens had long since been abandoned by Chinese painters, as the widespread use of chairs and tables formalized in the ninth century led to different habits of household decoration. More particularly, the use of the empty paper to represent mist, water and sky, although learned from China, became for Japanese artists an important compositional element rather than primarily a background to the painted sections. Finally, the sense of the landscape floating in space rather than firmly anchored was a Japanese characteristic even in the most sinified of Nanga paintings.

Personal elements of Taizan in these screens appear in the understated yet firm brushwork depicting the grouping of trees in twos and threes, the low rounded mountains rising above lake scenery and the clustered dotting on the hillocks.[2] By 1865 Taizan had mastered his art; although his paintings are not overtly dramatic, he was able to convey the pleasure of the literatus enjoying nature with relaxed skill and mature confidence.

SA

1. This is an elaborate pun. In Japanese, "day" can be pronounced *hi* and "small year" can be pronounced *shōnen*, thus forming Taizan's most familiar art name.

2. One may note similar features not so fully developed in another pair of Taizan screens in the Gitter collection dated 1860; see Stephen Addiss, *Zenga and Nanga* (New Orleans, 1976), pp. 174-177.

64

溪山秋霽

春山明媚
乙丑晚春寫于
夢山樓中思齊

191

Nakabayashi Chikkei 1816-1867

Landscape Screens 1857

Pair of six-panel screens, ink and light color on paper,
 each 156.7 x 363.2 cm., 61 11/16 x 143 in.
SIGNATURES: Painted by Chikkei
SEALS: Seigyō no in, Azana Shōfū
INSCRIPTIONS: Painted in the summer of 1857, at the Higashi-
 yama Grass Studio
PUBLISHED: Stephen Addiss, ed., *One Thousand Years of Art
 in Japan* (London, 1981), no. 30.

Nakabayashi Chikkei studied painting first with his
father Chikutō (No. 59) and also with his father's
friend Baiitsu (No. 60). Nevertheless, Chikkei gradually
moved away from the conservative literati style towards
a more romantic view of man and nature, influenced

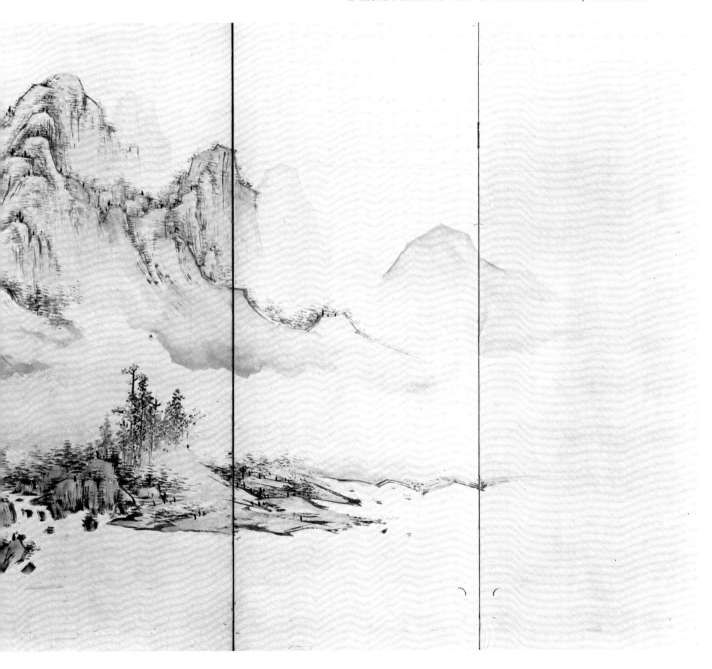

by the works of Yosa Buson (Nos. 44-46). In these screens, which date from the middle of Chikkei's career, we can see the nineteenth century orthodox Kyoto Nanga style still predominating, but there is a personal flavor to the brushwork which suggests the artist's individualistic character. Unlike his father, Chikkei was noted for his eccentricities, such as painting in the nude while welcoming friends and visitors, playing the *shakuhachi* (bamboo flute) with wild abandon and walking the streets in the robes of a medieval warrior.

One distinctive feature of Chikkei's brushwork is an impression of sharpness, with thin lines and abrupt angles which are often softened by his appealing use of muted colors. In the left screen, the season of autumn is presented subtly; instead of the bold expression of colorful autumn leaves such as Rimpa artists painted (see Nos. 13, 14, 17), Chikkei has been satisfied with small touches of color, as in the small trees on the left. A sage pauses on a bridge to admire the distant mountains; the diagonal movement of the bridge is echoed by the tree branch above it and continued by the line of mist. Empty space plays a vital role in this screen, suggesting not only the mist but also sky and water.

In the right screen, the foreground is also dominated by a leaning tree sheltering a scholar, this time seated in a boat with a servant. Small trees, also positioned at diagonals, point the viewer's attention towards the center of the screen where a massive mountain arises from the mists. In both screens Chikkei utilized a split-brush technique, imparting a dry and slightly astringent texture to the paintings. The soft tonality of combined wet and dry brushwork in the main clump of trees presents a richly patterned contrast to the more dessicated brushwork of the land, rock and mountain areas.

Although his work has been little studied in either Japan or the West, Chikkei was certainly one of the

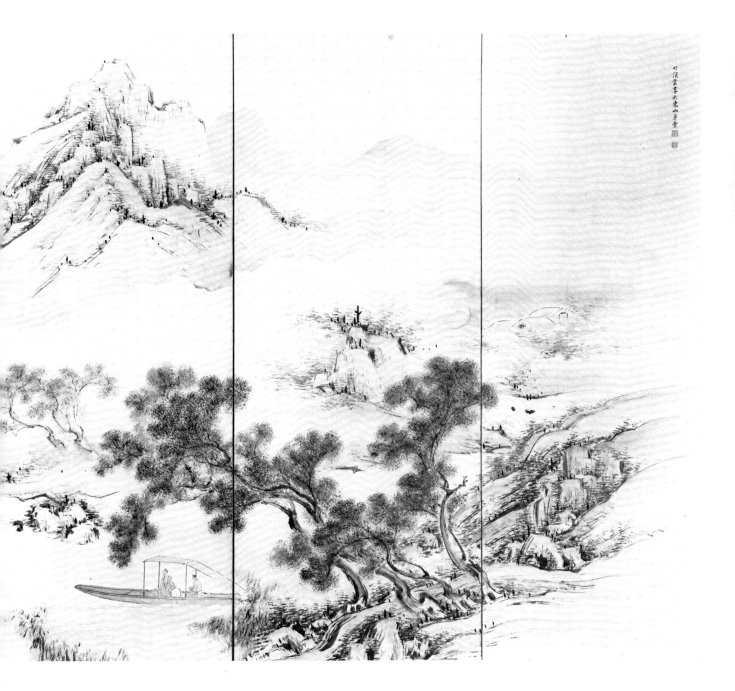

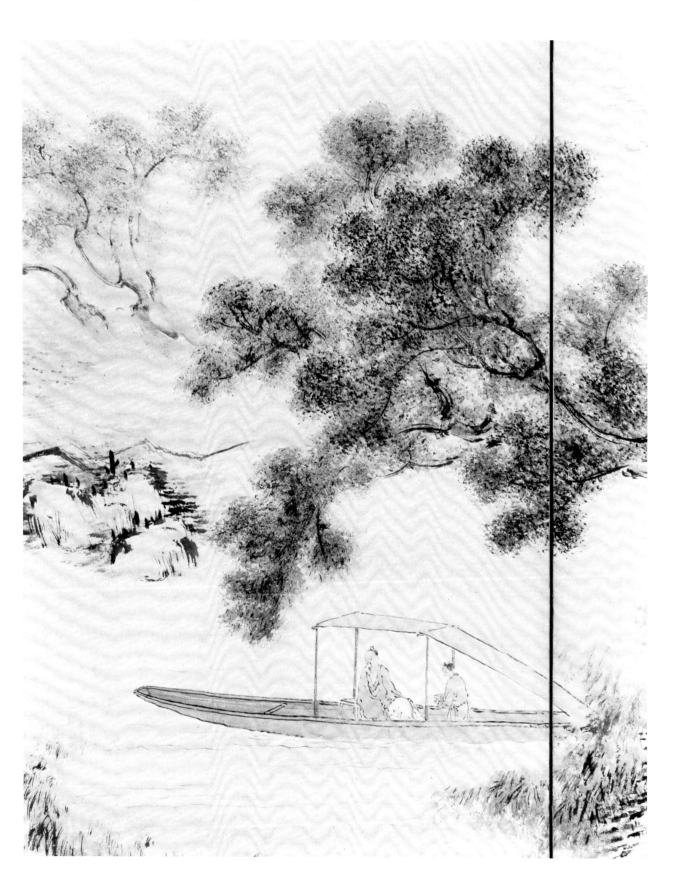

finest artists of the late Edo period; his range of subjects was great, and he imparted his own personality to each of his paintings. These screens show the artist when he had achieved his own transformation of the Chikutō-Baiitsu tradition, but before his final phase of more romantic and less restrained lyricism.

SA

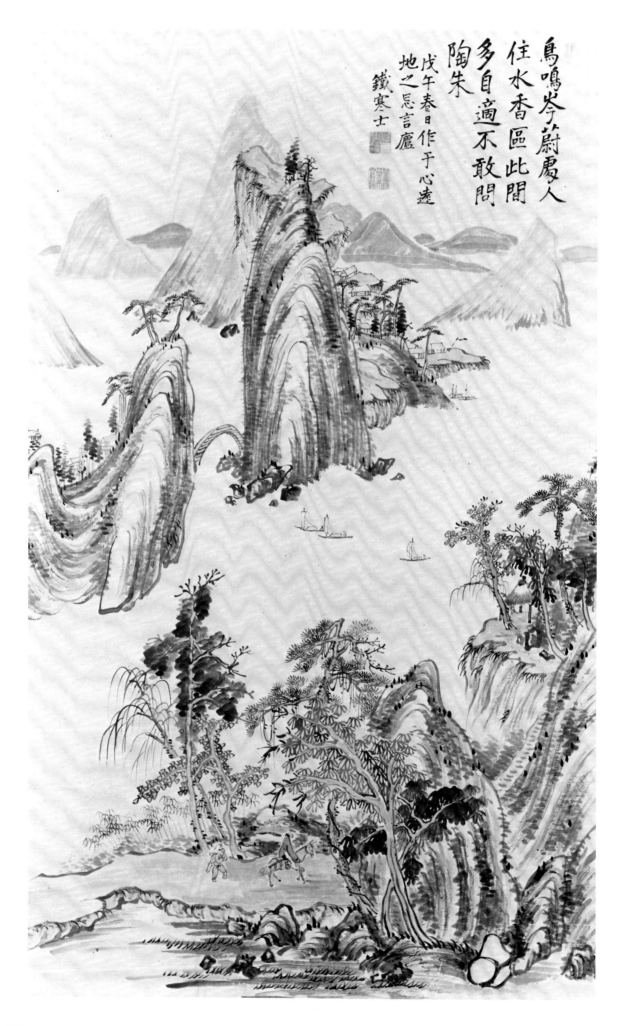

鳥鳴岑寸蔚厲人
住水香區此間
多自適不敢問
陶朱
戊午春日作于心遠
地之忌言廬
鐵寒士

198

66

Fujimoto Tesseki 1817-1863
Myriad Peaks and Fragrant Waters 1858

Hanging scroll, ink and color on paper, 194.2 x 119.8 cm.,
 76 7/16 x 47 3/16 in.
Signature: Tekkanshi
Seals: Tesseki;[1] Gen makane no in, Tetsumon Baisai, Kichibi
 Chūsanjin, (?); Ryo-on shūkō bi (haku?) saiki
Inscription: poem as given below, "painted on a spring day
 of 1858 at Shin'enchi's Kigon Studio"

This huge landscape is one of the most impressive paintings by Fujimoto Tesseki, a samurai from Okayama who lived in Kyoto. Skilled at literature and calligraphy as well as painting, he was a fierce loyalist, supporting the restoration of the Emperor to power. This was a position taken by many leading literati of the nineteenth century. Rai San'yō (No. 58) had written a history of Japan emphasizing the Imperial line, and by the late 1850's and 1860's, loyalist forces saw an opportunity for their cause to triumph. Tesseki, a noted swordsman, was killed in fighting near Nara; his personality and deeds inspired the young artist Tomioka Tessai (1836-1924) to adopt one character of his art name from that of Tesseki. Tessai later regretted that he too had not taken a more active role in the Meiji restoration.

Tesseki's paintings and calligraphy show a bold strength that has been attributed to his samurai heritage.[2] His brushstrokes are more decisive and unfettered than most other artists of his era, and the surging mountain forms that he often portrayed are vigorous and dynamic, sometimes to the point of seeming fanciful.

Here the islands rising from the inland sea suggest the strong imagination of the artist, but in fact there are similar island forms off the coast of China that Tesseki may have seen pictured in an imported scroll or woodblock book. The composition and brushwork, however, are characteristic of the artist. The mountainous forms are arranged primarily in diagonals, with broad expanses of water between them. In the upper middle, a tall hill is surmounted by an angled plateau framed by a far mountain, creating a progression of vertical peaks that is unusually dramatic. Long ropy brushstrokes describe land and mountain forms, with an overlay of horizontal dots adding texture. A variety of trees grow in small groups, while travelers, boats, huts and a pavilion evoke man's pleasure in such splendid scenery. Tesseki's poem suggests that this enjoyment is beyond price, referring to the legendary T'ao Chu (Fan Li), famous in China for his immense wealth.

Birds sing in the myriad peaks,
Men dwell by the fragrant waters;
This is a most suitable place for me,
There's no need to ask T'ao Chu!

Tesseki seems to have been a true samurai-literatus, lodging his exhilaration in paintings like this large landscape. Bright colors and long curving brushstrokes manifest his outgoing personality; dynamic shapes, diagonal thrusts and the dramatic composition attest to his exuberant character. His untimely death at age forty-six, when many Nanga artists were just beginning their mature period, was a loss to Japanese literati art, but his beliefs helped lead to one of the most significant political changes in Japanese history. Ironically, the new Meiji government, which turned to the West for educational, political and cultural reforms, eventually spelled the end to literati art as practiced by Tesseki. Nevertheless, he remains one of the most vibrant painters of the late Edo period.

SA

1. Another version of this opening seal appears on several Tesseki paintings including *Chrysanthemums* (1860) reproduced in *Kokka* no. 953.

2. For further discussion of warrior artists, see Stephen Addiss and G. Cameron Hurst, *Samurai Painters* (Tokyo, 1983).

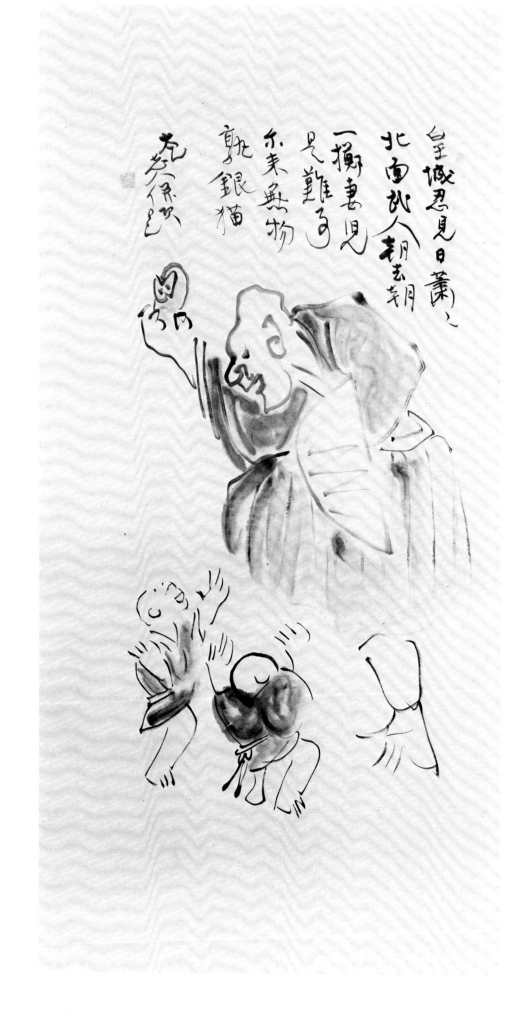

皇城忍見日蕭々
北面臣人朝去朝
一擲妻見
足難了
求来無物
乾銀猫
花蕊保以

200

Murase Taiitsu 1803-1881

Western Journey

Hanging scroll, ink on paper, 136.5 x 67.9 cm., 53¾ x 26¾ in.
SIGNATURE: Painted and inscribed by Taiitsu Rōjin
SEALS: Taiitsu Rōjin sanzetsu (Old man Taiitsu's three talents),
Hakuseki (White snow)
INSCRIPTION: see text below
PUBLISHED: Stephen Addiss, "Japanese Literati Artists of the
Meiji Period," *Essays on Japanese Art* (London, 1982).
Stephen Addiss, *A Japanese Eccentric: The Three Arts
of Murase Taiitsu* (New Orleans, 1979)[1], no. 9.

Although Murase Taiitsu professed life-long devotion to his conservative teacher Rai San'yō (No. 58), he was one of the most individualistic artists of the entire Nanga movement. A scholar and teacher in Nagoya and later in the small castle town of Inuyama, Taiitsu lost his position at the beginning of the Meiji period when Confucian education was abandoned in favor of Western principles. During the last decade of his life he supported himself by giving private lessons, but since pupils were scarce he had a good deal of leisure time in which to indulge his taste for painting and calligraphy. His unusual habits, which included excessive flatulence brought on by eating sweet potatoes, made him a local character, and his art was not taken very seriously until after his death. When he was no longer around to be a nuisance, however, there was considerable local pride in his achievements, and several of his former pupils brushed copies of his paintings to meet the new demand.[2]

Taiitsu typically painted without color, almost always adding one of his poems in spiky and flavorful calligraphy. *Western Journey* is one of his strongest works, and like many of Taiitsu's themes it was drawn from Japanese history rather than Chinese tradition. The year is 1186, and the elderly monk-poet Saigyō (1118-1190) has just finished an audience with the military leader Minamoto no Yoritomo. Saigyō, who many years earlier left his wife and child to become a monk, has been presented with the gift of a silver cat by the Shogun. The old poet, however, once a "North-facing Warrior" for the Emperor, is now beyond any worldly honors, so he gives away the precious gift to some children outside the palace. Taiitsu's poem reflects Saigyo's Buddhist state of mind.[3]

> *The Imperial palace endures, more lonely every day,*
> *And this 'North-facing Warrior' lives on dawn*
> *after dawn.*
> *Leaving a wife and child was truly difficult;*
> *Since then, even a cat of silver is as nothing.*

Taiitsu's characteristic energy is fully revealed in this painting. The lines of the monk's face and head, the children's hands and faces, the legs and feet and the calligraphy are all full of energy and vitality. The diagonal poses of the figures are also echoed in the brushlines of the poem. At a time when Nanga was becoming increasingly traditional, Taiitsu's individualistic painting style was the personal expression of a true eccentric.

SA

1. *Western Journey* was not fully explained in this catalogue. I am grateful to Burton Watson for his suggestions in this regard.

2. For a further discussion of his life and works, see Stephen Addiss, *A Japanese Eccentric: The Three Arts of Murase Taiitsu* (New Orleans, 1979). A later forgery was included in this catalogue for comparison purposes.

3. Another allusion in this painting may be to the Chinese Zen master Nan-ch'uan (Nanzen, 748-834) who had once held a cat up before his followers and challenged them to say the word that would keep him from killing it. They failed the test.

INDIVIDUALISTS

Eighteenth century Japan was an age of tremendous vitality in the arts. Ushered in by the ebullient Genroku era (1688-1709) and the reign of the scholarly but eccentric Shōgun Tsunayoshi, this segment of Japanese history is marked by the spread of literacy, the relaxation of traditional barriers between the social classes, increasing affluence among the middle class (accompanied by a parallel expansion in the demand for works of art), and the restless desire for novelty in all levels of society. It was a time of iconoclasm, eccentricity and individuality, which nurtured such artists as Soga Shōhaku (No. 69) and Itō Jakuchū (No. 68). Because of their unique and individualistic styles, these two artists cannot be comfortably grouped with any of the major schools of painting.

A noted eccentric, Soga Shōhaku ignored the newly emerging artistic trends and turned back to the fifteenth century ink painting tradition for inspiration. Feeling it necessary to establish some sort of lineage, he claimed to be the tenth generation heir of Soga Dasoku (Jasoku). Although the basic vocabulary of his art comes from the tradition of Muromachi period ink painting, Shōhaku added a quality of personal dynamism and fantasy to his works that boldly distinguishes them as Edo period creations.

The son of a grocer in Kyoto, Itō Jakuchū developed a distinctive style of painting which, although based on natural observation, shows equal interest in design and decorative pattern. Instead of following an established painting tradition and studying with a teacher, Jakuchū was inspired directly by the world around him and borrowed freely from a diversity of styles. The majority of his works are colorful depictions of birds and flowers, but he also painted in monochrome ink. The latter style, exemplified by *Kanzan and Jittoku* (No. 68), is marked by simple, dramatic designs and bold, vigorous brushwork.

MT and PF

Itō Jakuchū 1713-1800

Kanzan and Jittoku 1761

Hanging scroll, ink on paper, 39.9 x 58.6 cm., 15 $^{11}/_{16}$ x 23 $^{1}/_{16}$ in.
SIGNATURE: Painted in the summer of 1761 by the master of
 the Shinenkan (studio)
SEALS: Tō Jokin, Jakuchū Koji
INSCRIPTION by Tangai (d. 1763)
 Sleeping, indulging themselves
 They rest oblivious to the world.
 Time passes, mountain roads disappear
 while flowers bloom continuously.
 This existence flows like a stream,
 there is no end to it.
PUBLISHED: Nihon Keizai Shimbunsha, *Kinsei itan no geijutsuten*
 (Ōsaka, 1973), pl. 5.
 Kobayashi Tadashi, *Jakuchū Shōhaku, Rosetsu*
 (Tokyo, 1973), pl. 54.
 Tokyo National Museum, *Jakuchū* (Tokyo, 1971), pl. 10.
 Awakawa Yasuichi, *Zen Painting*
 (Tokyo, 1970), no. 112.

The eighteenth century artistic environment in Kyoto surely ranks as one of the most fertile in Japanese cultural history. The Nanga painting masters Ike Taiga (Nos. 33-39) and Yosa Buson (Nos. 44-46), the Maruyama-Shijō painters Ōkyo (1733-1795) and Matsumura Goshun (Nos. 75-76), the individualists Soga Shōhaku (No. 69) and Nagasawa Rosetsu (No. 71) all contributed significantly to the spirit of excitement and innovation in the visual arts which pervaded the old capital. In painting and calligraphy an increased emphasis on lucid, personal visual accents stands out as a prominent feature of artistic expression at that time. The charged, overtly expressive qualities of a painting became both the immediately recognizable "signature" of its creator and an integral part of the content of the work. Its "meaning" then, in addition to the traditional exercise of understanding subject matter and artistic references, assumed expanded dimensions by almost forcefully engaging the viewer's awareness in a dialogue between the traditional and contemporary visual modes. This predilection for the new, while certainly not a novel or revolutionary position in Japanese painting history, did initially startle, then intimidate the forces of artistic conservatism (such as the Kanō), especially when elements of a renewed interest in realism could not be ignored.

Thus the later Nanga painter Nakabayashi Chikutō (No. 59) could write following Itō Jakuchū's death that he was "immature," no doubt a reference to his lack of attention to proper literati values, themes, and painting style. Indeed Jakuchū executed very few landscapes and only a handful of figure paintings—both staples of the Nanga and Kanō artists. Instead Jakuchū was preoccupied with the realms of birds, flowers, and animals. He rendered them on silk using lustrous colors with a faultless technique, and on paper in energetic swaths of *sumi* ink. These compositions rank among the most original of the eighteenth century, utilizing unconventional tonal harmonies and placements which essentially echo past *yamato-e* (painting) ideals.

Jakuchū was a native of Kyoto where his family owned a substantial business. He studied painting with a minor Kanō artist from Ōsaka, followed by an independent examination of Rimpa and Chinese painting. Presumably a pious man, he was able to see classical Chinese paintings at several Zen monasteries, especially the Shōkoku-ji whose famous *Phoenix* by Lin Liang (active ca. 1450-1500) helped secure Jakuchū's considerable interest in the painting of birds and fowl. Following the loss of his studio and the family business in a major Kyoto fire of 1788, Jakuchū established himself either near Fushimi, painting and strengthening his religious convictions in affiliation with the Mampuku-ji, or at the Shōkoku-ji.

A small number of his paintings bear inscriptions by Zen prelates with whom he was friendly, such as Taiten (1719-1801) of Shōkoku-ji and Tangai (died 1763). An Ōbaku sect priest (also known as Musen Jōzen), Tangai's inscriptions appear on this and at least two other works by Jakuchū which may be characterized as traditional Zen subject matter executed in *sumi* on paper. This bravura rendering of the prototypical Zen figure pair, *Kanzan and Jittoku*, is currently the earliest document of their collaboration.

In addition, it provides insights into the artist's working method as it was tempered by a rather sophisticated knowledge of Chinese painting in Japan. Instead of mimicking the many versions by various Chinese (and Japanese) artists of these figures standing, Jakuchū places them seated facing one another, one with his back to

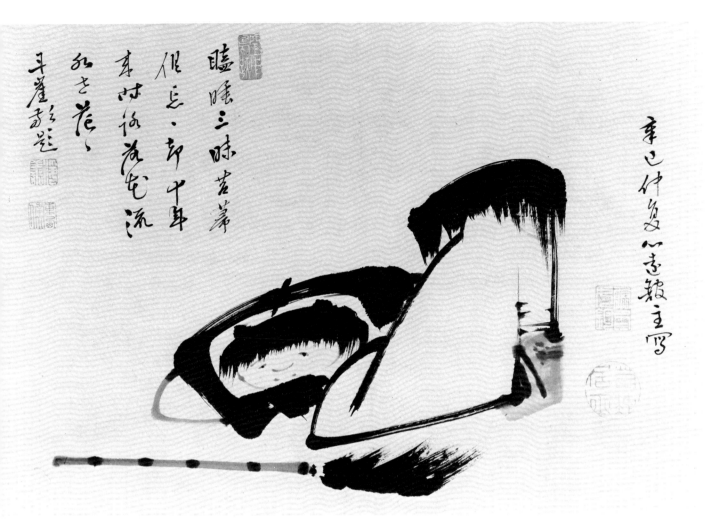

臨睡三昧是筆
但是中年
専時所為宅流
私去莊

斗崖歌題

辛巳仲夏心遠教主写

the viewer. The composition is carefully planned, allowing just enough space for the inscription. There is no "setting" except for Jittoku's broom — but which figure is he?

The twenty-odd brushstrokes forming the entire image bespeak considerable control of ink and brush. They strongly suggest Jakuchū's study of two renowned Zen painters, Liang K'ai (early 13th century) and Yin-t'o-lo (active ca. mid-14th century). The former's portrait of Li Po and other Zen figurative subjects had been in Japan for some time and were justly esteemed for their energetic, scrubby brushwork and subtle washes. Yin-t'o-lo's paintings of Zen patriarchs, including an unusual scroll of a seated Kanzan and Jittoku devoid of identifying attributes, feature abrupt sooty ink highlights placed over evenly-toned brush lines which characteristically form expansive rounded or jutting shapes. Such paintings strongly suggest appropriate stylistic antecedents from which Jakuchū could have drawn for his own work.

Compositionally, another fourteenth century prototype suggests itself for the artist's inventive transformation: the Four Sleepers (see No. 10). Specifically, one may point to the scroll in the Ryōkō-in at Daitoku-ji in which the interlocking figures include two young men, one of whom faces directly out at the viewer while the other rests anonymously, his sleepy profile parallel to the picture plane. Coincidentally a Yin-t'o-lo Zen patriarch painting is also held by the Ryōkō-in, suggesting a tangible monastic location at which the religious Jakuchū might have absorbed these thematic and stylistic lessons, prodding him towards this reduced, light-hearted metamorphosis of Zen imagery. The extent of Tangai's involvement in this exercise is suggested by the inscription and his signature (with date) to the right of the artist's seals.

MRC

REFERENCES:
Tsuji Nobuo. *Jakuchū* (Tokyo, 1974)

Kanazawa Hiroshi. "Paintings of Kanzan and Jittoku," *Kobijutsu,* no. 27 (September, 1969), pp. 33-44.

Soga Shōhaku 1730-1781

Orchid Pavilion

Hanging scroll, ink on paper, 129.2 x 56.7 cm., 50⁷/₈ x 22⁵/₁₆ in.
SIGNATURE: Painted by Soga Shōhaku Kiyō
SEAL: Joki

In the middle of his career Soga Shōhaku began increasingly to emphasize the subject of landscape in his painting. He focused particularly on views of Mt. Fuji, Chinese scenes composed following Muromachi ink painting ideals, and the *Orchid Pavilion* of Wang Hsi-chih (321-379), the subject of this hanging scroll. Wang is prominently visible, seated high in his studio intently composing the *Orchid Pavilion Preface*, which is celebrated in the lore of Chinese literature, painting, and calligraphy. The preface accompanies a collection of poetry which is purported to have been composed in the spring of 353 when Wang Hsi-chih invited a large group of literati friends to the pavilion for the purpose of celebrating the annual spring rite of purification. In this painting the esteemed guests are assembled along the banks of a broad winding river, composing and reciting verse. They drink cups of wine which are gently retrieved by attendants whose robes are rather unceremoniously rolled up.

This gathering was memorialized in numerous paintings in China, especially during the Ming Dynasty, and the subject was best received in Japan by the Nanga artists of the Edo Period. However earlier, Kanō painters also pursued the theme with Kanō Sansetsu (1590-1651) in particular achieving a quite remarkable interpretation in the pair of colorful eight-fold screens in the Zuishin-in.[1] This is noteworthy, since although Shōhaku's early training history remains unclear, textual sources regularly name Takada Reihō (1674-1755), a Kanō school artist, as his mentor. However, this relationship could not have been a protracted one and certainly Shōhaku's mature oeuvre bears little resemblance in pictorial conception and execution to the work of his teacher. Subsequent references to Shōhaku's artistic pedigree mention indebtedness to the contemporary Nanga painters Minagawa Kien (1734-1807) and Ike Taiga (Nos. 33-39) and to the Unkoku school painters of early Edo, such as Tōeki (1591-1644).

It would seem that Shōhaku at one time or another relied to some extent upon each of these sources, and upon an increasing profusion of illustrated books *(ehon)*, especially for his figural compositions. Nevertheless his individualistic disposition and fertile imagination eschew strict categorization, despite even his own efforts to construct a Soga school ancestry for himself. His novel approach to subject and composition are fully demonstrated in this scroll, beginning with the departure from a traditional horizontal format. Instead Shōhaku's setting features a deeply furrowed valley bordered on one side by soaring precipices, some craggy, others curiously domed — hardly the cultivated groves apparent in most representations of the subject. In addition, the spatial setting is quite deep, extending from the detailed immediate foreground of foliate profusion typical of Nanga practices to a mist-shrouded river plain with its Rosetsu-like (No. 71) tree grove.

Stylistically, Shōhaku has employed taut "iron-wire" lines to describe the jagged peaks of the distant mountains, the trees, and architectural elements. The tense activity of this linear technique is played against the flat tonal washes used in non-literal areas, producing a curious visual exuberance that is intimately associated with his name in Edo painting. While this technique also appears as a feature in the more creative efforts of Sanraku, Sansetsu, and the Unkoku painters, Shōhaku seized upon it early in his career, embellishing such accents with increasing calculation later in life.

This painting probably represents one of the artist's initial versions of the Orchid Pavilion theme, predating other examples in Boston (BMFA 11.7007) and Cleveland (dated 1777),[2] and similarly structured landscape scrolls in the collection of Tokyo University of Arts. It can be reasonably dated within the ten year period 1767-1777, when Shōhaku had left the Ise region for the Okayama coast and then Kyoto. There he would have had ample opportunity to see the work of the Nanga and Maruyama-Shijō artists as well as good examples of Soga school, Kanō school, and Korean painting.

The slightly cursive signature, "Joki" seal, and fluid, compact figural style are consistent with Shōhaku's efforts during his late thirties and early forties. Of special interest in this scroll is the clear, personal character of a few gentlemen who occupy the foreground area near the pavilion. In contrast to the severely abbreviated figural descriptions of distant figures, these men seem almost identifiable, particularly the scholar with a white hood in the lower left-hand corner peering calmly out at the viewer. Seeing this, one cannot help but recall the custom of some Netherlandish artists (especially Rembrandt, 1606-1669) to incorporate their own portraits into historical paintings on occasion.

MRC

1. See Tokyo National Museum, *Kanō-ha no kaiga* (Tokyo, 1979), pl. 154 for reproductions.

2. For a reproduction, see *The Bulletin of the Cleveland Museum of Art* LXVII (March, 1980), no. 120, p. 93.

REFERENCES:
Hickman, Money. *Paintings of Soga Shōhaku* (Harvard University Ph.D. Dissertation, 1976).

Kobayashi Tadashi. *Jakuchū, Shōhaku, Rosetsu* (Tokyo, 1973), pls. 85-86.

Tsuji Nobuo, et. al. *Jakuchū-Shōhaku* (Tokyo, 1977), pl. 70.

69

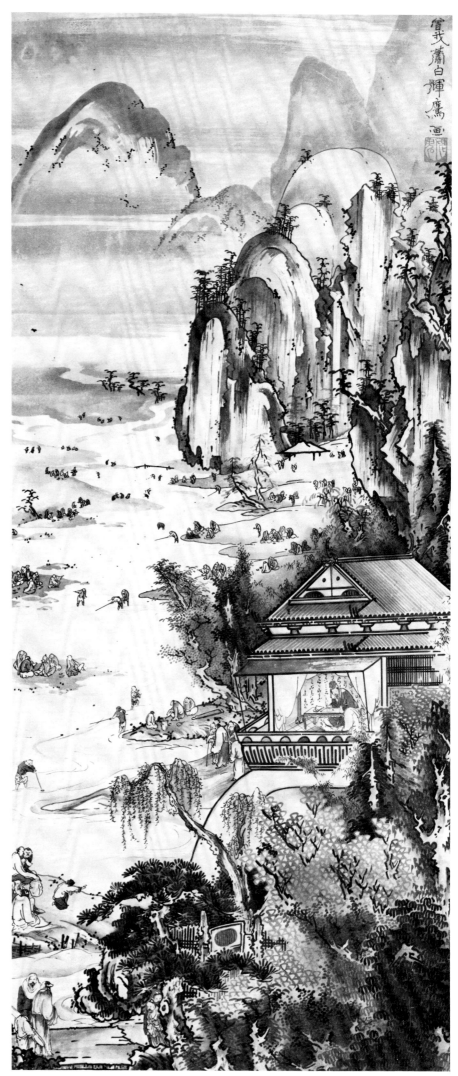

MARUYAMA SCHOOL PAINTING

The affluence of Kyoto merchants, who had previously supported the decorative Rimpa School, led to the development in the late eighteenth century of two other schools which also catered to their tastes. Since they sprang from the same source, the Maruyama and Shijō Schools are often linked together. The Maruyama School was named after its founder Maruyama Ōkyo (1733-1795), who developed a style based on a slightly idealized visual reality, emphasizing sketching from nature and technical mastery of brushwork. Like many Edo period painters, Ōkyo received his first training from a member of the Kanō School; however, in his mature style, he drew upon a variety of other traditions as well. Ōkyo's ideas on painting were influenced greatly by his encounter with Western techniques, which filtered into Japan via European engravings and woodblock prints by Chinese Suchou artists. One of Ōkyo's early employers was a toy merchant who sold a kind of three-dimensional viewing device called *nozoki karakuri,* originally imported from Holland. Small prints or paintings called *megane-e* were inserted into the device, which then reflected and magnified the views of landscape or city life. The machine caused a great stir in eighteenth century Japan, just as 3-D movies have enjoyed popularity today. The *megane-e* employed Western techniques of vanishing point perspective and chiaroscuro which were considered novelties by the Japanese.

While working for the toy merchant, Ōkyo copied and designed new *megane-e,* and this early experimentation with Western techniques significantly influenced the development of his later work. Ōkyo was later invited by the abbot Yūjō to work for him at his temple, the Emman-in outside of Kyoto, which greatly influenced the young painter. Like many other intellectuals of the day, Yūjō was interested in *honzogaku,* Chinese pharmacology which entailed precise studies of the medicinal properties of animal, vegetable and mineral substances. Yūjō himself attempted to make accurate sketches of plants and animals, and recognizing Ōkyo's skill, directed him to do the same. Ōkyo also did many sketches of figures, emphasizing correct proportions and individual facial features. The careful attention Ōkyo paid to the human body was unprecedented in Japanese art.

In addition to learning to sketch from nature, Ōkyo studied Chinese academic bird and flower painting as well as other Japanese traditions such as Rimpa. The style of painting he eventually developed has elements from many of these sources, but its most outstanding feature is the combination of decorative beauty and a strong sense of realism in both the suggestion of volume and the handling of space.

The Japanese public was fascinated with the naturalistic quality of Ōkyo's work, and his paintings of birds, animals, figures and landscapes met with widespread success. He worked on major projects at temples and palaces, and as a result of the increasing number of commissions, he maintained a flourishing workshop. Four of Ōkyo's ten best pupils (Nos. 70-73), as well as his adopted grandson Ōshin (No. 74), are represented in this exhibition.

The figure paintings by Komai Genki (No. 70), Yamaguchi Soken (No. 72), Watanabe Nangaku (No. 73) and Maruyama Ōshin (No. 74) all remain basically faithful to Ōkyo's style. The human forms are correctly proportioned

and display a natural sense of movement and posture. However, like their teacher, Genki and Nangaku softened the sense of realism by idealizing the figures. In the background, the artists' knowledge of Western shading is evident in the use of graded washes in such landscape elements as the flowing water of the river.

The most individualistic of Ōkyo's pupils was Nagasawa Rosetsu (No. 71), who was born into a samurai family. He entered Ōkyo's studio at the age of 25, and four years later was listed among the painters in a kind of Who's Who of Kyoto, testifying that he had already gained respect as an artist. Rosetsu's early works were faithfully based on Ōkyo's models, but he gradually drew away from his mentor and painted in a more lively and sometimes eccentric manner. Like Ōkyo, Rosetsu limited his use of outlines, painting mostly in the so-called "boneless" manner. Rosetsu's handling of the brush, however, is much freer and bolder, and he imparted to his figures and animals some of his own exuberant character.

PF

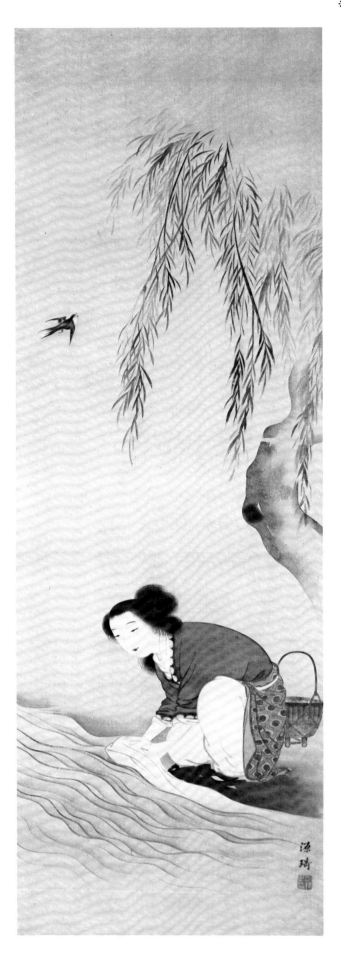

Komai Genki 1749-1779

Woman Washing Clothes in a Stream

Hanging scroll, ink and color on silk, 102 x 36.9 cm.,
 $40^3/_{16}$ x $14^1/_2$ in.
SIGNATURE: Genki
SEAL: Genki
PUBLISHED: Tsuji Nobuo, ed., *Zaigai Nihon no shihō* (Tokyo,
 1980), vol. 6, pl. 53.
 Huntsville Museum of Art, *Art of China and Japan*
 (Huntsville, AL, 1977), no. 298.

Contrasts of style within individual paintings frequently constitute a basic artistic theme for Japanese painters. This is especially apparent in the work of the Maruyama-Shijō school artists, of whom Komai Genki was a highly-esteemed second-generation master.

The relaxed, dry, yet fluid descriptive ease of the stream with its rippling surface serves as a foil for the rich tonalities in the embankment, and, of course, the figure of the washerwoman. Her appearance is characterized by the simplified, pristine drawing of her facial features and coiffure, and by the style of her clothes. These include an exposed white undergarment over which a Chinese-style robe with locking hexagonal design and plain jacket have been drawn. The tonal values of the inks are carefully adjusted and arranged to produce a mellifluous account of an otherwise prosaic vignette focusing on the woman's seeming reverie, rather than the task at hand. Abrupt, even startling contrasts of drawing are also summoned in this effort, although usually between larger, contiguous areas.

For example, the artist's "boneless" treatment of the willow with the more precisely drawn swallow enhances the clarity of both, while providing a believable setting for the figure. This constitutes an abiding characteristic of Genki's work in which narrow, foreshortened compositions predominate. A kind of formula adopted from his teacher Ōkyo, and used by several of the master's students, Genki's colorful style and finely executed paintings in this format are among the most successful of the Maruyama school artists. His *bijin* (beauty) paintings differ from portrayals of the same subject by Yamaguchi Soken (No. 72) or Watanabe Nangaku (No. 73) in possessing a contemplative air, occasionally disquieting, which depends upon a very few natural elements to enhance the surface charm which distinguishes his work. Although derived from Ōkyo as a subject popular among eighteenth century Kyoto collectors, Genki's *bijin* differ considerably in execution and effect. Both men in fact painted the subject contemporaneously, and Ōkyo seems to have

acknowledged his student's superior talents as a colorist by permitting Genki to "fill in" his paintings on occasion.

However, in his rather short career Genki did not limit himself to the *bijin* theme of famous Chinese ladies of history. He collaborated with Ōkyo on major screen projects and multiple hanging scroll sets, painted landscapes, Nō drama themes, animal paintings, and religious *emaki* of the *otogi-zōshi*[1] genre. Apparently quite accomplished by his thirties, Genki became well-known in Kyoto in his forties, an often surprisingly awesome professional artist. The increasingly refined sense of color and gentle nuances of characterization in his later figure studies established him as a steady, minor master of the time. Modern taste and scholarship sees superficial beauty, and lack of personality and vitality in his work. While Genki did derive his technique wholly from Ōkyo, becoming a kind of purist unswayed by the contemporary Shijō conventions, such estimates of his work may be too harsh, particularly when viewed in the context of the esteem with which he was held in his own day, his shortened lifespan, and a pervasive trend in modern scholarship to exalt "individualism" above all.

An additional note of interest pertinent to this scroll is the artist's apparent allusion to the *Kume no Sennin* (Kume the transcendent or immortal) parable, recently elucidated by Money Hickman.[2] As he demonstrates, several versions of the story developed in *ehon* (printed illustrated books), paintings, and woodblock prints of the seventeenth and eighteenth centuries, most of which actually incorporate the depiction of an attractive woman washing clothes in a stream. Although the settings for this activity vary, a preponderance show the maiden framed between an overhanging tree and the stream, as in this example by Genki. Surely he knew this popularly illustrated tale and used it in conjunction with the more common Chinese *bijin* subject to create an enriched, spontaneous account which is unusual in Maruyama school painting.

MRC

1. Short folk tales, sometimes similar to fairy stories, which often contain moral precepts.

2. Money Hickman, "On the Trail of Kume the Transcendent," *Museum of Fine Arts Bulletin*, vol. 79 (1981), pp. 20-43.

REFERENCES:

Kyoto National Museum. *Ōkyo meigafu* (Kyoto, 1936).

Sasaki Jōhei. *Ōkyo and the Maruyama-Shijō School of Japanese Painting* (St. Louis, 1980).

Nagasawa Rosetsu 1754-1799

Cormorant Fishing

Pair of sliding panels, ink and color on silk, each 23 x 51.7 cm.,
9 1/16 x 20 3/8 in.
SIGNATURE: Rosetsu
SEAL: Myō, myō (?)

The reputation of Nagasawa Rosetsu in the last twenty-five years has risen more dramatically than perhaps any other Edo period painter. This phenomenon is largely due to the interest in his work expressed by western collectors and new research into his career by young Japanese art historians following the lead of the scholar Doi Tsugiyoshi. Much of Rosetsu's oeuvre possesses a bold, expressive brush character very sympathetic to the modern western eye and sensibility. In Japan he has traditionally been viewed, like Shōhaku (No. 69) and Jakuchū (No. 68), as an eccentric, an artist of strong individualistic bent, difficult to categorize neatly. Yet, while it is true Rosetsu never enjoyed the sustained patronage of the court or wealthy, enlightened benefactors as did other Kyoto artists, his surviving works indicate that he was a highly motivated artistic talent possessing exceptional skill with brush and ink, who did not stray dramatically from traditional painting themes.

Rosetsu studied with Maruyama Ōkyo for several years, probably during his late twenties. Early dated paintings illustrate his virtual mastery of his teacher's figural and bird and flower styles, while his ensuing efforts attest to his gradual abandonment of Maruyama principals of visual decorum and respectability. Ōkyo evidently continued to respect Rosetsu's talent, as they collaborated occasionally until five years before Ōkyo's death. However, Rosetsu was clearly an independent professional artist by his thirties, whose deepening relationship with Zen Buddhist establishments appears to have influenced his life considerably. His initial contact with Zen originated through friendships with several Zen prelates in Kyoto, some of whom he met through Ōkyo. These contacts later helped secure commissions for a series of extensive *fusuma* cycles done for temples located in the Kii peninsula south of Ōsaka. Other, later ink compositions of major importance in comprehending Rosetsu's development remain at the Yakushi-ji, Nara, and the Daijō-ji in Hyogo, ca. 1795.[1]

The bulk of Rosetsu's work, however, survives as a multitude of individual hanging scrolls, painted primarily in *sumi* ink, which the artist sold as his means of livelihood. Most are executed on paper and possess the charged brush swaths and controlled suffused ink washes with which he is identified and which caught the attention of Kyoto's literati artists at the biannual exhibitions of calligraphy and painting organized by his friend Minagawa Kien (1734-1807). Rosetsu's compositions on silk, such as this pair of small sliding doors, typically depict more traditional, even decorative, subject matter using a tempered brush manner and, as the subject required, a subdued palette.

He painted the subject of cormorant fishing at least twice on silk, playing a subdued range of *sumi* ink values against the red and the lightly washed areas of white silk to suggest the ambience in which this night-time activity takes place. The baskets of fire floating in the water are meant to attract the *ayu* fish, a delicacy in Japan, for which the cormorants dive. However, the lariat attached to their necks does not permit them to swallow the fish. The cormorants are pulled back into the boat and the *ayu* are collected in the waiting buckets.

It is likely that Rosetsu meant to depict the Arashi-yama area in western Kyoto in these panel paintings, since cormorant fishing has traditionally been practiced on the river there, amid the picturesque hills covered with graceful pines. The sliding panels originally served as compartment doors of an elaborate shelf system (*chigaidana*) within a *tokonoma*, or just above such an alcove or closet. The lack of wear on the wooden frames and *hikite* (finger catches) indicates they are modern replacements.

MRC

1. For reproductions see vol. 14 of *Suiboku bijutsu taikei* (Tokyo, 1973).

REFERENCES:

Doi Tsugiyoshi. *Kinsei Nihon kaiga no kenkyū* (Tokyo, 1970).

Moes, Robert. *Rosetsu* (Denver, 1973).

Yamakawa Takeshi. "Nagasawa Rosetsu denreki to nenpu," and other articles in *Kokka*, no. 860 (November, 1963).

Colnaghi Oriental. *One Thousand Years of Art in Japan* (London, 1981), no. 46.

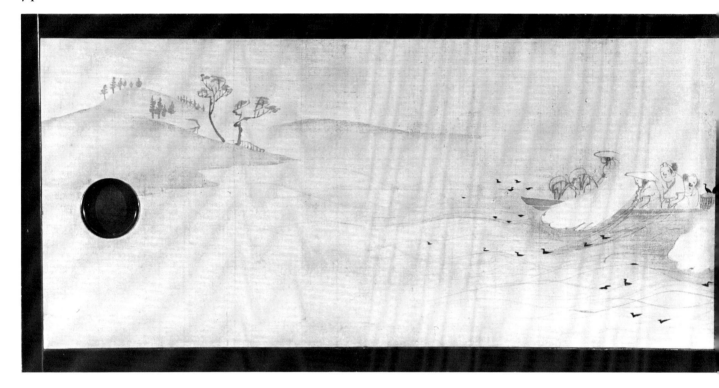

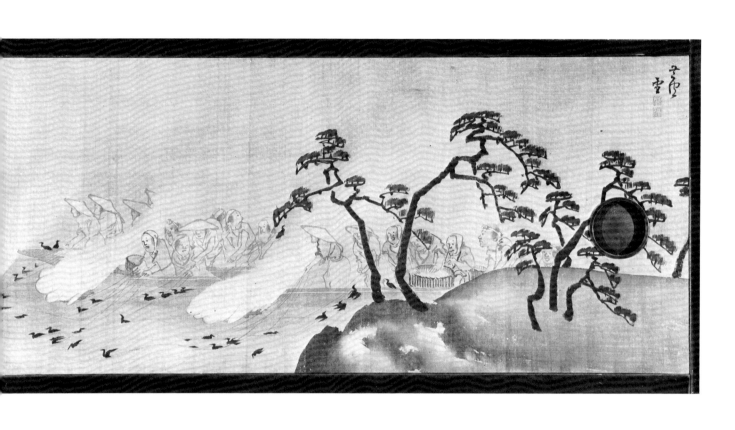

215

*72

Yamaguchi Soken 1759-1818

Kamo River Party

Hanging scroll, ink and color on silk, 50.1 x 71.6 cm.,
 19³/₄ x 28³/₁₆ in.
SIGNATURE: Soken
SEAL: Yamaguchi

One of Maruyama Ōkyo's most intriguing compositions is a relatively uncelebrated handscroll, *Scenes of the Four Seasons*,[1] owned by the Tokugawa Museum in Nagoya. Executed in two scrolls during the artist's early forties, it provides fresh, comprehensive insights into the young master's powers of naturalistic depiction, flavored by his absorption in the study of Western perspectival techniques. The entirely innovative treatment in brush manner, figural definition and color modalities of an otherwise traditional subject mark these scrolls, together with the better-known *Seven Fortunes and Misfortunes* handscrolls in the Emman-in, as major Edo period *emaki* by the preeminent painter of Kyoto (and possibly all eighteenth-century Japan). Not since the landmark *emakimono* of the late Heian and Kamakura periods, produced largely through collaborative efforts, had an artist captured the complexities of human endeavor in Japan with such zest and compassion.

Quite naturally, these compositions established standards for Ōkyo's followers, a number of whom copied either the finished paintings, the preparatory sketch scrolls, or both. Several exist today, including those in the Burke collection by Komai Genki (see No. 70) and possibly Ōkyo, another ascribed to Ōkyo in the Detroit Institute of Arts, and those by Ōkyo in the Emman-in. Perhaps the scenes most familiar to viewers of the various *emaki* are those of the summer pastimes enjoyed by Kyoto residents and visitors since the early seventeenth century along the Kamo River, which flows in a southerly direction just east of the city's central districts. Between the Sanjō and Shijō avenue bridges on the Kamo, restaurants bordering the river set up *tatami*-covered benches on the riverbanks adjacent to their establishments for entertaining guests out-of-doors. There, men and their female companions enjoyed food, drink, and good conversation, enveloped by the cool evening breezes as the sun set to the west and the moon rose over the Higashiyama hills.

This modest hanging scroll by Yamaguchi Soken was surely inspired by his teacher's painting, although it represents but a vignette from that more extensive composition. In this condensed version of an evening's revelry, Soken depicts five couples in light summer garb together with a young boy attendant. The men appear somewhat coarse in attire, physique, and gesture, surely an effect heightened by drink and consciously repre-

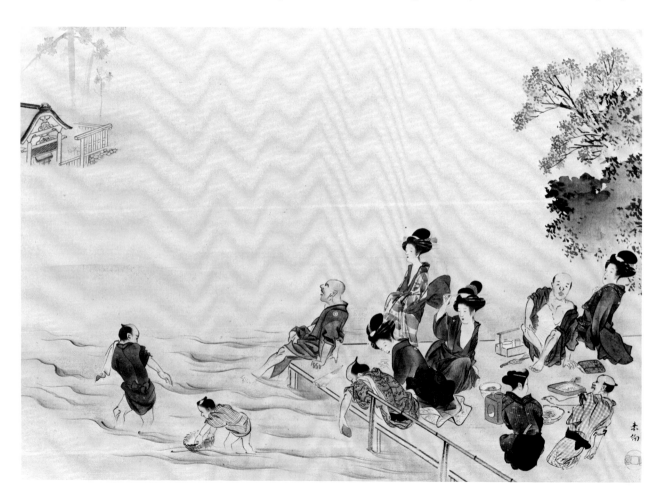

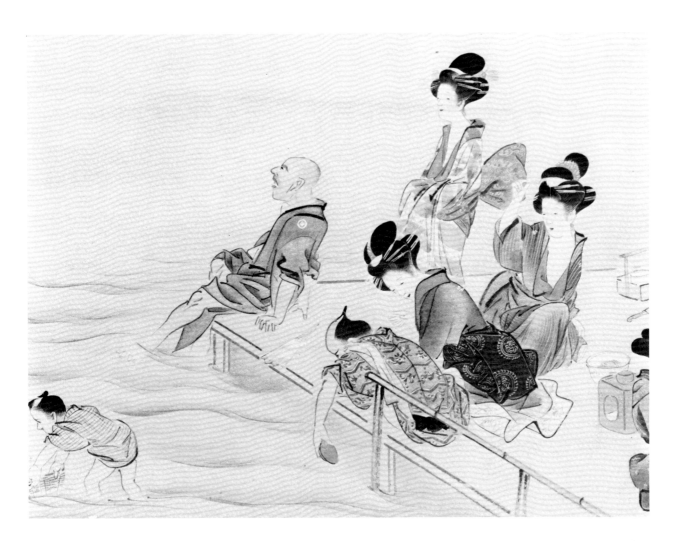

sented by the artist. In contrast, the women who attend these partygoers assume distant attitudes and possess an air of resignation mingled with a detachment that the artist has admirably captured.

Such women, courtesans, as well as traditional Japanese and Chinese figures of high social standing, constitute the overwhelming bulk of Soken's oeuvre, usually depicted singly in good-sized hanging scrolls, swathed in sumptuous clothing meticulously rendered in fine-line drawing with generous areas of vivid colors.[2] These paintings were extremely popular in Kyoto and remind one of the earlier Kaigetsudō *bijinga* of Edo in scale and effect. More than Nangaku or Genki, Soken seems to have been able to capture not only the "pin-up" nature of the subject, but at his best imbues his women with a worldliness and a languor not evident in the work of his contemporaries. In this respect, Soken appears to share Ōkyo's delight in observing and portraying the foibles of human nature from a fundamentally optimistic point of view.

Thus, while this striking painting casts the female attendants in typical roles and places greater emphasis upon defining the individual appearances of the men, any personal dignity among the characters finally resides within the composed attitudes of the women. Except for the intriguing figure of the man fanning himself as he looks directly at the viewer, none of the men appears especially attractive or intelligent. Indeed,

the fellow seated at the corner of the platform, feet dangling in the water, mouth agape, seems to have no idea that his immediate pleasures have brought him to this juncture of gazing directly across the river at a distant building of the Kamo shrine, one of Kyoto's most venerated Shintō institutions and intimately associated with the imperial family.

MRC

1. Published in Yamakawa Takeshi, *Ōkyo/Goshun* (Tokyo, 1977).

2. For an example, see Stephen Addiss et. al., *Japanese Paintings 1600-1900 from the New Orleans Museum of Art* (Birmingham, AL, 1982), no. 34.

REFERENCES:

Murase, Miyeko. *Japanese Art: Selections from the Mary and Jackson Burke Collection* (New York, 1975), no. 63.

Nihon Keizai Shimbunsha. *Maruyama Ōkyo ten* (Ōsaka, 1980).

Yamakawa Takeshi. *Ōkyo/Goshun* (Tokyo, 1977), pls. 10-11.

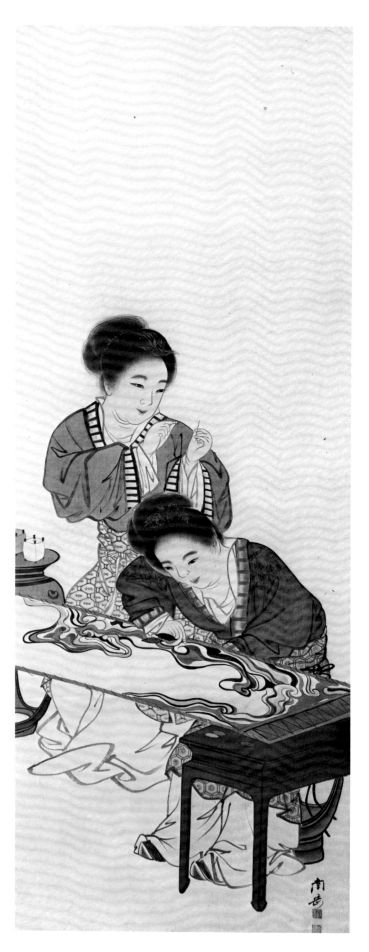

Watanabe Nangaku 1767-1813

Two Women Embroidering

Hanging scroll, ink and color on silk, 112.9 x 42.7 cm.,
44⁷⁄₁₆ x 16¹³⁄₁₆ in.
Signature: Nangaku
Seals: Iwao, Iseki

The two figures portrayed here are young Chinese women preparing what is to become an elaborate, colorful embroidery. Their bodily proportions are ample and somewhat compressed, fulfilling traditional Chinese (and contemporary Japanese) ideals of female beauty associated with the T'ang dynasty (618-906). However, these women depict working class retainers or court attendants rather than aristocratic individuals, despite their obvious attractiveness. Both are seated, one leaning over the stretched cloth, actively applying stitches in two distinct colors from small spools lying by her right hand. Despite a certain lack of focus in her attention to the task at hand, her gesture and the few wisps of hair trailing from an otherwise impeccable coiffure, indicate the performance of real work. She wears Chinese-style pointed slippers, white underrobe, double-locked hexagonal patterned outer skirt and a jacket with simple floriated designs on the shoulders. A hairpin of similar configuration rests prominently in her hair, in contrast to the phoenix-shaped example worn by the other attendant.

This second woman seems to be threading a needle or perhaps checking its condition, but no thread can be seen close at hand except for the square spool from which the small oval spools are formed. Similarly, it is not clear how Nangaku intended the embroidery stretcher to be secured to the table (of Ming, 1368-1644, design), although the stitching holding the silk cloth to the stretcher has been clearly illustrated. It is just such elements of artifice with which Nangaku customarily imbued his portrayals of Chinese and Japanese *bijin* that enhance their attractiveness. Compared to Genki's washerwoman (No. 70) these attendants appear to be "big" children, more precious than Ōshin's "little" grown-ups (No. 74), and certainly not as worldly as Soken's courtesans (No. 72).

While such a constricted scene may test one's credulity, clearly Nangaku relished the opportunity to execute the vivid, free-form embroidery design and such less formal elements as the white undergarments. Indeed this is his forte and provides not only the focus for this work, but for much of his oeuvre. Nangaku was a rather prolific artist, removed by a generation

from Ōkyo, which allowed him easier access to the other current artistic styles outside the realm of Maruyama tenets. Thus, although Nangaku studied with Ōkyo and then Genki, as indicated by the *bijin* subject and his impressive control of color tonalities and highlights, he also knew Rimpa and Nanga techniques. Sakai Hōitsu (Nos. 13, 14) is said to have studied with him, as did the Shijō and Nanga painters in Edo, Suzuki Nanrei (1775-1840), Ōnishi Chinnen (1792-1851) and Tani Bun'ichi (1787-1818).

Nangaku appears to have been a peripatetic, eclectic artist whose most spirited compositions—such as the long handscroll of *Plants and Animals in the Four Seasons* in the collection of the Tokyo University of the Arts[1]—reflect increasingly individualistic demonstrations of "boneless" painting. As an important transmitter to Edo artists of the Maruyama and Shijō school conventions he would also have had ample opportunity to see, for example, Tani Bunchō's (No. 52) fine exercises in this difficult, but highly expressive brush mode. Seen in this light, his later career assumes potentially intriguing art historical and aesthetic dimensions, transcending the forced, somewhat coquettish air of his earlier efforts within the strict Maruyama repertory.

MRC

1. For reproductions, see Tokyo University of the Arts, *Zōhin zuroku* (Tokyo, 1960), vol. 4, pl. 54.

REFERENCES:

Hillier, Jack. *The Uninhibited Brush* (London, 1974).

Maruyama Ōshin 1790-1838
Children Playing in Summer and Winter

Pair of six-panel screens, ink and color with gold on paper,
82 x 262.1 cm., 36¼ x 103³/₁₆ in.
SIGNATURE: Ōshin
SEALS: Ōshin

The continuity of the Maruyama school after Ōkyo
provides a fairly typical example of the transmission
of an artistic legacy in Japan. Ōkyo's two sons Ōzui
(1776-1829) and Ōju (1777-1815) both studied painting
in their father's studio, with Ōzui succeeding as titular
head of the family shortly after Ōkyo's death. As might
be expected, his work does not diverge markedly from
his father's, although a slightly greater emphasis on
landscape painting containing pronounced decorative
effects characterizes much of his work. He maintained
the Maruyama family studio, training students and exe-
cuting commissions, but few of these could be termed
especially distinguished.

In selecting his own successor, Ōzui bypassed his
sons in favor of a son of his younger brother, who had
adopted their mother's family name, Kinoshita, ap-
parently believing Ōshin to be the most promising talent
of the young Maruyama-trained artists. By the time
Ōshin had been formally adopted by his uncle, he was
in his late thirties. He had studied with his father Ōju,
and with Komai Genki (No. 70). Although it is not known
precisely when he studied with his uncle prior to as-
suming the third generation leadership of the Maruyama
atelier, it is clear Ōshin continued to favor the standard
painting formulas practiced by these artists.

A year after Ōzui's death, Ōshin executed a com-
mission for the emperor Ninkō (1817-1846) at the
Hōkyō-ji, painting scenes of *Harvesting in the Four
Seasons* on *fusuma* separating two rooms in the temple.
Done in vivid color, with generous applications of gold
flecks in the shapes of clouds, the eight panels possess
an unusual combination of western illusionistic depth
and native *yamato-e* concentration on selected detail.
Already a special characteristic of Ōkyo's more dramatic
landscape paintings, Ōshin's Hōkyō-ji paintings exag-
gerate these features, partly through the dissipation of
even more sparse landscape and figural elements.

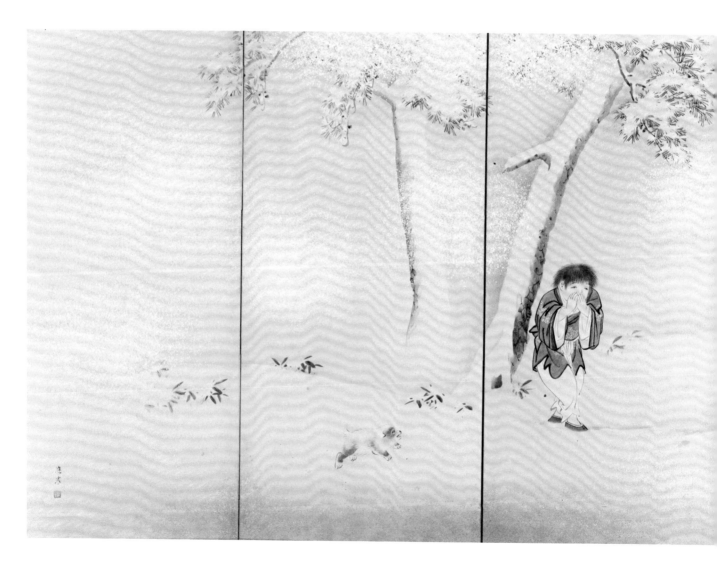

from Ōkyo, which allowed him easier access to the other current artistic styles outside the realm of Maruyama tenets. Thus, although Nangaku studied with Ōkyo and then Genki, as indicated by the *bijin* subject and his impressive control of color tonalities and highlights, he also knew Rimpa and Nanga techniques. Sakai Hōitsu (Nos. 13, 14) is said to have studied with him, as did the Shijō and Nanga painters in Edo, Suzuki Nanrei (1775-1840), Ōnishi Chinnen (1792-1851) and Tani Bun'ichi (1787-1818).

Nangaku appears to have been a peripatetic, eclectic artist whose most spirited compositions—such as the long handscroll of *Plants and Animals in the Four Seasons* in the collection of the Tokyo University of the Arts[1]—reflect increasingly individualistic demonstrations of "boneless" painting. As an important transmitter to Edo artists of the Maruyama and Shijō school conventions he would also have had ample opportunity to see, for example, Tani Bunchō's (No. 52) fine exercises in this difficult, but highly expressive brush mode. Seen in this light, his later career assumes potentially intriguing art historical and aesthetic dimensions, transcending the forced, somewhat coquettish air of his earlier efforts within the strict Maruyama repertory.

MRC

1. For reproductions, see Tokyo University of the Arts, *Zōhin zuroku* (Tokyo, 1960), vol. 4, pl. 54.

REFERENCES:

Hillier, Jack. *The Uninhibited Brush* (London, 1974).

Maruyama Ōshin 1790-1838

Children Playing in Summer and Winter

Pair of six-panel screens, ink and color with gold on paper,
82 x 262.1 cm., 36¼ x 103³/₁₆ in.
SIGNATURE: Ōshin
SEALS: Ōshin

The continuity of the Maruyama school after Ōkyo
provides a fairly typical example of the transmission
of an artistic legacy in Japan. Ōkyo's two sons Ōzui
(1776-1829) and Ōju (1777-1815) both studied painting
in their father's studio, with Ōzui succeeding as titular
head of the family shortly after Ōkyo's death. As might
be expected, his work does not diverge markedly from
his father's, although a slightly greater emphasis on
landscape painting containing pronounced decorative
effects characterizes much of his work. He maintained
the Maruyama family studio, training students and exe-
cuting commissions, but few of these could be termed
especially distinguished.

In selecting his own successor, Ōzui bypassed his
sons in favor of a son of his younger brother, who had
adopted their mother's family name, Kinoshita, ap-
parently believing Ōshin to be the most promising talent
of the young Maruyama-trained artists. By the time
Ōshin had been formally adopted by his uncle, he was
in his late thirties. He had studied with his father Ōju,
and with Komai Genki (No. 70). Although it is not known
precisely when he studied with his uncle prior to as-
suming the third generation leadership of the Maruyama
atelier, it is clear Ōshin continued to favor the standard
painting formulas practiced by these artists.

A year after Ōzui's death, Ōshin executed a com-
mission for the emperor Ninkō (1817-1846) at the
Hōkyō-ji, painting scenes of *Harvesting in the Four
Seasons* on *fusuma* separating two rooms in the temple.
Done in vivid color, with generous applications of gold
flecks in the shapes of clouds, the eight panels possess
an unusual combination of western illusionistic depth
and native *yamato-e* concentration on selected detail.
Already a special characteristic of Ōkyo's more dramatic
landscape paintings, Ōshin's Hōkyō-ji paintings exag-
gerate these features, partly through the dissipation of
even more sparse landscape and figural elements.

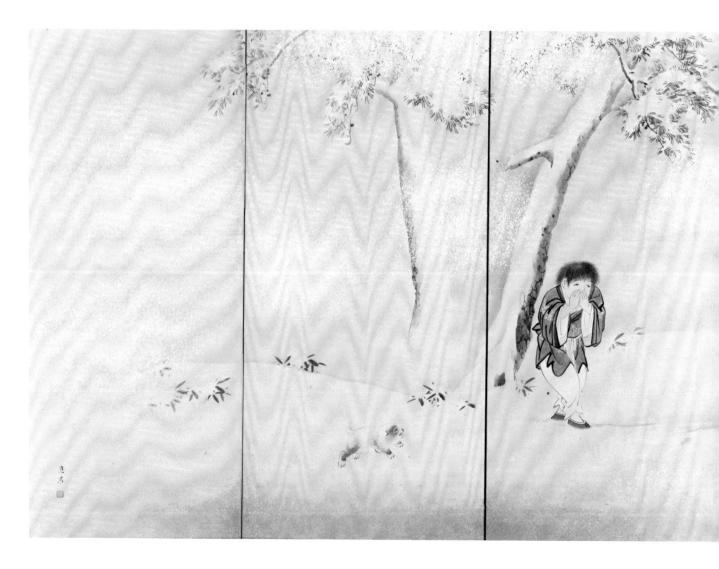

This tendency may also be discerned in these small decorative screens depicting summer and winter pastimes, and helps to explain their amusing, rather mannered nature. In particular, the rather curious shapes of the children are taken from Ōkyo's idea of Chinese youngsters, but Ōshin presents them as an even more attractive confection, now difficult to appreciate fully. The winter scene with the large snowball and puppy appears in the New Year's preparations section of the Tokugawa *Festivities of the Four Seasons* handscroll by Ōkyo,[1] albeit in a more believable setting than occurs here.

Other works by Ōshin display a similar dependency upon Ōkyo and especially Ōzui in animal and dragon paintings, landscapes, and figure painting. The landscapes appear to be Ōshin's forte, following the tendency of Ōzui, and effectively remove the Maruyama from the privileged leadership in Kyoto's painting circles. For by then the status of the Maruyama had been compromised by the accomplishments of the literati and individualist painters, and by the steady shift of cultural and economic resources from Kyoto to Edo. In this sense, Ōshin's career represents both a brief revival of the Maruyama fortunes and its future artistic demise with his early death. The lingering reputation of protean artists like Ōkyo in Japanese history has traditionally had a tendency to so overshadow the accomplishments of those successors who vigorously follow their mentor's style, that survival becomes an even more difficult task. The extended, conservative apprenticeship of such students seems to assist in precluding second and third generation diversity and creativity. Ōshin's limited oeuvre suggests that had he lived longer he might have overcome the burden of the Ōkyo legacy, since his landscapes evince an interest in the contemporary achievements of the Shijō and Nanga artists.

MRC

1. For reproductions see Yamakawa Takeshi, *Ōkyo/Goshun* (Tokyo, 1977).

REFERENCES:

Kyoto-fu Bunkazai Hogo Kikin. *Kyoto no Edo jidai shōhekiga* (Kyoto, 1978), pp. 42-43.

Kyoto Furitsu Sōgō Shiryōkan. *Kyoto gaha no genryū* (Kyoto, 1965).

SHIJŌ SCHOOL PAINTING

Matsumura Goshun, the founder of the Shijō School, was initially a pupil of Yosa Buson (Nos. 44-46), and under his tutelage became recognized as both a fine Nanga painter and *haiku* poet. *Sweeping Flower Petals* (No. 75) by Goshun well exemplifies the Buson tradition. In contrast to most Nanga painters, Buson had enlarged the scale of the figures in nature so that they played a more important role. When viewing more closely the activities of man in his natural surroundings, the scene becomes more intimate. Goshun's definition of rocks by long, fibrous strokes, and rendition of tree foliage by myriads of short, feathery strokes are clearly derived from Buson as well.

Goshun also became skillful at rendering figures in Buson's more abbreviated style featuring fluid brushwork. This style of painting developed from *haiga*, which Buson brought to fruition. A combination of the term *hai* which refers to *haiku* and *ga*, meaning picture, *haiga* is usually defined as a work in which painting and *haiku* poetry are fully integrated. Having learned from *haiku* poetry to evoke a mood and image in just seventeen syllables, Buson and Goshun became masters at communicating the spirit and movement of figures or essence of an object in just a few strokes of the brush. Although Goshun's pair of paintings (No. 76) bear Chinese-style inscriptions rather than *haiku*, the simplified treatment of the figures clearly puts them within the light-hearted *haiga* tradition.

After Buson's death, Goshun became interested in the new naturalistic style of Maruyama Ōkyo. Goshun gradually drew away from the linear Nanga landscape tradition, and evolved his own style characterized by extensive use of ink and color washes. Although inspired by his new mentor's brushwork and subject matter, Goshun further simplified and refined the forms, and his compositions frequently possess a poetic, abstract quality emphasizing design rather than representation. Goshun also rendered his forms in a looser and more relaxed manner than Ōkyo, who tended to utilize rather tightly controlled brushwork. Goshun quickly attracted a host of new followers, and his school came to be called Shijō because he lived and worked on Shijō street in Kyoto.

Goshun's most avid pupils included his brother Keibun, who had also studied with Ōkyo. Keibun specialized in paintings of birds and flowers, exemplified by his pair of screens depicting *Spring and Autumn* (No. 77). The brushwork making up the plants features a wide range of tonal variations, giving the forms a convincing sense of naturalism. However, in contrast to the Maruyama School, the strokes were applied with a spontaneity and lightness of touch.

One of the most active Shijō painters in the nineteenth century was Shiokawa Bunrin, who relied increasingly on atmospheric effects, sometimes achieved through Western techniques of shading and perspective. Bunrin's pair of screens *Boating Party and Farmers* (No. 78) are especially interesting since they incorporate features of Buson's figure style. Although usually associated with Nanga, through Goshun's example many of Buson's figure types were adopted by artists working in the Shijō tradition. These paintings often focused on the life of city merchants or farmers, whereas Maruyama School artists leaned toward idealized beauties or legendary heroes.

Shibata Zeshin is another outstanding nineteenth century painter who was also well-known for his work in the medium of lacquer. He received training in the Shijō brushwork tradition in Edo and during his many visits to Kyoto. As a result, *Samurai by the Bridge* (No. 79) exhibits many Shijō features, including the extensive use of wash in the landscape and loosely conceived brushwork. The humorous facial expression also suggests the lingering influence of the *haiga* tradition. The Shijō School continued to be extremely popular late into the nineteenth century; this style made such an impact that some of its features can still be seen in Japanese art produced today.

PF

Matsumura Goshun 1752-1811

Sweeping Flower Petals

Hanging scroll, ink and color on silk, 111.1 x 52 cm.,
 43¾ x 20½ in.
SIGNATURE: Goshun
SEALS: Goshun, Hakubō

Matsumura Goshun's ancestors came from the Mino area northeast of present-day Nagoya, before settling in Kyoto, where four successive generations worked as supervisors at the government mint. Goshun himself took a position in this prestigious office, while maintaining outside interests in music, Nō chanting, seal carving, and painting as befitted a young Kyoto gentleman of his background and means. Nevertheless, Goshun left the mint, probably towards the end of the Anei era (1772-1780) to pursue a career in painting. For social as well as economic reasons, this represented a daring course of action for a young man in his early twenties, but it is certain that he received the permission of his family and the firm encouragement of his painting instructors Ōnishi Suigetsu, a minor artist, and Yosa Buson (Nos. 44-46).

Then in his sixties and at the height of his powers as a painter and poet, Buson tutored Goshun in both these artistic pursuits and was instrumental in introducing his protegé to his circle of friends and supporters, some of whom were to become admirers of the young literatus. Goshun's earliest known painting dates in the Anei period when he was twenty-three. At the time, like Buson, he occupied a studio on the Kamo river in central Kyoto. His principal creative efforts appear to have been directed towards the writing of *haiku* poetry, of which Buson was the reigning master in all Japan. It was while immersed in such literary-oriented circles that he took the name "Gekkei" which appears in such diverse sources as illustrated Buddhist sutras, historical chronicles, and the more usual Nanga-style paintings. Not long thereafter, Goshun's wife of only three years, a rather distinguished entertainer (*taiyu*), died in a shipwreck, followed by the death of his father, who had recently remarried, fostering another son. Amid these emotional upheavals and considerable financial responsibilities, the young artist left Kyoto for Ikeda, located just outside Ōsaka, became a lay priest assuming the name "Goshun," and maintained his residence there for eight years (or, by other accounts, five years).

Ikeda was a prosperous community founded on the manufacture of fine silk clothing. Its merchants were attracted to Goshun's talents, thus providing him with an immediate cultural circle of *haiku* and painting enthusiasts who also constituted a viable financial base for the young artist. These circumstances must have encouraged Goshun as well as Buson, who had undoubtedly arranged for his pupil's welcome in Ikeda.

Consequently when Buson became seriously ill in 1783, Goshun returned to Kyoto to care for him until his death. Following this he returned to Ikeda, but assumed some of the financial burden of maintaining his mentor's family. He raised funds by publishing selected *haiku* of Buson's accompanied by his own illustrations, and he painted *emaki* for the family to sell.

Goshun's Ikeda years were certainly foremost in his development as a literary figure and as a painter of increasingly major significance. Amidst that environment of gourmands, literary circles, and amateur painters which he helped found and nurture, he gradually formulated the painting style and imagery present in this hanging scroll. The theme of the aged, humble gardener-servant, occasionally accompanied by a boy attendant or depicted with the image of the pensive master of the secluded country estate, is derived from Buson. In these paintings the rustic, craggy features of the old man, together with the rocks, trees, and other natural elements, share consonance of form with the sinuous, energetic brushwork that echoes throughout the entire composition. The paintings represent paradigms of that hallowed Eastern virtue said to be found in the studied retreat from the egotistical machinations of sophisticated institutions and urban society.

Such ideas abound in Southern Sung and Yüan paintings of courtly and literati persuasions, and, especially vividly, in portrayals of the religious immortals (Buddhist *arhats* and Taoist *sennin*). Buson's revival of this ideal in the cultured, affluent societies of Kyoto and its outlying commercial centers in the Ōsaka area, was authentic and novel. In general, he reinvigorated a languishing interest in actually attempting to incorporate native (*yamato-e*) sensibilities and poetic content into painting and, specifically, forged a new standard of figural ideal. As is evident in this painting, Goshun effectively transmitted the appearance and spirit of Buson's imagery, occasionally enhancing it with feathery brushwork and numinous color values that are remindful of the impressionists.

MRC

REFERENCES:

Amagasaki-shi Sōgō Bunka Senta. *Goshun ten* (Amagasaki, 1979).

Suntory Art Museum. *Itsuō Bijutsukan meihinten* (Tokyo, 1981).

Suzuki Susumu. *Ōkyo to Goshun,* vol. 39 of *Nihon no bijutsu* (Tokyo, 1969).

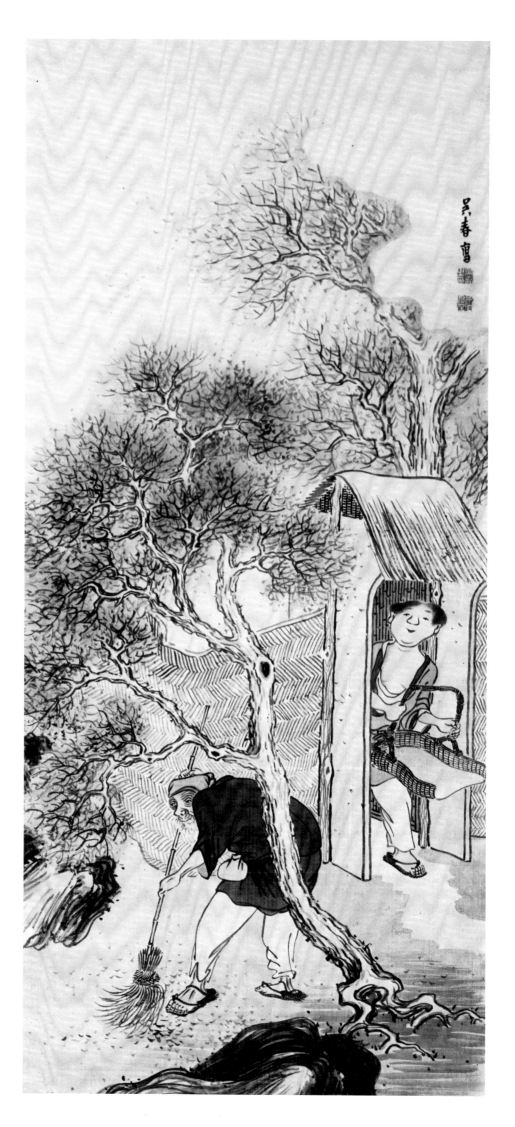

Matsumura Goshun 1752-1811

Man with Hoe and Bamboo (right)
Old Man with Hoe and Basket (left)

Pair of hanging scrolls, ink and light color on paper, each
 127 x 28.4 cm., 50 x 11^5/$_{32}$ in.
SIGNATURES: Painted by Goshun
SEALS: Goshun (right)
 Goshun Hakubo (left)
Inscriptions by Kozan Garyo (1718-1792)
(right):
 The old man transplanted the bamboo,
 Why?
 In order to obtain bamboo shoots in snow, and invite
 coolness in all the heat [of summer].
(left)
 Returning with raincoat, rainhat, one hoe and one basket
 What blessing from Yao and Shun?
 They commanded that there be *ch'u-kung* (offerings?).
 (Translated by Fumiko E. Cranston)

During Goshun's years in Ikeda he occasionally visited Kyoto to see his teacher Buson, his family, and other artist friends. Some of these included the painters Minagawa Kien (1734-1807) and Maruyama Ōkyo (1733-1795), who once joined Goshun on an autumn maple-viewing excursion. Following this "Ikeda period" he returned to Kyoto, prompted no doubt by the death of his mentor, responsibilities to his own family and to Buson's, as well as the attraction of Kyoto's vibrant cultural environment. For while nominally referred to as a Nanga painter, Buson's art clearly exceeded the creative range of its average practitioners, including his other students Ki Baitei (Nos. 47-48) and his follower Yokoi Kinkoku (No. 49). It is perhaps in this light that Goshun's return to his birthplace might be viewed as a conscious effort to preserve the continuity of the Buson tradition by assuming his teacher's mantle.

Goshun settled in the central Kiyamachi district in the early summer of 1786 (conflicting sources state 1789). His acquaintance with Ōkyo promptly led to an invitation the next year to participate as Buson's leading student in a painting project at the Daijō-ji in Hyōgo. This relationship with Ōkyo resulted in yet another important commission soon thereafter at the Myōhō-in, Kyoto, through the invitation of an imperial prince Ōkyo had introduced to Goshun. For both projects Goshun executed extensive, linked landscape compositions on *fusuma*, which clearly demonstrate his movement away from the literati painting style towards Maruyama naturalistic conventions. Thus, Buson's overwhelming influence on Goshun's compositional arrangements, color values, and brush manner gave way in the later 1780s to Ōkyo's commanding presence—not an uncommon phenomenon in Kyoto at that time among acknowledged professional artists.

This pair of figure paintings bearing inscriptions by Kozan Garyō were done by Goshun at least three years prior to Ōkyo's death, when the young artist was attempting to assimilate both his Nanga and Maruyama experiences in an effort to forge his own style. Although his later style became known as Shijō school painting, named after the new location of Goshun's studio, and bears closer affinities to Ōkyo's "realistic" art, these two figure paintings indicate his continued reliance on Buson's standards of figural delineation. Both recall the master's light-hearted portrayals of distinctly Japanese characters normally placed in settings devoid of landscape features—in contrast to his Chinese figural subjects. The impression conveyed of free brushwork, coupled with spare, direct gestures and light washes of color, impart a slightly whimsical air.

Unencumbered by strict Chinese or *yamato-e* iconographical or pictorial conventions, these paintings belong to a figural genre situated between didactic Zen subjects and more contemporary *haiku* painting. Goshun depicted numerous such figures, most of which bear inscriptions by himself, Buson, or his many literary friends. Priest Kōzan, for example, is known as the author of an important eighteenth-century study of Zen history and was abbot of Zen sect temples in the Ikeda area after leaving Kyoto in 1775. Indeed, Goshun's circle of peers, friends, and acquaintances—both literary and artistic—may be counted among the most engaging artists of the later eighteenth century. Future study of their web of interrelationships, of which this pair of scrolls will necessarily be a part, should provide one of the most illuminating inquiries into Kyoto's cultural history in the Edo period.

MRC

REFERENCES:

French, Calvin, et. al. *The Poet-Painters: Buson and His Followers* (Ann Arbor, 1974).

Sasaki Jōhei. *Ōkyo and the Maruyama-Shijō School of Japanese Painting* (St. Louis, 1980).

Yamakawa Takeshi. *Ōkyo/Goshun* (Tokyo, 1977), pls. 61, 66.

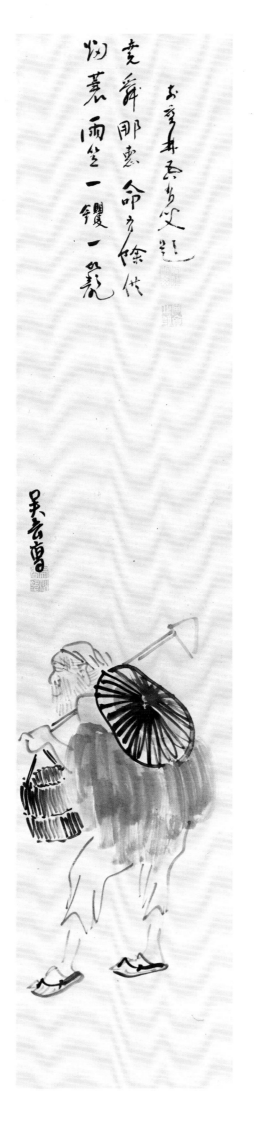

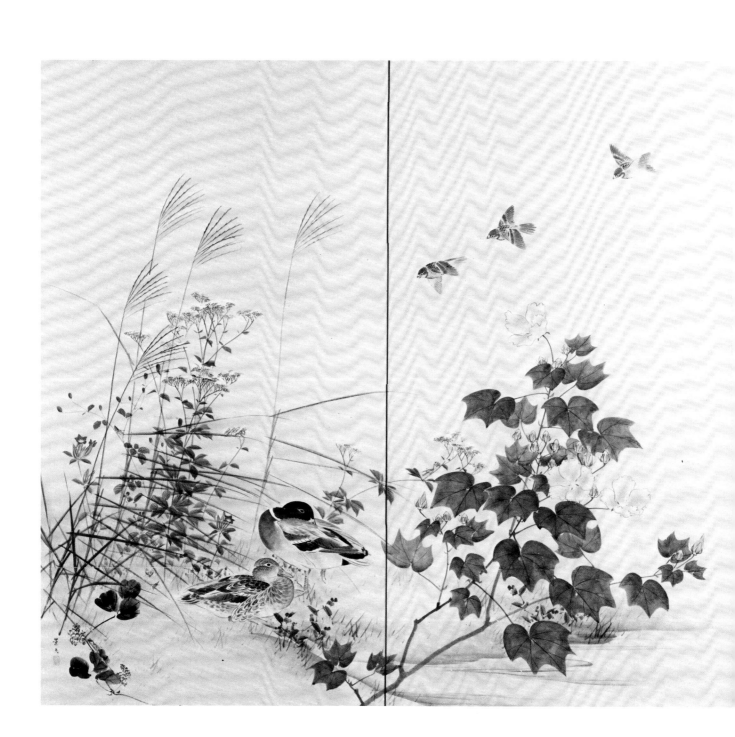

Matsumura Keibun 1779-1843

Spring and Autumn

Pair of two-panel screens, ink and color on paper,
 each 155.9 x 174.8 cm., 61³/₈ x 68¹³/₁₆ in.
SIGNATURE: Keibun
SEALS: Keibun Keika (?)
PUBLISHED: Takeda Tsuneo, *Bekkan*, vol. 18 of *Nihon byōbu-e
 shusei* (Tokyo, 1981), p. 145.

Matsumura Keibun's colorful, finished paintings such
as this pair of two-panel screens of fall and spring themes
give little indication that he was an avid, perceptive
chronicler of nature's workings. Indeed, the highly-
conscious assemblage of various flora and birds in dis-
crete, attractive units across the surface of the screens
challenges the viewer's sense of true naturalistic ex-
perience, as does the startling seasonal gap between
the screens themselves. Spatially and temporally these
compositions invoke a curious, recreated landscape,
whose components Keibun included in numerous similar
compositions, but whose apparent sense of "reality"
lies in a terrain quite removed from, for instance,
Morikage's *Hollyhock and Sparrows* (No. 4).

A small group of notebooks containing detailed
life sketches attest to Keibun's early absorption with
the fascinating minutiae of the plants, animals and
birds of everyday existence. Beginning when he was
twenty-four, he compiled nearly seven hundred pages
of remarkable ink sketches which extend in date until
his sixtieth year, five years before his death. Flowering
plants and trees are the predominant subjects, although
birds, some insects, fish, shells, turtles, and even an
odd single sheet of a flintlock rifle are included. Clearly
Keibun was preoccupied—like Kano Tan'yū (1602-1674),
Watanabe Shikō (1683-1755), Ōgata Kōrin (1658-
1716), and Maruyama Ōkyo—with developing his finest
compositions based on verisimilitude as observed and
recorded in his field notebooks. Thus, for example,
Keibun's notations indicate not only the various aspects

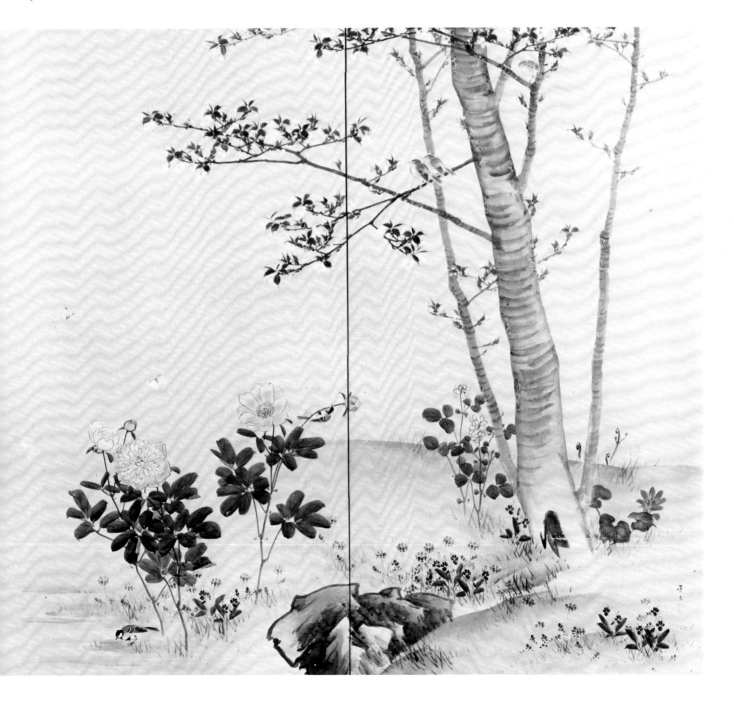

of a camellia or hydrangea blossom, but also its numerous states of budding, the time of year/month/day, and the colors of the plants. Composite settings for the plants or entire flowering branches appear rarely.

Okyo followed a similar working method, as did Korin, and the influence of both men in this sketch genre is as crucial as that of Keibun's older brother Goshun, from whom he received his initial training. His many hanging scrolls of birds, trees, and flowers in subtle ink washes using a broad flat *hake* brush to produce lyrical passages, attest to Keibun's mastery of the Shijō technique, and can be seen throughout these screens. Indeed he may be regarded as an artist virtually untouched by the Nanga literati techniques although he knew some of these painters personally such as Rai San'yō (No. 58). Instead he took heed of the Rimpa and individualist tendencies. The specific idiosyncracies of Hoitsu (Nos. 13, 14), Kiitsu (Nos. 15, 16), and Jakuchu (No. 68) appear in Keibun's more decorative compositions on *byōbu* or, for example, panel paintings for a palanquin in the Myōhō-in. Unfortunately, few of these works can be dated reliably.

Like this pair of screens, Keibun's hanging scrolls depart from Goshun's techniques, themes, and feeling to a considerable degree, although this pair represent an intermediate stage in that passage. The distinctive groupings of major and minor pictorial elements with a generous breadth of space allocated to the more significant plants, reflect Keibun's study of Rimpa design methods and the possible tensions therein. Angular maskings couple with lithe, absorbent brush lines, and washes heighten such contrasts, as well as serving frequently as transitional motifs across the painting surface. While this immediate decorative appeal possesses an ancestry dating back at least to Muromachi era large screen painting, it probably never enjoyed the genuinely popular acclaim evident in the late eighteenth to early nineteenth centuries when artists such as Keibun, Hōitsu, and Jakuchū flourished. Their detailed comprehension of nature's mechanisms were constructed with the utmost care in a seemingly piecemeal, isolated fashion, progressing towards a sophisticated integration of the whole. Such paintings present a new order of heightened reality, somewhat disturbing in their circumscribed, timeless perfection that, paradoxically, is irresistible in appearance.

<div align="right">MRC</div>

REFERENCES:

Lee, Sherman E. *Reflections of Reality in Japanese Art* (Cleveland, 1983), nos. 99, 104.

Sakakibara Yoshirō. *Keibun no shasei-chō* (Kyoto, 1978).

Yamakawa Takeshi. *Kachōga: kachō, sansui,* vol. 8 of *Nihon byōbu-e shūsei* (Tokyo, 1978), pls. 86-91.

Shiokawa Bunrin 1808-1877

Boating Party and Farmers 1865

Pair of six-panel screens, ink and color on paper,
 155.6 x 164.6 cm., 61¼ x 143½ in.
SIGNATURE: Painted in the summer of 1865 by Sensei Tōsai,
 Shio Bunrin (right)
 Painted by the *kachiku* old man, Shio Bunrin (left)
SEALS: Shio Bunrin, Shion (right)
 Shio Bunrin, Shion (left)

A most fascinating aspect of Shiokawa Bunrin's oeuvre is its surprising range, both stylistically and thematically. Just when one becomes accustomed to his expansive large screen compositions depicting Chinese pavilions set on high mountains amidst the clouds, an equally compelling *yamato-e byōbu* pair appear. These, too, characteristically employ broad seasonal vistas of mountains or shorelines inhabited by only a meagre number of figures. Typically such works possess a sense of clarity and precise compositional organization that bespeak Bunrin's familiarity with Maruyama-Shijō painting canons, including an awareness of Western perspective and lighting techniques that presage the dramatic effects of such Meiji period (1868-1912) artists as Hashimoto Gahō (1835-1908), Kanō Hōgai (1828-1888), and Mori Kansai (1814-1894), Bunrin's successor as head of the Maruyama-Shijō line.

His novel treatment of customary *emakimono* themes in the *otogi zōshi* genre as major *byōbu* subjects or the number of lyrical, evanescent glimpses of quiet mountain streams mark him as one of the more original and underrated painters of the nineteenth century. Bunrin studied with Okamoto Toyohiko (1773-1845), a well-regarded third-generation Maruyama-Shijō school follower whose forte was bird and flower subjects, usually modest in scale. Bunrin also painted a large number of hanging scrolls, but it is noteworthy that he frequently bypassed the favored school subjects to focus on the landscape theme in this format. These paintings are often Chinese vistas of towering peaks reminiscent of Northern Sung (960-1126) formulations or of one of their more recent interpreters such as Tani Bunchō (No. 52).

Bunrin's predilection for the *byōbu* format appears to have been founded on his careful study of the paintings of Ōkyo, Buson (Nos. 44-46), Goshun (Nos. 75-76), and Keibun (No. 77). Indeed, his more imaginative efforts rely on the Maruyama-Shijō artists for determining dramatic concepts of scale and space, while looking to the Nanga painters in addition for figural models. In particular, his imposing Chinese figural screen paintings reflect an examination of early Buson paintings of historical personages. These delightful screens reiterate his reliance on Buson's abbreviated,

engaging characterizations, although with an even more cursory manner consistent with a contemporary, popular subject.

Free of any moralistic undertones, these *byōbu* portray a ferrying scene, probably on one of the several rivers leading to Kyoto. The occasion is surely a festival or special holiday in which individuals of all social and economic stations took part, especially in summer. Bunrin's obvious delight in portraying the varied figures in the boat—their attire, gestures, possessions, and different ages—is wonderfully conveyed by the verve of his brushwork. The dramatic scale of the boat placed across all six panels of the left screen has its counterpart in the horizontal sweep of the landing area accented by the stubby willow tree in the adjoining *byōbu*. There, the expectant expressions of the waiting figures mirror the anticipation in the faces of the peddlers, entertainers, and travelers in the boat as they approach the shore.

The engaging ambience of these screens invokes that peaceful, carefree attitude of earlier sixteenth and seventeenth century genre and *ukiyo-e* painting subjects. Such classical *yamato-e* themes and stylistic mannerisms enjoyed a revival in the eighteenth and nineteenth centuries, culminating in the work of Tomioka Tessai (1836-1924), but due credit should be paid to Bunrin's role as a predecessor.

MRC

REFERENCES:

Kyoto Shiritsu Bijutsukan. *Kyoto gadan: Edo-matsu Meiji no gajintachi* (Kyoto, 1975).

Stern, Harold. *Birds, Beasts, Blossoms, and Bugs* (New York, 1976), no. 77.

Takeda Tsuneo. *Bekkan*, vol. 18 of *Nihon byōbu-e shūsei* (Tokyo, 1981).

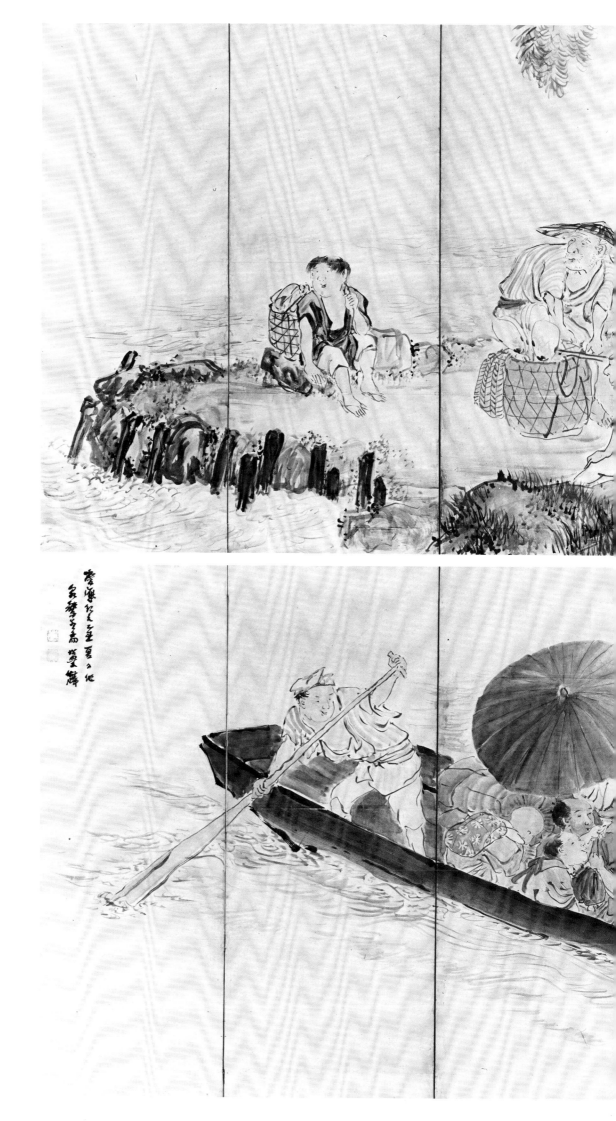

雲濤に浴する童叟の他
谷峯を行舟　雪鱗

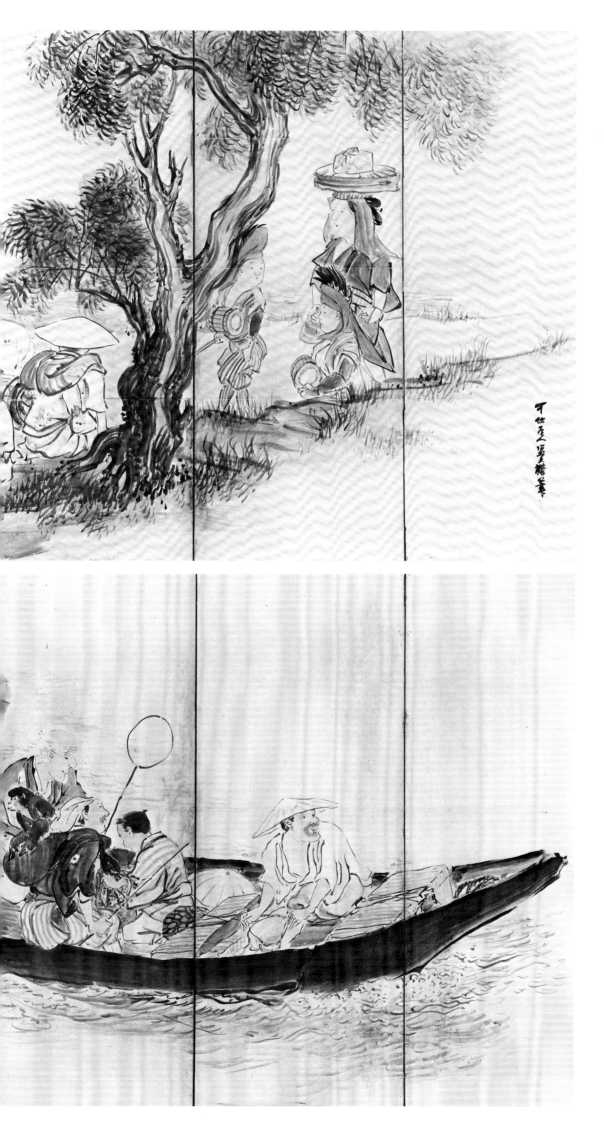

237

Shibata Zeshin 1807-1891

Samurai by the Bridge 1888

Hanging scroll, ink and color on silk, 44.1 x 54 cm.,
 17⅜ x 21¼ in.
SIGNATURE: Tairyukyo Zeshin
SEAL: Ima hachiju ni (Now 82 [years old])

Shibata Zeshin is perhaps the best-known nineteenth-century Japanese artist in the West, due principally to the fame he gained at the international expositions in Vienna (1873), Philadelphia (1876), and Paris (1889), and to accounts of his prodigious talents as a master lacquerer. Judging from the sheer numbers of known surviving works, he was an indefatigable artist who produced an astonishing array of lacquer wares, ceramics, woodblock prints, and paintings well into his eighties. Evidently he also had the assistance of a group of well-trained apprentices and professional artisans, who labored for him in what must have been Edo's most celebrated artisan studio.

Zeshin himself began studying the art of lacquer at a very young age with a distinguished master whose family was employed at the Shogunal workshops. Zeshin's technique quickly became first-rate, nurtured by the patience required in his own family's businesses: the fabrication and sale of small bags and tobacco pouches, and, later, a fan shop. After about seven years of lacquer study, he undertook painting lessons with Suzuki Nanrei (1775-1844), an Edo artist trained in Maruyama school techniques, and Utagawa Kuniyoshi (1797-1861), the renowned *ukiyo-e* artist with whom Zeshin is said to have collaborated on occasion. By 1830 Zeshin had moved to Kyoto, establishing himself as a pupil of the Shijō painter Okamoto Toyohiko (as had Bunrin, see also No. 78). Zeshin studied Buddhist painting, as well as Japanese and Chinese history and literature, produced a number of notebooks containing sketches from life, and executed a few paintings, the most notable of which are the sixteen *fusuma* panels of Chinese figures and flower subjects at the Daiyū-in, Myōshin-ji (ca. 1832).

By the fall of 1832 Zeshin returned to Edo, established his studio *Tairyūkyō*, and began a period of intensive study of *haiku* and the lacquer techniques of his predecessors, beginning with the early Rimpa artists. This involvement took him to the superb lacquer collections at the temples and shrines of Nara, and led him to retrace Bashō's (1644-1694) famous journey on the "Narrow Road to the Deep North" (*Oku no Hosomichi*). It also stimulated a series of revivals and genuinely new discoveries in lacquer techniques which settled unequivocally his stature as the preeminent lacquer artisan of Edo. His success came despite a series of personal and financial setbacks amid the early unsettled years of the Meiji Restoration (1868). His rising stature both as a contemporary artist and a judicious arbiter of classical traditions, who also encouraged the industrial arts, was marked by a reluctantly accepted Imperial commission in 1872 and an invitation to participate in the Vienna exposition in 1873. Zeshin received his most exalted honor when he was named Court Artist by the Emperor in 1890.

Of the artists who shared this honor with him, Zeshin was the only lacquerer. However, he also painted extensively—with lacquer as well as ink and color, on all formats and in varying scale—as can be seen in this painting. It depicts a nighttime scene in which the Kamakura era samurai Aoto Fujitsuna is seated on a rock beneath a willow tree watching two laborers probing the shallows of a river. They have in fact been engaged by the samurai to search for money entrusted to him which he lost crossing the bridge, seen in the background. The painting serves as a visual metaphor of the parable in which the coins are ultimately retrieved, but at greater expense to the samurai than the original amount of money—a reminder of *busshi* (warrior) integrity.

Zeshin painted comparable subjects infrequently, preferring everyday genre to historical parables, sometimes rendered in an uncanny melange of Western and Japanese techniques and effects. He clearly enjoyed telling a story in his paintings and prints rather than playing upon the expressive, dramatic gestures of brush and ink, a departure from his Shijō and *ukiyo-e* contemporaries. His striking arrangement of compositional elements with intriguing spatial relationships is a hallmark of his finest designs, and is evident here in a tentative, amusing way. The whimsical incorporation of two gold lacquer coins into the roller ends enhances the scroll's basic decorative appeal.[1]

MRC

1. The right knob bears the incised signature "Zeshin" which indicates the lacquered coins are by the master.

REFERENCES:

Gōke Tadaomi. *Shibata Zeshin*, vol. 93 of *Nihon no bijutsu* (Tokyo, 1974).

Gōke Tadaomi, ed. *Shibata Zeshin meihinshū* (Tokyo, 1981).

Honolulu Academy of Arts. *The Art of Shibata Zeshin* (Honolulu, 1979).

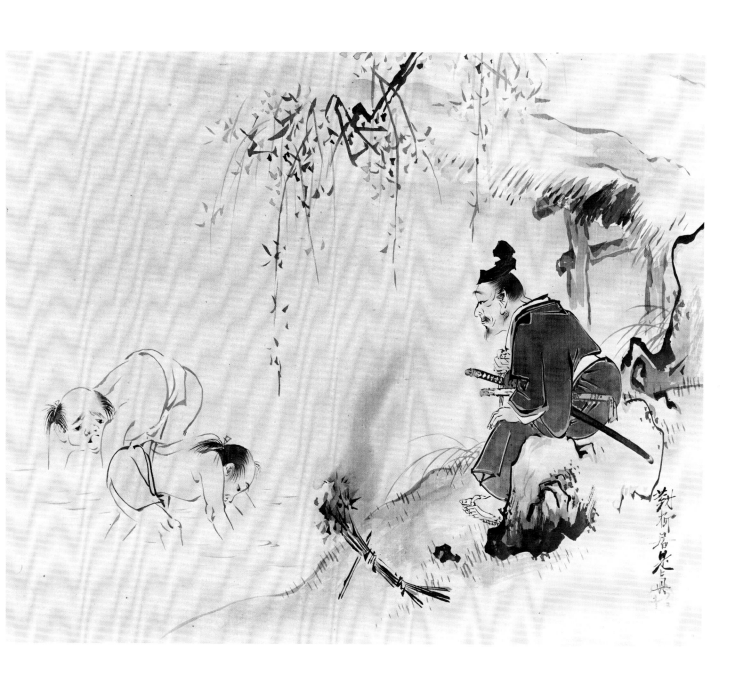

239

CERAMICS

Ceramics have held a unique place in the expression of the spiritual and aesthetic aspirations of Japanese culture as it has evolved over the centuries. There is an admiration for ceramics among Japanese that was perhaps first born in the mystery of the flames which magically turned slippery mud into a hard, durable product, in the mystery of the unlimited potential for shaping which, like the Jōmon period pots, could bring life to thoughts too enigmatic to express in words.

The fabulously modeled pottery wares of the prehistoric Jōmon were the earliest manifestation of a continuing history of art in ceramics—whether sacred or secular—which remains vigorous today. No other civilization, perhaps, has had such a tenacious attachment to ceramics. The appreciation for nature and natural materials, for ritual purification that was fostered by Shintō might well be the original source of this fascination. It is a fascination with the shaping process of the potting, that extension of the human spirit and hand and arm into the materials. It is a fascination with the supernatural power of the action of the flames in the kiln—those special forces inside the kiln that transform clay and water into stoneware, that create shining, colored glazes, often fortuitously and upredictably. It might be said that the potters were the unwitting alchemists of Japan, turning base substances into treasures the equal of gold.

The Gitter collection of Japanese ceramics, while not encyclopedic, contains many exceptional examples. These center on the stonewares of the medieval period and their succesors, the folk wares of the Edo period. Of the primitive types, only the Yayoi period *hajiki* jar represents these ditch-fired, unglazed ceramics of prehistory. The surprisingly fluid grace of this jar, however, imparts a sophisticated elegance that, like many other Japanese ceramics, belies its great antiquity.

The medieval stonewares in the collection, as a group, range from the highly sinified Ko Seto ware bottle, or vase, to the handsome Shigaraki and Tamba ware storage jars. The survival of these jars is an eloquent tribute to the peasant-potters who transmitted to these rugged forms the energy of their own bodies and tempered their designs with their intimate knowledge of nature and the cycles of the seasons. These pots are living symbols of the immutable spirit of the ceramic art of Japan.

The Bizen ware seed jar, like the storage jars, was a type developed in response to agricultural needs beginning in the late Heian period. As an extension of these peasant pots into sophisticated society, the tea men of the sixteenth century converted some, like the seed jar, to their own uses. They found in them a sincerity and natural simplicity that personified the ideals they were shaping in the tea ceremony. A number of the Gitter collection ceramics richly reflect the essence of this uniquely Japanese institution, the cult of ceremonial tea. Perhaps the premier piece is the Iga ware *mizusashi*, or cold water jar, which embodies much of the highly intuitive aesthetic that focused not only on function within the ceremony, but also on the nuances of color and texture of glazes and ceramic body and on the intricacies of shape in an amplification of the philosophy of tea.

A second major grouping in the collection features utilitarian wares of

the Edo period. These humble pieces were designed and executed by anonymous artisans who masterfully blended utility with charming, sometimes dramatic, design. Pots and plates like the jar from the Yumino kiln in Kyūshū, or the Seto ware oil plates and serving dishes, project a naive charm amid a rustic simplicity that has endeared them to folk art collectors and admirers of Japanese ceramics throughout the world.

A final selection focuses on the art of one of Japan's greatest artists of this century, Kitaōji Rosanjin. A supremely talented man, he was during his lifetime regarded as a noted calligrapher, seal carver, painter, lacquer designer and, above all, a renowned gourmet of Japanese food. Today, Rosanjin is perhaps best remembered for his ceramics; his appetite for design was as limitless as his love of good food. The Gitter collection contains an extraordinary number of fine Rosanjin ceramics; in particular, there are pieces inspired by traditional wares like Shino, Oribe and Bizen.

The Gitter collection stonewares, tea ceramics and Rosanjin pieces form a superior and impressive sample of some of Japan's finest ceramics. They provide an excellent platform from which to view in part the continuing flow of Japanese ceramic history, and bring to the public a fine array of choice examples of a uniquely Japanese art form.

WJR

80 Jar 4th century
(tsubo)

Haji ware *(hajiki)*
Unglazed pottery, 36.7 x 32.7 cm., 14-7/16 x 12-5/16 in.

Haji ware, or *hajiki*, was produced in a major way over a period of seven hundred years, from the fourth to the eleventh century. It was a reddish, unglazed pottery that was simply fired in ditches in an oxidizing atmosphere. The ware, although associated with many historical periods, emerged from the traditions of Yayoi pottery. Throughout its long history *hajiki* was prepared largely by hand—whether modeling miniature pieces in the palm, or building pots with coils of clay which were then smoothed with a spatula. After the introduction of Korean ceramic technology in the fifth century, the shapes and the use of the potter's wheel were eventually incorporated into the production of *hajiki*.

Hajiki retained the utilitarian character that had been the hallmark of the Yayoi period pottery, in which function dictated form and decorative enhancement was limited or used sparingly. The Yayoi wares of central and northern Honshū, however, continued to reflect an interest in surface elaboration that was reminiscent of the taste for dynamic decoration so strong in the previous Jōmon culture.

The sense of regional difference which appeared so markedly in Jōmon and to a lesser degree in Yayoi pottery wares was greatly diminished in *hajiki*. The emphasis was rather on serviceable, standardized vessel forms. Regional types appeared, inevitably, but the shapes became more uniform as time passed, and there was a similarity in the type of clay and the appearance of fired wares extending from Kyūshū to the Kantō area. This uniformity is regarded as a reflection of the increased measure of political unity in the settled, agricultural society that gradually evolved from northern Kyūshū eastward along the Inland Sea to central Honshū. This unification was accomplished by the clans in the fertile Yamato plain, known as the Kansai or the Kinai district which centers around modern Nara and Ōsaka. These clans succeeded in establishing a controlling authority reaching south to Kyūshū and to the northeast. Under their leadership, this Kinai district became the home of a culture which grew up around the metal technology and tomb-building customs borrowed from southern Korea sometime after the middle of the third century. Their culture flourished in the rich Yamato plain supported by the cultivation of rice—a wet paddy technique originally introduced with the Yayoi peoples about the middle of the third century B.C.—under the control of a strict hierarchical aristocratic society.

The tombs became a prominent distinguishing trait of the age and have given this time the name by which it is known in history—the Kofun period. The prodigious size these tomb mounds reached by the fifth and sixth century manifestly describe a regal majesty and express the great political power available to the Yamato rulers. In a clear indication of the Yamato leadership position, the tomb-type eventually spread outwards to northern Kyūshū in the west and to the Kantō in the east.

The exact date for the emergence of a true *haji* ceramic distinct from earlier Yayoi types is difficult to pinpoint, but archaeologically, the appearance of unique, small-scale, round-bottomed pots represents the full emergence of *hajiki* standards. The earliest examples recovered in the Kansai area date to the fourth century. A transitional period existed between the end of the true Yayoi pottery types and the fully developed *hajiki* which spans the late third and early fourth centuries. During this period, there was a distinct loss of decoration, and the shapes became rounder, smoother and appear to be made with thinner, almost brittle bodies. Illustrated transitional examples dated to the late Yayoi period come from western Honshū and similar pieces excavated in the Kansai area are identified as *hajiki* of the fourth century.

Hajiki, as descendants of the utilitarian Yayoi pottery wares, remained the everyday ware useful for the storage, cooking and serving of food. After the introduction of high-fired stonewares from Korea in the second half of the fifth century, the *hajiki* served in tandem with the new *sueki*, or Sue ware, to meet the ceramic needs of the populace. These Kofun period *hajiki* were less carefully formed than the Yayoi wares from which they sprang and, after the middle of the seventh century, as the demands for the utilitarian wares grew, the workmanship became increasingly cursory, and the shapes and finishes reflected the mass-produced quality of the work. At the eighth century Heijo palace site at Nara, for instance, some 50,000 pieces of *hajiki* were recovered, an indication of the popularity of this reddish pottery ware. After the seventh century, the potter's wheel, introduced with the *sueki* technology from Korea, was used to produce bowls and plates of *hajiki*, and *sueki* shapes became mixed with the customary *hajiki* forms.

The Gitter collection jar has been tested at the Oxford Research Laboratory for Archaeology and the History of Art (Ref.: V12.81a), and the thermoluminescence analysis revealed that the piece can be dated between the first and the eighth century. It is reassuring to know that this striking jar is indeed of ancient manufacture; however, the changes which

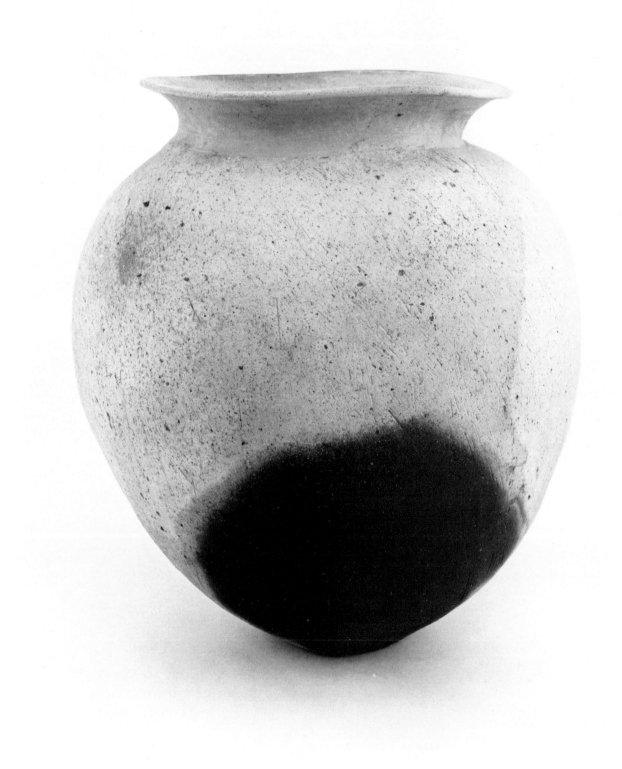

occurred in Japanese ceramics during this space of time present some perplexing questions as to a more precise dating for the piece. When the progression of the style of pottery wares during those eight centuries is examined, the jar seems naturally to find its place at the transitional stage at the end of the Yayoi and the beginning of the Kofun period in about the fourth century.

The Gitter jar shows a smoothly-finished. fine-grained, sandy body with a small and unstable base, and is undecorated. These are characteristics which place it in closer relation to the transitional examples from the late Yayoi, in particular from western Honshū, yet suggest it is not greatly removed from a jar found at the Furu type-site at Tenri city near Nara and dated to the fourth century. Of particular interest is the jar with incised geometric decoration (chokko-mon) about the neck and dated to the third century. This jar comes from a site near modern Kurashiki city, about mid-way between northern Kyūshū and the Kansai area, and Professor Narasaki has called it typical of the earliest style of hajiki in western Japan.

The supple movement of the line of the body reveals the hand-building technique of smoothing coils of clay typical of the early examples, showing no influence of the iron-hard line imparted by the mechanical turning of the potter's wheel of the sueki. Also, the lack of comparable examples among sueki of the sixth and seventh centuries would indicate a relationship to earlier, less standardized forms and a separation from the later phases of this extremely long-lived pottery.

There is a personal warmth to the jar, recalling the individual nature of the Yayoi creations, and a delightfully varied color to the body. The fortuitous appearance of different shades of buff and reddish-tan and the dramatic patch of black from the fire animate the delicate texture of the minutely worked body surface. There is a rather jaunty nonchalance about the lightly wavy lip that turns back with such effortless ease — a feature undoubtedly difficult to master in this medium. Altogether there is both a sense of discrete identity that ties this piece to the imaginative Yayoi wares and a simplified, understated reserve that forecasts the uniformity of Kofun period hajiki.

WJR

References:

Kidder, J. Edward. Early Japanese Art, the Great Tombs and Treasures (Princeton, 1964).

Kōraku Yoshimichi. Yayoi doki. Nihon no genshi bijutsu, vol. 3 (Tokyo, 1979), cf. pl. 84, 89, 98; pp. 38, 40, 42, 72 ff.

Narasaki Shōichi, ed. Hajiki, Sueki. Genshoku aizōban Nihon no tōji, vol. 1, Kodai chūsei-hen (Tokyo, 1976), cf. pl. 1, 9, pp. 113 ff.

Sansom, George. A History of Japan to 1334 (Stanford, 1958).

Tokyo National Museum. Nihon kōko-ten, Kōko-gaku: kono 25-nen no ayumi (Tokyo, 1969), cf. no. 163.

81 Vase 13-14th century
(mei-p'ing)

Seto ware

Stoneware with incised decoration and ash glaze, 28 x 17.5 cm., 11-1/16 x 6-7/8 in.

PUBLISHED: Huntsville Museum of Art, *Art of China and Japan* (Huntsville, AL, 1977), no. 286.

The technology to produce high-fired stone-wares came to Japan from Korea in about the mid-fifth century. These new techniques included the potter's wheel and a new type of kiln which could achieve higher temperatures than previously possible. An important aspect of this new technology was the knowledge to select appropriate clays that were pliable enough to maintain the symmetrical, attenuated shapes fashioned on the potter's wheel and refractory enough to withstand the increased temperatures of the kiln. These ceramics, known as *sueki*, were for centuries the prestige wares, serving ritual and religious needs and eventually providing utility wares for the elite. The main area of production was originally in the Kinai district, the "home provinces" of the Yamato ruling class, and eventually stoneware production spread throughout Japan.

It was once believed that these *sueki* kiln centers were essentially uniform and that they provided the initial impetus for the development of the medieval stoneware kiln centers that developed beginning at the end of the Heian period. The investigations of Professor Narasaki Shōichi, of Nagoya University, have shown, through archaeological survey at the kiln complex in the Sanage mountains east of Seto in Aichi prefecture, that, by the Nara period, a distinctive stoneware was being produced at Sanage which was influenced by Chinese technology and standards and was essentially different from *sueki*. This complex of kilns became the source for other kiln development in eastern Japan, the Tōkai region.

Out of this ancestry at Sanage of ceramics thrown on the wheel, covered with ash glazes and baked in high temperature kilns, there arose in the Kamakura period several stoneware kiln groups. The one which grew up around Seto produced intention-ally glazed ware sometimes known today as Ko Seto, that is, old *(ko)* Seto, to distinguish them from later production. There were many areas where new stoneware-producing centers sprang up around the country, beginning in the late Heian period, to cater to local agrarian needs. It was only at the Seto and at the nearby Mino kilns, however, that the wares were intentionally glazed (see Nos. 81-86). Early Seto wares were small-scale food vessels, vases and objects for religious uses and were aimed at the elite classes. Further, the location between the seat of imperial power at Kyoto and the new capital of the Shōgun at Kamakura imposed special demands on Seto area potters, and many of these early Seto ware pieces reflected contemporary Chinese styles.

The earlier Sanage kilns had produced wares reflecting Chinese influence; however, regular contact with China—abandoned in 894—was once more encouraged in the late Heian period, and interest in Chinese wares quickened. Chineses traders began visiting Japanese ports again, particularly those in Kyūshū, where Chinese merchants are reported to have been in residence. This interest in trade with China led Taira no Kiyomori (1118-1181), a military commander powerful at court who virtually ruled Japan from 1165 until his death, to establish the port of Fukuhara (modern Kōbe) in order to develop shipping along the Inland Sea routes and to encourage contact overseas. Later, the Kamakura period Shōgun Minamoto no Sanetomo (1192-1219) is said to have invited a Chinese to design a large ship. The project, however, was abandoned. The story suggests the strength of the renewed interest in the China trade, and imports of silk, brocades, medicine, perfumes, incense and precious woods have been reported.

Religious pilgrims also traveled to China where they found inspiration in philosophy and literature. They also brought back to Japan ink paintings, ceramics, and a new type of tea which were to prove influential on developments in Japanese culture. The priest Eisai (1141-1215) traveled twice to Sung dynasty China and it was he who introduced recreational tea drink-ing to Japan. In 1191, he returned from his second visit, bringing seeds of the tea plant with him; he prepared texts detailing not only the blessings of tea drinking, but how to nurture and harvest the plants. His treatise, the *Kissa yōjō-ki*, was reproduced and circulated over many centuries.

The shogunal capital at Kamakura became a potent cultural force competing with Kyoto. Many important temples were built there, one founded by Eisai. Much material was imported from China and over the centuries the beaches of Kamakura have revealed thousands of discarded shards of Chinese stonewares. Many celadons and *Ching-pai* wares, too, have been recovered from graves in the area, and the chronicles of the temples include lists of Chinese ceramics.

The Gitter collection vase is clearly fashioned after the Sung dynasty prototype known as a *mei-p'ing* or plum blossom vase. The narrow opening and the tall shape were thought especially suitable to the display of a single branch of blossom. This is another name for a bottle-type known in Japan as *heishi*. Professor Narasaki identifies two types of *heishi*: this type, with the body dropping in a straight line from

246

the shoulder to a foot of slightly narrower diameter, and another with broad shoulders and a narrow waist with slightly flaring foot. Kamakura period Seto ware had a strong emphasis on religious vessels, and these *heishi* were used in pairs to hold *saké* at Shintō alters, or, with the neck broken away, for ash and bone in burials. The restoration of the neck of this piece suggests its probable use as an ash urn. Seto ware of the succeeding Muromachi period featured everyday objects, especially things for the tea ceremony.

Early Seto ware *heishi*, like this example, were formed by a combination of building with coils and by wheel-throwing, in which the body is built up of coils of clay, and the neck portion is formed on the potter's wheel. Small-scale pieces seem to have been entirely wheel-thrown. The simple ash glaze has fired a soft, pale brown color—the dead leaf brown so much admired by ceramic enthusiasts of later centuries. Examples of the fourteenth and fifteenth centuries were often covered with a dark, iron-brown glaze. Elaborate overall incised or moulded decoration also later replaced the simple incised bands at the shoulder, as seen on this early piece. The neck shape, too, became thicker. The unexpected trail of bright blue down the front of this vase, caused by some accidental impurity in the glaze, adds a touch of excitement to this otherwise elegantly subdued piece.

WJR

REFERENCES:

Cort, Louise Allison. *Shigaraki, Potters' Valley* (Tokyo/New York/San Francisco, 1979), pp. 20-22.

Hasebe Gakuji. *Shōrai bijutsu (tōgei)*. Genshoku Nihon no bijutsu, vol. 30 (Tokyo, 1972), cf. pl. 56, pp. 175 ff., cf. figs. 11, 13.

Koyama Fujio, ed. *Japanese Ceramics from Ancient to Modern Times* (Oakland, 1961), cf. pl. 17.

Mikami Tsugio. *The Art of Japanese Ceramics* (New York/Tokyo, 1972).

Narasaki Shōichi, ed. *Seto, Mino*. Genshoku aizōban Nihon no tōji, vol. 3, Kodai chūsei-hen (Tokyo, 1976), cf. pl. 3, 4, 9, pp. 133 ff.

Narasaki Shōichi, and The Zauho Press, eds. *Nihon chūsei*. Sekai tōji zenshū, vol. 3 (Tokyo, 1977), cf. pl. 5, 6, 115, 119, 120, pp. 158 ff.

Tokyo National Museum. *Tōyō kobijutsu-ten: Kubosō korekushion* (Tokyo, 1982), cf. no. 34.

82 Storage jar 14th century
(tsubo)
Shigaraki ware
Stoneware with slight ash glaze, 48.9 x 45.7 cm., 19-1/4 x 18 in.
PUBLISHED: Huntsville Museum of Art, *Art of China and Japan* (Huntsville, AL, 1977), no. 287.

83 Storage jar 15th century
(tsubo)
Shigaraki ware
Stoneware with mat ash glaze, 47 x 40.7 cm., 18-1/2 x 16 in.
PUBLISHED: Kawahara Masahiko, et al., *Tsuchi to hi no happyaku-nen: Shigaraki-ten*
(Tokyo, 1979), no. 20.

84 Tea jar 16th century
(cha tsubo)
Shigaraki ware
Stoneware with slight ash glaze, 32.2 x 29.8 cm., 12-11/16 x 11-3/4 in.

New ceramic centers producing stonewares arose during the late Heian period and emerged as distinctive regional types during the Kamakura period. Many of these kiln centers traced their origins to the long-lived *sueki* traditions which had originally entered Japan during the Kofun period (see No. 80). With the exception of the wares produced at the kilns around Seto (see No. 81), these new wares were unglazed, or only accidentally glazed during the long periods of firing when ash would settle on the surfaces.

These wares had developed in response to the agricultural needs of the peasants as the feudal estates system *(shōen)* grew up and as farming techniques improved and greater control was exercised over crops. This led to the intensification of land use in two-crop seasons, and safe, long-term storage became imperative. Large jars called *tsubo* and *kame* developed in response to these needs. The *tsubo* were of different sizes, but were typically tall, shouldered jars, large enough to contain a substantial amount of food. The *kame*, with its wide, open mouth was developed for liquid storage. One special use for *kame* was to store wastes to be used as fertilizer. Naturally, a handy jar was put to any convenient use, and there are many excavated examples of such jars used for the ritual burial of sutra texts or the interment of human ash and bone.

A third shape typical of the medieval stoneware kilns was the *suribachi*. This was a grinding dish which was essentially a deep, often wide bowl, which before firing was scored across the interior and given a pinch along the rim to form a pouring lip. The two jar-types were not unknown among earlier ceramic production, but the appearance of the *suribachi* signaled a change in eating habits. This was related to the introduction of new ideas in food from China with the visits of Zen priests during this time, and might be said to indicate a rise in the standard of living among the populace.

The wares produced at the kiln center which developed along the Shigaraki valley southeast of Kyoto have come to represent to many collectors the classic medieval stoneware. Some *tsubo*, in particular, display an awesome sense of permanence. The typical methods at medieval stoneware kilns of building the jars in sections with coils of clay which were then compacted and smoothed by hand, were also followed at Shigaraki kilns. Among early Shigaraki jars, this method imparted a singularly rugged appearance, often charmingly awkward, and speaking strongly of the potting process. The brawny stance of many Shigaraki pieces was in part the result of this forming method, but also resulted from the unique manner in which the clays reacted to the heat of the kiln and the chance accumulations of ash and resultant touches of glaze.

The *anagama* kilns were originally tunneled out of the slope of a hill. Later a trough was dug along the slope, roofed over and plastered with fire-resistant clays. The sandy bodies of the Shigaraki wares contained a large percentage of granules of feldspar which, incompletely melted in the firing, remained to dot the surfaces of the finished pots, shining brightly against the dark bodies. After the middle of the Kamakura period, the standards of medieval kilns were essentially established, and the wares fired in an oxidizing atmosphere which admitted air freely to the kiln. This produced in the iron-rich clays colors— ranging from tawny brown, to salmon, to chocolate. The tone depended partly on the location of the piece in the kiln and its relative distance from the flames. Glaze effects, too, were similarly affected and were, of course, dependent on the amount of ash circulating inside the kiln. Often these glaze effects produced dramatic and surprising configurations.

These three examples from the Gitter collection are typical of the production of these kilns during the period of the fourteenth to the sixteenth century. This encompasses the late Kamakura and early part of the Muromachi period of the fourteenth century, the middle Muromachi period of about the first half of the fifteenth century, and the early sixteenth century. The earliest jars often exhibit highly individual characteristics, and a uniform stylistic formula seems impossible to identify. Neck and lip forms vary and, perhaps because the workmen were still part-time farmers and the kilns less well constructed than those of the sixteenth century, the jars often show profound variance from a stereotype of balanced symmetry we have learned to expect of ceramics. Of course it is exactly this unique, individual identity that recommends them so strongly to modern viewers.

Some characteristic *tsubo* dated to the late Kamakura period, like No. 82, do incorporate a flared neck with a smooth, slightly everted lip. The line of the broad shoulders, as in this example, suddenly sweeps downward to a narrow foot. The Gitter piece is formed of at least four sections, and the profile swings erratically, due to the imaginative ballooning of one section. This is an effect noted in other similarly dated examples. The color is a subtle, quiet brown tone with darker wandering passages and only a slight haze of kiln-gloss on the upper surfaces. The piece

must have been well protected by other vessels during the firing and in a position where the ash, moving in a fast stream of air, did not settle thickly.

Where the earlier example ballooned with a youthful energy, the somewhat later jar (No. 83), when viewed at certain angles, seems about to dance, gyrating about a central vertical, dipping slightly to one side, where a section began to buckle. Comparable examples of this date exhibit a more standardized verticality than previously seen, and without the incipient buckle of one section, this jar, also, would have seemed more regular in appearance.

The neck—intended to be straight and with a bead-shaped roll to the rim—has been pulled slightly off center by a sag in the shoulder. This tilt reverses the movement of the lower twist and adds to the sense of animation. More dramatic in glaze effect than the earlier *tsubo* (No. 82), there is a considerable deposit of scorched ash across the front which has remained mat, forming rich black patches that melt into mysterious, inky rivulets. The grayish white body is clearly revealed at a chip in the heavy lip and at a scar on the side where the jar was separated from an adjoining pot. The two had become attached during firing, probably when the one section began to sag.

By the late fifteenth century, *tsubo* had more or less straight necks with a rounded, bead-form lip. This small tea jar (No. 84) demonstrates this shift and contrasts markedly with the flattened roll of the lip of the mid-Muromachi period example. Tea jars of this small size and general shape were a popular item beginning in the sixteenth century, and the somewhat irregular placement of the neck opening suggests a rather early date in the linear development of the type. A deep crack opened in the neck during firing.

WJR

REFERENCES:

Cort, Louise Allison. *Shigaraki, Potters' Valley* (Tokyo/New York/San Francisco, 1979), pp. 19 ff.

Mikami Tsugio. *The Art of Japanese Ceramics* (New York/Tokyo, 1972), pp. 115 ff.

Narasaki Shōichi, ed. *Kodai chūsei-hen: Shigaraki, Bizen, Tamba.* Aizōban Nihon no tōji (Tokyo, 1976), pp. 141 ff., cf. nos. 2, 3, 25, 27, 32.

Narasaki Shōichi and The Zauho Press, eds. *Nihon no chūsei.* Sekai tōji zenshū, vol. 3 (Tokyo, 1977), pp. 266, ff., cf. pl. 69, 318.

85 Storage jar 14th century
(tsubo)
Tamba ware
Stoneware with natural ash glaze, 43.8 x 34.2 cm., 17-1/4 x 13-1/2 in.

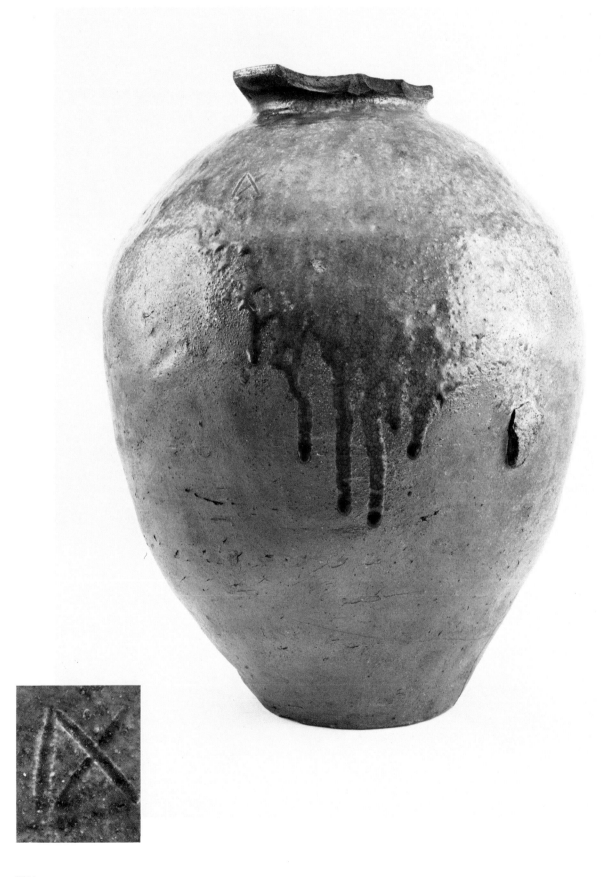

86 Storage jar 14-15th century
(tsubo)

Echizen ware
Stoneware with natural ash glaze, 26.7 x 33.7 cm., 10-1/2 x 13-5/16 in.

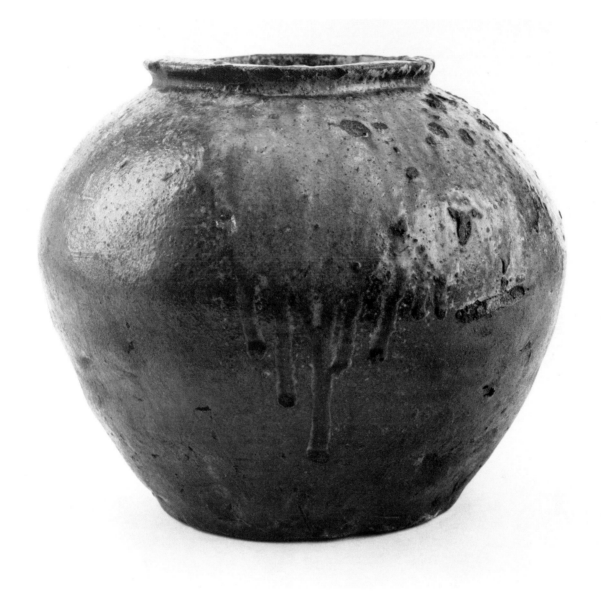

A theory once popular among Japanese scholars and collectors postulated that all medieval stonewares emerged from the earlier *sueki* kiln centers. The loss of aristocratic support at the end of the Heian period, it was surmised, induced a shrinking of the once widespread stoneware producing centers to a small number of regional kilns which were able to survive into modern times producing, for the most part, agrarian utility wares. These were the venerable six old kilns, the *roku dai koyō,* namely the kilns known as Tokoname, Seto, Shigaraki, Echizen, Tamba, and Bizen. Professor Narasaki Shōichi, of Nagoya University has shown, however, that the Seto and Tokoname groups developed from roots buried in a separate stoneware tradition that had grown up in the Sanage mountains near Seto (see No. 81). Further archaeological research in recent decades has revealed many more than six regional medieval stoneware kiln centers.

As was the case for the others of the six old kilns, the name Tamba and Echizen derived from the names for ancient districts where each of these wares was produced. These became collective names for the various wares produced at a number of kilns in the area. Tamba ware was produced in the area that is now Hyōgo prefecture, west of Kyoto, and Echizen wares were produced in Fukui prefecture to the north. Typically, as at all but the kilns at Seto, Tamba and Echizen potters produced unglazed wares in response

to farming needs—the *tsubo, kame* and *suribachi*—and these two *tsubo*, or storage jars, were formed in sections by building the walls of rolls of clay which were compacted and smoothed, the method common to most of these stonewares. Fired in the standard tunnel kiln for long periods, these jars have collected the natural ash glaze which marked many of these pots.

Following the process Professor Narasaki feels was common among kilns in western Japan, Tamba potters continued the *sueki* traditions, eventually changing from the reducing atmosphere which limited the oxygen supply in the kiln to an oxidizing atmosphere which freely admitted air during firing. The focus of production also shifted from ritual forms or utility wares for the elite to meeting agrarian needs. The evidence for Tamba ware development, particularly in the earliest stages during the Kamakura period, is somewhat less explicit than for some wares, but the process seems evident.

Echizen potters, however, received their techniques and ideas from the Tokoname kiln center which had emerged, along with that at Seto, from the Sanage kiln traditions, and many of the early Echizen wares very closely resemble the dark-bodied Tokoname ceramics. In fact, when post-World War II archaeological excavations finally determined the locations of the Echizen kilns, it became clear that many Echizen pieces had been mistakenly identified as Tokoname. The influence of Tokoname wares throughout the whole of Japan was greatly magnified by energetic export of the wares, and early Tokoname jars have been excavated at burials and other sites ranging from the far north of Japan to the southern end of the Inland Sea. The potting techniques of the area were also exported, though the exact method is unclear, to distant areas such as Echizen, and the Sanage traditions, through Tokoname, seem to have been a major source for ceramic development in a wide area reaching from the Hokuriku (which included Echizen) to the Tōhoku region. Professor Narasaki has also suggested some tentative influences from Tokoname were early felt both at the Tamba and Shigaraki kilns.

The large Tamba ware jar exhibits the clear articulation of the three sections by which it was built. Three major portions were connected, and then the neck and lip section was added—after forming on the wheel. This shaping contrasts with the rather haphazard forming of the earlier types, and represents a decided move to more controlled, somewhat standardized shaping. The stout neck with little or almost no space between shoulder and the turn of the lip belongs to the Kamakura period, and differs from the style of the Muromachi period with its greater open space between shoulder and lip. The smartly smacked and stroked surfaces recall other early Tamba wares. A rich accumulation of greenish glaze also suggests the shift in the late Kamakura period to more regularized kiln construction. The natural ash glaze flows with languorous ease over the sloping shoulder.

The jar is given futher individualization by the chunk of another vessel stuck to its side where they touched in the kiln. Such accidents were less likely to occur in later generations. The incised mark, which resembles the Roman numeral IX, is thought to be a mark identifying the potter. This same mark and other similar marks are noted on jars of this time and of the early Muromachi period.

Echizen wares of the fourteenth century frequently display dark brown bodies and murky glazes resembling early Tokoname wares. The Gitter collection example shows a pooling of ash glaze textured with kiln debris which has fallen from the ceiling during firing. The jar is somewhat atypical by its very short neck and overall truncated profile. Professor Narasaki Shōichi, in correspondence regarding this piece, suggests it belongs to that vast number of Echizen pieces almost daily coming to light of which we have previously been unaware. The neck shape and body color seem quite within acceptable limits for a Kamakura period dating. The vigorous, resilient stance of the piece alone would recommend it as a valiant survivor of the perils of time.

WJR

REFERENCES:

Cort, Louise Allison. *Shigaraki, Potters' Valley* (Tokyo/New York/San Francisco, 1979), pp. 20-22, p.56.

Nakanishi Tōru. *Ko Tamba* (Tokyo, 1981), pp. 17 ff., cf. pl. 5, 8, 11-14, fig. p. 171.

Narasaki Shōichi, ed. *Echizen, Suzu*. Genshoku aizōban Nihon no tōji, Kodaichūsei hen, vol. 5 (Tokyo, 1976) pp. 109 ff., cf. pl. 12.

Narasaki Shōichi, ed. *Shigaraki, Bizen, Tamba*. Genshoku aizōban Nihon no tōji, Kodai-chūsei hen, vol. 6 (Tokyo, 1976), pp. 156 ff., cf. pl. 134, 138.

Rhodes, Daniel. *Tamba Pottery, The Timeless Art of a Japanese Village*. (Tokyo/Palo Alto, 1970), pp. 29 ff., cf. pl. 2).

87 Seed jar used as cold water jar for tea ceremony 16th century
(tane tsubo mizusashi)

Bizen ware
Stoneware with degraded natural ash glaze, 18.4 x 16.9 cm., 7-1/4 x 6-5/8 in.
PUBLISHED: Huntsville Museum of Art, *Art of China and Japan*
(Huntsville, AL, 1977), no. 289.

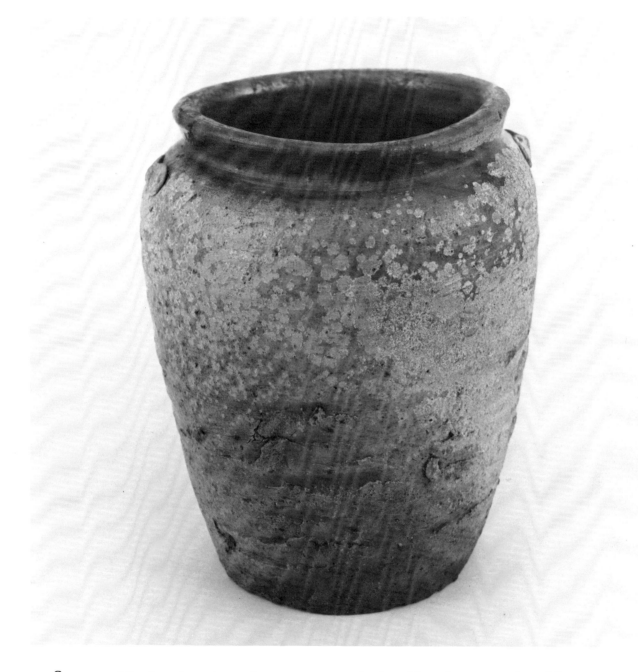

Stoneware kilns have been in continuous operation since at least the Kamakura period in the area known today as Okayama prefecture. Like the other major ceramic centers at Shigaraki and Tamba, this stoneware emerged from ancient pottery types sometime after the end of the Heian period, and the product is known today as Bizen ware after the ancient name of the area. As at the other medieval stoneware centers, production of utility wares for agrarian needs was the main purpose of the kilns during these centuries. However, after the development of the new taste in ceremonial tea wares during

the late fifteenth century, these kilns came to the attention of the tea masters.

The new taste in tea ceremony announced a shift away from the formal qualities reflected in the use of exotic antique wares from China. Murata Jukō (1422 or 1423-1502), as tea master to the Ashikaga Shōgun Yoshimasa (1435-1490), had established the ritual formula for a new concept of tea in *wabi cha* and the four and a half mat room which he developed at the Tōgu-dō in 1486 as part of the Shōgun's retreat, the Silver Pavilion, in the eastern hills of Kyoto.

Prior to that time, Muromachi sophisticated taste

257

88 Tea jar with four loop handles 16th century
(yotsu-mimi cha tsubo)
Bizen ware
Stoneware with slight natural ash glaze, 26.5 x 25.2 cm., 10-3/8 x 10 in.

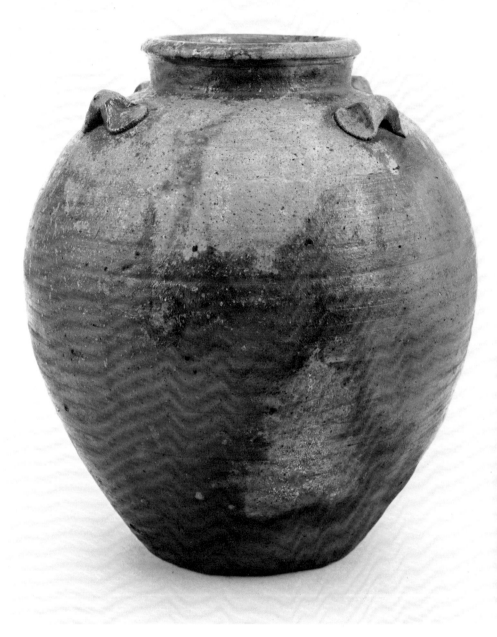

found expression in mirroring Chinese culture—whether accurately or not—and the tea tasting parties of the Chinese courtiers and priests assumed in Japan the form of a codified mode of behavior. The taking of tea gradually assumed the appearance of a ceremonial tribute to connoisseurship and erudition. This formality, however, had often been spiked with sessions of excess of food and drink and even accompanied by uncouth display of wealth when expensive Chinese ceramics, lacquers, bronzes, and paintings were arrayed in gorgeous display and the guests encouraged to indulge to the point of boisterousness.

Takeno Jōō (1502-1555), following in the wake of Jukō, perceived the futility of pursuing a path of brittle formality, and, in addition to Chinese wares, he sought out rough domestic wares, the jars and bottles created to meet farmers' needs, and converted them to the purposes of ceremonial tea. Jōō's move into rough and unassuming wares for the tea ceremony marked an advance into an uncharted void which eventually generated a uniquely Japanese expression of aesthetics and discipline. The hand-hewn quality of peasant wares symbolized the fresh, unpretentious spirit of *wabi cha* that Jōō sought, and wares like Shigaraki,

258

Tamba and Bizen were examined for vessels suitable to this expression. The *tane tsubo* shape was one of those seized upon and pieces like this example proved suitable for use as *mizusashi* when fitted with a lid. Other examples might become flower vases.

The Bizen ceramics were formed of a finely divided clay that lent itself to manipulation and produced smooth surfaces. The outer surfaces were sometimes dusted with natural ash glaze from the kiln. The settling ash during firing produced a characteristic caramel colored spotting, known among Japanese connoisseurs as *goma-yū*, or sesame seed glaze. These patches and dots of lighter color contrasted pleasingly against rich red-brown stoneware bodies. Sometimes, as in this *tane tsubo*, the natural ash glaze disintegrated, revealing the gray body beneath, leaving a ghost to recall the original accidental glaze effect. The Buddhist lament of the transience of life is evoked by this: it is as well, a reminder of the persistence of homely virtues and the rich visual effect of the passage of time.

At a later date during the Momoyama period, the shape of these farmers' seed jars was imitated purposely to create *mizusashi*. The innocently open mouth and casual distortion of the shape of the body in this example, however, suggest strongly that it began life as a rural utility vessel; later examples were given a lip consciously designed to cradle a lid and the shapes appear to be less spontaneously formed.

In the fifteenth century, successful tea cultivation at Uji near Kyoto gave rise to a greater interest in tea, not only as a form of drink, but as a commodity for commerce and taxation. A need for jars to store tea leaves securely and attractively led to the development of specific shapes and sizes for transport, storage and display. This small-scale jar is recognizable as a tea jar by the four lugs or ears about the shoulder intended for a lacing of ties to insure freshness and secure the seal against damp and vermin. The neatly raised neck and bead-form lip indicate the plug arrangement typical for this kind of seal.

This tea jar closely resembles the tea jar type known in Japan as Luzon jars. Actually they came from southern China in the fourteenth and fifteenth centuries, transshipped through the Philippines. They became popular among tea votaries by the name *Ruson-tsubo*. Typically they had the four lugs about the shoulder, and a plain, rounded type, the *ma-tsubo* type, is very reminiscent of the shape and size of this Bizen ware jar. An example very close to the Gitter collection jar which is in the Kubosō collection, Izumi city, Ōsaka prefecture, is said once to have belonged to Sen no Rikyū.

Similar to the mark on the shoulder of the Tamba were jar (No. 85), this *tane tsubo* and *cha tsubo* carry on the undersides incised marks used by the potters to distinguish their wares in the communal kiln firings. The *tane tsubo* has an incised streak of comb markings across the base, and the *cha tsubo* has an incised or impressed circular mark. Both these marks are found on a variety of Bizen ceramics from this period.

These two pieces represent transitional phases of tea ceremony ceramics. The *mizusashi* moves out of the period of "discovered" pieces to the intentional tea ware designs of the Momoyama period as exemplified by the tea jar.

WJR

REFERENCES:

Cort, Louise Allison. *Shigaraki, Potters' Valley* (Tokyo/New York/San Francisco, 1979), pp. 104-106, 109-110, p. 118, p. 130.

Fujioka Ryōichi. *Tea Ceremony Utensils.* Arts of Japan, vol. 3 (New York/Tokyo, 1973), pp. 9-11, pp. 49-52, pp. 80 ff.

Hayashiya Seizō, ed. *Bizen.* Genshoku aizōban Nihon no tōji, vol. 6 (Tokyo, 1974), pp. 122-123, 132-133, cf. pl. 67-70, 141-144.

Hayashiya Tatsusaburo, Nakamura Masao and Hayashiya Seizō. *Japanese Arts and the Tea Ceremony.* The Heibonsha Survey of Japanese Art, vol. 15 (New York/Tokyo, 1974), pp. 11-58.

Koyama Fujio. *The Heritage of Japanese Ceramics* (New York/Tokyo, 1973), pp. 45 ff.

Mitsuoka Tadanari, Okuda Naoshige and The Zauho Press, eds. *Momoyama [I]: Bizen, Tamba, Shigaraki and Iga.* Sekai tōji zenshū, vol. 4 (Tokyo, 1977), cf. pl. 15, 16, 17, 28, p. 275 fig. 19, 22.

Tokyo National Museum. *Tōyō kobijutsu-ten: Kubosō korekushion* (Tokyo, 1982), cf. no. 43.

*89 Cold water jar for the tea ceremony first quarter of 17th century
(*mizusashi*)
Iga ware
Stoneware with incised and impressed decoration and ash glaze, 19.3 x 23 cm., 7-9/16 x 9-1/16 in.
Published: Mitsuoka Tadanari, ed., *Kinki (I)*. Nihon yakimono no shūsei
 (Tokyo, 1981), no. 281.

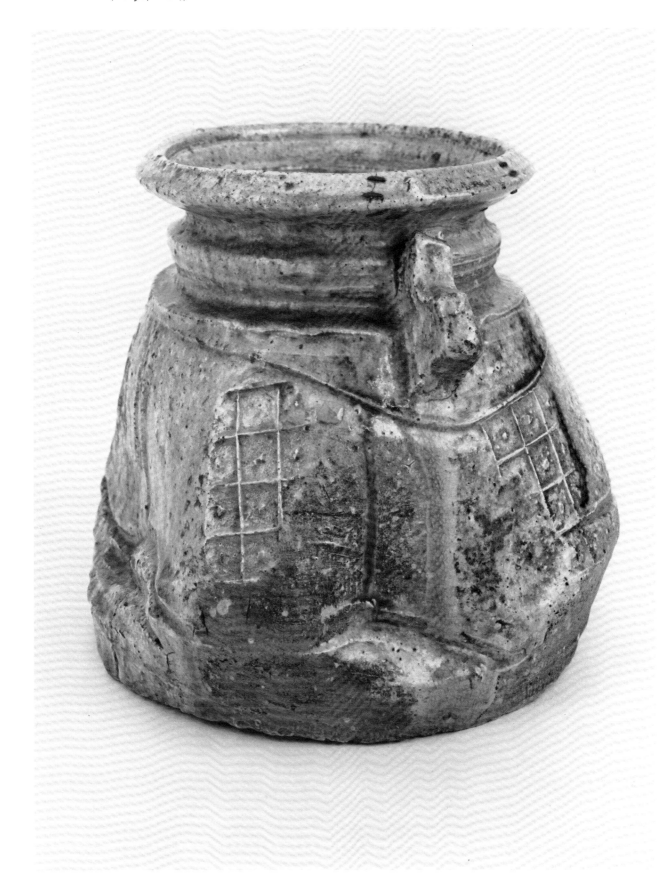

The history of the Iga kilns in the Kamakura and Muromachi periods remains unclear, obscured in part by the ambiguities of ancient political boundaries, uncharted population shifts, and conflicting textual references. More specifically, the potters of both Shigaraki (see No. 82) and Iga, which lay just south of Shigaraki, used clay from the same stratum, and the early medieval wares of the two kiln groups are almost indistinguishable. Iga ware is best known for tea utensils produced during the Momoyama and early Edo periods, and it is here the record of Iga ware production is much better understood.

Iga tea wares came to their greatest renown under the influence of Furuta Oribe during the Bunroku and Keichō eras (1592-1615). Oribe was then the arbiter of tea taste, succeeding his master Sen no Rikyū, as the preeminent figure in the world of tea. Moreover, the peak of Oribe-style tea ware production at Iga might be said to have occurred during the period the area was controlled by the daimyō Tsutsui Sadatsugu. In 1585 Sadatsugu, son-in-law of Oda Nobunaga, was placed in charge of Iga province. An avid tea cultist, he had kilns constructed at Iga Ueno castle to produce tea wares. As a student and close associate of Oribe, it is not surprising that Oribe's taste for dramatic shapes in tea vessels appeared in Sadatsugu's ceramics.

Production at the castle no doubt ceased in 1608 with the removal of Sadatsugu. Kilns in the neighborhood, however, continued production and it is difficult to distinguish exactly the so-called Tsutsui-Iga from contemporary wares made at other Iga kilns. It has been suggested that Oribe himself supervised some of the production, and several pieces have come down through history with notes from his hand. The flower vase known by the name "Nama-zume" is identified by a letter from Oribe as once belonging to him, and the famous mizusashi known as "Yabure-bukuro," (presently in the collection of the Gotō Museum, Tokyo) came down as a densei-hin, or heirloom piece, in the Tōdō family, successors to Sadatsugu. This piece, registered as an Important Cultural Property, also was accompanied by a handwritten note from Oribe until the paper was lost in a fire in 1923.

According to the letter, the yabure-bukuro, or burst-bag shape, was something of an interesting novelty to Oribe. The type had a large, rounded, lower section of the body which was rent by splits and fissures as a full cloth bag would appear when ripped or torn. This effect resulted partly from kiln accidents when the thickly potted pieces reacted to the very high heat of the Iga kilns. Once it was learned that these natural splits might be of interest, other vessels were encouraged to develop cracks and the spatula was used to create lines and deep incisions which could give way to fissures.

Oribe preferred large-scale pieces and exuberant shapes which reflected his own samurai sense of importance and energetic well-being. As a student of

Rikyū, Oribe's dynamic flair was held in check by the prevailing taste of his master, who preferred subdued, unadorned pieces. Once freed of this restraint at Rikyū's death in 1591, Oribe began to encourage local pottery makers, supplying ideas for pieces. In this he was expanding a precedent established by Rikyū, and the brightly colored wares produced at kilns in the Mino area have become known as Oribe ware in an indication of his profound influence on their development. He was equally influential in the development of other tea ceramics at the Mino kilns, such as Shino wares (see No. 90).

Oribe received great recognition at the court of the Tokugawa Shōguns. After the death of Rikyū, there was a discernable shift among the students of tea from the merchant class of Rikyū's generation to the samurai class under Oribe's leadership. Oribe, who had studied with Rikyū, created a style that could hardly have been more different from that of his master. The quiet, secluded wabi cha of Rikyū became colorful, angular, and activated in the Oribe style. The new mood struck an appealing note among the warrior class who found this kind of tea a more attractive and satisfying pastime. As his master before him, however, Oribe too fell victim to the vagaries of feudal politics, and in 1615, at the battle of Ōsaka castle, accused of treachery, he was compelled to commit suicide.

Upon Oribe's death, the role of arbiter of tea was assumed by one of his students, Kobori Masakazu. He is better known by the name Enshū, a sobriquet derived from one of the names for Tōtōmi province (modern Shizuoka Prefecture) where he was once titular ruler. A daimyō, like his master Oribe, Enshū was a familiar among circles of military and noble political power and wealth. He was also a man of unusual erudition and intellectual intensity. Reflecting the Tokugawa belief in the virtue of scholarship and literary pursuits, he became a noted calligrapher in the style of Fujiwara no Teika, an early Kamakura period poet and calligrapher.

Enshū was, as well, a proficient feudal administrator. His talent for organization and design shone in his role as a commissioner for construction, and in addition to the supervision of such daimyō related works as Nagoya and Ōsaka castles and parts of Edo and Fushimi castles, he worked on the retired emperor's residence and garden, the Sentō Gosho in Kyoto. His talent as a garden designer, in fact, has sometimes prompted people to credit him with the design of the Katsura Rikyū.

A taste for ancient Japanese literature and painting was current among certain art circles of the early Edo period, and artists like Honami Kōetsu (see No. 8) and Tawaraya Sōtatsu (see Nos. 9, 10) found inspiration among the medieval manuscripts and classical poetry. Enshū, too, took interest in the art of earlier periods and strove to reestablish a classical mode in tea. Highly innovative, however, he transformed these experiences into many new elements for tea

room design and furnishings. Along with this, his taste in tea wares prompted the rise of the term *kirei sabi*, denoting a visually rich aesthetic which consciously evoked a classical mode. This arose from his fusion of the elegant rusticity of *wabi cha* of the fifteenth and sixteenth centuries with the arcane beauty of Heian culture. To help achieve these innovative designs, he promoted particular kilns. Only Iga, which is sometimes included among the list of Enshū's favorite seven kilns, remained from among those associated with Rikyū and Oribe.

Obviously a different taste from the rough-hewn wares of the Bunroku-Keichō eras of Iga production, the Gitter collection *mizusashi*, or water jar, nevertheless lies clearly in the lineage of the famous Iga ware *mizusashi* named "Yabure-bukuro" at the Gotō Museum, Tokyo. In its forming, the Gitter collection piece was given a full, rounded body that was then smartly smacked with a spatula in order to flatten one side. This became the intended "front" of the piece. Reinforcing this orientation is a pair of small, notched ears, or handles at the neck. A cascade of transparent, greenish ash glaze has pooled inside the cup of the lip, at the shoulder and in the recesses of the spatula marks and incisions slashed across the flattened body. The lip flares, rising high above the shoulder, and the broad, comfortable base imparts a stable appearance to the highly activated form.

Still large-scale in character, the piece recalls the essentials of Oribe taste with its unexpected changes and dramatic glaze effects. The rising and spreading mouth is reminiscent of another *mizusashi* named "Yabure-bukuro" of the period of Oribe's prominence. It is in a private collection in Japan and, like the Gotō Museum example, is registered as an Important Cultural Property. The Gitter piece and this "Yabure-bukuro" share certain similarities in addition to the flaring lip. Both have the well-filled lower "bag" shape and a rather tall neck. The "bag" has split and cracked in both—somewhat less extravagantly on the Gitter example—and the tall neck on the Gitter example has been given a collar which breaks the straight line and imparts a rather "stepped" profile not shared by the "Yabure-bukuro."

The highly self-conscious manipulation of the profile and the glazing suggests an attitude that has been guided by an over-riding interest in maximizing effect, no longer willing to leave accidents entirely to natural developments. There still remains, however, the Oribe consideration of scale and drama.

Precision of execution and articulation clearly suggests a strict concern for technical mastery. Skillfully contrived yet playful distortions further indicate the intellectual climate of Enshū's era. Similarly self-conscious are the stepped stages of the neck and, in particular, the trimly beveled lip and the pleasant two-dimensional symmetry of the "front" of the jar. The intriguing motif carved into the spatula which has left its charming design in the wet clay shines as a

clearly intentional reminder of ancient practices. The obvious delight in the revealing of the rounded original shape as the other faces of the pot are turned to the viewer invokes an intellectual control very suggestive of Enshū's penetrating personality. Enshū, however, ultimately returned to smaller scale objects of a time before Oribe, to pieces more thinly potted than the Gitter *mizusashi*. For this reason, the Gitter piece can be thought to date from an interim period when the Oribe style still lingered at the kilns and before Enshū had made complete his classical renaissance in tea.

A large "V" shaped incision on the foot suggests a maker's mark. At some time in the past, the lip has been repaired with metal staples, in testimony to the antiquity of the piece and the esteem accorded it.

WJR

REFERENCES:

Cort, Louise Allison. *Shigaraki, Potters' Valley* (Tokyo/New York/San Francisco, 1979), pp. 53 ff., pp. 164 ff.

Fujioka Ryōichi, et al. *Tea Ceremony Utensils.* Arts of Japan, vol. 3 (New York/Tokyo, 1973), pp. 72 ff., pp. 91 ff.

Hayashiya Seizō. *Chanoyu: Japanese Tea Ceremony* (New York, 1979), cf. no. 68, pp. 141 ff., pp. 16-31.

Hayashiya Seizō, ed. *Bizen, Tamba, Iga, Shigaraki.* Nihon no tōji, vol. 2 (Tokyo, 1972), cf. pl. 310, 311, 312, 365, 306; pp. 285 ff.

Hayashiya Seizō, ed. *Iga, Shigaraki, Tamba.* Genshoku aizōban Nihon no tōji, vol. 7 (Tokyo, 1974), cf. no. 14, 18, 19, 21, 53, 73, pp. 135 ff.

Hayashiya Seizō and The Zauho Press, eds. *Momoyama Period (II).* Sekai tōji zenshū, vol. 5 (Tokyo, 1976), cf. pl. 261, 262.

Hayashiya Tatsusaburo, et al. *Japanese Arts and the Tea Ceremony.* The Heibonsha Survey of Japanese Art, vol. 15 (New York/Tokyo, 1974), cf. pl. 85, pp. 59 ff., pp. 81 ff., pp. 89 ff.

Murase, Miyeko. *Japanese Art: Selections from the Mary and Jackson Burke Collection* (New York, 1975), cf. pl. 97, pp. 316-317.

Tanaka Senō. *The Tea Ceremony* (New York, 1977), pp. 23 ff.

Tokyo National Museum. *Cha no bijutsu* (Tokyo, 1980), cf. no. 184, pp. 259-260.

90 Food dish for the tea ceremony late 16th century
(mukōzuke)
Mino ware, E Shino type
Stoneware with iron brown decoration of landscape and feldspathic
white glaze, 4 x 18.3 x 14 cm., 1-9/16 x 7-3/16 x 5-1/2 in.

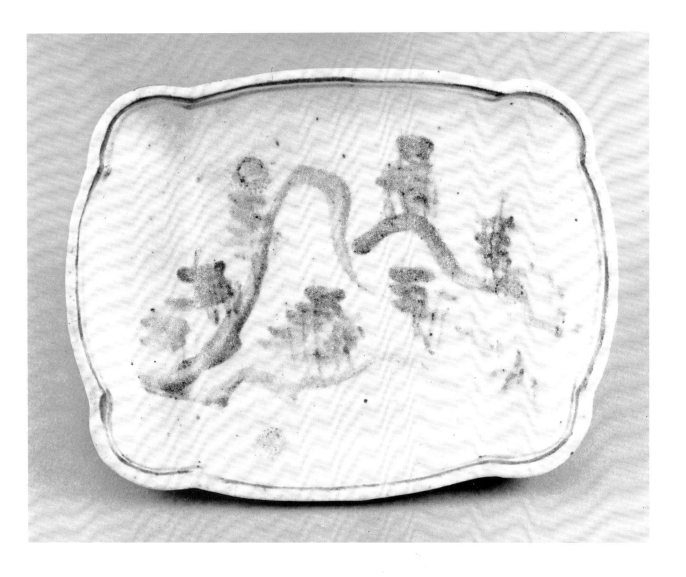

The Momoyama period was a time marked by the emergence of leaders of great energy and imagination. Men like Oda Nobunaga (1534-1582) and Toyotomi Hideyoshi (1536-1598) firmly stamped the imprint of their personalities on the political and economic life of the country. Their interests extended to the arts and through the rebuilding of the capital—devastated by years of civil war—and their own building projects like Nobunaga's castle at Azuchi, Hideyoshi's Jurakudai and Fushimi palaces, and the spectacular castle at Ōsaka, they were influential in developing taste in architecture, interior design and painting.

Their concerted destruction of the militant Buddhist clergy signaled the beginning of a secular and non-aristocratic orientation in society. This was also reflected in the tea ceremony, which previously had been largely the province of the shogunal courtiers. By the sixteenth century, taking tea had become popular among the *daimyō*, samurai and wealthy merchants, and Hideyoshi gave it an undeniable democratization when he held a ten day marathon tea ceremony at Kitano shrine in 1587. The country-wide meet was originally planned to last ten days, but was scaled down to a one-day affair. Among the tea masters, a number of forceful leaders had also arisen to prominence during this time; Sen no Rikyū (1522-1591) was the personal advisor to Hideyoshi in tea matters. The relationship of these two was perhaps the ultimate irony in an already topsy-turvy society. Rikyū's taste in tea culture—the restrained, muted and subdued—was diametrically opposed to the flamboyant nature of Hideyoshi. The exact reason is not known, but the tension between these two leaders eventually ended in Rikyū's suicide at Hideyoshi's command.

The early history of the tea ceremony witnessed the shift away from elegant and exotic Chinese wares to "discovered" pieces of simple peasant ware (see No. 87). By the sixteenth century, the tea masters like Rikyū were actively seeking out native Japanese kilns to produce wares specifically for the tea ceremony. Among the earliest of these native kilns to be patronized were those at Mino east of Kyoto, in the mountains beyond Seto. Furuta Oribe (1543-1615), Rikyū's leading pupil, was related to the Toki family who controlled the Mino area at that time. It is perhaps for this reason that he took considerable interest in the tea ceramics that were produced there, known today as Shino ware and Oribe ware. Upon Rikyū's death Oribe succeeded to a position of prominence in matters of tea, and the interest in Mino wares among the tea enthusiasts was intensified under Oribe's influence.

The food service preceding a formal tea ceremony, the *kaiseki ryōri*, originally reflected the monastic background of tea and was essentially a sober, vegetarian fare. After about 1550, however, the tea masters began to focus on this aspect of the ceremony and many changes in the service and the utensils occurred. Originally wooden vessels and trays, either plain or lacquered, were used with the occasional addition of some Chinese or Korean ceramics. Under first Rikyū's and then Oribe's influence, the use of ceramic forms increased until by the beginning of the seventeenth century, ceramics made up the bulk of the service. The dish illustrated here with its sketchy landscape pattern is typical of many of the side dishes which were produced in sets for the tea ceremony of that time.

Fluent shapes and misty, opaque white glaze with the suffused underglaze iron designs are qualities which have endeared Shino ware to the tea masters over the ages. Among the Mino tea wares, Shino is unusual in that it employs a feldspathic glaze which melts at a higher temperature than the usual ash glaze, and by its special properties, lends a muted tone to the underglaze decoration. It was the first ceramic in Japan to have a white body and glaze; perhaps a Chinese white ware like *Ting* inspired the potters. The white glaze varied in thickness and accordingly modulated the color of the iron pigment. This casual, irregular and random development imparted an individuality to each piece and heightened the awareness of the presence of the unknown potter who fashioned the piece and the mystery of the fire in the kiln. This profound sense of personality present in some pieces has caused the owners to bestow fanciful names on some of them intended to evoke the unique spirit of the piece.

The E Shino, or decorated Shino, were among the first ceramics in Japan to carry painted designs. Earlier decorative schemes employed primarily incised, stamped or moulded decoration under ash glaze, and this lively innovation was obviously a welcome addition to the tea room atmosphere for these Momoyama and early Edo period tea masters. Beyond the visual appeal of Shino pieces is the joy of the sensation of holding a piece in the hand or touching the tea bowl to the lip in drinking. These tactile sensations have played an important role in the appreciation of tea wares; none has been more highly esteemed than Shino for its subtle charm.

WJR

REFERENCES:

Fujioka Ryōichi. *Tea Ceremony Utensils*. Arts of Japan, vol. 3 (New York/Tokyo, 1973), pp. 10-11, 109 ff.

Fujioka Ryōichi. *Shino and Oribe Ceramics* (Tokyo/New York/San Francisco, 1977), pp. 13-84, cf. figs. 19, 31, 43.

Hayashiya Seizō, ed. *Shino*. Genshoku aizōban Nihon no tōji, vol. 2 (Tokyo, 1974), pp. 163 ff., cf. fig. 184.

Hayashiya Seizō and The Zauho Press. *Momoyama (II): Mino, Chōjiro and Kōetsu*. Sekai tōji zenshū, vol. 5 (Tokyo, 1976), pp. 147 ff., cf. pl. 287.

Lee, Sherman E. *The Genius of Japanese Design* (Tokyo/New York/San Francisco, 1981), cf. pl. 14.

91 Wide-mouth storage jar 18th century
(kame)
Takeo Karatsu ware, Yumino kiln
Stoneware with white slip and copper green and iron brown painted
decoration of a pine tree, 33.6 x 36 cm., 3-1/4 x 14-3/16 in.

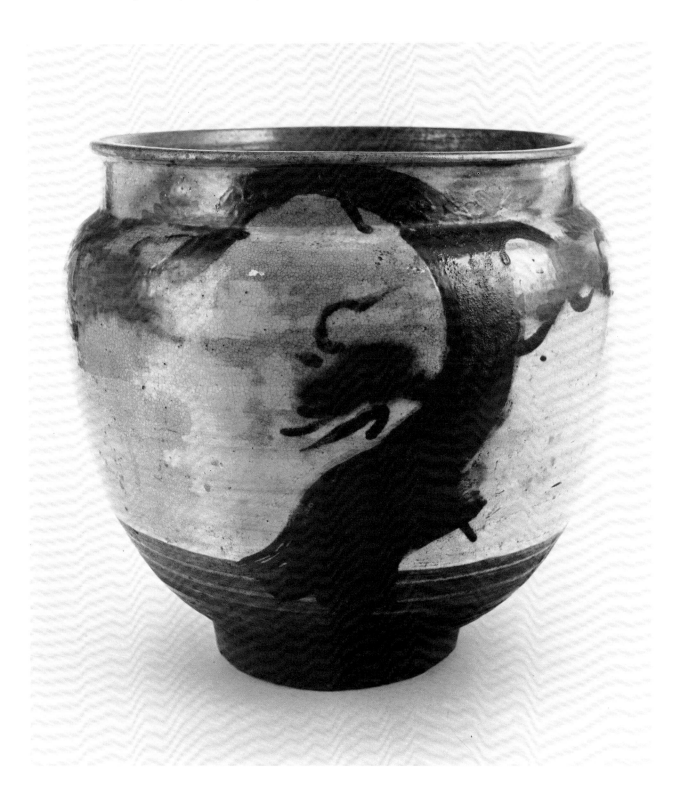

92 Saké bottle 19th century
(tokkuri)

Takeo Karatsu ware, possibly Yumino kiln
Stoneware with white slip and calligraphic inscription in iron brown,
21.6 x 16.2 cm., 8-1/2 x 6-38 in.

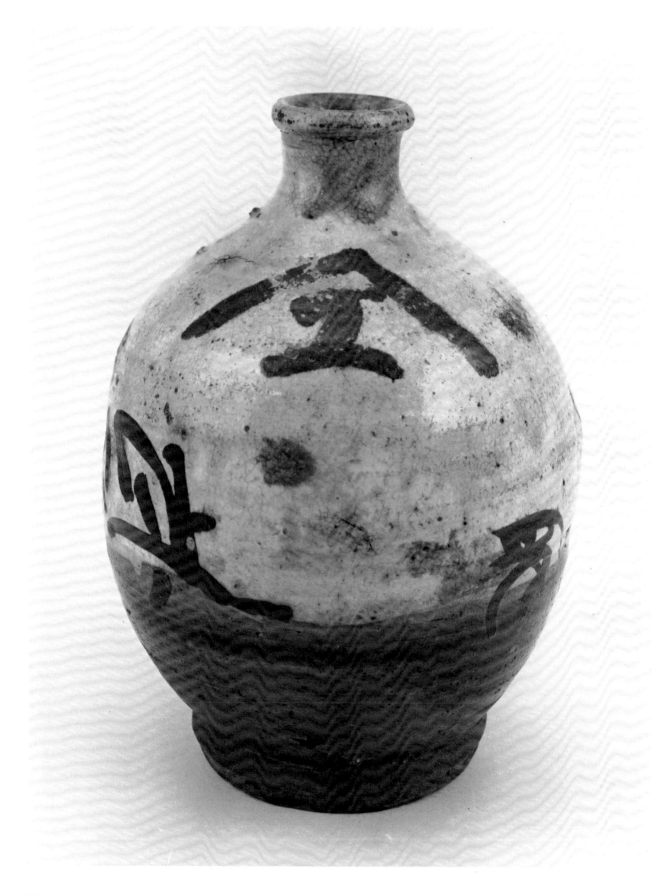

Since prehistoric times, northern Kyūshū has been one of the main points of arrival for people and ideas entering Japan from the rest of Asia. It was also to northern Kyūshū—which earlier had served as the base of operations—that the Japanese armies returned at the conclusion of the disastrous Korean invasions of 1592 and 1597. The returning *daimyō*—many of whom had come from Kyūshū—brought with them numerous Korean craftsmen, in particular potters; consequently, during the early decades of the seventeenth century, many new potteries were constructed and the feudal lords were pleased to promote the new local industries. Some among these lords who had learned about the tea ceremony took pains to develop kilns for the manufacture of privately controlled tea wares. Everyday pottery wares, however, were produced at new kilns from one end of the island to the other.

In the western part of the island, that area closest to Korea, the newly arrived potters produced high-fired stonewares of the type produced in Korea for everyday use. Many of the wares from this area are termed Karatsu wares after the city of that name around which kilns producing Korean style ceramics had been established, probably no later than soon after the mid-sixteenth century. The earlier kilns had also been established by Koreans, settled in the domain of the Hatta family. The Hatta, once extremely powerful, had probably initiated the local ceramics industry by inviting Korean potters to immigrate. In 1595, at the conclusion of the first campaign in Korea, Toyotomi Hideyoshi confiscated the fief, however, and installed a Hatta family rival. At that time the original Karatsu ware kilns were closed and the potters scattered to various locations. Later the new feudal lord opened his own kilns with newly arrived Korean potters.

Korean ceramic technology had wrought changes in Japanese ceramic production in earlier centuries (see Nos. 80, 81). These new potters brought with them the techniques of the fast kick-wheel for throwing pots and a type of kiln which made possible greater temperatures and more reliable results in the firings. This was a kiln built above ground and climbing the slope of a hill, with ports at the sides to allow the introduction of fuel along the length of the kiln. With modifications this became the linked-chamber climbing kiln, the *noborigama*, which eventually transformed the production of ceramics throughout the country.

Soon after the beginning of the Edo period, in about 1615, one of the Korean potters discovered porcelain stone near the village of Arita. This discovery led to a completely new ceramic industry in Japan. Korean potters, like the Chinese, had for centuries known the techniques of making porcelain, but the Japanese had never mastered the secrets. There was, moreover, a great demand for porcelains; quantities were imported annually to Japan from China during the late sixteenth century. These wares were mostly for use in the tea ceremony, but, in general, there was considerable interest in porcelain. In a short time, the world was introduced to enamel-colored and underglaze cobalt blue decorated porcelains called Imari ware after the Kyūshū port from which they were shipped. The profits to be garnered from the production of porcelain for export to Europe through the Dutch East India Company—and for sale within the country—soon prompted many Kyūshū stoneware kilns to convert, and many types of Karatsu stonewares were discontinued.

One of the centers which refused to abandon the stoneware traditions was a group of kilns around the village of Takeo. These Takeo Karatsu wares were typified by a reddish stoneware body covered with an opaque white slip which was incised, wiped away or otherwise decoratively manipulated. A distinctive colored decoration was also sometimes added in copper green and iron brown to produced a unique type of decorated Karatsu ware called "two-color Karatsu." Before the seclusion policy was enforced by the Tokugawa shogunate in 1639, large amounts of these Takeo Karatsu wares were shipped to Southeast Asia.

The Yumino kiln became famous from the eighteenth century until its abandonment in the latter part of the nineteenth century for large storage jars, or *kame*, like the one illustrated here. Wide-mouth jars like this were utilized for many purposes, but they were especially adapted to storing liquids; this type is called a *mizu-game*, or water vat. Other large bowls of Yumino ware were used in the production of wax and in dyeing yarn for weaving, both prominent industries in northern Kyūshū at that time. Large-scale *saké* and oil bottles also seem to have been a product of the Yumino potters.

Among the most frequently encountered motifs on these *kame* is the form of a massive pine tree. The Gitter collection example shows an especially energetic rendition, revealing an exuberance on the part of the decorator. The dynamic form of the trunk presses forcefully against the lip of the jar as if to explode its bounds. There is commonly a second, somewhat less developed motif painted on the opposite side from the pine. This *kame*, however, has been decorated with a fantastic landscape scene. The decorator has laid down a thick impasto of brown, imparting a rich surface texture to the trunk of the tree and the mounded hills of the landscape opposite. The deep tone of the brown is particularly dramatic against the creamy-white ground. Included in the impressionistic landscape are suggestions of wooded hills covered with verdant growth, and evident everywhere in the powerfully rising, symmetrical shape and the bold decoration are the potter's deep acquaintance with the surge of growth and the power of nature.

A popular prototype for this pine tree theme might well have been the rows of Japanese black pines

growing in twisted profusion on the windswept beach at nearby Niji-no-matsubara, south of Karatsu city. The crescent shape of the beach apparently gave rise to the name Niji which means rainbow, and it is said the trees were originally planted in the seventeenth century as a windbreak. The beach soon became known as a place of great scenic beauty, and remains to this day a popular site.

The *saké* bottle comes from a slightly later time and reflects a very pronounced commercialism. The stout and sturdy form has been quickly shaped on the wheel. The bottle was then covered with white slip and a line of dark slip laid on to mark the lower limit. Dark slip has been trailed over this white to spell out the name of the resort for which the bottle was produced. The name reads *Takeo yu (no) machi. Yu* means hot water, or hot spring; *machi* means town or quarter, and by supplying the particle *no* the name reads "hot spring town" and can be translated Takeo hot spring resort, or *Takeo Onsen*. The insignia on the shoulder is a commercial shorthand form in which the peaked roof is automatically read *yama*, or mountain, beneath which is the slightly miswritten syllabary character for *yu*. These, when taken together read *yama (no) yu*, or mountain hot (spring). The entire piece was dipped in a clear glaze before firing. All of this was quite quickly performed in the practiced hands of master potters and decorators.

These serviceable bottles were probably designed to be refilled with *saké* and reused indefinitely; however, just as travellers collect souvenirs today, an enthusiastic guest or a tipsy reveler might easily have been allowed to return home with one of these bottles as a reminder of a pleasant visit. The continued presence of the name of the *onsen* in the hands of the possessor shows a clear understanding of advertising potential. These simple but pleasing wares were the things of the everyday lives of the common people during the Edo period. Pots like these not only functioned effectively, they brought pleasure in the handling and in the using of them. These are the qualities that lift commonplace objects into the realm of folk art.

WJR

REFERENCES:

Cort, Louise Allison. *Shigaraki, Potters' Valley* (Tokyo/New York/San Francisco, 1979), p. 119.

Hauge, Victor and Takako. *Folk Traditions in Japanese Art* (New York, 1978), cf. pl. 80, 84.

Jenyns, Soame. *Japanese Pottery* (London, 1971), cf. pl. 77B.

Koyama Fujio, ed. *Japanese Ceramics from Ancient to Modern Times* (Oakland, 1961), cf. pl. 62.

Okamura Kichiemon. *Folk Kilns (II).* Famous Ceramics of Japan, vol. 4 (New York/Tokyo/San Francisco, 1981), pp. 11 ff.

Saint-Gilles, Amaury. *Earth'n'Fire, A Survey Guide to Contemporary Japanese Ceramics* (Tokyo, 1978), p. 47.

Seattle Art Museum, ed. *International Symposium on Japanese Ceramics* (Seattle, 1973), pp. 166 ff.

93 Oil plate early 19th century
(abura-zara or andon-zara)
Seto ware
Stoneware with decoration of chrysanthemum blossoms in underglaze
iron brown and green glaze, D. 22.4 cm., 8-13/16 in.

Interior lighting became increasingly common throughout the Edo period. In addition to candles for which a great variety of holders were devised, there were various types of lanterns—some portable, some designed to hang and some which rested on the floor. There was even a kind of chandelier and a hand-held search light. A popular type of lantern for homes consisted of a round or square base above which rose a wooden or metal frame which was covered with white paper. The source of light was a candle or a saucer of vegetable or fish oil which was burnt with a wick. From a crosspiece, the metal or ceramic saucer was either hung by a hook or supported in a cradle inside the lantern. This style of lantern was about two and a half feet tall, and represented an important element in the interior furnishings of a room.

Frequently these round lanterns featured a circular shade made in two semi-circular panels, one of which slid in front of the other to reveal the oil saucer and to allow brighter illumination. This opening also facilitated replenishing the oil or replacing the wick. Illustrated woodblock-printed books of the late seventeenth century already showed such lanterns, and artists like Suzuki Harunobu (1725-1770) and other print makers of the middle and late Edo period, frequently depicted interiors which included these lanterns.

A very important part of the design of these standing lanterns *(andon)* was the *andon-azara*, a shallow dish or tray which was placed on the base to hold the pot of oil for filling the saucer. These plates are also called *abura-zara*, after the drips of oil *(abura)*

94 Oil plate early 19th century
(abura-zara or *andon-zara)*
Seto ware
Stoneware with decoration of reeds and grasses in underglaze iron brown
and green glaze, D. 19.7 cm., 7-3/4 in.

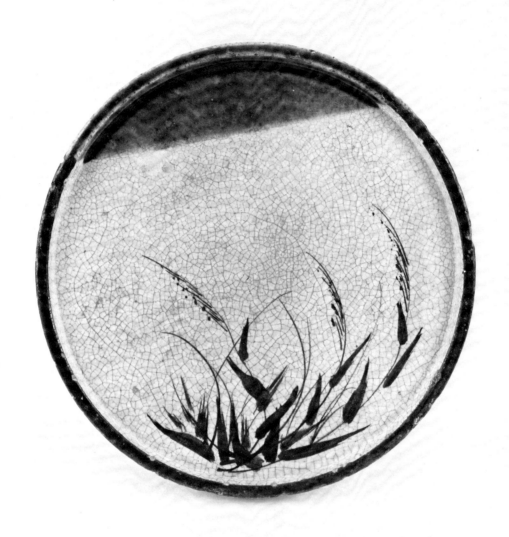

which spilled in the filling process or dropped as the lamp sputtered. These examples from the Gitter collection demonstrate three of the most popular types of *andon-zara* that were produced from perhaps the late eighteenth century until the introduction of kerosene lamps in the Meiji era. Plain metal drip plates were also in use, but these stoneware plates with colored glaze and painted decoration presented a more lively choice for the Edo period householder.

Production of these oil plates was centered around a group of kilns at Seto, in modern Aichi prefecture. This was the same general area which has been producing ceramic wares since ancient times (see No. 81). These very active Seto area kilns continued to produce stonewares throughout the Edo period and by the early nineteenth century, potters had also learned the techniques of porcelain production and

underglaze cobalt blue decoration from the Imari ware producers in Kyūshū. The Seto area remains one of Japan's busiest ceramic centers.

Specialty stonewares like these *andon-zara* and the *ishi-zara* (Nos. 96, 97) were produced in enormous quantities during the late Edo period. Created for a mass market, these dishes were decorated with quickly brushed designs which usually featured plants and flowers. Landscape, as a theme, was typically painted in underglaze iron brown. Sometimes in combination with the underglaze decoration, as in No. 94, the edge of a plate was dipped into a green glaze which resembles the green of the famous Momoyama period Oribe wares made for the tea ceremony at the nearby kilns of Mino. A somewhat rarer type of *andon-zara* design is that of the plate (No. 93) with the allover green glaze and small

95 Oil plate 19th century
(abura-zara or *andon-zara)*
Seto ware
Stoneware with decoration of landscape in underglaze iron brown, D. 22.9 cm., 9 in.
PUBLISHED: Huntsville Museum of Art, *Art of China and Japan* (Huntsville, AL, 1977), no. 379.

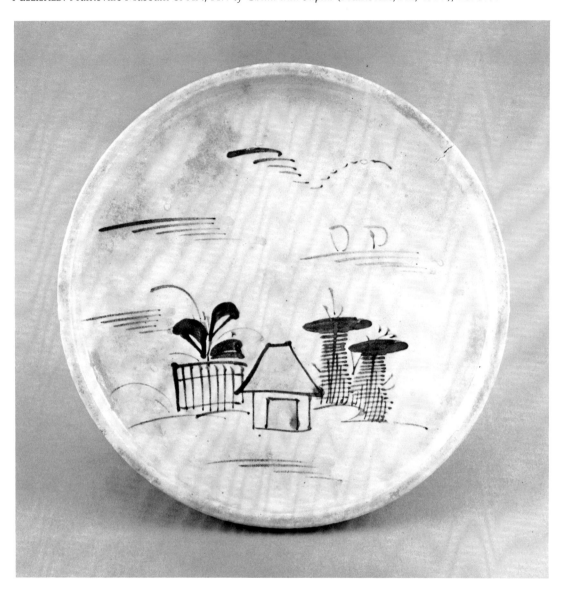

circular reserved area. These areas have been decorated with chrysanthemum blossoms in underglaze brown and covered with a clear glaze.

Human figures or animal motifs are less frequently found, and when they appear, they display a gentle humor and untutored directness. This naive display of brushwork once prompted people mistakenly to think these dishes were decorated by children. There is, however, as these examples in the Gitter collection show, a wide range of character encompassed by these humble wares, and the rendering of plants and flower motifs might reveal a surprisingly succinct delicacy and adroit composition, as in the design of the plate with the spray of wild grasses (No. 94). In contrast, there is the dense richness of the expanse of green glaze punctuated by the two blossoms (No. 93) and the comic abbreviation of the farmhouse and

landscape—complete with distant sails and a flock of birds in the sky (No. 95). It is this unaffected yet complex aesthetic which has recommended these unassuming wares to collectors of folk art and admirers of Japanese ceramics everywhere.

WJR

REFERENCES:

Hata Hideo, ed. *Seto e-zara no bi* (Tokyo, 1969), pp. 10 ff., pp. 47 ff., cf. pl. 36, 38, 40, 117-163.

Koyama Fujio, ed. *Japanese Ceramics from Ancient to Modern Times* (Oakland, 1961), pp. 41-43, cf. pl. 70a, 70b.

Mizuo Hiroshi. *Folk Kilns (I)*. Famous Ceramics of Japan, vol. 3 (Tokyo/New York/San Francisco, 1981), pp. 9 ff., cf. pl. 53-56.

Muraoka Kageo and Okamura Kichiemon. *Folk Arts and Crafts of Japan*. The Heibonsha Survey of Japanese Art, vol. 26 (New York/Tokyo, 1973), pp. 27 ff., cf. pl. 25, 79.

Tanaka Kana, ed. *Ishizara to aburazara* (Kyoto, 1960), pp. 13-15, cf. pl. 7, 8, 9, 10, 11, 81-138.

96 Serving plate ca. 1800
(ishi-zara)

Seto ware
Stoneware with decoration of willow tree in underglaze iron
brown and cobalt blue, 6.1 x 28.6 cm., 2-3/8 x 11-1/4 in.
PUBLISHED: Huntsville Museum of Art, *Art of China and Japan*
(Huntsville, AL, 1977), no. 380.

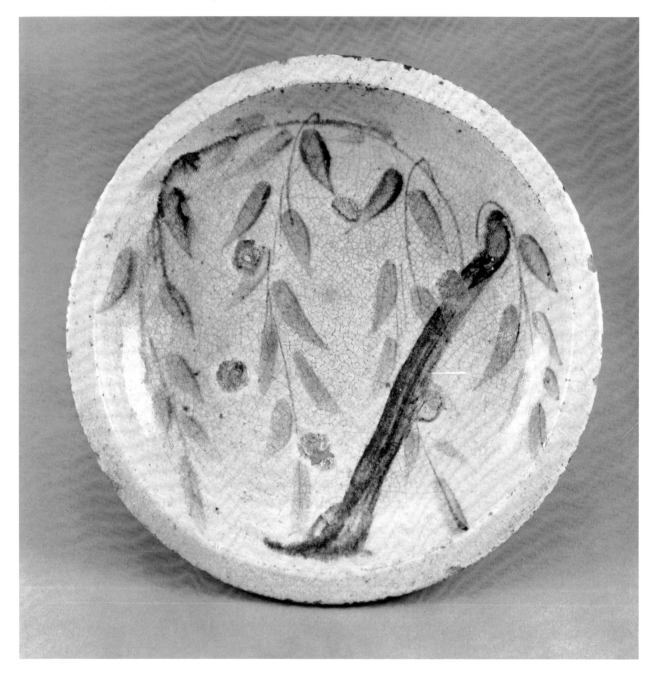

These sturdy, handsome plates were designed as a popular utility dish for the mass market. *Ishi-zara* means literally "stone plate." This curious name is explained as a corruption of the words *nishime-zara*, but the exact origin is unknown. *Nishime* is a commonly served dish of boiled fish and vegetables for which these plates were perhaps designed as a standardized serving vessel—they seem to have been made in large, medium and small sizes—and in casual usage the name was shortened to *ishi-zara*. Reinforcing the idea of "stone plate" is the characteristically dense body

of the ware which give the plates a substantial heft.

There are literary references noted from the late seventeenth and early eighteenth centuries suggesting that a type of *ishi-zara* was in use then, but the appearance and place of manufacture are unknown. Examples like these from the Gitter collection were produced at kilns near Seto in modern Aichi prefecture, the home of ancient ceramic traditions. They are typically round with stoneware bodies and decorated with designs in underglaze cobalt blue and iron brown, covered with a clear glaze. This type seems to

97 Serving plate ca. 1800
(ishi-zara)
Seto ware
Stoneware with decoration of cherry blossoms in underglaze
iron brown and cobalt blue, 5.5 x 27.9 cm., 2-1/8 x 11 in.

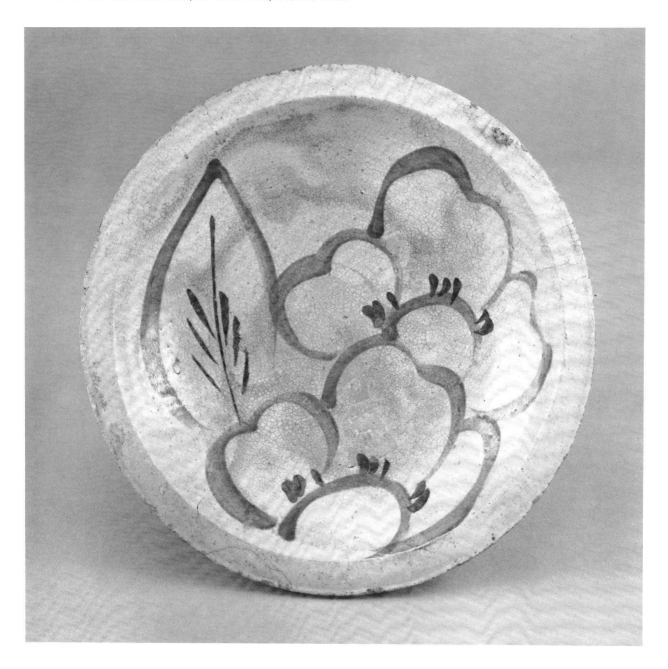

have originated about 1800 and production continued probably until the beginning of the Meiji era in 1868. After that time, the whole Seto area ceramic industry experienced a major reorientation with the end of feudal control. *Ishi-zara*, like the *andon-zara* (Nos. 93-95), were made in enormous quantities for the domestic market, but after 1868 with the opening up of foreign trade and under the impact of Westernization, such wares no longer held an economic importance for the potters.

Ishi-zara represent an important decorative style of painted Edo period stonewares. The painters regarded the plates as surfaces to be filled with decoration, and the motifs found on *ishi-zara* reach out to fill the entire space, expanding the scale of the images and heightening the impact of the brushwork. One of the most frequently found motifs is the willow tree, the trunk and branches in iron brown and the leaves in cobalt blue. This example is typical of the painterly freedom the potters achieved in decorating these humble wares. After brushing perhaps scores of plates, the speeding brush set down a tree trunk with a single, bold stroke; branches were laid lightly across the face of the plate, probably with the same brush held with just the tip touching the surface. Then a few

quick touches with a brush of blue pigment clothed the tree with foliage. Dipping the brush for fresh pigment at the top of each branch, the color of the leaves lightened as the brush moved down to the tip, rendering the final leaves a misty blue. The modulated tones reinforce the swaying motion of the branches, lending a special visual appeal to this plate.

The other example takes a very small-scale motif and renders it in extraordinary magnification. Two cherry blossoms—recognized by the indented petal—and a single leaf expand completely to fill the plate. The composition pulses with a calligraphic cadence. The eye can follow the exact path of the brush as it moved first to form the left side of the leaf, then the right. Each fresh brushload of pigment is marked by an instant of deliberate movement at the point of contact, a stronger tone and heavier line, trailing off to lighter tone and freer movement.

The surfaces of these plates are marked with a ring of *me-ato*, the spots where the plates were stacked one on the other in the kiln. Such space-saving techniques as stacking plates and bowls were used only for the most common of wares, because of the scars left when the pieces were separated. These marks, however, are proudly ignored by collectors and they seldom interfere with the enjoyment of the piece. The *me-ato* serve also to remind us of the plebian nature of *ishi-zara*. The crackled clear glaze enhances the surface texture. As a secondary level of enjoyment, the traces of use and time are evident in the staining—on the cherry blossom plate—like a cloud-strewn sky, bringing to mind the clouds of springtime blossoms on Mount Yoshino.

WJR

REFERENCES:

Hata Hideo, ed. *Seto e-zara no bi* (Tokyo, 1963), pp. 10 ff., cf. pl. 5-26, 41-102.

Hayashiya Seizō and The Zauho Press, eds. *Momoyama [II].* Sekai tōji zenshū, vol. 5 (Tokyo, 1976), pp. 249 ff.; cf. pl. 339, 340.

Koyama Fujio, ed. *Japanese Ceramics from Ancient to Modern Times* (Oakland, 1961), pp. 41-43; cf. pl. 65-68.

Mizuo Hiroshi. *Folk Kilns [I].* Famous Ceramics of Japan, vol. 3 (Tokyo/New York/San Francisco, 1981), pp. 9 ff.; cf. pl. 58, 59.

Muraoka Kageo and Okamura Kichiemon. *Folk Arts and Crafts of Japan.* The Heibonsha Survey of Japanese Art, vol. 26 (New York/Tokyo, 1973), pp. 27 ff.; cf. pl. 25, 79.

Tanaka Kana, ed. *Ishizara to aburazara* (Kyoto, 1960), pp. 11-12; cf. pl. 1-6, 12-80.

Yanagi Sōetsu. *Mingei zukan, vol. 1* (Tokyo, 1963), cf. pl. 35, 36.

KITAŌJI ROSANJIN (1883-1959)

Rosanjin was an acknowledged eccentric. More than a mere crank, he was one of the most talented figures to appear in Japanese circles in modern times. Within his dynamic, unconventional personality, he combined a passion for exquisite Japanese food, a love of bottled beer, a joy in the company of women, whom he treated roughly—marrying and divorcing several times—and a desire to possess beautiful antiques, especially ceramics. He was at times undisciplined in his extravagance, both in terms of finances and personal style, and he cut a swath through society with an aristocratic hauteur and sharp-tongued wit.

For all his dramatic ways, he was not exactly frivolous, and he set rigid, almost unattainable goals for himself and—much to their dismay—for others. It was perhaps this demand for excellence in the most minute detail that made him a genius of culinary arts, calligraphic brushwork, and ceramic and lacquer design. Unfortunately, it was sometimes too much for those around him to sustain his levels of enthusiasm, and in 1936 his co-workers drove him out of the Hoshigaoka, the Tokyo restaurant where he was majordomo, charged with direction of matters gustatorial.

Rosanjin's zeal in preparing gourmet Japanese dishes, and presenting them on exactly the appropriate vessel to complement the food and satisfy the soul as well as the appetite of the diner, had made of the Hoshigaoka Japan's most famed dining place. Government dignitaries and business and financial leaders vied for places at dinner, willingly paying almost unbelievable prices for the experience, and during his years there, Rosanjin became a wealthy man.

As with his restaurant venture, life had always been something out of the ordinary for Rosanjin, but he had not always been financially comfortable. Born to a family attached to the Kamigamo Shrine in Kyoto, his father died soon and the child was sent to live first in one foster home and then another. Reports of neglect and maltreatment in those early days suggest he developed his obstinate and independent ways partly as a result of those experiences. Finally sent to live with a woodcarver named Fukuda, he was at last adopted formally.

Schooling for him was minimal by today's standards, but the usual four year primary school was perhaps about all many people could expect in 1888. Following successful completion of the fourth grade, he began four years of futile apprenticeship to a druggist or perhaps a Chinese herb doctor. This experience produced in him a desire to be a painter, following the Japanese style school, whose preeminent figure at the time was Takeuchi Seihō. Frustrated in his desire to enter formal training as a painter, he vowed to teach himself, and in order to obtain materials, he decided, at fourteen, to enter an important calligraphy contest in Kyoto. His natural artistic talent had been set moving perhaps by some experience with the shop sign carving of his stepfather, but his innate talent could not be denied. His entries won valuable prizes. He was eventually to be known as one of modern Japan's most important calligraphers. *

He began supporting himself teaching calligraphy and designing sign boards. He learned seal carving, another field in which he came to excel.

Rosanjin's life, however, was seemingly destined to follow surprising, not to say sometimes melodramatic twists. In 1903, for instance, he went to Tokyo, traced the whereabouts of his real mother and sought her out. Horrified, she rebuffed him. Undaunted, Rosanjin established himself in the capital, supporting himself with his calligraphy.

By 1908, he was in Korea, working at the Printing Bureau. He was able to visit China and took the opportunity to study Chinese calligraphy and seal carving. His artistic reputation was growing, and on his return to Japan in 1910, began receiving notice from wealthy patrons. He affected the art name Fukuda Taikan and began moving in more important art circles. He later met his childhood idol, Takeuchi Seihō, and with the encouragement of a powerful Kyoto merchant named Naiki Seibei, he began forming a life-long fascination with antiquities, particularly ceramics. He was also developing his epicurean tastes in food. His adoptive mother, for all her slovenly ways, had even in his early youth taught him an appreciation of fresh food, and food was the one luxury the painfully poor family had allowed themselves.

By 1913 his future career as one of Japan's most celebrated artists was beginning to take shape. In his personal life, he assumed the role of head of family and took back the Kitaōji name after the death of his brother. His artistic reputation was bringing him much attention and in 1915 he was invited to spend some time as a guest of a wealthy patron in Kanazawa. This ancient and cultured city is steeped—not to say saturated—in the traditions of Kutani porcelain, and during his stay of more than a year, Rosanjin was inevitably drawn into the world of ceramics. He studied with a noted potter, Suda Seika, and this encounter was fateful for his future, for it brought him a knowledge of the processes of ceramic production and an awareness of how he could manipulate the materials to influence the appearance of ceramic wares.

A sudden move to Kita Kamakura in 1917 brought him within easy travel time of the heart of Tokyo, yet afforded him the relaxed life of what was then rural countryside. It was from this location that Rosanjin was to play out the remainder of his fabulous life. He had already begun collecting antiquities, and his natural enthusiasm, as in many of his adventures in life, led him to open an antique shop in Tokyo. This was called the Taiga-dō and was located in the fashionable Kyobashi area.

It is customary in Japanese shops to offer refreshment to guests and prospective customers, but again, Rosanjin could not be content with simple tea and a sweet. He began serving more elaborate bits of food, and moreover, served them on antique dishes. Almost without noticing it, he developed a clientele for his food, and in 1921, he opened a place above the Taiga-dō where a select group of fellow gourmets could gather. This was the Bishoku Club.

Success with the Bishoku Club led him, after the great Kantō earthquake and fire, to open the Hoshigaoka Saryō in 1925. This establishment was to be the key to his success as a restauranteur and eventually as a designer of ceramics and lacquers. The never-ending search for exactly the correct ceramic for serving his exquisite foods led him to new adventures, and he built his own kiln to create dishes that would meet his almost fanatical standards of connoisseurship.

Earlier in 1925, Rosanjin had spent time in Kyoto visiting with the potter Arakawa Toyozō, and in the autumn, he built the Hoshigaoka kiln at his home in Kita Kamakura. In 1927 Rosanjin invited Arakawa to join him at the kiln. Included among other potters who also worked there, and who—like Arakawa—were later to become leading artistic figures, was Kaneshige Tōyō. Both these men have since been designated as Living National Treasures. Rosanjin knew excellence when he saw it.

There is much discussion regarding the extent to which Rosanjin himself participated in the production of his ceramics, and it seems clear he was more interested in designing and decorating pieces that others formed under his supervision than in the actual potting. The Hoshigaoka kiln employed many potters and assistants, and the volume of production alone suggests Rosanjin was more a supervisor and grand designer than a producing potter in the strictest sense.

One piece in the Gitter collection, however, might easily be one from Rosanjin's own hand. This is the blue-and-white porcelain bowl (No. 98). The inscription on the underside, written in underglaze blue, bears a date of autumn, 1926. This would have been just a year after the founding of the kiln and his first exhibition at the restaurant—a time before the appearance of men like Arakawa, a time when Rosanjin might well have been still making pots himself.

The design, too, speaks strongly of Rosanjin. He had collected many Chinese blue-and-white wares, and he eventually designed and produced a two volume set of books illustrating his collection. The shape of the bowl derives from Chinese prototypes, and of course his talent at calligraphic brushwork appears evident. All this, combined with the fact that he had studied with Suda Seika at Kanazawa, where he undoubtedly worked in porcelain, strongly suggests the piece was Rosanjin's own in design and execution.

After leaving the restaurant, he was somewhat at a loss for income, and his carefree nature had not prepared him for the proverbial rainy day. His luck held, and he attracted the loving and generous support of a company owner, Nagao Kinya and his wife. Other patrons followed. From Nagao's patent medicine company and from other companies, the Hoshigaoka kiln began receiving orders for commemorative plates and vessels for company gifts, which was a commercial godsend. Thereafter, Rosanjin entered into art potting that was to produce some of his most characteristic works.

His interest in antique ceramics had early centered on Chinese porcelains, but later he turned to Japanese stonewares and the tea wares, in particular, the works of Kenzan. The Bizen and other medieval stoneware types are prominent in his production. Kaneshige Tōyō came to Kita Kamakura in 1952 to construct a kiln to produce Bizen type wares in the ancient manner. He stayed to work a while. Shino and Oribe type wares, too, were among Rosanjin's favorites, and the Gitter collection includes examples of all these types.

Rosanjin followed his desire for scholarly accuracy and for close identification with the originals by collecting sherds at the kiln sites. He and Arakawa and others visited kiln sites in southern Korea in 1928 and brought back material for making pots. Clays from the various regions of Japan, too, were kept in readiness at the Hoshigaoka kiln, and Rosanjin made sure the

ingredients for his pots were as appropriate as the ingredients had been fresh for his cooking. Arakawa discovered, in 1930, the original site of Momoyama period Shino ware production and later built his own kiln there. He was eventually able to recreate the beauty of Shino of the sixteenth century.

Food vessels and tea wares, including vases, became the staple products of the Rosanjin kiln in later years. After a tour to the United States and Europe in 1954, he was greatly in need of cash, and the kiln put forth even greater efforts. The results were sometimes less than brilliant. Numerous exhibitions were arranged in Tokyo and elsewhere. His reputation had grown both among Japanese and foreign collectors, and he had made many new friends around the world.

Rosanjin's unique position in Japanese ceramic art is not the result only of his genius for design, which is a quality easily understood by Westerners, but arises perhaps more from the fact that he came to preeminence against all odds—forsaking the conventional constraints of traditional artistic lineage and apprenticeship patterns which prevailed in his day and still linger to a great extent today in Japanese art circles. He was the solitary walker, the independent one, a *doppo*, in Japanese modern art. *Doppo*, which can also mean unique or unparalleled, had been the name of a short-lived magazine he published as a sort of clearinghouse for his ideas and as a showcase for his ceramics. This man of many talents, supremely independent, yet inextricably bound to the traditions of his artistic culture, became perhaps the first truly contemporary Japanese potter, in the Western sense. Yet, while his was a vision that created something new, his art grew from ancient standards and recognizable models that gave his creations aesthetic relevance and spiritual union with the past.

WJR

REFERENCES:

Cardozo, Sidney B. *Rosanjin, 20th Century Master Potter of Japan* (New York, 1972).

Hata Hideo, ed. *Kitaōji Rosanjin sakuhin shū* (Tokyo, 1972).

Kitaōji Rokyo. *Ko Sometsuke hyappin shū* (Kyoto, 1931).

Kuhara Hideki. *Arakawa Toyozō*. Nihon no yakimono, Gendai no kyoshō, vol. 2 (Tokyo, 1978).

Kuroda Ryōji. *Kitaōji Rosanjin*. Nihon no yakimono, Gendai no kyoshō, vol. 2 (Tokyo, 1977).

Rosanjin-kai, ed. *Rosanjin no yakimono* (Tokyo, 1963).

Takekoshi Nagao. *Nyūmon Rosanjin no tōki* (Tokyo, 1977).

Takeuchi Junichi. *Kaneshige Tōyō*. Nihon no yakimono, Gendai no kyoshō (Tokyo, 1978).

The Ceramic Art of Kitaoji Rosanjin: Three American Collections (Kyoto, 1964).

98 Rectangular deep bowl
(hachi)

Porcelain with design of Chinese characters in underglaze cobalt blue,
10.8 x 23.5 x 22.3 cm, 4-1/4 x 9-1/4 x 8-3/4 in.

Underglaze inscription and Rosanjin signature on underside;
dated in inscription to autumn, 1926

Signature on box lid

PUBLISHED: Takekoshi Nagao, *Nyūmon Rosanjin no tōki* (Tokyo, 1977), p. 117.
The Ceramic Art of Kitaoji Rosanjin: Three American Collections
(Kyoto, 1964), no. 58.

The four characters read *sei fū ka getsu*. They constitute a poetic inscription in Chinese which blends the beauties of a refreshing breeze *(sei fū)* with blossoms *(ka)* and the moon *(getsu)*. The style of the calligraphy alternates the highly cursive script *(sō sho)* with the semi-cursive script *(gyō sho)*. Rosanjin's talent in calligraphy was recognized early and he won prizes in competitions while still in his teens. Later he supported himself at times as a teacher of calligraphy. His skill with the brush is nowhere better illustrated than in a simple but forceful display in this decoration.

The vaguely star-shaped motif in the center of the bottom of the bowl is one version of an identifying mark he used on his ceramics. It derives from the *hoshi*, or star, in the name of his kiln, Hoshigaoka.

WJR

99 Bizen ware style jar
(tsubo)

Stoneware with slight natural ash glaze, 31 x 26.8 cm., 12-1/4 x 10-9/16 in.

Incised *katakana ro* signature on body

PUBLISHED: Sidney Cardozo, *Rosanjin, 20th Century Master Potter of Japan* (New York, 1972), no. 37.
The Ceramic Art of Kitaoji Rosanjin: Three American Collections (Kyoto, 1964), colorplate 1 (identified as Shigaraki).

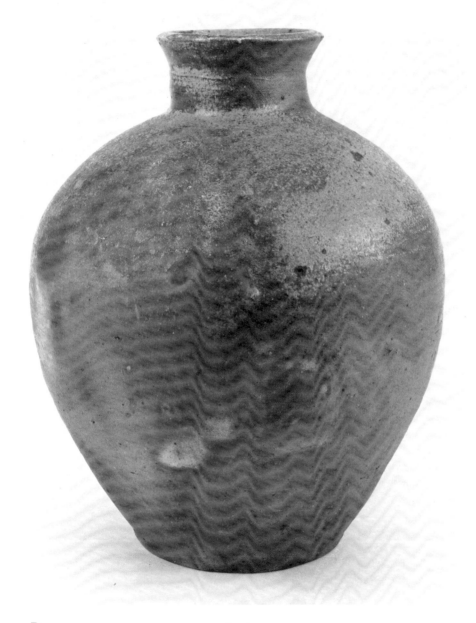

Bizen ware ceramics were among the first native stonewares to attract the attention of tea ceremony leaders of the sixteenth century (Nos. 87, 88). In this jar, Rosanjin has captured the characteristic stoneware body, shape and patina of surface texture that so recommended Bizen wares to the ancient aesthetes.

The shape was inspired by tea leaf storage jars of earlier times; such a jar as this, however, might today serve equally as a vase for a flower arrangement in the tea room.

WJR

100 Bizen ware style large plate
(ōzara)

Stoneware with slight natural ash glaze, D. 24.8 cm., 9-3/4 in.

Incised *katakana ro* signature on underside

PROVENANCE: Sidney Cardozo

PUBLISHED: Huntsville Museum of Art, *Art of China and Japan*
 (Huntsville, AL, 1977), no. 417.

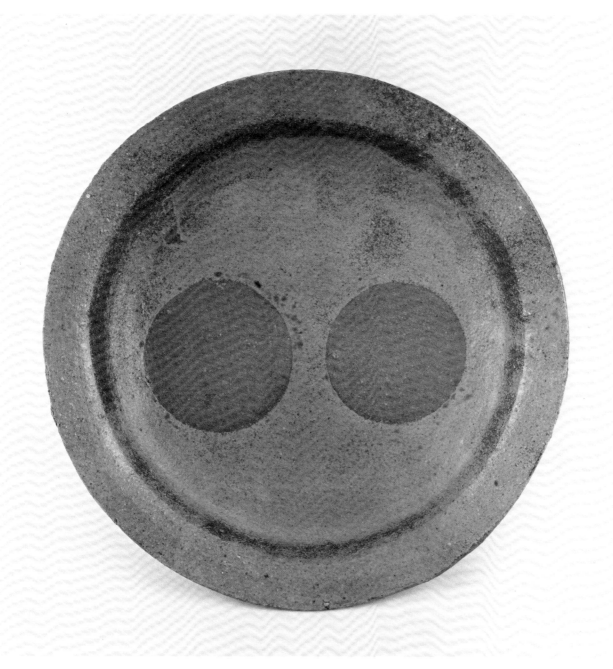

The subtle natural gloss that occurred in the firing of medieval Bizen stonewares gained distinctive presence when the ware body was protected in the kiln beneath other objects. Here Rosanjin has achieved the same dramatic revealing of the innocent body of a stoneware plate made in the time of Sen no Rikyū (Nos. 87, 88). The circular marks, indicating the presence of perhaps two *saké* bottles resting on the plate during firing, were no doubt intentionally and thoughtfully positioned in relation to the circular space of the plate in order to create a pleasing visual and textural pattern.

Rosajin was merely following the lead of Bizen potters, for they undoubtedly soon learned that such marks were attractive to the tea masters. Rosanjin created many effects that are as pleasing in his modern pieces as they must have seemed to sixteenth century tea masters.

WJR

281

101 Oribe ware style rectangular bowl
(hachi)

Stoneware with decoration of textile patterns in underglaze iron brown
and copper green glaze, 10.3 x 20.7 cm., 4-1/16 x 8-1/8 in.

Incised *Rosanjin* signature on underside

Signature on box lid

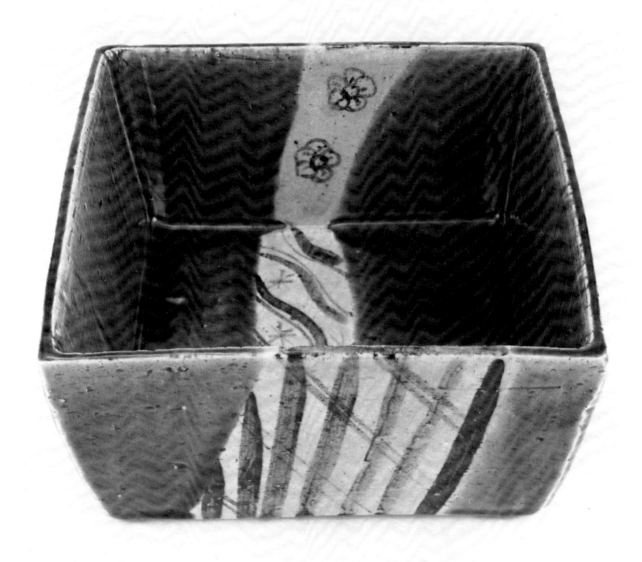

Rosanjin's penchant for dramatic shapes and colorful glaze decoration led him naturally to an appreciation of Oribe ware (see Nos. 89, 90). This sumptuous piece bears classic Oribe ware characteristics in the diagonal patterning and juxtaposition of deep-colored glaze with underglaze linear designs. Details like the slight bow of the profile—echoed in the slightly bowed lip—and the simple, but elegant brushwork of the delicate designs declare the touch of a sensitive ceramic artist thoroughly conversant with ancient Oribe ware pieces.

WJR

*102 Oribe ware style square bowl
(yohō hira-bachi)

Stoneware with incised and moulded decoration and copper green glaze,
4.4 x 29.8 cm., 1-3/4 x 11-3/4 in.

No signature on piece

Signature on box lid

PROVENANCE: Sidney Cardozo

Rich glaze colors, particularly deep green, typify much of the Oribe style tea wares of the late sixteenth and early seventeenth centuries. The surface of this Rosanjin piece has been textured to promote pooling of the glaze. This pooling has caused a modulated coloration which ranges to blue where the green glaze is thickest. This type is known as blue Oribe, or Ao Oribe ware. There is an unusual tinge of reddish brown color which perhaps results from the color of the body beneath the glaze.

Not perfectly square, nor really flat, the sides of the piece are slightly curved and the corners upraised. This effect creates a pleasing variation on the simple geometric shape and imparts an irregularity that reflects the basic attitude of the original Oribe wares.

Two parallel strips of clay are attached to the underside as supports.

WJR

103 E Shino Ware style square bowl
(yohō hira-bachi)

Stoneware with calligraphic design in underglaze iron brown and feldspathic white glaze, 6.8 x 29.8 cm., 2-5/8 x 11-3/4 in.

Iron brown *katakana ro* signature on underside

The vigorous shapes and evocative underglaze iron decoration of Shino tea wares of the Momoyama period served as inspiration for many Rosanjin designs (see No. 90). This square bowl bears a design recalling a large Roman numeral IX, a motif resembling the incised mark sometimes found on medieval stoneware jars (see No. 85). An ardent student of Japanese ceramic traditions, Rosanjin might have here translated an ancient artisan's kiln mark into a dramatic decoration. Such boldly calligraphic designs recall at the same time the artistry of modern calligraphers like the renowned Shinoda Toko.

The gradual loss of pigment as Rosanjin stroked the brush clearly reveals the movement of his hand. From the upper right, the large initial stroke came to approximately the center of the lower edge. A few dribbles of pigment trailed as he raised the brush to cross with the second stroke to the right. The final stroke closed the composition at the left.

In preparation to receive the decoration, a mould form was pressed into the slab of soft clay. A low ridge has formed about the edge of the bowl, indicating the presence of the mould. The bowl is only partially glazed underneath and rests directly on its underside.

WJR

104 Round dish with three feet
(ashi-tsuki sara)
Stoneware with decoration of wading heron in underglaze iron
brown and cobalt blue, 3.2 x 24.4 cm., 1-1/4 x 9-5/8 in.

Incised *katakana ro* signature on underside

Signature on box lid

PUBLISHED: Takekoshi Nagao, *Nyūmon Rosanjin no tōki*
 (Tokyo, 1977), p. 109.

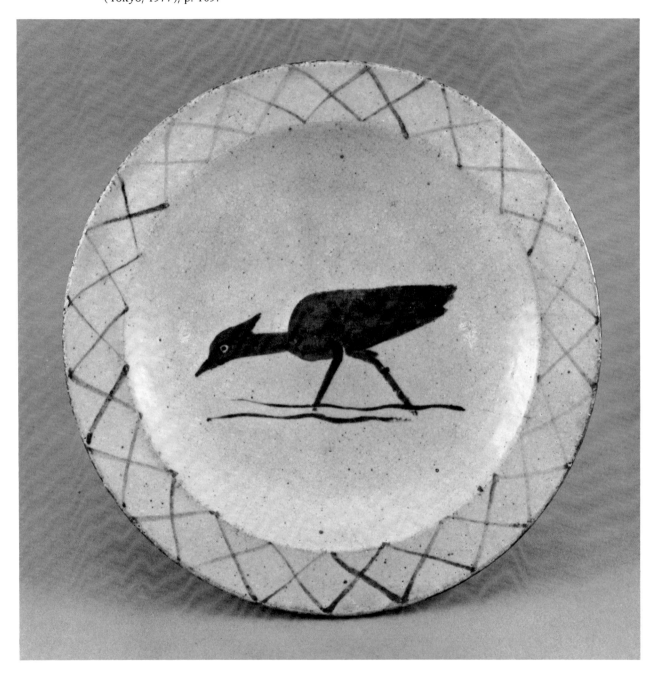

This simple, round plate of cream colored stone-ware bears the motif of a wading heron painted in underglaze cobalt blue. The broad, flat edge of the plate is marked with a crisscross pattern in underglaze iron brown. Shape, materials and colors, abbreviated images and rapid execution all suggest the essence of the late Edo period Seto ware *ishi-zara* (see Nos. 96, 97). These serving plates were designed for mass production and through an intuitive aesthetic, the decorators reached a striking modernity by reducing the motifs to their essential elements.

Rosanjin has brought to life again the directness and naivete of that earlier popular ceramic form. His eclectic spirit has allowed him latitude to include elements which are not strictly imitative of the *ishi-zara*, evoking the spirit rather than imitating, finding inspiration to create a new vision.

WJR

285

SCULPTURE

The earliest form of sculpture in Japan dates to the Jōmon period (ca. 8000-300 B.C.) and consists of figurines crudely fashioned from clay. The Jōmon people were supplanted by the Yayoi (ca. 300 B.C.-300 A.D.), a race from Korea who brought a more developed agricultural society with technically advanced pottery forms. During the Tumulus or Kofun era of the fourth and fifth centuries A.D., pottery techniques were utilized in producing *haniwa* (No. 105), which were placed on top of the huge tombs built for royal burials. Unlike Chinese tomb figurines, which were buried within the tombs to propitiate the spirits of the dead and to serve them in their afterlife, *haniwa* were placed so that they could be seen by the living, and thus represented a bridge between the world of the dead and the everyday world. Made of unadorned baked clay with a simplicity of design and directness of expression, *haniwa* already suggested the artistic strengths of later Japanese arts.

The introduction of Buddhism during the sixth century had a profound impact on Japanese art and culture. Buddhism was recognized as a unifying force which could help achieve national goals, and it was officially endorsed by the state. In less than one hundred years, it became firmly established as the dominant religion of Japan, and to this day Buddhist philosophy continues to be an important element in the beliefs and aesthetics of the country.

The adoption of Buddhism created the need to produce images and temples to house them. Buddhist establishments became major patrons of the arts, and from the seventh to the eleventh centuries, there are few surviving works of painting or sculpture in Japan that are not Buddhist in inspiration. The historical Buddha Sakyamuni had preached the idea of renunciation of passions, the ultimate goal being to achieve *nirvana*, the transcendent state in which all psychic and physical ties to the world are broken. However, by the time Buddhism reached Japan it had become a religion of the masses. Along with the historical Buddha there arose a pantheon of other Buddhas and subordinate deities who could be called upon to offer aid to the supplicant.

Early Japanese Buddhist artistic trends followed Chinese styles which had become the models for the whole of East Asia. However, by the ninth century, Japanese borrowings from China had decreased considerably, and native customs and traditions gradually returned to favor. During the Heian period (794-1185), Japanese art began to exhibit native sensibilities and took on pronounced Japanese characteristics. One feature of the Japanization of Buddhist sculpture was the increased use of wood, exemplified in the standing image of *Jizō* (No. 106). Wood had rarely been utilized in India and China, where images were usually made out of stone, clay, lacquer or bronze. An example of a lacquered wood image is the *Eleven-Headed Kannon* (No. 107), one of the most popular Buddhist deities of salvation.

It is often stated that the Japanese turned to wood because it was less expensive than bronze or lacquer, but they have always had an affinity for its natural beauty. This love of wood is also seen in early Shintō shrines, built and periodically rebuilt of unadorned logs and planks of cypress and pine.

Shintō is a form of nature worship considered to be the indigenous religion of Japan. The objects of Shintō worship were the spirits of dead ancestors and of certain powerful living men, as well as deities thought to inhabit rocks, streams, trees and mountains. Called *kami*, Shintō deities were believed to represent the awesome and mysterious natural forces. In time, the various cults of local deities became integrated through an official mythology which proclaimed the descent of the imperial dynasty from the Sun Goddess.

The foreign religion of Buddhism differed significantly from the native Shintō tradition, but it was able to absorb cults of native gods, and Shintō deities gradually came to be regarded as local incarnations of Buddhist gods. Shrines were often built and dedicated to certain deities, but anthropomorphic representations were unknown in early Shintō. The amalgamation with Buddhism provided a strong stimulus for the portrayal of Shintō deities in human form, and provided the stylistic and technical models as well. However, Shintō sculpture developed unique characteristics of its own, exemplified in Nos. 108 and 109. Made of wood, these images retain the natural strength and solidity inherent in the tree trunk from which they were carved.

Both Shintō and Buddhism have continued up to the present day as viable religions in Japan, but there were few new developments in sculpture after the thirteenth century. Images continued to be commissioned by temples and shrines, but were patterned for the most part after traditional models; the great age of Buddhist sculpture was now over.

PF

105 Haniwa: Standing Warrior 5th or 6th century

Low-fired clay with traces of paint, 64.5 cm., 25-3/8 in.
PUBLISHED: *New Orleans Collects,* (New Orleans Museum of Art, 1971), no. 289.

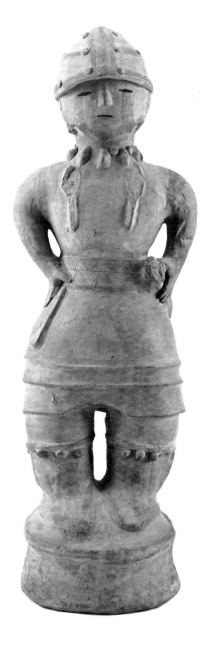 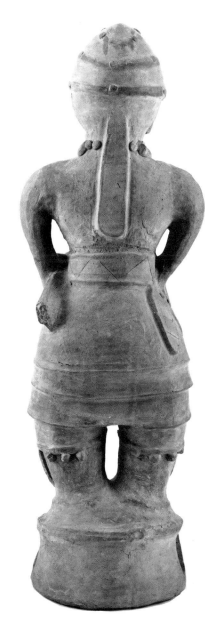

The Kofun period (ca. 300-600 A.D.) is so named for the large *kofun* tombs, many constructed in a unique keyhole shape, which were built for clan leaders. *Haniwa* figures were placed on mounds above these tombs, and they have fascinated viewers and puzzled historians ever since. It was once thought that they might have been influenced by Chinese burial ceramics, but the differences in both style and placement suggest that there was little connection. The more elaborately fashioned Chinese grave goods were placed within the tombs, to serve and placate the spirits of the dead. *Haniwa,* on the other hand, were placed above ground, usually along the edges of the huge tomb-sites. At first plain cylinders of low-fired clay sufficed, but gradually they developed into simple but evocative shapes of houses, boats, and then animals. Finally human forms were crafted such as the figure seen here.

One theory is that these figures were intended as guardians of the tombs, but if that had been their purpose, it seems unlikely that houses, boats and animals would have preceded the appearance of human forms. Furthermore, although many of the human figures are warriors, one may also see *haniwa* women, musicians and dancers. Perhaps these figures were a form of communication between the living and the dead, but whatever their meaning was when they were made, they still communicate an informal but profound artistry to viewers today.

The figure of the standing warrior in the Gitter

collection is complete with helmut, armor and a short sword![1] Diagonal lines have been incised in double layers on his belt, and there are traces of a natural paint on his cheeks, chin, helmet and arms. His toes are simply marked with incisions, and he is adorned with a necklace and anklets. Comparing his attire with that of other *haniwa* soldiers, we may deduce that he represented a middle-level warrior of his day. He stares out at us with a steady gaze, his hands at his waist ready for action. The very simplicity of the treatment allows for great expressivity; through the hollow areas for eyes and mouth, slightly asymmetrically placed, we are able to see inside the human forms to the inner void. Thus *haniwa* may have had some magical relationship to death in the midst of life.

Several features of *haniwa* also appear in later Japanese art, reflecting native aesthetic sensibilities that emerged in many different forms through the centuries. First, there is a simplicity of technical means rather than elaborations or ostentation. Second, there is a respect for the natural materials, so that the unglazed figures can be clearly seen as baked clay from the Japanese earth. Third, one may see an interest in everyday life rather than universalized or idealized forms. Finally, the viewer is given the opportunity to complete the artistic experience rather than every detail being carefully depicted. Because of the simplicity of treatment, the forms still resemble the cylinders from which they were constructed. Despite the uncertainties regarding the purpose of *haniwa*, we can experience their natural artistry from an age before the advent of Buddhism, a writing system, and advanced culture from abroad had changed the face of Japanese society.

SA

[1] A thermoluminescent test of this piece, done on April 14, 1977 by the Research Laboratory for Archaeology and the History of Art, Oxford, England, indicated that it was last fired between 1110 and 2140 years ago. Therefore the warrior was made between 163 B.C. and A.D. 867.

106 Jizō 12th century
Wood with color, 49.8 cm., 19-5/8 in.

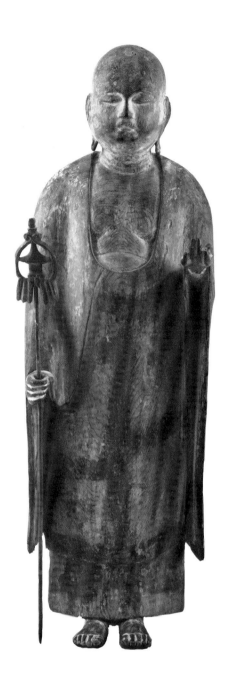

One of the most appealing deities in the pantheon of Mahayana Buddhism who assisted in directing mankind on the path to salvation was Jizō (Sanskrit: Ksitibarbha). He is referred to in religious documents and sutras as early as the eighth century, and by the following century he was placed among a select group of bodhisattvas in the Esoteric Buddhist tradition. In that position he appeared as an attractive, but rather arcane deity, who signified the complementary nature of Earth and Void.

Consequently, Jizō's fundamental role as an intermediary illuminating the path to Nirvana became obscured in Esoteric doctrine. Later, in the eleventh and twelfth centuries when worship of Amida, the

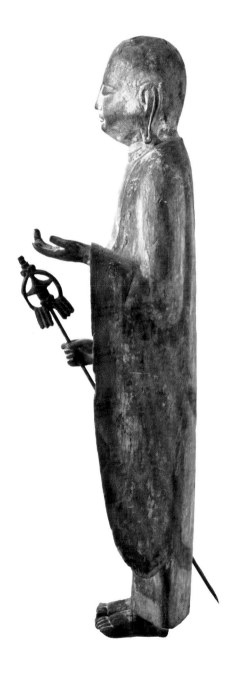

Buddha of the Western Paradise, attained widespread popularity, Jizō retained his place as a deity concerned with man's salvation, but also became associated with a specific range of maladies for which he provided cures or protection upon the proper invocation of his name. He was especially worshipped by women and travelers, and was viewed as the most efficacious protector of children, particularly in the Kamakura era. Then his appearance as a young monk with shaven head, often holding a walking staff, began to change, with increasingly realistic features being incorporated into the figure's quiet, idealized beauty—a tendency just visible in this image. The extended left hand at one time held a jewel symbolic of his ability to

answer sincere petitions for help. The monk's staff with six dangling rings topped by a small pagoda (tahoto) serves as a warning of his approach, both to accept alms and to warn creatures away that might be stepped on. The six rings refer to his position as an intercessor in the cycle of the six realms of existence (rokudō), a concept familiar among popular Buddhist sects of the Kamakura era.

Traces of pink, red, black, green, and white pigments remain of the once colorful garment designs on the otherwise simply carved surface. In addition, there were gold designs over lacquer that are now essentially lost. Originally such lavish decoration would have served to softly illumine the graceful image with

107 Eleven-Headed Kannon 13th century

Lacquered wood with gilding, 39.4 cm., 15-1/2 in.
PUBLISHED: *New Orleans Collects,* (New Orleans Museum of Art, 1971), no. 291.

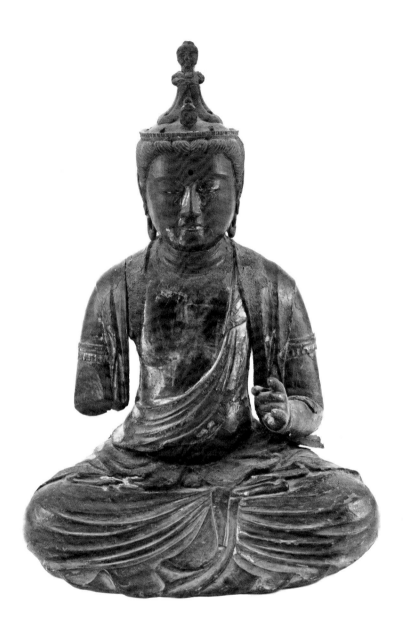

boyish, pale face and enhance its visibility in a subdued interior setting. Its single-block construction (*ichiboku-zukuri*) and the figural style and gesture point to a Fujiwara era date, probably in the twelfth century, and suggest a provenance of Shiga or Mie prefectures. Its diminutive size and traces of its original tasteful decoration indicate that it may once have graced the private chapel of a nobleman's home rather than a temple sanctuary.

The increasingly receptive enthusiasm given Pure Land Buddhism in the later Heian and early Kamakura periods occurred both in populist and aristocratic circles. Judging from extant examples, representations of Jizō in sculpture, and then painting, proliferated rapidly, many of them small scale with lavish materials. This suggests their use as private objects of

worship, whose efficacy as guides to salvation in the Western Paradise enjoyed widespread aristocratic support, both at home and in the monastic institutions to which they were donated.

Another deity who enjoyed considerably even greater popularity than Jizō in Buddhist history is Kannon (Sanskrit: Avalokiteśvara), a major bodhi-sattva of salvation who possessed many forms. One of these in Esoteric sect teachings, which flourished in the ninth and tenth centuries and was revived again in the thirteenth-fourteenth, was the Eleven-Headed Kannon. This image is unusual in that it is a seated form of the deity. Only two of the subsidiary heads which were attached to the headdress are still intact, but traces of the remaining heads indicate their former placement. All apparently shared the main

292

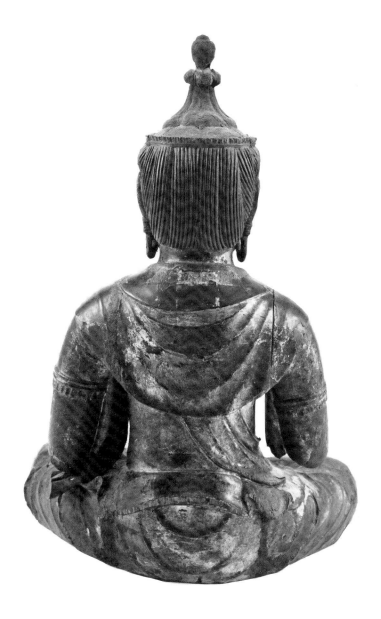

figure's benign countenance rather than exhibiting the more particularized expressions consistent with specific esoteric doctrine as can be seen in earlier Heian examples of the deity.

Originally the left hand of the image held a vase containing a lotus flower and bud, symbolic of Kannon. The right arm extended down and forward across the lap either with the palm upward, fingers extended in a welcoming *mudra*, or with some of the fingers curled to grasp a string of prayer beads. The image is constructed with a joined-wood block (*yosegi*) technique over which lacquer and then gilding were applied, giving it a patina characteristic of Kamakura sculpture. Painted crystal was inserted from the back of the head to fashion life-like eyes and a crown of intricate metalwork once encircled the head above the bulging hair curls.

Judging from its present appearance, this Eleven-Headed Kannon can reasonably be considered a fine, early Kamakura era revival of Fujiwara sculptural form and style, perhaps from the Nara-Ōsaka region. By that time it had likely become the central image of worship at a local temple rather than an ancillary deity, part of those magnificent early Heian sculptural mandalas now so few in number.　　　MRC

REFERENCES:

Bunkachō, ed. *Jūyō bunkazai*, vol. 3 (sculpture), part III (Tokyo, 1973).

Bunkachō, ed. *Kaisetsuban shin-shitei jūyō bunkazai*, vol. 3 (Tokyo, 1981).

Tokyo National Museum. *Kamakura jidai no chōkoku* (Tokyo, 1975).

108 Male Shintō Deity late 10th century
Wood with traces of color, 87 cm., 34-1/4 in.

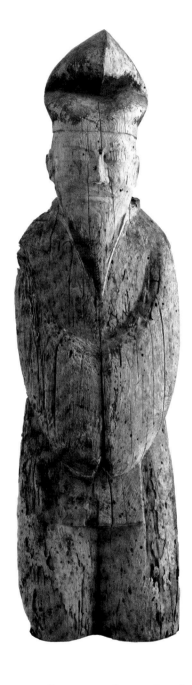
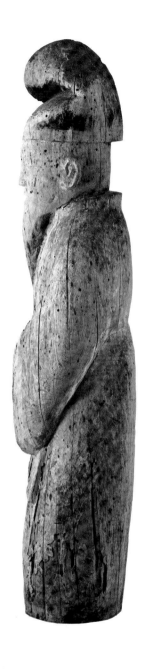

Shintō originally possessed no ordered system of visual images other than such natural forms as mountain sanctuaries, trees, or rock clusters, which were designated as tangible repositories for the religious beliefs, folk traditions, and social-political attitudes particular to local culture which constituted early Shintō thought. So far as is known, objects of worship in anthropomorphic form simply did not exist.

Certain relics identified with the Emperor and his family were eventually fashioned to enhance their political struggle towards national stability. These were placed in special buildings which were erected following architectural principles already extant in domestic housing and in modest provincial shrine

structures constructed to identify the presence of Shintō deities (kami). While these kami were thought to be in residence in these shrine enclosures, they were not visible until Buddhism's surging influence convinced Shintō officials that image-making would be appropriate. Evidently the Buddhist clergy was consulted for advice, since most techniques of carving, sculptural style, and even iconography are shared by Shintō and Buddhist imagery.

However, these two standing figures exemplify the diversity found in Shintō sculpture, particularly when it can be identified with shrines located outside the metropolitan Kyoto-Nara area where highly sophisticated Buddhist sculptural studios flourished. Both

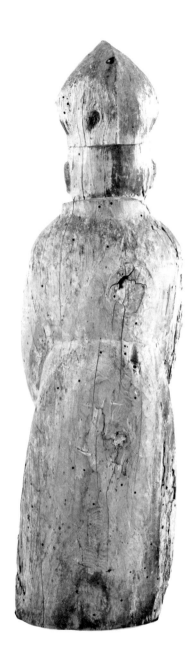

pieces are crafted from single blocks *(ichiboku-zukuri)* of specially selected wood which is thought to have been cut from trees in local sanctuaries related to the eventual installation site of the image. The fact that the wood of both figures has deteriorated so badly can be traced to their customary treatment as hidden, secret images *(hibutsu)*, seen only infrequently by shrine priests in poor light. Thus the effects of insect infestation and falling water from leaking roofs have removed most of the original polychromy, rendered limbs useless, and eroded sharply chiselled facial features.

For some, these conditions serve to enhance the raw, aged character of the wood, instilling it with such

109 Standing Shintō Figure late 10th century

Wood with traces of color, 101 cm. 39-3/4 in.
PUBLISHED: Huntsville Museum of Art, *Art of China and Japan* (Huntsville, AL, 1977), no. 283.
PROVENANCE: Howard Hollis Collection

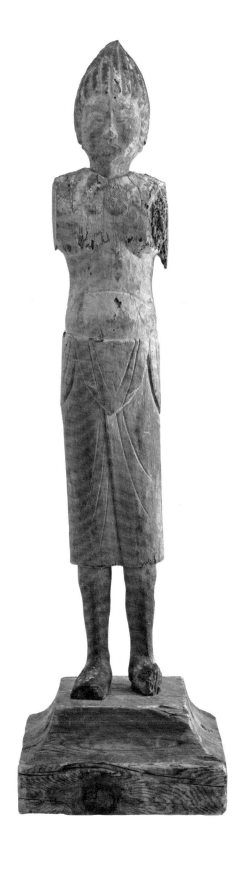
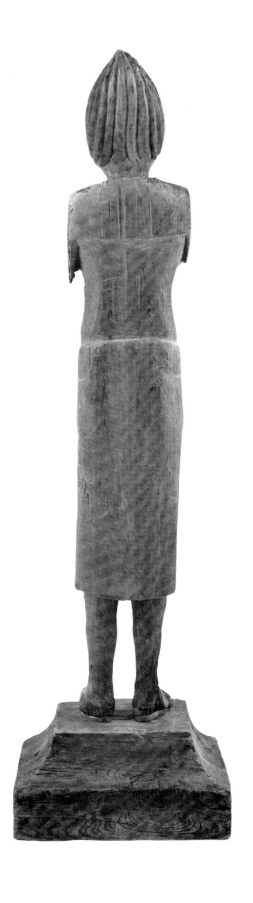

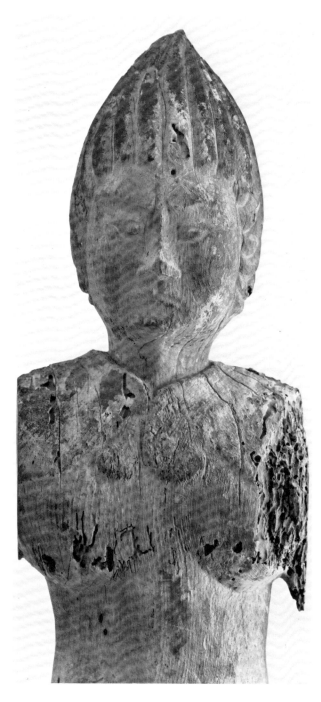

particular shrine *kami*. In this instance it is preferable to consider this figure simply as a male deity. Based upon sculptural style, it may tentatively be considered the product of a fine provincial sculptor from the Tōhoku area northeast of Tokyo where such images occur in Iwate prefecture at the Matsuoyama Kannondo and Manzō-ji. A Heian era stylistic dating is corroborated by radiocarbon data placing the material in the third quarter of the tenth century.

Identical analytical testing of the other standing figure places it in the same time frame, a fact traditionally expressed by owners of analogous images in the collections of the Royal Ontario, Honolulu, Brooklyn, Philadelphia, Chicago, and Cleveland museums, and by private owners in Japan who all suggest later Heian to early Kamakura dates for the icons. Although questioned by some art historians, clearly all the images bear distinct stylistic resemblances and are most likely members of one or more cult groups, now dispersed, which originated from the region southwest of Tokyo centering on the Izu domains. The planar surfaces of this image, with its summarily chiselled linear patterns and flat triangular-shaped drapery forms, may be seen in Buddhist and Shintō sculpture from the Kantō area south to Kamakura and beyond to Shizuoka and Nagano prefectures. They were produced over a period of approximately two hundred years.

The stark columnar torso with facial expressions organized about a prominent nose and thinly outlined eyes, and eyebrows capped by voluminous headgear or hair configurations, can be linked to images of varied iconographical subjects, both Shintō and Buddhist, in these areas. Indeed this intriguing sculptural tradition possesses roots in the syncretic *(suijaku)* visual manifestations of these two beliefs, particularly in Buddhism's esoteric sect concepts. Metal votive images of Zaō Gongen, which continue into the thirteenth century as *hibutsu* associated with temples located in a number of remote mountainous areas, provide apt sculptural sources. Their potent, symbolic character and highly idiosyncratic appearance can also be seen invested in this Fujiwara period image whose identity remains an enigma.

MRC

natural character as befits Shintō, rather than Buddhist ideals. This is particularly evident in the pensive bearded figure who stands with hands clasped beneath generous sleeves. His attire is courtly, identifiable both through his robes and the large, floppy-looking hat which in fact was a stiff black hat of lacquered gauze. It still retains some of its color as do portions of the triangular beard, another aristocratic trait of the Heian era clans.

Many other seated images of this period exhibit similar general features, but few depict such a robust, erect sculptural form virtually devoid now of the crisp sinicized court demeanor so prevalent in these male Shintō images. These images were on occasion termed cult images of Tenjin (Sugawara Michizane 845-903), a famous courtier intimately associated with Shintō history, or more interestingly, the cult image of a

REFERENCES:

Kageyama Haruki. *Shintō bijutsu*, vol. 18 of *Nihon no bijutsu* (Tokyo, 1967).

Kuno Takeshi. *Kantō chōkoku no kenkyū* (Tokyo, 1964), pl. 16, p. 197 and pl. 62, pp. 319-320.

Kuno Takeshi. *Tōhoku kodai chōkokushi no kenkyū* (Tokyo, 1975), pls. 157-163.

Maruyama Naokazu. *Chihōbutsu* (Tokyo, 1978).

Nara National Museum. *Suijaku bijutsu* (Nara, 1964).

Shimizu Zenzō. "Japanese Sculpture in American and Canadian Collections," *Bukkyō geijutsu*, no. 126, 1979.

Tokyo National Museum. *Heian jidai no chōkoku* (Tokyo, 1971), pls. 75-82.